Modeled Portrait Sculpture

Modeled Portrait Sculpture

by Louis E. Marrits

South Brunswick and New York: A. S. Barnes and Company
London: Thomas Yoseloff Ltd

© 1970 by A. S. Barnes and Co., Inc.
Library of Congress Catalogue Card Number: 75-81673

A. S. Barnes and Co., Inc.
Cranbury, New Jersey 08512

Thomas Yoseloff Ltd
108 New Bond Street
London W1Y OQX, England

Jacket Illustration:
RODIN, by Antoine Bourdelle
(1861–1929).
Courtesy of Roger-Viollet,
Paris

SBN: 498 07456 0
Printed in the United States of America

To my dear wife Cecelia,
whose interest and encouragement
in my efforts
have been
a
real
inspiration

Contents

Acknowledgments

Modeled Portrait Sculpture provides many selected quotations from the books listed below, in addition to the comprehensive text written by the author. In this expanded way, this book can be used profitably for a study of *comparative* techniques, procedures, and principles in the modeling of portraitures in clay and plasteline. What the author, or any one of the accomplished authors whose quotations are found in this volume, has to say is significant; what any two of us have to say is that much more helpful to the reader; what all of us have to say collectively is indeed more meaningful, particularly to the aspiring sculptor to whom this book is directed. The professional sculptor, too, will find this book refreshing in its presentation.

To the authors on sculpture, and their publishers, my deep thanks for the use of their informative material on sculptural techniques, procedures, and principles. My deep thanks also to the authors, and their publishers, on drawing/painting of portraits, and on anatomy, whose instructional data in part have application to the modeling of sculptural portraitures.

Sculpture

1. *Modelled Sculpture & Plaster Casting*
 ARNOLD AUERBACH
 Thomas Yoseloff, New York, 1961
2. *Fun and Fundamentals of Sculpture*
 MARJORIE JAY DAINGERFIELD
 Charles Scribner's Sons, New York, 1963
3. *Sculpture—Techniques in Clay, Wax, Slate*
 FRANK ELISCU
 Chilton Company, Philadelphia, 1959
4. *Modelling & Sculpture*
 FREDERICK JAMES GLASS
 Charles Scribner's Sons, New York, 1929
 B. T. Batsford, Ltd., London

The Author acknowledges with much appreciation the assistance of the National Sculpture Society, New York, for making available the two eminent sculptors, Mr. EvAngelos Frudakis and Mr. Edward Fenno Hoffman III, whose reviews of *Modeled Portrait Sculpture* appear on the jacket.

Grateful appreciation is extended to:

Mr. Robert Barnes who reviewed the "Lost-Wax" method in the chapter "Bronze Casting," and who made suggestions for an elementary presentation of this bronze casting process. Mr. Barnes maintains a commercial sculpture casting workshop in Lambertville, New Jersey.

Mr. Charles L. Wilson, Vice-President of Spencer Industries, Inc., Philadelphia, Pennsylvania, for his review of the "Sand-Mold" method in the chapter "Bronze Casting," and who made suggestions for an elementary presentation of this bronze casting process.

Mr. Pietro G. Carolfi who reviewed the chapter "Plaster Casting by Waste Mold," and who made suggestions for a detailed understanding of the plaster casting process. Mr. Carolfi maintains a commercial workshop for plaster casting, and other types of molds and casts, in Collingswood, New Jersey.

Mr. George Revak of Cinnaminson, New Jersey, for his excellent art work that so clearly illustrates the text of this book.

My deepest thanks to the National Sculpture Society, museums, art galleries, collections, artists, and photographers whose wholehearted cooperation made available for reproduction the photographs in "A Gallery of Portraits."

I express my debt to the many museums I have visited, whose existence makes possible knowledge of sculpture and other forms of art that I, like many others before me and others to come, have learned from them.

I express my debt to all those persons who have afforded me encouragement in the development of this book, and who have helped to make it a labor of love.

Louis E. Marrits

Philadelphia, Pennsylvania

Introduction

Modeled Portrait Sculpture is a book which discusses the basic techniques and principles, tools, equipment, and materials used in the modeling of portraits in clay and plasteline in preparation for their eventual casting into metal bronze.

Since almost all of the books on sculpture deal with more than one aspect of sculptural art—portrait, figure, animal—and also deal with a wide variety of materials and processes in a one-volume presentation, their authors must, of necessity, limit their information and instruction on any one of its aspects. Obviously, their informative and instructional data on the modeling of portraits is abridged, being circumscribed by the limitations of the single volume. This author, in *Modeled Portrait Sculpture,* seeks to make up for this loss by dealing as comprehensively as possible with only one subject—portraits—and only in the clay and plasteline mediums.

For the earnest beginner working alone without benefit of teacher instruction, for the ambitious amateur who wishes to explore beyond beginning experiences, for the student who wishes the written word as a companion to classroom instructions, for the non-professional sculptor who seeks further technical knowledge, I believe that this "what-to-do" and "how-to-do" book will be extremely helpful. It gives the aspiring sculptor who is uncertain of himself a chance to compare his own problems with the experiences of others. In this helpful way, he will be acquiring a sound technical basis for his own work, giving him confidence to do his job as expertly as possible in this all-absorbing art form.

The basic techniques and principles, tools, equipment, and materials used here in the modeling of portraitures in clay or plasteline are presented in highly informative detail in order to give the aspiring sculptor a substantial knowledge of the modeling processes, and subsequent steps on the way to eventual casting in metal bronze. To that end, the text is clear and to the point. It has been arranged in step-by-step sequence, and in compact divi-

13

sions for brevity and clarity. It succinctly and tangibly sets forth in simple terms—perhaps oversimplified in places—the fundamental and time-tested principles involved, and which lend themselves to immediate use and practical application for good sculpture.

May I say at this point that, while the techniques and principles, tools, equipment, and materials of sculpturing portraits dominate the text, it is to be understood that technical knowledge and skills are never an end in themselves, but only a part of the sculptor's expression of an idea. It is the mechanical side of the language he speaks, and which cannot be separated from the creative process. If the aspiring sculptor is to succeed at all, he must have a well-understood knowledge of the sculptor's craftsmanship before he can assimilate it into the creative process. With this technical knowledge, the aspirant becomes aware of the required craftsmanship that goes into the making of a good sculptural piece—methods and procedures that have emerged from long tradition. Fully sought for and absorbed at the outset, a great deal of lost time, frustration, and heartbreak can be avoided.

My own sculptural experiences in modeling portraits in clay and plasteline, closely and sympathetically related to the problems of others like myself, are here set down, not to take the place of the sculptor-teacher (for no text can replace the personal guidance of the sculptor-teacher in private class or art school), but to present the experiences of a non-professional, addressing himself to those developing sculptors who are having trials and tribulations in their quest for sculptural knowledge. I particularly have in mind those who cannot afford private instruction, or cannot conveniently, for one reason or another, attend classes in the art school or art center—those who are trying to learn by themselves, who must work at home, and who must fall back on the written word for the guidance it can offer them. Modeling portraits in clay or plasteline is a convenient way for such individuals to acquire sculptural training, for they have available at all times, in addition to easily purchasable material, a member of the family or a good friend who will sit for a portrait. They can thus train themselves at home, without waiting for the advantages of a formal class where professional models are available for portrait—or figure—studies.

It is my sincere belief that the written word in *Modeled Portrait Sculpture* will make a contribution to the learning efforts of all aspiring sculptors, providing them with another pass-key, as it were, to unlock the doors through which they may come to glimpse at least one aspect of sculpture—that of modeling heads and portrait busts in clay and plasteline for eventual casting into metal bronze. If such individuals, through reading this book, will have acquired a better understanding of sculpture, will have been encouraged to develop their own initiatives and disciplines, if it

will have inspired their creative urge, then this labor of love will not have been written in vain.

I am old fashioned enough—making no apologies for it—to add this point of view: that, notwithstanding new developments and modern trends in sculptural art forms, and which open up new materials and techniques for the aspiring sculptor to learn and conquer, his first training need is to have a thorough knowledge of the representational side of sculptural art—the ability to learn and recreate from nature and life. He should first be able to interpret literally the physical appearance of the object or person being modeled, before moving on to abstract and stylized departures from representational art form. Portrait sculpture, which by its very nature does not permit much deviation from representational forms, is indeed a very necessary first source for sculptural knowledge; and a very inspiring and absorbing art form it is, to say the least for it.

In addition to my own comprehensive contribution, this volume also makes available to the reader selected quotations from the writings of certain accomplished sculptor-authors, also selected quotations from authors on drawing and painting of portraits, and from authors on anatomy, whose material has application in part to the modeling of portrait sculpture. The names of these authors and their books are listed in the Acknowledgments and Sources of Selected Quotations. I take this opportunity to thank them and their publishers for their informative material. All the information and instructions in this book are time-tested and time-honored, and offer *comparative* guidelines in modeling portraitures in clay and plasteline. The reader will find it extremely beneficial to *compare* respective ideas and instructions—to place each point of view side by side. The net benefit, through such collective counsel, will give him a broader understanding of this form of sculptural art. Even though one or more of us makes the same point on any given subject, just saying it differently will give clearer emphasis to the idea or instruction. A divergent point of view, if any, may be better understood by the reader, and put to more effective use by him. All of which makes the range and diversity of the accumulative information more meaningful than would be the case in individual presentation. The reader should find these *comparative* ideas and instructions a firm foundation to stimulate him in his creative efforts. The professional sculptor, too, will enjoy its refreshing presentation.

Modeled Portrait Sculpture

1

What Is a Portrait
in Sculpture

A sculptural portrait in clay or plasteline represents more than the making of a head and its features. It is more than the making of a map of someone's physical likeness, for physical likeness alone falls into the category of a photograph. If we are to use the word "likeness" for descriptive purpose, the sculptural portrait must be a "likeness" in the fullest sense of that word, i.e., a unity of all of the individual characteristics of features, expression, personality, and spiritual essence of the sitter. The sculptural piece must arouse in the onlooker a feeling for the visual and inner qualities that distinguish the particular individual. Only then is the interpretative work a "portrait" of your sitter, rather than a photograph.

The sculptor has an extremely difficult problem, but an endlessly fascinating one, in his interpretation—four-fold in concept:

(1) He must transfer to the clay or plasteline those individual characteristics that distinguish the sitter's physical appearance from that of any other person, and which, unmistakably belong to him, and to him alone. It must be a strong resemblance, yet not the detailed "speaking likeness" of a photograph.

(2) He must show convincing evidence that he has not only interpreted the outward resemblance, but that he has captured the sitter's most natural characteristic expression or "look" (subtle and elusive, to be sure) which at that moment manifests itself or symbolizes itself in his thoughts, feelings, and moods, and which is most likely to identify him by others.

(3) He must capture the sitter's personality—that which gives the sitter his individual, personal distinctiveness, the singularity of his person. If likeness of features, and that of expression, is

19

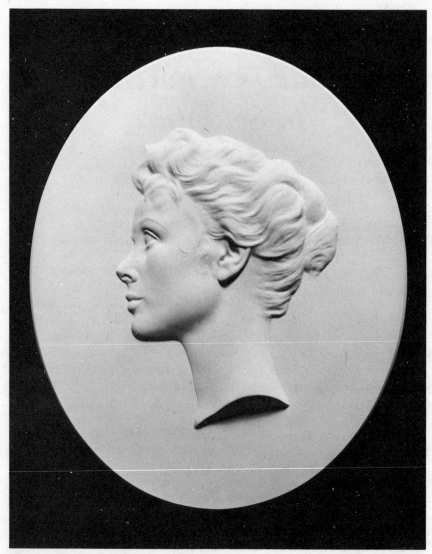

PRINCESSE GRACE DE MONACO, by Agop Agopoff. *Courtesy of the National Sculpture Society, N.Y.*

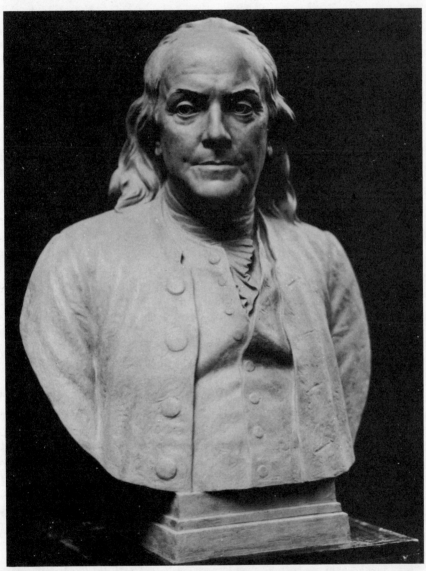

BENJAMIN FRANKLIN, by Robert Ingersoll Aitken (1878–1949). *The Hall Of Fame For Great Americans at New York University.*

convincingly described, a great deal of the personality of the sitter will emerge.

(4) Finally, the sculptor must seek to express the spiritual essence of the sitter by capturing in the portrait the most elusive of his objectives—the "inner spirit." It is this spirit which animates the overall image of likeness in the features, expression, and personality, giving the three-dimensional sculptural interpretation a manifestation of life or "soul"; this is a must since, in a sense the sculptor is recreating the sitter's life. The portrait is a biography of the sitter, and it is this unfolding of the inner spirit that gives the sculptural portrait a full measure of artistic merit which truly makes it a work of art.

The sculptor must start his search for all of the character elements beneath the surface appearance at the beginning of his work, even beforehand, if possible; he must learn something of his sitter's background, his feelings and emotions, his ambitions, etc. He must gain an insight into every thing of interest and value about the sitter so that the sculptural interpretation can be made with authority. To that end, the sculptor must establish a warm, relaxed, and sympathetic relationship with the sitter. All of this is possible if the sculptor has a passionate interest in sculptural portraiture, if he makes this special form of sculpture his means of artistic self-expression. If his work reflects an enthusiasm for this form of artistic expression, if he treats his efforts as an adventure in re-creating life, if he disciplines himself to go through with his objectives to the end, then the sculptor has the necessary qualifications for success in this demanding profession.

It is evident that the making of a sculptural portrait represents more than craftsmanship—the skillful knowledge of procedural techniques, and the handling of tools, equipment, and materials— even though good craftsmanship plays an important part in the creative process. The making of a portrait in clay or plasteline for eventual casting into metal bronze is a dedication to sculptural art in one of its highest forms, for a portrait with its harmony of form through unity, simplicity, proportion, balance, rhythm, etc., is indeed a true work of art. It is said by many artists that the highest expression of art is found in the face. This is as true of sculptural portraits as it is of the painting of portraits on a canvas.

To the average person, a sculptured head is a realistic likeness of someone—a recognizable portrait of someone he knows. To the artist, a sculptured head is registering in permanent form not only the likeness, which is surface resemblance, but the spirit and sculptural character of the person.[13]*

There must be a common sympathy or understanding between the sitter and the artist for it is not, as often believed, only three dimensions that

* See "Sources of Selected Quotations," Page 368.

are demanded of a portrait, but four, and this fourth one is the psychological atmosphere of the personality which must add expression and character and the endless variations of mood.[6]

A well composed portrait is good when it is a personal expression, regardless of the style and degree of realism.[9]

Let us take the spirit behind the form in sculpture portraiture. What is a portrait bust? It is not a mask; it is not a mechanical copy of a person's features. No! A portrait is a composite of the interpretation of the features, and the interpretation of the personality of the sitter, by the sculptor. I am really still old fashioned enough to think or believe that a portrait should look like the person it is supposed to represent, and I am not strange enough to try to startle people by advocating the making of a portrait which would represent only the personality of the sitter. In my opinion, a good portrait bust should be a resemblant. The artist searches carefully to discover the expression most natural to the person whose portrait is to be made. A certain tilt of the head, the least alteration at the corners of the mouth or the eyes, a slight lifting of the eyebrow—all combine both the features and the personality. Some times the way a portrait is "treated," or the final "finish" it is given, will emphasize the strength or the sweetness of the model. It is in the search for the best sculptural way of modeling—that elusive thing called "personality," that the artist will find the greatest joy, for that is the spirit behind the portrait.[10]

2

The Joy of Sculpturing

In doing portraitures in clay or plasteline, the aspiring sculptor will find nothing more arresting than the human head, and the variations that give each portrait its special likeness of features, expression, personality . . . yes, even an inner spirit. It can be as intensely interesting as any other aspect of sculpturing. You will never tire of the endless lines, shapes, and forms of the head construction and its features—each head surprisingly like no other. While the basic forms are similar, the variations run into countless numbers, each one different. You will never grow tired of trying to capture your sitter's expression of the moment, his personality, and that most elusive of objectives . . . the inner spirit. An appreciation of these factors, and of the character and beauty that the head and face holds, is a pass-key to your creative progress, and will hasten your joy of doing sculptural portraitures.

All the joys of sculpturing portraitures are yours if you are willing to work. An acceptable portrait does not take so-called "artistic endowment." The skill can be acquired if you have deep interest in your work. It will take a lot of perserverance, to be sure. Competence is merely a matter of having faith in yourself and in your determination to succeed. You will fail only if you lack deep interest and perserverance. Don't be impatient—don't expect rapid advancement overnight. Don't hurry your expectations; the way to progress is by steadily plodding away. Enjoy every moment of your work as you go along; remember you are sculpturing for yourself—your own pleasure. Relax, especially if sculpturing is a pastime or hobby with you. Every portrait will be an exciting adventure. Your whole life will be richer.

I suppose that when your portrait is finished, it will not come up to your expectations—never equalling the vision you had in your mind when you started. It is this feeling of not being completely satisfied with your work that will keep you going—next time, you will say to yourself, you will catch a more expressive

likeness, etc., in your new sitter. Disappointment is always a sign of progress. When we are disappointed, even discouraged, it means that we discern the limitations of our work, and that we must look to fresh ideas on how to improve it. One must always be wary of being completely satisfied, for an artist who is completely satisfied no longer feels impelled to move forward. Unless one strives for progress, one invariably goes backward. In spite of your frustrations, sculpture can promise you the thrill of creation at all stages in the development of your piece, whether at the beginning when you are wrestling with the conception, or when the head structure is taking shape, or when the final features are being refined. Giving life to your conception—taking an inert matter like a piece of clay or plasteline and fashioning it into a portrait—will make you blissfully happy all through your creative effort. There is a feeling of great joy and excitement in seeing your creation unfold. This feeling will become more frequent as you learn more and more about a well-composed, expressive portrait, and which will be reflected in your work. There will be additional joy in visiting the private galleries and the museums where you will find great works to inspire you. Your appreciation of the works of others—past and present—will be one definite outstanding gain from your active participation in sculpturing. This added pleasure is denied those who have not put their hands to work in the art form, who have not had the feel of clay or plasteline in their hands, who have not enjoyed the thrill of seeing their creations unfold. Very few people, without this experience, get beyond a superficial appreciation of a piece of sculpture.

A word to the retired, to the elderly, to those who have been ill—take up sculpturing. Preoccupation with it—and this would be true of other arts like painting, etc.—will keep you so involved that you will have little or no time to dwell upon your troubles. Obviously, sculpturing—or painting, etc.—is no cure-all for illness, but physicians and psychiatrists have long recognized the thereapeutic value of the arts as an aid for recovery, and for staying well. As for the aged, it has been pointed up by art historians that age is no handicap for creative effort, if we are to judge by Michelangelo, Titian, Rodin, and the host of other artists who did their best work in advanced years. At any age, it will help you to relieve tensions, clear your mind of the cares of the day. It will give you a mental, physical, and spiritual uplift.

Forget the idea that you cannot sculpt, or paint, etc. These arts are not reserved for special people with special talents, or for the young. You need only try—and succeed!

Sculpturing in one of its many forms can be a natural outlet for all who like to work with their hands and to create forms out of solid substances. To share in the joy that working in sculpture can bring, it is only

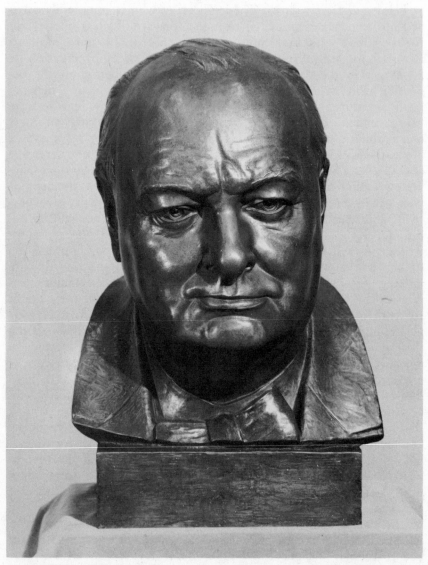

WINSTON CHURCHILL, by Bryant Baker. *National Portrait Gallery, Washington, D.C.*

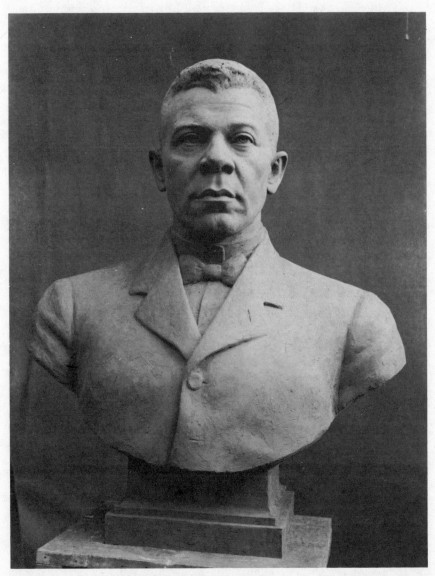

BOOKER T. WASHINGTON, by Richmond Barthe. *The Hall Of Fame For Great Americans at New York University.*

necessary to have the courage to work and the patience to try and make materials take on the form the imagination dictates. You who have the desire to model in clay, or carve in wood or stone, have a world of adventure before you. Through doing, you will come to understand the problems that other artists face. Through creating works of your own, you will come to know the beauty expressed by others. In every way your life will be enriched and your outlook broadened.[13]

It is a fantastic thing—possibly credible only among those to whom it has happened—how a person's total relationship to his environment is changed through the continued act of creating art. A creative outlet for the person growing older becomes more than fun—it can be a vital necessity. Creativity gives life a direction as any musician, artist or writer will agree. To creative, elderly people, age means nothing; you will never find senility among them. As a matter of record, for many artists (Titian, Michelangelo, Matisse, Carl Milles, Claude Monet, others) the most productive years have come toward the end of life. Creativity kept them active, and the totality of their experiences only increased their facility as they got older. Do not be afraid to begin. Do not be intimidated by any fear—or awe—of the word "Art." Remember that no artist ever started a piece of work with anything more than his two hands and an idea. You will discover that even a tentative excursion into the area of three-dimensional expression is a completely absorbing experience and one that may give your life a whole new direction.[3]

Psychologists and physicians agree that manual labor helps to readjust the mind to a balanced rhythm. The training of the hands to respond deftly to the mind is a distinct and joyful experience.[6]

You will feel like proud parents showing off your young when you present with shameless pride and delight a finished piece of sculpture that is all yours, created from your imagination and made with your own hands.[9]

Each new work upon which the sculptor embarks will hold forth the promise of successful and satisfying achievement. The end may be disappointment, bordering upon despair, for no real sculptor ever derived pleasure from his completed work. It is a will-o'-the-wisp which will elude him to the end of his days, ever beckoning but ever retreating. All this must be prepared for, but in the full assurance that if he faithfully serves the mistress to whom he has sworn allegiance, she will in her own way repay a thousandfold.[8]

3
Criticism

Concern for Client's Criticism

Epstein is quoted as saying that he rarely found a sitter who was pleased with his or her portrait; understanding was a rarity, also; and the sitter usually wanted to be flattered. He was often asked, "Can't you cheat a little" or "put in something" he had never observed. If the portrait sculptor is lured into making the sitter look younger, more handsome, or prettier as the case may be—improving on the original, so to speak—he is creating an idealized portrait rather than making a realistic statement. Pampering some relative's mental image of what the sitter should look like can have but one ending—an artificial result. The sculptor is under no obligation to please members of the sitter's family since no two persons in the family (or as a matter of fact, no two persons, related or unrelated) ever see the same person in an exact way. This is so because each individual, in addition to seeing with the eyes, "sees" with the mind, and with feelings and emotions that grow out of personal relationships. With relatives in particular, it seems that likeness, and likeness alone, is the paramount virtue of a portrait. No matter what other qualities the portrait possesses, they will not normally notice these qualities unless they are first contented with the likeness. This is apt to be true because their impression of the sitter's likeness is a very personal and sentimental relationship. Doting parents see their male offspring as handsome enough for any princess's hand, or their daughter as beautiful as any Miss America. Uncle Bill thinks that his favorite nephew has something of his good looks. Aunt Tillie thinks her niece to be her "spitting image" when she was young. These sentimental attitudes are hardly possible for the sculptor who must take a realistic view of the sitter and interpret likeness of features, expression, per-

29

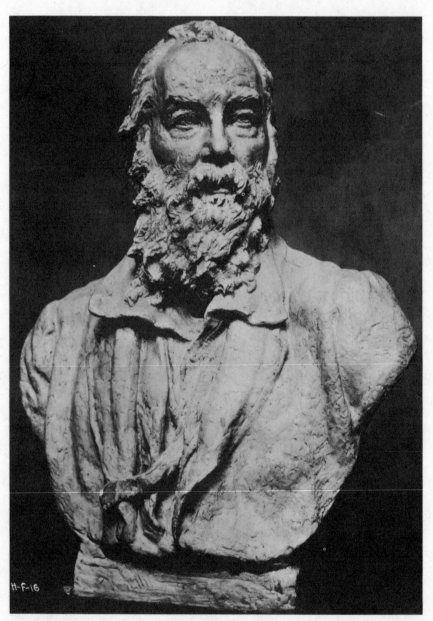

WALT WHITMAN, by Chester Beach (1881–1956). *The Hall Of Fame For Great Americans at New York University.*

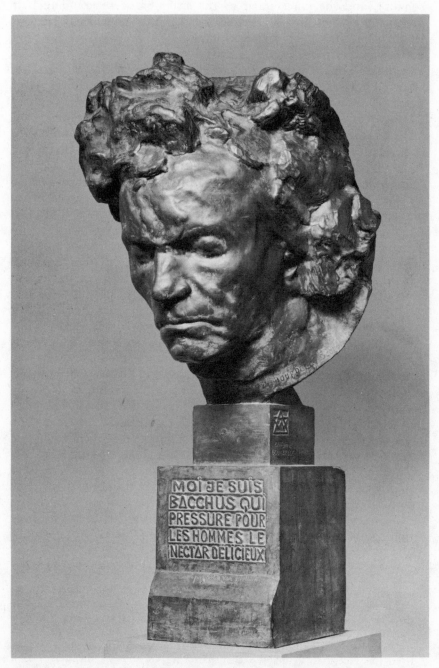

BEETHOVEN, by Antoine Bourdelle (1861–1929). *The Metropolitan Museum of Art, Rogers Fund, 1926.*

sonality, and the inner spirit of the sitter as he sees and feels it. The sculptor can possibly avoid much of this criticism if he were to restrain the sitter and his immediate family from accepting opinions of others, be they relatives, friends, business associates, or acquaintances, without making due allowance for the lack of artistic knowledge, temperament, favoritism, and prejudices which has much to do with the formation of individual opinion.

However, the sculptor, if at all possible, and providing it in no way compromises his artistic judgment, should be diplomatic enough to make any reasonable adjustment requested by the client. A minor change will not compromise him. Request for a minor change in a feature may grow out of the sitter's deep personal feelings about it and can make a great deal of difference in his pleasure or displeasure with the portrait. A portrait that displeases can cause a great deal of animosity toward the sculptor and his work. Perhaps the client's point of view has some merit, and may prove helpful. That much more is added to the client's appreciation when his point of view—his "contribution" to the portrait— is accepted.

However, if the client makes an unreasonable demand, for example, requesting the elimination of a very obvious double chin, the sculptor would be well within his rights to refuse the request and to model the double chin in all honesty as an essential physical characteristic. If the client continues to be displeased with the sculptural portrait, the sculptor should not attempt to force an unwanted one upon his client; rather, he should advise his client that if he is not satisfied with the work, he is under no obligation to purchase it. A cooling off period is always recommended . . . in time, all the interested parties may have a change of mind.

Most contractural agreements between sculptor and client have a provision in it that in the event the client is dissatisfied with the sculptural portrait, a stipulated fee (usually a small percentage of the fixed fee is to be paid to the sculptor—with the sculptor retaining the sculptural piece).

There are no two people who agree as to what anyone really does look like.[6]

The portrait artist is often lured into making a sitter seem younger than he or she really appears. The shallower and more fatuous the subject, the more the wrinkles disappear under the skilful manipulation of the artist. Much of the easy profit to portraitists in any medium accrues from the fact that so many accept flattering versions of themselves as a "good likeness."[14]

No two people see the same person alike, and some think of him more as he looked at an earlier age than he now appears. You should warn the

family against summoning a jury of relatives and friends, for they will all differ. If the commissioner is satisfied, the artist should not pay much attention to dissident opinions.[14]

Concern for Public Criticism

Never be discouraged by public criticism. In time you will come to recognize the unqualified, self-appointed critics whose adverse opinions are meaningless; likewise you will come to recognize well-wishing friends, relatives, and others whose praise of your work is just as meaningless, since their good will is greater than their knowledge of sculpture. You will learn to accept the fact that your work—any artist's work—invites comment and criticism. You will eventually learn to recognize worthwhile criticism, and accept such criticism as a help toward your goals. Sound advice and criticism is absolutely necessary for your advancement. If you are to make any progress in the practice of your art, you should have no fear of such criticism, especially from those with proven experience. Sources of inspiration will come from such worthwhile direction. Self-criticism, although very useful, is not enough. It is very difficult to judge one's own work. In the meantime, continue to have faith in yourself. Continue sculpturing—gain experience through practice. Eventually you will be able to do a good portrait, satisfying to both your client and yourself, and perhaps to a critical public as well.

4

Tools and Equipment

How Many Tools Needed?

There is an assortment of shapes and sizes in wire-end and wooden modeling tools to meet every need and individual preference. Most art supply stores are well stocked with them. Such tools, and objects like jagged wood and stone, and miscellaneous objects of all sorts, make a variety of marks on clay or plasteline—for hair, for garments, and for other textural finishes. Experiment with the various tools at your disposal; see what each one will do for you. A good tool is not to be underrated, but the novice should limit himself to a selected few until he finally settles upon his favorites—remembering, always, that tools should be regarded as "extensions" of the fingers and used only when needed. Your fingers will always be your best tool.

A large number of useful tools are usually collected as work proceeds; but the necessary minimum, to begin with, should include two or three spatulas (the best wooden tools are made of boxwood), and two or three wire tools also, for cutting and clearing hollows. In addition, one wire tool which has thin wire wrapped spirally round a more substantial and rigid brass wire can also be very helpful upon occasion; more especially when the clay has become a little hard or over smooth—this tool has "bite." A little practical experience will soon show how far it would be helpful to add to this collection, but it is better to start with a bare minimum. Every craftsman becomes attached to certain particular tools of his own choosing, or even of his own making.[1]

Wire-end Modeling Tools

A wire-end modeling tool has a wire-end on each side, or a wire-end on one side, and a wooden end on the other side. Each wire-end generally has a different shape, and intended for a different

34

use. In the main, the wire-end tool is used for cutting, scraping, shaping, hollowing, and pulling surfaces together in a general way. There are endless uses for them all, according to each sculptor's feel for their many-sided usefulness.

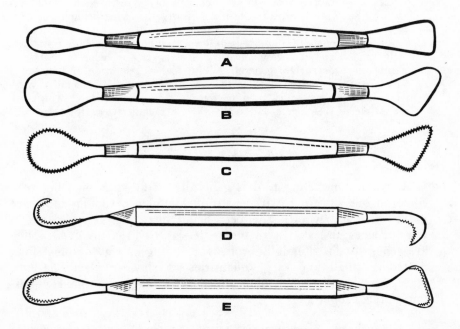

WIRE-END MODELING TOOLS

A & B: These are sharp-edged wire-end tools and which come in various sizes. One side generally comes in square or oblique shapes; the other side being oval-shaped or rounded. The square or oblique shapes are used to cut away excess surface clay or plasteline where it best serves the size of the area, and for establishing planes of different sizes. The oval-shaped and rounded ends are used according to the size of the hollow to be gouged out, cleared or shaped.

C: This is a wire wrapped, tooth-edged scratching tool, with thin wiring wrapped spirally around a stronger brass or steel wire. The ends are either rounded, oblique or square, and come in various sizes for scraping or removing lumpy, uneven surfaces. Helps, too, to roughen surfaces, pull surfaces together, and to achieve texture.

D & E: Ends of different shapes, showing teeth filed into cutting edges for scraping. Like C. above, the ends help to roughen surfaces, pull surfaces together, and to achieve texture.

Most tools serve two purposes because each end is a different shape. The cutting or scraping tools are similar in shape, having one rounded end and another that is square or oblique, but the scraper either has teeth filed along the cutting edge or fine copper wire is wound around both ends to form a toothed edge (you can also use a very inexpensive toothed

tool made of wood). For shaping or hollowing you need a rounded end; for cutting you need a square or diagonal sharp edge. The best tools are made of sturdy brass or steel wire. Each tool should have a certain flexibility and not be stiff or clumsy.[13]

The wire-wrapped tool (the scratching tool) is used to pull the surface together occasionally, to see more clearly the shape being modeled.[11]

The big wire-ended tool is used for scraping over the larger surfaces of the model, and removing any surplus clay. It also helps to unite and pull together the surface generally. This tool is best made of flat, broad iron wire, and provided with teeth at wide intervals. The smaller wire-ended tools are generally used to remove clay from hollows which are inaccessible to the fingers, but really there are endless uses for them all.[8]

Wooden Modeling Tools

A wooden modeling tool is generally an all-stick one, but may come on one side of a wire-end tool. Wooden modeling tools are made of many woods, the best being boxwood. They come in various sizes and shapes to meet the size of area involved. They are generally flat thumb-like tools for adding on clay or plasteline, flattening small and large quantities of clay or plasteline into place, for shaping, smoothing and finishing surfaces, and for pulling surfaces together.

For smoothing or patting the surface, very much as you would use the thumb—and for finishing—you need a flat, thumblike tool that is shaped like a spatula. The ball end tool is used in hollow places such as the eye sockets or ears. The best wooden tools are made of boxwood. Each tool should have a certain flexibility and not be stiff or clumsy.[13]

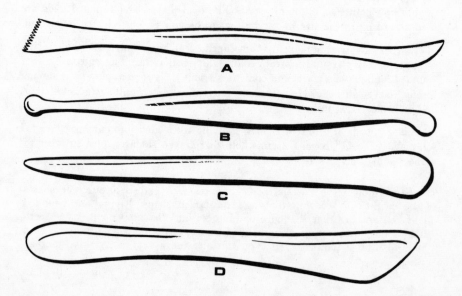

A

B

C

D

WOODEN MODELING TOOLS

See page 36

A: Flat; on one end the teeth are serrated for scraping. The other end is pointed for clearing out and shaping smaller hollows and corners.

B: One end is a small rounded point for shaping hollows and corners. The opposite end is a knob or ball-like shape for shaping hollow places like those in ears, eye sockets, nostrils, other small undercuts, too small for the fingers to reach.

C & D: Flat, thumb-shaped spatula-like ends of various sizes; the smaller ones for adding on and flattening bits of clay or plasteline into place in small areas—the larger ones for adding on and flattening larger quantities of clay or plasteline into place in larger areas. Also for shaping, smoothing and finishing very much as you would do with your thumb.

Caliper

A caliper is very helpful for measuring. It should have an easy operating adjustment screw at top center to tighten the arms, and with tapered tips that are shaped for accurate measuring of sitter and the clay or plasteline model. Ends should be blunted for safety when taking measurements of the sitter.

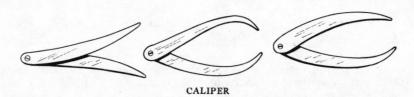

CALIPER

A pair of simple calipers, with butter-fly-headed bolt and screw for tightening the arms at the center will be necessary in order to take and compare measurements. These may be obtained in either wood or aluminum; the arms should not be less than nine inches in length.[1]

It is very helpful, particularly to the student who hasn't an instinctive feeling for proportion, to have a pair of calipers.[2]

Care of Tools

Keep your tools in good working condition. The work goes smoother with well-cared-for tools. Keep them clean by clearing

clay or plasteline from the tool after each modeling session; and when not in use for a long period of time the tools should be oiled. Wash them, if needed, but do not leave them in water as this weakens and cracks them. Dry tools after each washing.

> Good tools deserve good care. Each day after being used, a tool should be washed and dried and then oiled. This will do much to prevent deterioration of both wire and wood.[13]

> When you stop working, wash your tools and dry them. Do not carelessly leave them in a pail to soak. They will soon crack and decay if you do.[6]

Hands/Fingers As Tools

Use your fingers, especially the thumb, as much as you possibly can. Tools have a definite place in modeling, especially in places where the finger cannot reach, but no tool has the fine touch of the human finger. There is an intellectual communication, so it seems, that the pressure in the human touch imparts to the material that a tool does not provide.

> In modeling with clay, the sculptor uses his hands, the thumb being his most useful tool.[13]

> No sculptor's tools have yet been devised which can replace fingers for modeling purposes.[12]

> The student must realize at the outset that the most useful tools he possesses are his own two hands.[8]

> The more you depend on your fingers in preference to inanimate tools, the "freer" your final results. There is a transference of life from your own fingers that impart character to the clay—an instantaneous response, a rapport between the medium and the artist that you feel when you work the clay directly with your hands—an important communication that tools, many times, only seem to stultify.[3]

Baseboard

The baseboard should be a substantial one, about ¾" to 1" thick. A 5-ply, ¾" thick plywood board is satisfactory. Two crosspieces, 1" x 1", running almost the length of the board from side to side (against the grain) on the underside, facilitate handling and prevent warping. When the baseboard is too thin, it will warp because of the wet clay. For work heavier than a lifesize head, two wooden baseboards screwed together should be used, and

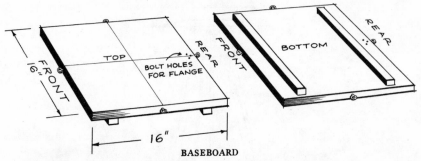

Crosspieces under baseboard to prevent warping and to facilitate lifting.
"Eye" of "Hook & Eye" on each side of baseboard (see "Keeping Cloths Away
From Surface" in Chapter "Clay Model Care.")

for added strength the grains of the two baseboards should run
in opposite directions. Use the crosspieces as above indicated. For
a lifesize head, a baseboard 16" x 16" is recommended; for a
portrait bust, use an 18" x 18" baseboard. Shellac baseboard—two
coats will help to prevent warping from moist clay, or absorption
of oil from plasteline. Shellac baseboard after each use, if needed.

Drawing parallel lines on the baseboard every two inches, both
horizontally and vertically, they can be used as guidelines to help
keep the outer forms within prescribed bounds—likewise thumb-
tacks can be inserted on the baseboard at convenient points and
used for similar guidelines.

To prevent clay or plasteline from sticking to the baseboard,
cover the board with a piece of transparent plastic. The plastic
bag usually provided by a laundry when returning shirts will do.

Baseboard should have two strong cleats underneath to prevent warp-
ing and to facilitate lifting.[6]

Put flanges (crosspieces) under baseboard to facilitate picking up—also
if you are using wet clay, it prevents your board from warping.[2]

Modeling Stand

The modeling stand, with its rotating top and adjustable height,
is the best means for modeling. It can be placed where you want
it, for lighting advantages, and for viewing of work from dif-
ferent angles. Casters make it possible to move the stand for such
purposes, and for removal to less needed areas between modeling
sessions. Notwithstanding the usefulness of the modeling stand,

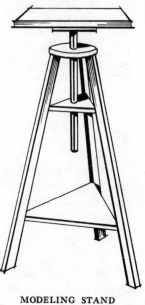

MODELING STAND

the novice, because of its cost, should find the turntable, properly placed on a table or desk, sufficient for his needs. The modeling stand and appropriate stool are available at most art supply houses, but they are expensive. They can be built, of course, if you have the skill to do so. Invariably, there is a need for two modeling stands, or a modeling stand and table; the modeling stand on which to place your model and immediately needed tools and material, the table or second modeling stand for additional material, modeling tools, cloths, etc.

A first consideration will be some suitable stand which to place the modelling while at work. It is of the first importance to be able to view the work constantly from any and every angle and a wooden stand with turn-table top is almost essential for any except the very smallest models.[1]

When modelling, it is essential to be able to turn the work around and, if possible, move it up and down. Stands suitable for modelling portrait heads can be purchased from artists' material dealers.[7]

Turntable

Turntables of varying sizes can be purchased at art supply houses. If you wish to make one yourself, it can be done in a variety of ways. The ones I have made are the same size as the

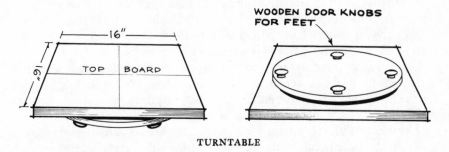

TURNTABLE

baseboards I've made (16" x 16" for a life-size head and 18" x 18" for a portrait bust). It consists of a 5-ply plywood board on top, with a bottom 5-ply plywood board (preferably round) several inches smaller in diameter than the top board. For a smooth, rotating movement between the boards, a ball-bearing "Lazy Susan" was used. "Lazy Susans" may be purchased in many places, among which is The Drumcliff Company, Towson, Maryland, 21204, whose No. T.651 . . . a 3" for turntables up to 18" in diameter . . . sells for $1.00 or so. I believe they are also available at Albert Constantine & Son, Inc., 2050 Eastchester Road, Bronx, N.Y. 10461, and from the manufacturer, the Triangle Mfg. Co., Oshkosh, Wisconsin. Four wooden door knobs screwed to the bottom board make suitable feet for this turntable.

If, however, it is only possible for reasons of cost or space, to make use of some solid table or bench, it is possible to purchase a turn-table stand of miniature height which can be placed upon it. Failing this, a turn-table itself, may be made in a variety of ways.[1]

As an alternative to a modelling stand, a rough turn-table for placing on a box or on an ordinary kitchen table, can be made from two wooden squares with a bolt through the center, the bearing surface being lubricated with graphite.[7]

The simplest type of turntable can be made by putting a bolt through the center of two square boards that have been greased so that one will slide over the other when it is turned on the bolt axis. This can be used on top of a work-table, or it can be mounted on legs and made into an independent modeling stand.[13]

Cleanliness at Work

Cleanliness, while modeling or casting, pays dividends in better work. Unneeded tools and equipment should be put out of sight, or made as inconspicuous as possible; unclean items of any kind

should be cleaned and put away. Excess clay or plaster on turn-table or modeling stand and on floor should be gathered together and thrown away. Everything else that is superfluous for the moment should be set aside—if valueless, should be discarded. Everything that is unnecessary for the work at hand can unconsciously attract the eye and act as a distraction from your effort, and your work will suffer thereby. Sculpturing requires a respect for its artistic worth. Uncleanliness and untidiness can only mean a lack of respect, understanding, and appreciation of your ultimate goals, which, in turn, can only produce inferior, inartistic results. A thought in passing: the sculptor need not have clay, plasteline, or plaster all over his garments to prove that he is a sculptor.

5

Armatures

What Is An Armature

An armature is a firm, internal supporting framework upon which
the sculpture in clay, plasteline, wax, or plaster can be fashioned.
It is to the sculptural piece what the skeleton is to the body, or the
inner structure is to a building. It must be strong or rigid enough
to prevent movement or collapse of the weight to be placed upon
it. The upper portion of the armature, intended for a head, should
have a flexibility to permit some slight tilt or change, if desired.
It may be made of wood, wire, metal, or a combination of all
three. The advantage of an armature made up of short pipes
(nipples) and pipe fittings, as here illustrated, is that it can be
more readily taken apart, and stored more conveniently.

An armature is for the support of clay and plasteline.[6]

Few sculptors would work upon any scale above a few inches without
making a firm inner support for the clay out of more rigid materials. Such
a support is called an "armature."[1]

An armature for sculpture is any contrivance that will serve as a firm
support for the weight, stresses and strains of the work to be modeled.
It must be so designed as to be able to bear the increasing weight as the
modeling material is added and yet not so rigid as to prevent you from
making changes before the clay hardens.[12]

The usual armature to hold and support the clay is made up of a
threaded iron pipe screwed onto a wooden base; or of wood the desired
length, about two by two inches thick, firmly nailed or screwed to a base.
Onto this base is screwed a flange and into it is set the piece of iron pipe
cut to the desired length. This pipe has a tee joint at the top into which
you insert your lead tubing and secure it with a wooden wedge. This is
your main support.[13]

When An Armature Is Needed

For a life-size head or a portrait bust, or larger sizes, an arma-ture is required, around which to build the clay or plasteline form. This understructure acts as a much-needed support for the amount of clay or plasteline required for such sizes. Without it, the weight of the material would sag or collapse.

> When modeling anything the size of a head, portrait bust or figure, an armature is necessary to support and hold the clay.[13]

> An armature is a supporting structure you must build as a supporting core to almost all wet clay modeling you plan. An armature is necessary, too, for the majority of the work you will do in plasteline.[11]

When An Armature Is Not Needed

Your first sculptural head will, in all likelihood, be under life-size. Do these first pieces without an armature. The head is a solid mass, and the small head lends itself to sculptural development without the armature support. An armature is not to be used where the work is to be eventually fired hard as in terra-cotta (This volume does not deal with any type of terra-cotta as a sculptural medium.)

> Your first piece of sculpture could be built with no inner support (arm-ature), so pick a solid unit of shape. No matter what subject you pick, be sure the composition has these elements: simplicity, unity and solidity.[11]

Bought: Own Make

For those who are incapable of making their own armatures, who do not wish to make their own armatures, a ready-made one is available at most art supply stores. They come in a number of sizes for heads and portrait busts, and the sculptor should find one suitable for his needs. However, the armature, as here illus-trated, for use of self-hardening clay (since you likely will be removing it for "hollowing") will have to be made. All of the armatures here illustrated were made by the author and were found to be very practical for assembly, disassembly, and storage.

> There are very complicated and impressive-looking armatures made and for sale, but the home-made article, if constructed by a good craftsman, generally answers his need better and gives him useful practice in han-dling his tools and relying on his intelligence.[6]

I feel that every student should know how to make an armature because an armature can make or break your piece of sculpture—literally as well as figuratively. You can buy one ready made. But someone has built it for you who knew nothing about what you intend to do, and too often knew nothing about sculpture. If you make your own armature, you assume mastery of the situation and you yourself dictate the forms and proportions you are going to use. This you can never do if you buy a ready made armature.[13]

Visualize Proportions Before Preparing Armature

There is no doubt that the biggest problem in the making and use of an armature is in its proportions. The size of your intended head or portrait bust will be the determining factor. Obviously, the armature must be built smaller than the intended size of the clay or plasteline form. If you are adding a plinth to your sculptural piece, height of armature should be increased accordingly. The armatures illustrated here can easily be adjusted by shortening or lengthening the upright short pipes (nipples), and by enlargening or reducing size of the wire loops for the head. It is evident that the matter of armature proportions must be visualized beforehand in relation to the size of the intended sculptural piece.

The armature you use is going to dictate your proportion and silhouette, hence you must have your sculpture visualized before building the armature.[13]

You must, of course, first be fairly clear in your mind what shape you intend your armature to support before you build it.[12]

Determine the position of the head and composition or plan of the sculpture. Will it include the neck and the shoulder? Or will it have a neck set on a base? Will the base be a part of it, or will it be mounted on another material? All this should be planned before starting, for major changes are more trouble than starting anew.[9]

In making armatures for any size sculptural piece, allow enough leeway for any clay plinth (a base which is a part of the sculptural piece).[11]

Diagram For Armature Measurements

Plan your armature beforehand with the help of a diagram showing the exact measurements of its component parts. You need not be skilled in drawing to make a rough diagram. Slow, careful planning at this stage will avoid trouble later on, for once measurements are determined, it becomes rather difficult to make changes.

Make a careful diagram with exact measurements of the required pipe and wiring.[13]

Build Armature Firmly

Build your armature firmly so as to take the weight of the clay or plasteline to be placed upon it. Moist clay in particular is a heavy, dense material and tends to sag under its own weight. When moist clay or plasteline that eventually will be cast in plaster is used, the additional weight of the wet plaster must also be taken into consideration. A weakly constructed armature can easily sag or collapse under the aforementioned weight, and no heartache can be greater than to find your work, after weeks or perhaps months of effort, folding or collapsing because the armature was poorly conceived. It is also important that the armature be firmly fixed to the baseboard so that it does not loosen under the weight placed upon it. If the armature is made of iron parts as illustrated here, the iron flange may be screwed to the baseboard, but it is much more firmly anchored when bolted (not screwed) to the baseboard. Repeated use of screws on the baseboard position eventually enlargens the holes and the screws may become too loose to hold down the flange firmly. Use a wrench to tighten up all parts of an iron armature. A loose part can cause the armature to sway under the pressure of the material.

It must be rigid enough so that when clay (or any other material) is added to it, it will not sag or collapse.[9]

The armature should, at any stage, support the weight of clay to be built upon it. In addition, it should be remembered that it will also have to support, later, a considerable weight of wet plaster while the mould is being made on it to take a cast in plaster. Nothing can be more disappointing than collapse or movement of clay after considerable work has been put into the modelling.[1]

Prepare your armature carefully and avoid the heartbreak that comes when some sculpture you have worked on for weeks collapses or sadly folds over or disintegrates because the armature was poorly fashioned. If the armature is not well considered or is weakly constructed, it might stick out of your sculpture piece and your enthusiasm for sculpture might receive a setback.[11]

By whatever method the armature is fixed to the board, it must be made absolutely firm as it has to take the weight of the clay model, and it should on no account, whatsoever, be liable to sway or loosen as the work proceeds.[1]

Place Armature Centrally In Clay Or Plasteline Form

Keeping the armature centrally in the form can be overlooked. If you are not constantly alert to this possibility, you will suddenly

find your armature sticking out in the most unexpected places, and you then have a problem on your hands of making corrections, or possibly starting all over again. Drawing parallel lines on the baseboard, vertically and horizontally, say two inches apart—also using thumbtacks on the baseboard at convenient points—will help to keep the outer form within prescribed bounds, and the centrality of the armature can thus be more readily visualized. A thin rounded object like a cuticle stick or a long knitting needle, firmly attached to the armature and projecting out of the center of the armature at the top of the head, becomes an excellent marker to show centrality of the armature within the form. Because of the forward slant of the neck in an orderly head, and the likelihood of only a limited amount of material along its forward angle, care must be taken that the armature be properly located, if not centrally in the neck, at least carefully placed so that there is sufficient material covering the armature at this point.

Keep in mind the mass and silhouette of the head to be built on the armature, so that you always allow for enough clay between the armature and the finished surface. Leave enough space in front and all around the armature for freedom in modeling. Better too much than too little.[6]

Ideal armature should always run near the center of the mass being modelled.[1]

From the top of the sternum (pit of neck) you will measure to the back of the neck and find the position of the seventh vertebrae. This is the most important point to establish, and great care must be taken to ensure that the armature is buried centrally between them.[8]

One point to remember is that the iron pipe should project into the exact center of your clay model.[13]

Relatively little clay covers the armature at the pit of the neck. The armature at this part must therefore be most accurately placed.[5]

ARMATURE WHEN USING SELF-HARDENING CLAY

Construction

Each sculptor has his own ideas on the type of armature and the materials best suited for his sculptural needs—wood, wire, metal, or a combination of all three; and all of them can be very serviceable. In the making of a life-size head or a portrait bust, *using self-hardening clay,* practical armatures are illustrated in this section. They follow the principles of those time-tested armatures used for modeling figures—an armature supported by an iron pipe set in a flange attached to the baseboard on the outside

of the form. In the case of the figure, a horizontal pipe centers the small of the back, or the hips; in the case of a head, the horizontal pipe enters the neck, or it enters the portrait bust at a lower level. This type of armature is best suited for self-hardening clay since, no doubt, you will want to remove the armature (after the clay dries sufficiently).

Life-size head

The flange (A) connecting the iron pipe to the baseboard should be placed outside the clay form at the rear center of the baseboard; rising out of the flange will be a 1″ to 2″ nipple (B); attach to the nipple an "elbow" fitting (C); attach to the elbow a 4″ to 6″ nipple (D) which extends into the clay form; to the nipple (D) attach an elbow (E), and from this elbow attach an upright nipple (F) 2″ to 4″ (depending upon the length of the neck) to a point under the chin level. (*See* "Wire Loops" for remaining instruction.)

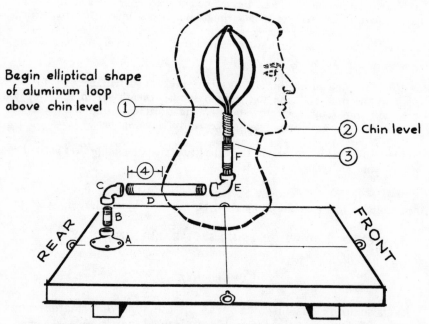

Begin elliptical shape of aluminum loop above chin level (1)

(2) Chin level

(3)

ARMATURE FOR SELF-HARDENING CLAY FOR LIFE-SIZE HEAD

Top of iron nipple should always be below chin level. If the rigid portion of the armature is higher than this point, it will be difficult to change pose of head, if desired (3). Leave space between elbow C and clay form for use of a wrench to loosen nipple D when removing A, B, C & D portion of armature from the form (4).

When making holes at the rear center of the baseboard for the placing of flange (A), see that the grain of the wood runs from front to this rear side as the crosspieces (*See* "Baseboard" under the Chapter "Tools and Equipment) on the underside of the baseboard, for added strength, will be placed from side to side against the grain of the wood.

Life-size portrait bust

The flange (A) connecting the iron pipe to the baseboard should be placed outside the clay form at the rear center of the baseboard; rising out of the flange will be a 1" to 2" nipple (B); attach to the nipple an "elbow" fitting (C); attach to the elbow a 4" to 6" nipple (D) which extends into the clay form; to the nipple (D) attach an elbow (E); to this elbow attach an upright 2" to 3" nipple (F) (depending upon the height of the bust); attach to the nipple a "cross" fitting (G) the top of which must be below the neck at the level of the shoulders; from this "cross" fitting attach an upright nipple (H) 2" to 4" (depending upon the length of the neck) to a point under the chin level. (*See* "Wire Loops" for remaining instruction.) Use the side openings of the "cross" fitting as a crossbar to carry a separate length of aluminum wiring for the shoulders.

The nipple (D) requires a 4" to 6" length (the more the better) so as not to interfere with the modeling, and to allow enough room for the grip of a wrench on it for removal. The length of the nipple (D), if extended, will move the form somewhat forward of the middle of the baseboard, hence make sure that the crosspieces attached to the underside of the baseboard run from side to side instead of from front to rear, and that they be placed within 1" to 1½" of the front and rear edges, to steady the baseboard, and to help prevent possible forward tipping over.

(See additional armatures for Self-Hardening Clay on page 50)

ARMATURE FOR MOIST CLAY AND PLASTELINE

Construction

While the type of armature used for self-hardening clay can be used for moist clay and plasteline, the horizontal pipe extending into the self-hardening clay form could interfere with the casting of a moist clay or plasteline form. A more serviceable armature for moist clay and plasteline, then, is the time-tested one that encases the entire armature within the moist clay or plasteline form.

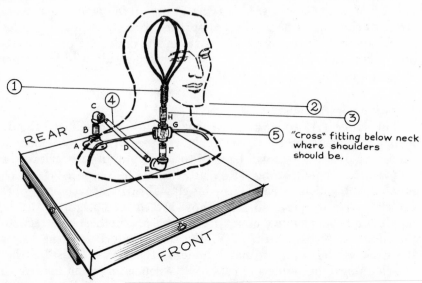

ARMATURE FOR SELF-HARDENING CLAY FOR LIFE-SIZE PORTRAIT BUST

See text on (1), (2), (3) and (4) on Page **48** (Armature for Self-Hardening Clay—Life-Size Head.)

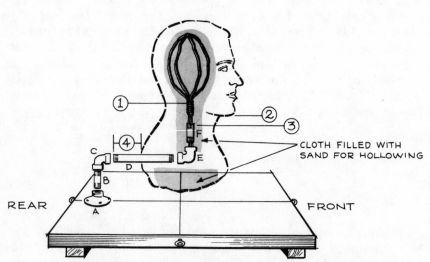

ARMATURE FOR SELF-HARDENING CLAY FOR LIFE-SIZE HEAD
HOLLOWING WITH SAND

(See text on "Hollowing" in chapter "Clay—Self-Hardening.") See text on (1), (2), (3) and (4) on Page **48** (Armature for Self-Hardening Clay—Life-Size Head.)

Life-size head

The flange (A) connecting the iron pipe to the baseboard should be bolted down in the center of the baseboard so that the armature projects upward into the exact center of the clay or plasteline form. To the flange, attach an upright nipple (B) 2″ to 4″ in length (depending upon the length of the neck) to a point under the chin level (*See* "Wire Loops" in this chapter for remaining instruction.)

Life-size portrait bust

The flange (A) connecting the iron pipe to the baseboard should be bolted down to the center of the baseboard so that the armature projects upward into the exact center of the clay or plasteline form. To the flange, attach an upright nipple (B) 2″ to 3″ in length (depending on the height of the bust); attach to the nipple a "cross" fitting (C), the top of which must be below the neck

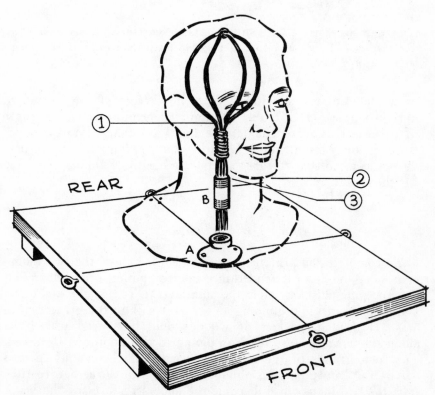

ARMATURE FOR MOIST CLAY AND PLASTELINE FOR LIFE-SIZE HEAD
See text on (1), (2) and (3) on Page 48 (Armature for Self-hardening Clay—Life-Size head.)

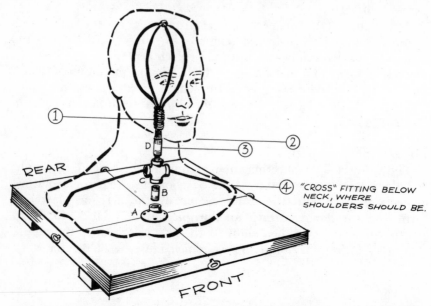

ARMATURE FOR MOIST CLAY AND PLASTELINE FOR LIFE-SIZE PORTRAIT BUST
See text on (1), (2) and (3) on Page 48 (Armature for Self-hardening
Clay—Life-Size head.)

at the level of the shoulders; from this "cross" fitting attach an
upright nipple (D) 2" to 4" in length (depending upon the length
of the neck) to a point under the chin level (*See* "Wire Loops"
for remaining instruction.) Use the side openings of the "cross"
fittings as a crossbar to carry a separate length of aluminum wiring
for the shoulders.

Wire Loops

To complete the armature, both ends of each of the two alumi-
num wires should be extended into the iron piping (remember that
the iron pipe must be below the chin level). Thrust the aluminum
wiring down inside the piping as far as it will go for greater firm-
ness. If needed, wedges of wood should be placed where the
aluminum wiring enters the iron piping to add additional firmness.
The four strands of the aluminum wiring should extend upward
out of the iron piping to about 1" above chin level before they
start the two loops which become the understructure for the head.
The two loops should be at right angles to each other, and extend
upward about three-quarters into the head form. The diameter
of each loop at its widest point should be about 2½" to 3" which
will permit enough clay around it to fill out the form. The two

right-angled loops should be bound together at the top with thin copper wrapping wire. Wrapping wire should also bind the four strands of aluminum wire between the iron piping and where the two loops begin, to give added strength to that area.

Use two 3′ lengths of aluminum wiring for the loops, cutting away excess length. The unneeded length will depend on whether you are modeling a head or a portrait bust, and the size of the sculptural piece.

Aluminum wire for flexibility

Aluminum composition wire is best for the wire loops. It is a light, strong wire which comes in a variety of thickness, and which can be bent easily. It is more flexible than lead wiring. The need of greater flexibility becomes apparent when you want to slightly change the position of the head during modeling without disturbing too much what you have already done. The aluminum wire is non-staining and non-corrosive. Three-sixteenths inch thickness is recommended for life-size work. It is available in most art supply stores; if not, it can be purchased (in addition to other sculptor's tools and materials) from (a) Sculpture House, 38 East 30th Street, New York, N.Y. 10016 under their trade name "Almaloy" (b) Sculpture Associates, 101 St. Mark's Place, New York, N.Y. 10009 as "Non-Co Armature Wire" (c) Ettl Studios, Inc., Glenville, Connecticut, as "Non-Co Armature Wire."

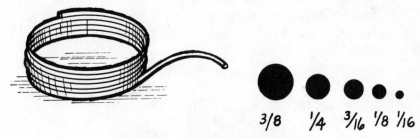

3/8 1/4 3/16 1/8 1/16

ALUMINUM WIRE FOR ARMATURES

Wrapping Wire

The wire loops and rigid piping should be wrapped with a spiral of thin wrapping wire to help prevent the clay or plasteline from slipping. Copper wire is preferable, though galvanized wrap-

ping wire can be used. Wrapping wire can be purchased cheaply at any hardware store, art supply store, or department stores such as Woolworth's.

Wrapping wire is used in order to prevent the clay from slipping on the smooth surface of the piping and wiring.[8]

When using piping or any other smooth material in an armature, the clay may be inclined to slip over it and fail to grip. This failing may be corrected by twisting some non-rusting wire, spirally, down its length which will act as a break and prevent the clay from slipping. If necessary, even, some small flat pieces of wooden lath may be inserted into the wire spiral, here and there, and these will form an excellent break and support. This is particularly required with any elongated form such as an extended limb in a figure—but quite unnecessary in an armature for a head only, especially where the head is of a simple design.[1]

Butterflies

Butterflies are used as an added means to hold the clay or plasteline on the armature. They are made of two small pieces of wood laid crosswise, and tied together with wrapping wire. Two inches in length and about ½″ to ¾″ in width is about a right size for them. They should be suspended with wrapping wire from the wire loops and rigid portions of the armature. Place them in different positions—4 or 5 for a life-size head; perhaps one or two more for a portrait bust. Since they hang loosely, they can be pushed into the clay or plasteline and away from the surface, or pulled out of the clay or plasteline toward the surface, as required. Butterflies are less essential when plasteline is used, as plasteline holds to the armature more so than clay.

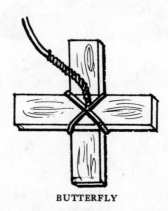

BUTTERFLY

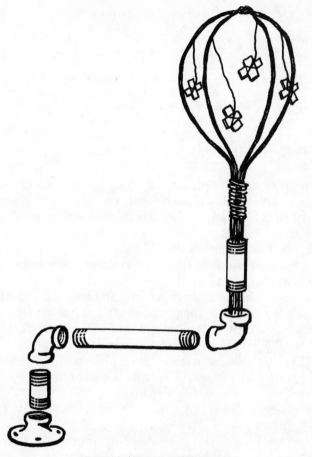

PLACEMENT OF BUTTERFLIES

Butterflies are little crosses of wood tied together and suspended by wire. They should be suspended at intervals to keep the clay from shifting.[9]

A butterfly is two small pieces of wood placed crosswise and bound together by wrapping wire. Hang on piping and wiring to further hold and support the heavy clay from sinking or slipping. An advantage of these butterflies is that they can be pushed in or pulled out as easy as required in the course of building up the clay, and yet they will give very strong support.[1]

An indentation with a penknife in the middle of each crosspiece will hold the wire better.[10]

To further hold and support the clay, "butterflies" are fastened and hung on the armature. Butterflies are little wood crosses about 2″ in length by ½″ to ¾″ in width. Two pieces are laid crossways and wired together with copper wire and then wired in different positions to the armature. They are absolutely essential. Without them, the clay will

crack and drop away. Suspended on wires, they can easily be pushed about and kept away from the surface.[13]

Butterflies are hung from the armature to help support large masses of clay in the bulky portions of your design. A butterfly is made in the shape of a cross by wiring together two small pieces of wood.[5]

Removal/Non-Removal of Armature

When using moist clay or plasteline

When moist clay or plasteline is used, the armature is removed when the clay or plasteline is dug out of the waste mold.

When using self-hardening clay

1. *If you have no objection to the armature remaining in the head or portrait bust:* When the outside clay is sufficiently hard so as not to mar the modeling while handling, the flange and armature outside the clay form can be removed easily with a wrench. It is important that nipple (D), as illustrated, be long enough (4″ to 6″) to use a wrench on it effectively. First, loosen the nipple (D) slightly from the elbow (E) *while the flange is still attached to the baseboard.* Have someone hold the clay form (without marring any modeling) while loosening the nipple in this way; then detach flange (A) from the baseboard before using the wrench again on nipple (D) to separate (A), (B), (C), and (D) from elbow (E). Again ask someone to hold the clay form in the latter procedure. Elbow (E) and the rest of the upright piping and wiring inside the clay form can safely remain inside with most self-hardening clays. "Modoclay" (*see* "Clay-Self-Hardening") was found satisfactory as it dries on the armature with little or no cracking. This may be true also with other self-hardening clays.

2. *If you have objection to elbow (E) and the rest of the upright piping and wiring remaining inside the head or portrait bust:* The armature can be removed in one of two ways:

(a) Detach (A), (B), (C) and (D) from elbow (E) as above stated. Then hollow out some of the inside clay next to the armature with any carving knife. (Woolworth sells a curved knife used for cutting linoleum which effectively removes the clay.) With sufficient clay hollowed out, elbow (E) and the upright portion of the armature can be pulled down easily. If newspaper or sand was used for "hollowing" (*see* "Clay-Self-Hardening"), remove newspaper, or sand by pricking the cloth sleeve and allowing the sand to trickle out. The armature can then be pulled down with little or no trouble.

(b) If you have any trouble removing (A), (B), (C) and (D) from elbow (E), loosen flange (A) from baseboard; then pull down the entire armature in one piece (first removing some clay, newspaper or sand as the case may be, next to the armature). In this method you will be disturbing some of the clay at and below the place where nipple (D) enters the clay form, but this can be easily repaired.

"Hollowing" the form by removing as much clay from the inside as possible is most desirable as it lightens the weight of the sculptured piece.

Remember, at all times when removing the armature the outside clay must be sufficiently hard so as not to mar the modeling in handling. And have someone hold the clay form during removal procedures, taking care, of course, not to mar the modeling in handling.

Reuse of Armature

If your armature has proven just right in size for any life-size head or portrait bust, or any other size you've modeled, it would be advisable not to dismantle it, particularly elbow (E) and the remaining upright portion. Leaving it intact, you can use it again for the same sized head or portrait bust. If your subsequent work is a different size, make another upright piping and wiring portion of the armature to fit the new need.

Rust Prevention

Iron armatures should be coated with shellac or lacquer to prevent rusting. Rust on the armature affects the clay near it, making the clay weak and breakable.

6
Clay
(MOIST)

What Is Clay

Clay is a water soluble, natural earth material, ready for use substantially as it is dug from the earth. In its moist state it is plastic—that is, capable of being molded or modeled into almost any desired shape. It is responsive to precise, detailed modeling, and especially well adapted for refining features in portraiture. Surface textures are easily created by it. Each sculptural material has its own qualities and limitations—among all materials, clay is probably the most versatile for expressing three-dimensional ideas.

Moist clay is a natural clay dug from the earth.[13]

Clay is a soft plastic earth formed for the most part as the result of the wearing down and decomposition of rocks containing aluminum minerals, such as granite. Many other ingredients are often present—among them oxide of iron.[1]

Clay was used to create pottery and sculpture as far back in the history of art as we have records. The reason for this is obvious. The material came from the earth.[9]

Where Bought

If much modeling is planned, buying moist clay in larger quantities is advisable; and it is more economical. It is generally available in 50 lb. and 100 lb. containers. In buying clay moist, there is the advantage of proper consistency prepared by experienced hands, as the mixing of water and dry powdered clay to produce the right plastic consistency can prove too messy and too much

of a gamble for the inexperienced novice. True. buying clay in powdered form has the advantage of not paying for a substantial amount of water that comes in the moist clay, and is more readily purchasable in the local art supply store. (When dry powdered clay is mixed with water, use only a sufficient amount of water to give it a putty or bread dough consistency. If mixed too thin, it must be allowed to dry somewhat and then must be kneaded back to a proper consistency.)

It may be bought at most art material shops in either powder or moist form. The moist form of clay is generally recommended for beginners, as the addition of water to the powder can be messy and uncertain job for the inexperienced, before a proper consistency is obtained.[1]

You can buy clay at the local art store; people with initiative go to the brickyards for it when they cannot find it anywhere else.[3]

Color

Moist clay may be purchased in different colors—gray, green, and in darker shades. It is best to use a light-colored clay like gray, instead of the darker shades. The delicate places in modeling can best be discerned with the use of lighter-colored clays.

Consistency

The texture should be smooth and even, about the consistency of putty or bread dough. It should handle easily; not too wet and sticky to the fingers. A good working consistency, easy to manipulate (this knowledge will come to you with its continued use), adds a greater measure of enjoyment to your modeling effort.

Clay must be of a proper consistency, not too wet and sticky to the finger. For modeling, the clay should be pliable, about the consistency of putty, not too wet and not too dry.[13]

If the clay is of proper consistency, neither too wet to be pleasantly firm nor too sticky, not too dry to adhere easily or crumble unpleasantly into flakes, the actual method of applying the clay should be decided upon by the trial and error approach.[12]

Wet clay should be easily pliable, yet not so soft that it is sticky and clings to your fingers as you work it. If clay is carelessly handled, gets mushy, or is allowed to harden and lump up, it is a very discouraging medium.[11]

ROBERT FROST, by Margaret Cassidy. *Courtesy of John Manship.*

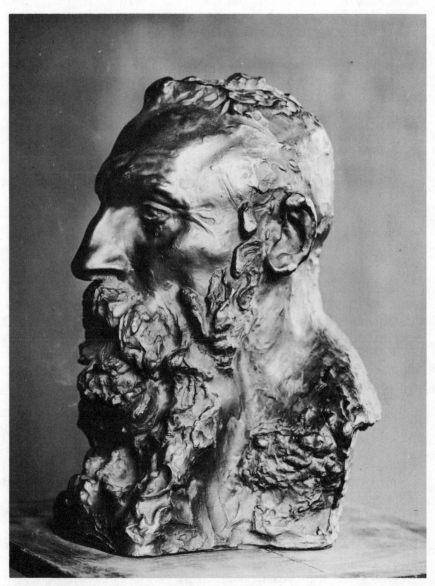

RODIN, by Camille Claudel (1856–1920). *Musee Du Petit Palais, Paris,
Photograph by J. E. Bulloz, Paris.*

Kneading When Too Wet

When clay is too wet and sticky to the fingers, you should knead it on a clean, dry board to get the air and water out of it, and to give it an even texture for modeling. The board should be unpainted and unshellacked. Try rolling a ball of clay in your hands; if none of it sticks to your fingers, you have the putty-like or bread-dough-like consistency suitable for working. Squeezing small quantities of moist clay in a rough towel before using it takes some excess moisture out.

Kneading takes the air pockets out of clay and makes it relatively solid. Kneading helps to give clay plasticity and lets it regain its full cohesive property.[1]

If your clay becomes too mushy pile it on a large unpainted, unshellacked dry board. Let it stand uncovered for a day or so. Then beat it with a stick, turning it now and then, and knead it the way bakers do dough to a smooth, plastic, consistent texture.[11]

Hard Clay

If clay is to be kept moist and in a suitable condition for modeling, it obviously must not be allowed to harden. During a modeling session, it would be wise to keep exposed only the amount of clay to be used immediately; additional quantity intended for use during the working session should be kept under damp cloths to keep it moist. Lumpy, or dry, clay is a handicap for good modeling, not only for reasons that soon become apparent, but also because it robs you of the enjoyment that proper consistency gives to your sculptural effort. If clay becomes dry, or of an uneven consistency, it must be made moist again. It should be completely immersed in water—overnight, or longer if required—and the water then drained off. If the process makes the clay too wet, as it most likely will, kneading will be necessary for re-conditioning and return to pliability. Exposing to the air will help to dry it. If clay is not too dry, a simpler method of returning it to proper consistency is to make deep holes in it, and pouring water into the holes. This method, or covering clay with wet cloths overnight, may be sufficient. A reminder at this point: not only must your clay be kept moist all through the sculptural process, but the clay form, too, must be kept moist, especially between working sessions. The latter procedure is fully explained under "Clay Model Care." Remember, too, that the clay form must be kept moist for casting purposes.

If hard, cover with water in a container and leave for 24 hours. Drain water.[1]

If clay becomes hard or of an uneven consistency, place in a can, cover with water, and allow to stand overnight. In the morning the water should be poured off.[13]

If clay dries completely, it can be used again by wetting it thoroughly and kneading it until it is of a soft, pliable consistency.[9]

If it dries out a little, dig deep holes into the clay. Pour water into the holes, and cover the clay snugly with wet cloths. Let it stand for a few days.[11]

If you find, that when you next go to work the clay has become too hard, you can easily bring it back to a workable condition. Make holes in the clay with a nail and fill them with water.[5]

Cracking, Shrinkage

Moist clay will shrink a little as its water content evaporates. The clay form, therefore, must be kept moist throughout the modeling process, especially between working sessions. For details in keeping the clay model moist, read the chapter on "Clay Model Care." Keeping the clay model moist does not mean soaking it with water. Too great an application of water can mar or break up the finely modeled features, and possibly weaken the adhesion of clay to a point where it can fall away from the armature. Remember, too, that the clay model must be kept moist for casting; if dry when casting, the clay will absorb water from the plaster— this is not desirable as more fully explained in the chapter "Plaster Casting by 'Waste Mold.'"

One way to avoid shrinkage is to press clay firmly into the form, thereby eliminating air pockets. This will keep shrinking to a minimum. If cracks appear on the clay form as the result of shrinkage, it should not be treated lightly. A crack is not a superficial thing. It is usually deep, and it is advisable to press a thin modeling tool into the crack as far as it will go, widen the crack if possible without disturbing the remainder of the form, and then fill in the crack with clay. A surface covering of the crack does not mend the crack. If carelessly repaired, the crack could undermine the area around it, and some of the adjacent clay may break away. Thoroughly moisten the area of the repair for better adhesion of the old and new clay.

Unless the clay used is of the "self-setting" (self-hardening) variety, the ordinary sculptor's clay will, if allowed to dry, crack and shrink as

the moisture evaporates. It must be moistened periodically and kept wrapped in moist cloth over which it is well to put a waterproof cover of plastic cloth.[12]

Clay shrinks an imperceptible amount as it dries, enough so that if you put anything inside a solid clay form, like a stick to hold up a statue, you have to figure on the shrinkage pulling the clay away from the stick. Cracks may form that could ruin your work.[3]

Application of Clay

Application of clay—the actual modeling technique—can only be learned by experience. As explained under "Hands/Fingers as Tools" in the chapter "Tools and Equipment," your hands and fingers are your best tools, and most of the application of clay or plasteline will be done in this more proficient way. Applying the clay or plasteline with a human touch gives the sculptor a tactile feel for modeling that no tool can provide. Modeling is an additive process—you build up your forms a little at a time, layer upon layer, with due regard for the three-dimensional cohesiveness of all the parts of the form. The form of the head or portrait bust should be built up smaller than the final requirement, leaving room to add more clay or plasteline if the form demands it. The material may be applied in pellet or coil form, whichever suits your own convenience and style. Whichever method you like best will come with experimentation. Most likely, one method will give you a greater confidence of control than the other.

The pellet is made by rolling bits of material between the thumb and index finger. The pellets are applied either uniformly, or irregularly according to size and shape. They are pressed or flattened in with the thumb or finger tip, or with a spatula-like wooden tool. Larger pellets are put on first; smaller ones later on as shaping takes place. Each pellet should contribute toward some intended shape, not put on in a meaningless, random fashion. Since pellets are intended for an eventual rough surface—they should not be smoothed out. One by-product of the use of pellets is the very attractive surface texture they create.

The application of clay or plasteline by coil or roll is more frequently used by the beginner, amateur, and student. They find it more convenient to use than pellets. They are made up in large and small sizes, depending upon need. Larger coils are applied first—the smaller ones later on when shaping takes place. It is desirable to make up a quantity of these coils or rolls in advance of modeling and keep them near at hand for use (the clay ones under damp cloths).

In either method—pellet or coil—the clay or plasteline must be

applied firmly, one to the other, so that better adhesion is maintained and no air pockets created.

The simple method of building up the final form (after the core hardens a little) by means of adding flattened pellets of suitable size is one of the most logical and amenable techniques used in modern sculpture in clay. If the pellets are applied in sensitive precision and the forms desired are conceived clearly, the work will have a certain very attractive and also decorative aspect.[1]

Use the spatula for the most part to place pellets in position.[1]

Clay pellets are the accepted way of adding to surfaces as they build up to a desired solidity of structure.[13]

Apply in coils. Avoid too thin a connection of coils which create air pockets—press well together to exclude air.[4]

Air Pockets

Avoid air pockets by pressing clay or plasteline firmly into your sculpture. No air should remain between pieces of clay, otherwise contraction and cracking will take place.

Pack the clay well around the supporting armature, making the sausages of clay join together by punching and merging one with another. Try to avoid air pockets or too thin connections.[12]

Core

Clay, when first applied to the armature, should contain less moisture than the applications that follow. The danger of sagging will be lessened when the initially applied clay is firmer in its consistency, and pressed compactly around the armature. It should form a solid foundation, with no air pockets to invite contraction and cracking. Sponging the armature will help the clay to adhere. Allow the core to harden somewhat, overnight if necessary.

Begin by covering the armature with large pieces of well-kneaded clay, filling the spaces between the loops of wiring very solidly, and making use also of the butterflies to hold up the main mass in the center; cover and fill in also the lower part of the piping. Press, mould and pummel the clay very firmly together until it is one mass, so that there are no air spaces inside the armature—it is well to use fairly stiff clay for this operation so that it will not sink or settle down within the armature later.[1]

Allow the core to harden somewhat. Clay must be harder inside than outside, otherwise it will fall apart.[13]

The first clay which is to be applied to the armature should be firm and solid in its consistency. If too soft it will not hold its shape or serve as a reliable foundation upon which to build up the rest of the work.[6]

In order to help the clay adhere, sponge the armature. Squeeze the clay firmly around the armature.[5]

Storage

Moist clay must be kept in its dampened condition at all times. If allowed to harden, the clay will dry out, crack, and crumble. Obviously, clay in a dried state loses its plasticity, and cannot be used for modeling. Proper storage becomes an absolute necessity. An airtight and watertight receptacle will do, providing it will not rust or deteriorate with moisture. An ordinary garbage can will do if it is airtight and watertight. A clean, moist cloth, heavy in body to hold moisture, placed inside the container, will help to keep the clay moist; however, do examine the cloth (or sponge, if you wish) from time to time to see that it is still quite moist, and that no fungus has grown on it.

Clay must of course be kept in a constantly damp state for use, and contained therefore, in some sort of receptacle which will not rust or deteriorate with moisture. A well damped and not too light cloth should be placed on top of the moist clay before the lid is closed down. The lid should be removed from time to time and the cloth examined to see that it is quite damp. The cloth should be absolutely clean when put in first, in order to avoid the possibility of any fungus developing.[1]

Place in an airtight and watertight galvanized iron can—the ordinary garbage can with soldered seams will do.[13]

A good wooden bin with a cover, lined in tin, in which to keep your moist clay in good working condition, will help materially in sparing you the annoyance of not having a supply available when you want it. Lacking a bin, you can use an ashcan admirably. It is necessary to have two containers, one for clay suitable for use at once and the other for clay pieces dried and broken from past work, discarded starts, etc. This clay is collected for eventual breaking up and dampening so as to bring it back to good working condition again.[12]

Always make sure that the clay is covered and airtight when not in use. It is a good trick to keep a damp sponge right in the container with your clay.[3]

Clay for Terra Cotta

Modeling clays known as "terra cotta," capable of being fired

in a kiln to render them hard and relatively permanent, are not dealt with in this volume because we are interested only with clays more suitable for sculpturing, and not "potter's clay" for ceramics. These clays are more refined than the clays normally used for sculpture and require understanding of their special purposes. It is suggested that the novice wait to use terra-cotta clays until he has gained some experience with clays and learns when it is advisable for him to use terra cotta. There is a great deal of material on the subject of terra-cotta clays in most books on sculpture.

7
Clay
(SELF-HARDENING)

What Is Self-Hardening Clay?

Self-hardening clay is a commercially prepared clay. Like other moist clays, it is an easy-to-use medium for modeling. It is ready for use just as it comes from the maker's plastic container (though it may need a little drying out). *See* "Storage" in this chapter. It is easily kept soft and pliable when stored in any plastic bag or container. It needs no kiln firing for hardness. It will air dry bone-hard in a few days (for small heads), or a week or two (for life-size heads and portrait busts). It may be patined. Self-hardening clay is less messy than moist clay, and, therefore, better adapted for home use. Like moist clay, it is responsive to precise, detailed modeling. It is well adapted for refining features in portraiture. Surface textures are easily created with it. Self-hardening clay is as versatile as moist clay in expressing three-dimensional ideas.

Self-hardening clay is a new method of preparing clay commercially so that it hardens when dry to a consistency equal in permanence and beauty to Plaster of Paris.[12]

Self-hardening materials: There are various patent modelling materials obtainable, which, like clay, are kept at the right consistency with water, but when allowed to dry do so with very little shrinkage. Some are harder than plaster, and as permanent, without the trouble of casting.[7]

Where Bought

There are a number of self-hardening clays on the market which can be purchased at most art supply stores. They are generally available in 5 lb. containers, or in larger quantities of 25 lbs. or

68

more. Self-hardening clay is, of course, more expensive than moist clay, or the dry powdered form of moist clay.

The author has found "Modoclay" to be a smooth, soft-textured, self-hardening clay with fine working qualities for modeling. It needs no preparation. It is ready for use the moment you open the maker's plastic container (though sometimes it may need a little drying out (*see* "Storage" in this chapter). It is soft and pliable, and creates shapes easily. You can add to "Modoclay" while modeling, whether the already applied "Modoclay" on the model is wet or dry. If not available at your local supply store, it can be purchased direct from the manufacturer, the Montgomery Studio, Northbrook, Pennsylvania, Zip Code 19361.

Color

"Modoclay," referred to above, is gray-colored, as are several other self-hardening clays seen in art supply stores. They have been observed in darker shades. As explained under "Color" in the chapter "Clay-Moist," it is best to use a light-colored clay such as gray, instead of a darker shade. The small, delicate places in modeling can best be discerned with the use of lighter colored clays.

Consistency

Like moist clay, self-hardening clay must be of a proper consistency for modeling. It should not be too wet and sticky to the fingers, or harden up. If the clay is of proper consistency, its soft texture will handle easily, and will add a great measure of enjoyment of your modeling effort. Let the trial and error method guide you as to what is good consistency for you.

When Too Wet

Larger quantities that come in the maker's single plastic container may be a little wet and sticky to the fingers. It may need some drying out. Separate the quantity purchased into the smaller plastic bags referred to under "Storage" in this chapter. If necessary, keep the smaller plastic bags open for a few days, turning the clay in the bag daily for uniform drying out to the consistency desired. For added care against drying out, the smaller plastic bags can be conveniently placed in lid-covered, open-mouthed glass jars, or any other type of airtight and watertight receptacle. Moist

AJAYENTAH, by Marjorie Jay Daingerfield. *Courtesy of the National Sculpture Society, N.Y.*

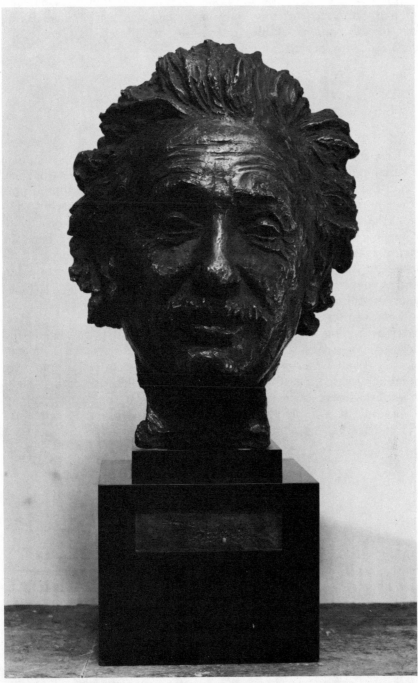

ALBERT EINSTEIN, by Jo Davidson (1883–1952). *Collection Whitney Museum of American Art, New York. Photograph by Geoffrey Clements, N.Y.*

"Modoclay" keeps malleable indefinitely in the tightly closed plastic bag, but watch for tiny holes in the bag which will cause drying out of the content. Holes or rips in the plastic bag are easily repaired with Scotch Tape.

Hard Clay

Like moist clay, self-hardening clay must be kept moist and in a suitable condition for modeling. It must not be allowed to harden. As in the case of moist clay, it would be wise to keep exposed only the amount of self-hardening clay to be used immediately; additional quantity intended for use during the working session should remain in its plastic bag. Close the bag with a rubber band or string to keep air out to prevent evaporation of moisture. If allowed to harden, the clay becomes a handicap for good modeling, and it robs you of the enjoyment that proper consistency gives to your modeling effort.

Leftover scraps of self-hardening clay may be returned to plasticity by adding some water, and kneaded back with the hands for desired consistency. Larger pieces, or unwanted self-hardening clay models if not water-proofed or patined, can also be reclaimed by breaking them up into smaller pieces and then immersing them in water. Leave overnight, and then drain off the water. Knead a handful at a time after soaking until smooth and malleable. Place the salvaged clay in the airtight plastic bag.

Cracking, Shrinkage

"Modoclay," used by the author, is a self-hardening clay that can dry safely without cracking, even with the armature permanently inside, should you decide to let it remain there. However, care should be taken when clay is first put on to see that it is firmly applied so that there are no air pockets, and that the clay firmly adheres to the armature. Also, allow the first applied clay to form a somewhat hardened core. If the armature is removed after "hollowing" (see below for "hollowing"), there also will be no cracking while the sculptural piece is drying out. If tiny cracks do develop, these are easily repaired with clay slip. To make a slip, mix the self-hardening clay with water to make a light,

creamy consistency. Smooth the repair with sandpaper, and it will not show.

"Modoclay," or any other self-hardening clay, will shrink a little since it hardens by air drying—generally so little as to be hardly noticeable. It is important that you do not consider your work finished, and particularly to color ("patina") same, until several weeks have gone by to ascertain whether there has been any shrinkage. It cannot be denied that even a small amount of shrinkage to some features may distort them, hence the precaution to wait several weeks before considering the piece finished. If any shrinkage takes place, you can make adjustments even after the piece has dried. Remember always, that if you press the clay firmly to the armature, and one application (pellet or coil) firmly to the other, you lessen the chances of shrinkage. Building up the core to almost total proportions of head or portrait bust, and then letting it dry before outer forms are developed, is a means of preventing shrinkage.

Various self-hardening clays, when allowed to dry, do so with very little shrinkage. Some are harder than plaster and as permanent.[7]

Self-hardening clay will shrink away from the armature when it dries, causing some surface cracks. This can easily be remedied by filling the cracks with a slip of the same material. Slip also acts as a glue when adding small forms such as ears, etc.[9]

Application of Clay (*see "Clay-Moist"*)

Air Pockets (*see "Clay-Moist"*)

Core (*see "Clay-Moist"*)

CORE FOR HOLLOWING

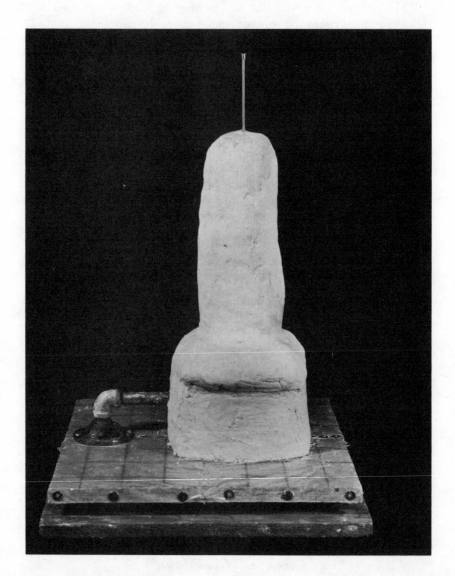

This illustration shows a core of self-hardening clay built over the cloth covering sand and newspapers used for hollowing (see "Hollowing," in this chapter). The self-hardening clay has been allowed to air-dry for 3 to 5 days to make a solid foundation for additional modeling, and to lessen possible sagging and shrinkage. Read in this chapter for further data on "Cracking; Shrinkage."

Storage

Self-hardening clay must be kept in a constantly pliable state for use, and should, therefore, be kept in airtight and watertight plastic bags. Larger quantities that come in the maker's single plastic container should be transferred to smaller plastic bags for convenience of handling. "Frozen Food Bags," size 5" x 3" x 15", sold by Sears or any department or hardware store, are both serviceable and economical for this purpose. Additional storage care is to place the smaller plastic bag in a lid-covered, open-mouthed jar, or any other airtight and watertight receptacle. Freezing does not harm "Modoclay" but it must be thawed out before you can use it.

Hollowing

with sand

For a life-size head: Take a piece of cloth about 12" x 20" and make a sleeve of it by sewing up the sides. The sleeve when sewed up should be about 4½" to 5" wide and about twice the length of the upright portion of the armature, say about 20". This 20" height will lessen as the sleeve is filled with sand, and any excess of the sleeve at the top can be cut away, or preferably turned down after pouring sand into it. Place sleeve over the armature and tie its bottom above the elbow (E) (*see* "Armature—when using self-hardening clay") securely with cord to prevent sand from spilling out. Fill the sleeve with sand in sections about 2" to 2½", tying each section with cord until the sand reaches to about 1" above the crown of the aluminum loops . . . where the sleeve, as stated, can be tied up and excess cut away, or preferably turned down. Filling the sleeves in sections helps to keep the circumference of the sleeve within bounds, smaller at the bottom because of the neck size, and larger as the sleeve goes above the neck. The circumference of the sleeve should be no greater than the need to enclose the armature, and to permit its withdrawal. Too large a circumference narrows the thickness of the outer clay areas which might break through to the surface, especially in the neck area.

A separate sleeve filled with sand can be used to fill out the area below elbow (E), and for the shoulder and chest areas when making a portrait bust.

Any quality of sand can be used; the fine sand of the south New Jersey beaches is especially desirable.

For removal of the armature, *see* "Removal of Armature—when self-hardening clay is used" in the chapter "Armature."

with newspapers

Another acceptable method of "hollowing" is to use newspapers. The newspapers are tied to the armature. Do not wrap newspapers too tightly around armature, for it is much more difficult to remove, especially from the upper portions of the head. Also use the newspapers to fill out the lower regions of the neck, and for the shoulders and chest when making a portrait bust. Cover newspapers with a thin cloth for a better surface for the clay to adhere. For removal of the armature, *see* "Removal of Armature—when self-hardening clay is used" in the chapter "Armature."

HOLLOWING WITH SAND AND NEWSPAPERS
FOR
LIFE-SIZE PORTRAIT BUST

In this illustrated method for the hollowing of a life-size portrait bust, a cloth sleeve filled with sand was placed over the upper portion of the armature and tied at the bottom above the "cross" fitting (G). Below the "cross" fitting and the aluminum wire shoulder crossbars extending from its side openings, newspapers instead of sand were used for hollowing to lighten the weight since newspapers are lighter than the required amount of sand. Cloth was sewed over the newspapers. The area of the "cross" fitting (between sand and newspapers) was a wrap-around of sand encased in a plastic bag over which a cloth covering was placed. Cloth is a desirable material for adhesion of the self-hardening clay. Moistening the cloth a little establishes better adhesion.

It is possible to dummy up a shape approximately the size of a head, so that only a shell of clay will be necessary. This is the only practical way to work a full-size head with self-hardening clay. The support in such a case is a piece of wood secured to a base with angle irons. There are several acceptable methods to build up a dummy shape. One convenient way is to wrap and tie newspaper to the supporting wood. Then make a shell of clay around it, one-half to three-quarters of an inch thick. Model the features. When the clay has a chance to harden, the support and paper can be gently removed, leaving a hollow well-built head which can be mounted on a base.[9]

Drying Clay Model

A sculptural piece made of self-hardening clay should be allowed to dry thoroughly by natural, slow evaporation of the moisture. It may appear dry externally, and yet internally it may still contain a substantial amount of moisture. Atmospheric conditions, temperature, air circulation, and size of the piece affects period of evaporation. Play it safe by letting it dry naturally (a few days for small heads—a week or two for life-size heads and portrait busts) before further handling for coloring ("patining"). You can hasten drying time without danger of cracking by placing work on a radiator, in front of an infra-red lamp, or in the sun (even with the armature permanently left in it), but drying naturally in normal room temperature is recommended. If there is any shrinkage in the clay, it will show up at the end of the drying period, and re-touching can then be done if needed, even though the piece is now dry. While "Modoclay" can be applied when clay form is dry or moist, remoistening of the clay form helps to bind the new clay to the old.

Repairing

There may be an imperceptible contraction or shrinkage while the self-hardening clay is drying out. Some adjustment may be required on the form—perhaps a feature need be retouched. Chips and dents are easily repaired. A smoother texture may be wanted —a rasp, sandpaper, steel wool, and pumice stone are handy tools for smoothing.

When using self-hardening "Modoclay," the use of shellac for sealing pores (before "patining") may reveal some slight imperfections which you would like to touch up. Don't hesitate to make any changes, even at this stage. Just wipe off the shellac with a little alcohol—the clay form, dry or moist, will take added "Modoclay" anytime. Remoistening of the clay form in the area of the repair helps to bind the new clay to the old.

When using self-hardening clay, do not hesitate to make any corrections even though you have color ("patining") on the piece. I take a hard look at my work after my first coat (undertone) is put on. At this point, the uniformity of color of the undertone gives maximum opportunity to really judge the true results of your modeling, and to reflect on any changes you wish to make. I do not hesitate for one moment, even at this late stage, to wash off some of the color of the undertone with paint thinner or alcohol (depending upon the solvent used with the color—*see* "Solvents" under "Coloring Plaster Cast") and to make the necessary correction. "Modoclay," and I assume other self-hardening clays will do the same thing, will receive new clay when the old clay is either hard or moist. I remoisten the dry clay before applying new clay for greater adhesion.

Coloring ("Patining")

You can paint your model made of self-hardening clay with water-base paint when wet, or any kind of paint when dry. *See* chapters relating to Coloring ("Patining").

Casting Eliminated

The essential value of self-hardening clays lies in the fact that it air dries bone-hard, and therefore needs no casting into plaster, or kiln firing, for hardening. The novice thereby avoids the expensive cost of casting if turned over to a professional caster, or avoids the messy job of his own uncertain casting which could

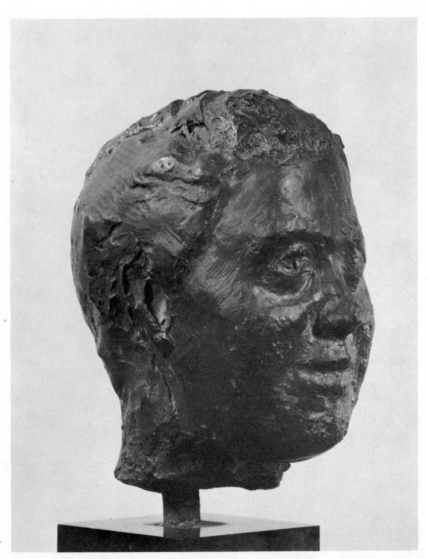

HEAD OF A WOMAN, by Edgar Degas (1834–1917). *The Metropolitan Museum of Art, Bequest of Mrs. H. O. Havemeyer, 1929. The H. O. Havemeyer Collection.*

result in a great deal of discouragement should he lose his first sculptural piece in the process.

I prefer self-hardening clay and thereby eliminate the need for casting for preservation.[12]

Avoids the trouble of casting.[7]

8
Clay Model Care

Prevention of Moisture Loss

There are different methods of preventing moisture loss through evaporation to keep the clay model in suitable condition while working on it. This applies to clay models made from either moist or self-hardening clays. Experiment with any method, or a combination of methods, until you find the convenient way for you. Whatever preventive method you use, the principle remains the same—keeping the air from drying out the clay. After each working session, put your work as far away from heated radiators and open windows as possible.

Spraying

At the end of a working session, spray the clay model lightly before using damp cloths, or using any other method, for prevention of moisture loss. The spray should be light; not so strong as to run off the clay model, and certainly not so strong as to mar or destroy delicate features. An ordinary flit gun is ideal for this purpose. Spraying alone, without use of damp cloths or other methods for the prevention of moisture loss, may be sufficient if you are to return next day to do some modeling on your piece. However, if your next working session is longer than that, the other methods referred to in this chapter, or a combination of them, must be considered.

While working upon the model without the cloths, the clay should be kept in good condition either by spraying it all over, every now and again, with a blow-spray or a hand-spray, or by sprinkling it vigorously with water from a wet sponge.[1]

A flit gun to keep the clay moist is good—anything that gives a fine

spray—the finer the better. Water should never run off the model, and the model should never be moistened enough to blur the surface. When you have finished working for the day, spray the model lightly. Dip a cotton flannel cloth in water, wring it out so that it is just damp, and wrap it around the clay. Wrapping a wet cloth directly around the clay will destroy the surface form.[13]

Damp Cloths

It is necessary to keep the clay model in a suitable condition while working on it. Wrapping damp (damp, not wet) cloths around it in the early stages of modeling is proper technique, but as the work progresses and delicate features are defined, the damp cloths directly on the clay form can mar or destroy the work. Therefore, the cloths must be kept away from the surface—such precautions are more fully detailed in this chapter under "Keeping Cloths Away From Surface." Be particularly sure that you cover the base of your clay model with the damp cloths. Neglecting to cover the base will allow air to get in, hastening the evaporation of the clay's moisture. How often you re-dampen cloths between working sessions depends upon the method used, how well it is done, and the length of time between working sessions. If you cover your damp cloths with several light plastic sheets, and enclose the cloths and sheets in a plastic bag (closed with a zipper, if possible), all tied up well at the bottom to further exclude air from evaporating the clay's moisture, once a week or once every two weeks is sufficient to re-dampen your cloths. With this thorough method, I've returned to a working session after a lapse of two to three weeks and found the clay model in a suitable condition for working on it. Obviously, with less thorough protection, cloths must be re-dampened more frequently. It is a matter of being ever-conscious of the need to keep the clay form moist and in a suitable working condition. If, for any reason, the completion of work will run into an extended period of time, the continued use of the same cloths may develop a mold or fungus on the cloth. This is due to its long period of dampness. A rust-like discoloration will indicate the growth of the mold or fungus. Cloths should be constantly checked for it.

Wrap your clay model carefully in clean wet cloths. Wring them out before applying them to clay, otherwise the excess moisture will dissolve and injure the surface modeling.[6]

Never wrap your model in soaking wet cloth.[13]

It will, of course, be necessary to keep the clay model in suitable condition for continuous working, sometimes over a period of many months.

In early stages it will be sufficient to place damp cloths over the whole surface of the model. The cloths should of course be soft and not of a thick or strongly textured character, which would be liable to upset the actual surface of the model. They should be laid directly upon the clay as lightly as possible and not dragged over it in any way. They should be thoroughly damped and rung out and applied freshly about once every 24 hours. As the forms become more complete, it will be necessary to keep the model damp, when not being worked upon, with the minimum of interference to the surface. Obviously the cloths must be kept, as far as possible, from direct contact with it.[1]

Plastic Covers

The use of damp cloths alone (after spraying as above indicated) may be sufficient for short periods of time between working sessions. How certain can you be that your next session will be on schedule? Things do happen to upset your planning, and your next working session could be delayed. For my own needs, I like to do a thorough job of excluding air to prevent moisture loss, no matter how soon my next working session is scheduled— on the theory that some situation may interrupt it. I want to be sure that the suitable condition of my piece is not affected by an unexpected delay. I should like to repeat, therefore, what I said under "Damp Cloths" in this chapter, to wit: that I cover my damp cloths with two types of plastic covers: first, over the damp cloths I place several thin plastic sheets, and secondly, I enclose cloths and sheets in a plastic bag that has a zipper on it. This type of zipper bag is generally used for the storage of blankets, and is available in department stores where bed supplies are sold. It should be remembered at all times that any and all of these protective means should not put pressure on the clay form so as to mar or destroy the modeling, particularly the delicate features of the portrait.

After the damped cloth is wound around the model, carefully wrap the whole in oiled silk, rubberized cloth, or oil cloth. Oiled silk is best as it is light as well as airtight.[13]

For extended period, without possibility of cloths being re-damped, a sheet of plastic wrapped lightly around cloth and tied at base with cord or clothespins will exclude air and will keep the clay model in perfect condition for some weeks.[1]

After you have neatly tucked your cloth around your clay, wrap an oil-cloth around the cloths and secure the edges of it firmly with wooden clasps, clothespins or a cord tied around to keep the air out and the moisture in. The purpose of this process is to retain the moisture of your clay. If you have a better system, or materials such as a piece of oiled silk instead

of an oilcloth, or a piece of plastic sheet, try it out. But whatever you use, be sure to use lightweight materials, or to arrange your covering so that it does not put too much pressure on your clay work.[11]

When doing work that has to be left for any length of time, a plastic film bag pulled over the work will keep it pliable until you can get back and finish the job.[3]

Keeping Cloths Away From Surface

matchsticks, pins, nails, toothpicks

As your work progresses and delicate features in the portrait are defined, the direct application of the damp cloths to the clay form must be avoided, otherwise the delicate features can be marred or destroyed. The use of matchsticks, pins, nails, and toothpicks serves the purpose of keeping the cloths away. Long sewing needles, or nails, are more rigid than wooden matchsticks and toothpicks, and will best serve the intended purpose. Place them wherever needed to keep the cloths away, particularly at critical points where damage may likely ensue.

Poke nails or pins or strong toothpicks cut in half into the clay model at all high points so that the cloth will not rest on the clay.[13]

If the figure is in action, or has delicate detail, take a few wooden sticks or bend a strong wire (galvanized) and push ends into the clay so that the cloths will be held away from the surface.[6]

Another method to protect surface is to insert pointed matchsticks or other fine lengths of wood at any point where it is desirable to prevent the cloth from touching the clay.[1]

Wire Hoops

Toward the last stages of your work, when delicate modeling of the features must be protected, the use of cloths directly on the clay form (even cloths kept away by matchsticks, pins, etc.) is inadvisable. Your surface detail may be too delicate to withstand the pressure of the damp cloths. It is, therefore, advisable to first place wire hoops around the clay form, over which you can then place your damp cloths and plastic coverings. The following wire hoop method has been used by me, and proven very feasible:

Screw "eye" portion of an ordinary, commonplace small "hook and eye" (purchased in Woolworth or any hardware store) to the four sides of the baseboard equidistant from the ends. Make two hoops out of your aluminum armature wire, long enough for one hoop to go from the front "eye" and over the top of the form to the rear "eye"—the second hoop going from a side "eye" and

over the top of the form to the "eye" on the opposite side. Attach
to the four hoop ends the kind of a fastener you see at the end
of a dog chain. Hook each of the four fasteners to one of the four
"eyes" screwed to the sides of the baseboard.

At the top or crown of the hoops where they intersect, run the
wires through a solid rubber ball. Then insert a matchstick, or
something similar made of wood or metal, into the rubber ball;
with the other end inserted into the top of the clay form. This
will keep the rubber ball with the wires running through it from
touching the clay form at that point—it also helps to keep the

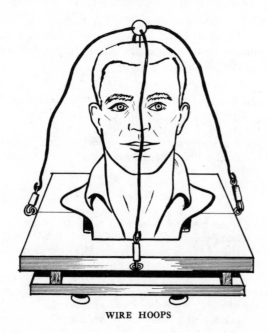

WIRE HOOPS

rest of the wire away from the clay model. An alternative method
is to let the rubber ball rest on some dry cloths placed on top
of the head.

Cover hoops with the damp cloths, over which place several thin
plastic sheets. For added protection against air evaporating the
clay's moisture, tie the bottom of the coverings with cord. For
extended periods between working sessions, and if the circumfer-
ence of the wire hoops and coverings is not too large for a zippered
plastic bag, I add the latter to my over-all protection.

Another good way is to bend a rather stiff wire and fold it over the
model directly over the profile and sides before wrapping.[13]

Lengths of thin, rustless wire may be bent into flattening hoops, and

the two ends inserted into the clay until some sort of cage is left projecting from the model and thus fixed around it.[1]

As your modeling advances, you might find it feasible to insert temporary galvanized wire before wrapping your damp cloth around your clay model. The weight of your cloths resting on the wires will keep them from blurring your modeling.[11]

Cage

Instead of wrapping the clay form in damp cloths and plastic coverings (and using wire hoops when needed), some sculptors build a cage or framework to encase it as a protective means to avoid evaporation of moisture by air. They cover the cage with necessary airtight material. I have never found the need to use any cage or similar framework or compartment for my work. The use of damp cloths and plastic sheets has proven sufficient for short periods between working sessions; for extended periods, the use of the zippered bag for additional coverage has proven more than sufficient . . . wire hoops being used, when needed.

You can build a framework, cover it with oilcloth tacked in place, and set it over the model. This makes an airtight chamber, and the model need not be wrapped.[13]

One method is to make an airtight case which should enclose the clay model without touching it. Construct a rectangular box-like framework and then cover it on top and sides with waterproof plastic material. One of these sides should consist of a loose flap which will pull up to the top, and the bottom bar of this framework should be omitted on this side. This will enable the whole case to be drawn over the model—after which, the waterproof flap can be pulled down and fixed with drawing-pins to the wooden framework uprights at the sides. The loose flap should be opened periodically and the clay within sprayed with water. Insofar as this plastic covered cage remains airtight, the model within should retain its dampness for an almost indefinite period.[1]

Some sculptors make a lightweight box such as an apple crate lined with flannel, which they spray with a garden sprayer, and set this down over the head instead of wrapping it—this is a good way, too.[2]

It is sometimes advisable to construct a light wooden frame and cover the top and four sides with oilcloth, wooly side inside. This covering can be sprayed with water and, when thoroughly soaked, placed over the clay model instead of cloths. Your cage can also be made to open on one side, so that the work can be examined and sprayed without lifting. If you have a removable side, be sure it fits snugly, and is held tight all around when closed by hooks and staples.[6]

Build a wooden frame that can be slipped on or off. Tack airtight material—oil cloth or rubber sheeting—on the top, back and the two sides of the wooden frame. The front should be a loose flap of the same material. The flap can be thumbtacked down after the compartment is put in position. This airtight contrivance can be easily removed and replaced.[5]

If your surface is so precious to you and you have the energy, build yourself a waterproof oilcloth box. Personally, I never use one. For I believe that if the surface detail is so dainty it cannot withstand the light pressure of a cloth, it is best that it be wiped out. And I am grateful to my clay cloths for doing that to my work occasionally.[11]

Casting for Moist Clay Model

The clay form made from moist clay must be kept moist for casting. At time of casting, the drier it is, the more it will absorb water from the plaster. This could result in a poor casting job. It must also be kept moist in order to be dug out of the plaster mold. Read the chapter "Plaster Casting by 'Waste Mold'" for complete details.

The clay form made from self-hardening clay needs no casting into plaster. It will air dry bone-hard.

The clay model should be kept damp until you are ready to cast it. The reason for keeping the clay moist is that the clay shrinks and cracks in drying. It should not be allowed to get too hard before it is cast because it has to be dug out of the mould before casting.[13]

Plasteline

What Is Plasteline?

Since Plasteline is a commercial, chemically treated type of clay, and most frequently recommended for the beginner, amateur, and student, this chapter about it is included in *Modeled Portrait Sculpture*. The formula for each manufacturer's plasteline is a trade secret. It is generally believed to consist of about 60 per cent clay dug from the earth, and the balance in varying amounts of tallow, sulphur, and non-drying lanolin or glycerin. It is pliable and ready for use unless exposed to atmosphere for a long period of time, or to cold weather. It will then harden. In moderate temperature, it does not dry and harden, even for a period of years. It can be used over and over again. It has sticking qualities, allowing it to easily hug an armature. A sculptural piece made from it does not shrink or crack unless exposed too long to weather changes. It is a suitable modeling medium for the novice.

An oily manufactured substance that does not dry or harden.[13]

Plasteline is a commercial preparation available in most art supply shops. It is a mixture of clay and oil which has the property of remaining soft and may be reworked many times. It is a fine material for practice. It comes in wax wrappings in the form of oblong bars and is sold by the pound. It may be had in several colors, usually variations of earth greens, yellows, terra cotta and reds. It does not always require armature construction to keep it rigid, except where there are required extravagant gestures of thin forms like arms and legs.[12]

Where Bought

It can be bought in any art supply store. The cost of plasteline

—more expensive than moist or self-hardening clay—may preclude its use by those who cannot afford the additional cost, especially among young people who are beginners, amateurs, and students. It is best to buy plasteline in one color only, preferably a lighter shade like gray. Features can best be distinguished when modeling with a lighter shade. The use of more than one color in the same sculptural piece would become confusing, and is therefore not recommended.

Consistency

Plasteline is a pliable, easy-to-use medium. Its soft workable quality can remain for years; its use and re-use can actually improve the quality. Its oil content keeps it from drying out, though long exposure to atmosphere will dry it out because of the oxidation of surface oils. It hardens when exposed to cold weather, and will need re-working and kneading to restore it to its soft state. Placing it near a warm radiator or register will help to restore its plasticity. Vaseline kneaded into it will also help to restore its plasticity. It is most likely to soften in warm weather. It must be kept clean, as dust will rob it of its plastic quality. Some sculptors substantially harden the plasteline model for finishing the final surface and features. To do so, place it either in the refrigerator, or in a container in which some "dry ice" has been placed—or set it outdoors in cold weather.

Plasteline can be used over and over for many years, as long as dust is not allowed to rob it of its plasticity.[3]

It does respond to temperature changes, for it is harder when it is cold and softer when it is warm. It also responds to the natural warmth of the hand and becomes more softer and pliable while it is being worked.[9]

When to Use

It can be used for small and large work, and is favored by many sculptors who anticipate an extended period of time to complete their work, and who do not want the trouble of keeping the piece constantly moistened. Notwithstanding this advantage, other sculptors do not care to use plasteline as they find moist or self-hardening clay more sensitive mediums to work with. While it can be shaped to do most everything in modeling, the refining of small features in the portrait is somewhat more difficult when modeling with plasteline. Many sculptors find that plasteline has

an undesirable synthetic "feel." Still others think that it has a distinctive, unpleasant odor, particularly in hot weather.

> Very valuable where small models or sketches are required, or where it is not possible to take care of natural clay. It is also useful for building up high monumental models because it does not need to be nursed or continually worked or moistened. However, most sculptors find natural clay a much more sympathetic medium and prefer to use it wherever possible.[13]

> Plasteline has a distinct advantage for the sculptor who can work only periodically. The plasteline sculpture can be put aside for any length of time, yet it is ready to be worked on without notice or preparation.[9]

> Wet clay is a better all-around medium for sculpture, but there are cases where drying out becomes a problem. For the person who can work only at off moments at his sculpture, plasteline enables him to leave it and come back and start right in. Therefore, plasteline is usually used by sculptors for very large work. Of the two, I personally feel that wet clay is a more sensitive medium because you can control the plasticity.[3]

Plasteline Model Care

There is very little care that need be given to a plasteline model during or after working sessions. In moderate temperature, the model can be left for long periods of time, and it will not dry and harden. A plastic cover to keep off dust is all that is needed. However, after each working session, place your work away from heated radiators, or the heat of the sun, to avoid any drying out of the plasteline—likewise, do not expose your work to cold temperature which will harden the plasteline.

Casting

A sculptural piece made of plasteline can remain in its soft state for a long time; however, it is susceptible to extreme weather changes and will harden, shrink, or crack if exposed to these extreme changes over an extended period of time. Plasteline, like moist clay, must be cast into a more permanent form—that of plaster. It must also be kept soft so that it can be dug out of the plaster mold during the casting process (*see* "Plaster Casting by Waste Mold").

> Sculpture done in plasteline must always go through another process to be made permanent. It has to be cast in plaster—and then cast again from the plaster cast into an even more permanent medium like bronze.[3]

It is an excellent medium for creating sculptures intended for casting, or for making experimental sketches for other sculptures. Because plasteline remains soft, a sculpture made of it could be accidentally dented or misshapen, therefore, if you are pleased with your adventure with plasteline, have it cast into a permanent material.[9]

Coloring ("Patining") (if left uncast)

The soft state of plasteline does not preclude its coloring ("patining"). Before doing so, try to harden the piece by exposure to extreme cold. Also shellac the surface which closes the pores. When shellac is dry, finish off with the coloring. "Sculp-Metal," purchased in most art supply stores, is often used as a hard, metal-like covering over the soft plasteline state, and then colored.

10

Elements of Sculpture

Composition

In discussing composition in sculpture, the very first thing to establish is a definition of the word. Webster defines composition as a "combination of the parts of a work of art to form a harmonious whole." This is as true of sculpture as it is of any other form of art. The component parts of the portrait, as in other aspect of sculpture or in any other art form, must be properly arranged—"composed" in the fullest meaning of the word. The elements in any sculptural piece must create a harmonious whole. There must be unity in line, plane, and form, so merged and blended as to make for oneness. There must be simplicity through the elimination of irrelevant detail. There must be due regard for proportion and balance in the composition. There should be a suggestion of movement in the way the forms are arranged. All these elements must have an interrelationship that gives the design a rhythm. Views from all sides must be equally seen and understood. Is there composition in a sculptural portrait? Decidedly, for composition is as much a part of the sculptural portrait as in any other aspect of sculpturing. Composition is required in a single head or a group of heads, as it would be in a single figure or object, or a group of figures or objects. In a sculptural portrait, the assemblage of a head structure, the neck, and the shoulders and bust if they accompany the head and neck . . . together with the shapes, proportion, placement, and spacing of the features . . . what is to be emphasized and what is to be toned down—must be effectively arranged—"composed," as it were. It must not only be good composition, but must esthetically express the sculptor's interpretation of the sitter's characteristics that give likeness, personality, expression, and that most sought for quality in a portrait —inner spirit.

There are some sculptors who feel that the head structure and features, with their fixed anatomical construction, do not hold the same compositional difficulties as other aspects of sculpture, but there is certainly enough composition in the former to test the creative talents of the very best sculptors.

A simple head constructed by a sculptor is a composition in itself or it is nothing. The placing of the units of the shapes of the head and neck, the momentous decision on how the smaller shapes of the mask are to be arranged, what is to be emphasized and what is to be subdued, the choice of movement of the related and counteracting planes to the fullnesses— all that is the sculptor's responsibility. That is composing and executing an esthetic expression at one and the same time by one artist. And, too, that procedure is true in all phases of sculpture.[11]

You will discover that putting together the parts of a composition is much like putting together the words of a satisfying sentence—when it is "right" the final effect is always greater than the sum of its parts. And when it is right you will know it.[3]

Plan Your Composition

The ultimate success of your portrait in clay or plasteline will, in large measure, depend upon the advance planning of your composition. Making a change after the work is under way can be very troublesome, or perhaps so impossible as to require a new start. There are a number of basic factors in planning a portrait composition, in addition to the elements of sculpture discussed in this chapter. Let us consider some of them: (a) the pose of the head, characteristic of the sitter. Will it be looking forward, or will the head be turned to a side? Will it be tilted upward or downward? Each has interesting effects (b) will the eyes be looking straight ahead following the forward direction of the head, or will they be glancing to a side? (c) will the face be expressing a feeling or mood? (d) will the neckline terminate where the neck joins the torso (e) if you are adding shoulders, will they terminate midway between neck and shoulders, or will the shoulders be full (f) will the bust, if any, be abbreviated or farther down in the torso. If the bust is full-shouldered, what portion of the upper arm will be included? (g) will the bust be naked or clothed? If clothed, what type of raiment which will be best suited to the portrait are you considering? You may want to leave off clothing, for often a collar or tie, jacket or dress, if it conveys no interest, can make a portrait dull (h) will there be a plinth to the head or bust—if so, what type, and what will be its depth? (i) other things in planning composition will come to your mind, I am sure.

MADAME STONE (L'Americaine), by Charles Despiau (1874–1946).
The Metropolitan Museum of Art, Gift of Chester Dale, 1963.

MME. JAILLOT, by Charles Despiau (1874–1946). *Philadelphia Museum of Art.*

Determine the position of the head and the composition or plan of the sculpture. Will it include the neck and the shoulder? Or will it have a neck set on a base? Will the base be a part of it, or will it be mounted on another material? All this should be planned before starting, for the major changes are usually more trouble than starting anew.[9]

Learning Composition

Of all the subjects taught in sculpture, it may be said that techniques are the least difficult, composition, the most difficult. Actually, it cannot be taught, for there are no definite laws or fixed instructions to teach it. There are no "schools" of thought to which the aspiring sculptor, yes, even the professional, can turn for guidance. Composition is the result of feeling and emotion, of idea and conception, of individual artistic expression. It cannot be imposed on another, otherwise the latter will be deprived of his ability to give expression to his own ideas, to develop original conceptions, to produce works of individual quality. This book, or the teacher, can only suggest, not impose, ideas on the learner; however, the willing and ambitious individual through suggestion can be helped to give expression to his own thoughts and feelings, to find the essence of good composition. Just helped!

There are, of course, generally accepted principles of composition which can be learned through fine sculptural work by the masters of old, and sculptural pieces by other accomplished sculptors, old and new. Visit the museums, the art exhibits, private galleries, and other sources of learning. There you will find the best of portraiture to inspire you—expressive heads from the Egyptian to the classical Greek periods, from the Renaissance, and on to the works of the many accomplished sculptors of the later years and into contemporary times. There, too, you will find other sculptural forms to inspire you in your efforts to create your own portraitures in clay or plasteline—works with overwhelming beauty of harmony of line and form, of idea and composition, design, rhythm, etc. Explore every avenue that offers knowledge and direction. It will give you a broader understanding of sculpture, painting, etc., that will enrich your own work. The simplest advice, then, that can be given to the beginner, the amateur, and the student is to seek out knowledge on composition wherever he can, assimilate this knowledge with his own ideas and feelings, and to interpret it to his own ideals. Artistic standards will come when sincere and conscientious studies and efforts are applied.

The novice sculptor should attend all the sculpture exhibitions he possibly can. That way he will not only know what is being done in contemporary American sculpture, but it will help his development.[11]

Design

Sculpture is the art of form in space. Materials used—hard substances like stone, wood or metal; soft substances like clay, plasteline or wax—play a decided part in the design used, for each material has its own qualities and limitations. All parts of the three-dimensional form in sculpture—large and small masses of form, line and plane—must be organized so as to bring all its elements—design, rhythm, unity, simplicity, proportion, balance, movement—into a harmonious relationship. It must express the same message from all points of view. Design, whether for head or any other phase of sculpturing, is the starting point of the piece. Good designing is unchanging in its principles.

There are certain fundamental truths that cut through all art forms—basic design tenets, many of them subconscious, that our age lives by. But design itself, the most important aspect of art, is at the same time, the most difficult thing about art. Unchanging principles of balance and movement, form and line, rhythm and flow, make up the philosophy we call design.[3]

Design in sculpture is the harmonious and moving organization of planes and masses. The organization of small forms is based on the large masses. If you organize the subdivisions without first realizing the big forms, you lose all feeling of sculpture.[5]

Design means establishing relationships so that the various elements seem to belong together. Design means creating order out of chaos. Just as we speak of an aimless life as one without design, so we find certain pieces of sculpture do not hold together because the sculptor has not established relationships that have meaning. I think of design as a great unifying, rhythmic pattern. Out of this grows the flow and interplay of minor forms and rhythms, all of which are held together by a larger plan so that a living entity exists. The element of design is important because it is the structure of the idea, but it must be remembered that design is a starting point, not the objective. A sculptor does not create the same form or design for bronze as for wood or for stone. Each material has a character and quality of its own. Your design forms should grow out of your findings and experience with materials.[13]

Rhythm

Rhythm is a harmonious relationship of the lines, planes, and masses of form as they make their transition gracefully one to the other in uninterrupted, flowing action. Each constituent that helps to produce the result has an identity of its own, yet is but a part of the whole structure. It is this harmonious interrelationship and flow of the parts into one another that gives the design its rhythm. Without rhythm, the design will never be properly composed.

Heads of all constructions have rhythm. Lines, planes, and masses of the head structure and features—all blending into one another, and making for a harmonious whole—are indeed fine examples of rhythm. Rhythm in the sculptural form is not easily and consciously defined. It is an elusive quality, and a person must have a taste and feeling for it. Your personal experience in modeling, the "doing" of sculpture which is the most important source of learning, will hasten your understanding of it. We see examples of rhythm in our daily lives, if you but reflect over it—a leaf falling, a butterfly in flight, an arrow in motion, the swaying of a tree, the movement of an ocean wave, etc. There can be nothing monotonous in rhythm, for rhythm has variety of movement that flows harmoniously in all directions. Rhythm abounds in the works of accomplished sculptors. Look carefully—you will see it.

> Rhythm is continuity—flow—an untiring, non-monotonous movement. Examples of movement, but no rhythm—a swing, a see-saw. The ticking of a clock and the swinging of a pendulum are movements, but have no variety—they are monotonous. In rhythm there is a variety of movement and also a combination of variety of movement flowing in different directions. Rhythm is produced by the selection and combination of various shapes and forms, and by the arrangement of them in a harmonic pattern or design, either two-or three-dimensional. It is, as it were, creating order out of chaos—a personal and individual order—balancing form against form, direction against direction. The most simple forms can have beautiful rhythm. A head may be extremely simple yet have subtle relationships of curves and straight lines which weld the individual features into a rhythmic whole.[13]

Unity

Unity is a matter of harmonious relationship, and oneness. Each part of the sculptural piece should be so merged and blended to all other parts as to make for a unifying, homogeneous whole. Sculpturally, then, unity should be an arrangement and balance of lines, planes, and masses of form to make for a unified design. Without unity, no worthwhile result is possible. The final effect, when unity is achieved, will reflect the value of each part, and the contribution each part makes to the whole. The sculptural quality of a portrait—likeness, characteristic expression, and personality of the sitter—will be greatly enhanced when the various elements making the three dimensions relate to each other in an effective and meaningful oneness.

> All parts of a piece of sculpture must be in perfect relation and harmony with one another, and the ensemble must form a perfect whole. Beside the unity of a piece of sculpture in itself, it must have unity with, and relation to, its surroundings—as an example, sizes vary under the influence of surrounding objects.[10]

Without a unifying structure, a work of art or even a life, is meaning-less. It may have certain qualities but without a feeling of unity holding the various forces together, the sculptor has not established relationships that have meaning.[13]

Simplicity

A portrait in pliable clay or plasteline belongs to the technique of modeling, as distinguished from direct carving in hard sub-stances like stone or wood. In the latter cutting-down process, larger planes and masses of form, and solidity of form, are estab-lished appropriate to the nature of the material, resulting in a simplicity that is a time-tested limitation of that process. In model-ing, however, whether it be clay, plasteline, or wax, the building-up process, unlike the carving process, permits detailed representa-tion. Here lies the danger of cluttering up the form with irrelevant detail. The modeling process, as in the direct carving process, must follow the rules of simplicity by the elimination of unnecessary detail. A wart adds nothing to expression or personality, or the inner spirit of the sitter. It has no important effect on likeness, neither does every last wrinkle enhance likeness. The modeling of each separate curl or lock of hair adds nothing to the sculptural quality of the hair design. Everything that is unnecessary must be rejected. There is little danger of erring on the part of simplicity.

Sculptural composition should be simple—it should be strong—balanced . . . and by simple strength I do not mean clumsy weight. That is not strength.[11]

Unity and simplicity are the most desirable features in sculpture. The essence of good sculpture lies in simplicity and can only be arrived at by disciplined elimination of the irrelevant, and the stress of the forms which are pertinent to the structure and flow.[12]

What you decide to leave out is also important, for everything that obscures and doesn't contribute to the conception must be left out.[13]

Proportion

Judging proportion is an essential requirement in sculpturing. Consideration must be given to height, width, depth, and their relationship to each other. All parts of a sculptural piece should be well proportioned, related to each other and to the whole. There must be a structural cohesion between skull and neck, and the bust in relation to head and neck, if the bust is a part of the composition. There are relative proportions in the features of the

face, although in some persons there may be a larger nose, or ears, or some other disproportionate feature. Though proportion can be measured, it is much more than that; it must be sensed. The sculptor must instinctively recognize any inharmony which may result from wrong proportions.

> The thing to remember about proportion and what people term proportion, is that a thing is right if it is designed right and expresses what the artist meant it to express. The proportions of a human figure, an animal or any living thing are what they are because they serve a natural function. In the same way the proportions of any sculptured figure are right when they function in an art way, that is, as related parts to a good design.[13]

Balance

A composition should have a balance of form through proper distribution of the masses. Much of the beauty in sculpture derives from the sensitive use of this factor. There is the symmetrical balance—the even, formal arrangement of form quite apparent in the shape and proportion of the human head and features, or the asymmetrical balance—the uneven, informal balance established through subtle variations in a form. The appearance of balance is as essential as physical balance itself. Balance is understood by most people, for most of us like order in things, as attested by our constantly placing objects in balanced arrangement. For example, most of us in arranging furniture at home or office, or in placing objects on a desk, will try almost unconsciously not to crowd pieces in one area, leaving the rest of the space relatively empty—or placing larger pieces together that unbalances the arrangement. Nature abounds in balance—tree shapes, foliage, most everything. This holds true equally in sculpture. Balance must consider the proper placement of the features in the face. Take the simple matter of eye placement—if placed too close together, or too far apart, you immediately have an unbalance that would ruin the portrait.

> Sculpture should be strong—it should be balanced. Look around you at growing living shape. The Good Lord (or Mother Nature) is a master designer. Study the balance and growth of tree shapes, plants, hills, people, rocks, shells, or whatever you are looking at.[11]

Movement

A simple head can portray a feeling of movement, even though in itself it is immobile. The thrust of a head forward is one example. The turning of a head, with the neck in a straightforward

direction, effects a twist or pull between the two which suggests movement. A turn of the head and neck, with shoulders in a straightforward direction, suggests movement. Eyes glancing to a side suggests movement. Emotional expressions like laughter, etc., reflect movement. An impression of movement in the form activates the portrait, giving vitality to it.

Show movement as gracefully as possible.[3]

Three-Dimensional

We speak of "volume" in describing the three-dimensional form of width, length, and depth—defined in the dictionary as a "mass or bulk occupying space as measured by cubic dimensions." Sculpture, therefore, is the art of form, its design interrelated to space. Essentially, the three-dimensional art form involves the organization of masses of form, both large and small, and includes all the elements of sculpture referred to in this chapter. It has an infinite number of views as the onlooker changes his position, no matter how slight—and all these views must be equally stated. All of these three-dimensional aspects must ever be in the sculptor's thoughts if his efforts are truly to be developed "in the round." A reminder is in order that when modeling keep turning your work so as to build three-dimensionally.

Sculpture is a parable in three dimensions, a symbol of a spiritual experience, and a means of conveying truth by concentrating its essence into visible form. Today we call it the interrelation of spatial design, and we look for its quality of volume, light and shade. It must be a reflection of the artist who creates it and of the era in which he lives, not an echo or a memory of other days and other ways.[6]

11
Working From Life

The Sitter

In choosing a sitter, the aspiring sculptor should—at first, any-way—make his task as easy as possible by selecting a friend or relative with the necessary interest in his sculptural effort, and the necessary patience to sit for him. He should choose a face with strongly marked features, preferably a smooth-faced male adult. The strongly marked features in the male face provide the needed characteristics that make for likeness, expression, and personality; characteristics that can be more readily caught and transferred to the sculptal interpretation. Avoid the adult who is a nervous type who seemingly lacks patience, and who would become easily bored while sitting for you. It would be a mistake to attempt a portrait of such an individual for you are bound to end up with a bad portrait, one that is unacceptable to you, or to the subject. The novice should delay doing childrens' portraits until he is well advanced in his training, for children are restless and cannot pose for any length of time. You will be losing impressions you wish to capture when the sitter is a restless child, likely to grow weary or become obstinate at any moment. The competent sculptor, however, has no hesitancy in the choice of subject. Man, woman, or child—all interest him equally; the child for its innocent beauty and delicacy of small features; the man for his strongly marked features, his masculinity and strength of character; the woman with less definite forms than the man, but possessing a refinement of feature and a feminine beauty that is a never-ending inspiration to the artist.

If you find a model to pose for you, I would suggest that you do so. There is much to be learned from observing solid form, motionless for your study and emulation in clay.[12]

Almost everyone very early in his career attempts a portrait of some member of his family or a patient friend. But I suggest that unless your mother is a particularly patient elderly lady, you get your father or some other man to pose for you. There are many reasons for choosing a masculine head (and one without whiskers) for your first subject. First, a rugged head is easier to do. The shapes and bumps on a man are easier to see. You have something to grab hold of as you model. Smoothfaced ladies or children are more difficult. You will find a man sitter more patient. A man sitter is usually less apt to object to exaggerations and emphasis on character essential in a portrait.[11]

Position Sitter/Yourself

The sculptor's head should be on the same level with that of the sitter and the clay or plasteline model. If you are looking down on the sitter, you will be seeing far too much of the top of his head and less of the lower face and neck . . . inversely, if you are looking up at the sitter, you will be seeing far too much of his neck and lower face and less of the forehead and top of the head. In either case, you are getting wrong perspectives. With all three —sitter, your work, and yourself—on the same level, you can make better comparisons between the sitter and your work. In all probability, you will be standing, or sitting on a high stool, while modeling—accordingly, the sitter and your work will be on that level. It may be necessary to place the sitter on some kind of platform to obtain height. A second-hand table, with legs cut off so that the top of the table is about 18" to 24" above the floor, would make a suitable, economical platform. If you find yourself tiring and wish to sit down on a low chair, or prefer to work all the time from a low chair, you must adjust the sitter's position and your work accordingly. Some sculptors prefer the sitter as near to the work as possible for better observation. Others prefer a greater distance for perspective. Some sculptors find that when modeling too close, the sitter can exert too strong an influence on them in their interpretations—also can lead to a personality clash. Distance, then, is a matter of choice.

Have your sitter sit on a high stool or chair set on a large box so that his eyes are level with yours. Your armature for a portrait head should be about eye-level, too.[11]

If the sculptor is working from a living model, the sitter should be placed, if possible, so that the head is on the level with the clay model; it is, of course, much more easy for the sculptor to compare them both from different viewpoints when placed thus.[1]

Position the model; the model's head and the clay should be on the

ALBERT THILLE, by Frank Eliscu. *Courtesy of the National Sculpture Society, N.Y.*

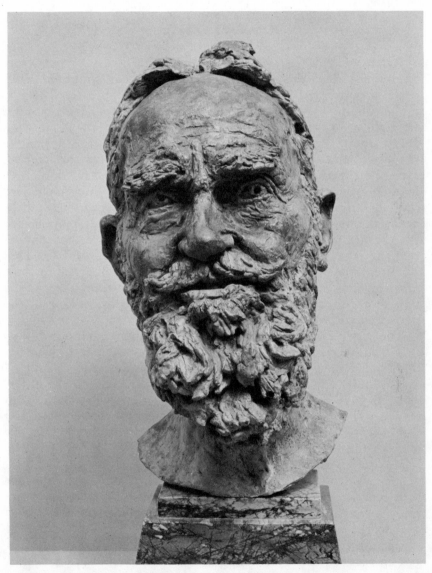

GEORGE BERNARD SHAW, by Sir Jacob Epstein (1880–1959). *The Metropolitan Museum of Art, Chapman Fund, 1948.*

same level. Place the model as near to the work as possible, and have enough room in which to stand back and compare the model with your clay. The importance cannot be overstressed of seeing both the model and the clay in the same position, slowly turning each one round and standing back to compare, also seeing them in various lights.[7]

Relax/Pose The Sitter

After you position your sitter, see that he is relaxed. Since naturalness is of the utmost importance in your sculptural interpretation, your subject should be completely at ease. There is nothing more harmful to the final result than to have the sitter sit rigidly, over-posed, self-conscious, and obviously ill at ease. By "natural" I mean that pose which is habitual and normal to the sitter, and which reveals him at his best—best for likeness, expression, personality, etc. It should be a pose easy for him to hold, and one easily resumed after a rest period. Any haphazard pose, or any pose that is stiffly formal and self-conscious, can be artificial, lifeless, and devoid of character. The pose may include the characteristic way the sitter carries his head; it may have a characteristic expression that particularizes and identifies him. You may want your sitter reading or writing, or occupied in some other manner, if that is the way you can get the right effect. Take time to get the pose that will be the natural representation of the subject as a whole.

The sitter's spirit should be kept as animated as possible so that characteristic expressions can be captured, and transferred to the clay or plasteline model. The enthusiasm and delight of the sculptor while working will communicate itself to the sitter, and can have the sought-for effect on the sitter. The entire proceedings should be a delightful experience for both sitter and sculptor. Whenever the sitter's spirit appears to be flagging, it is up to the sculptor to revive it. There must be this sympathetic relationship between the two, otherwise the portrait will suffer.

Some conversation is helpful so long as it does not interfere with your work. Getting the sitter interested in the portrait is one very worthwhile type of conversation. Talk to your sitter about your work; let him watch its progress by placing a mirror behind you in direct line of his vision. It helps to keep the sitter from getting restless, and by inducing a livelier interest in the portrait, the sitter's face may well take on the animation and expressiveness sought by the sculptor. (Another use of the mirror is for the sculptor to review his work in the reverse. It can prove helpful in judging how well he is developing an expressive likeness, etc.)

Make your sitter feel that he has qualities worth sculpturing.

Speak of some characteristic pose, or some feature or expression that you are seeking to capture. Everyone is interested in himself (or herself), and will lend you his cooperation if you invite it— so essential to the success of your work.

A musical background, or alternating music with conversation, is used by many sculptors to create the right atmosphere for a sitter's relaxed pose during the working session. Take frequent breaks in your work—the sitter needs it; you need it—both of you will return to the job at hand with renewed vigor and enthusiasm.

In making a portrait of someone who habitually wears glasses, let him continue to wear them during the sittings. It is better that the sitter continue to wear them for comfort and restfulness, even though you can't see his eyes completely. When you want closer observation of the details of the eye and surrounding forms, the glasses can be removed for short periods of time.

Measuring The Sitter

There are teachers of the modeling technique in sculpture who are opposed to measuring—who prefer the eye to be trained to measure proportions, placement, relationship of forms and features, etc. They say that measurements should be used sparingly for fear the eye will become lazy and too dependent upon mechanical means. There is much to be said for this point of view, and the reader is reminded that when mechanical measuring instruments are used such as the caliper and tape measure, they should be eliminated as soon as they can be dispensed with. To the experienced sculptor, the number of measurements listed in "Sitter's Measurements" below is, no doubt, decidedly excessive, and he would frown upon them. This book, however, is particularly written for the beginner, amateur, student and non-professional sculptor who may feel that his eyes alone—his observations—are not yet to be trusted, and that all of these measurements, or at least a part of them, are necessary to serve his modeling needs. One thing that can be said in favor of measurements: by setting them down on paper, you can later refer to them without troubling your sitter for re-measurements.

To facilitate the correct construction of planes and the features that are built into the general form of the head in their correct relation to it and to each other, it is advisable to take a set of measurements. These may be taken with a caliper and set on paper in a life-sized diagram for reference use.[6]

SITTER'S MEASUREMENTS

C for caliper, *T* for tape measure—whichever affords best means for measuring. As experience is gained, unneeded measurements can be eliminated.

1	Side line	Chin level to high curve of head	C	Side height—(A) below
2	Center line	Chin level to high curve of head	C	
3	Center line	Chin level to brow (eyebrow hairline level)	T	Equal to #4 & #13
4	Center line	Chin level to nose base level at lip juncture	T	
5	Center line	Chin point to neck (canopy under jaw)	T	
6	Center line	Pit of neck to high curve of head	C	
7	Center line	Pit of neck to chin	T	
8	Center line	Pit of neck to neck at chin level	T	
9	Center line	Pit of neck to ear (i) at nose base level	C	(i) "hinge" of jaw (at ear bottom)
10	Center line	Brow to hairline	T	
11	Center line	Brow to high curve of head	T	
12	Center line	Brow; overhead to brow level at back	T	
13	Center line	Brow to nose base level at lip juncture	T	approx. ear length (#31)
14	Center line	Brow to nose tip	T	
15	Center line	Brow to nose tip & inc. nose underside to lip	T	
16	Brow level	Frontal width	C	Widest width—see (B) below
17	Brow level	Front center line to rear center line	C	Widest depth—see (C) below
18	Brow level	Circumference	T	
19	Brow level	Ear (ii) to ear (ii)—back of head	T	(ii) angle line of ear
20	Median level	Eyes—left outside to right outside corners	T	
21	Median level	Eyes—width of each eye	T	
22	Median level	Eyes—width between inside corners	T	usually an eye width (#21)
23	Median level	Eyes—outside corners to angle line of ear (ii).	T	
24	Nose base level	Nose—bottom width	T	
25	Nose base level	(Cheek-bones—width	T	
26	Nose base level	(Cheek-bones—width	C	
27	Nose base level	Ear (i) to chin at center line	C	
28	Nose base level	Ear (i) to brow at center line	C	
29	Nose base level	Ear (i) to high curve of head at center line	C	
30	Nose base level	Ear (i) to ear (i)—back of head	T	
31	Nose base level	Ear length, brow level to nose base level	T	approx. length of #13
32	Mouth level	Mouth—width	T	usually 1½ times #24
33	Mouth level	(Jawbone width—side to side	T	
34	Mouth-level	(Jawbone width—side to side	C	
35	Neck	Circumference	T	
36	Neck	Pit of neck to 7th vertebra	C	
37	Shoulders level	Upper torso width—side to side	C	—for bust
38	Armpit level	Torso depth—front to back at center lines	C	—for bust
39	Armpit level	Torso frontal width—armpit to armpit	C	—for bust
40	Armpit level	Circumference of torso	T	—for bust

Average adult head size: *If reduced in modeling:*

(A)	Height	8″	7″	6″
(B)	Width	6″	5¼″	4½″
(C)	Depth	7½″	6½″	5½″

As to (B) and (C): Actually the widest width and depth is at the forehead level, above the brow level. It is placed here at the brow level because (a) difference is slight (b) convenience of measuring along the brow level, the line of which you will be incising on your basic clay or plasteline form.

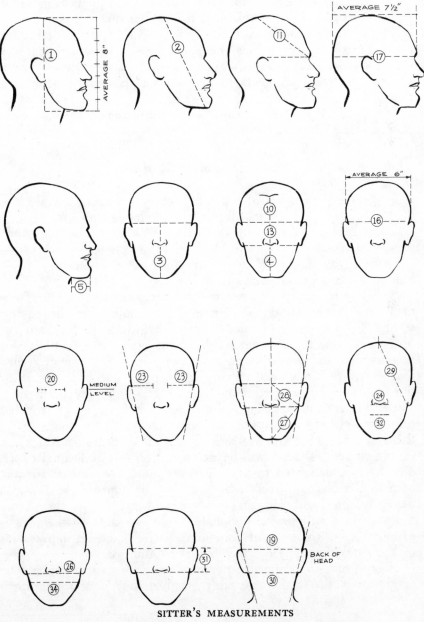

SITTER'S MEASUREMENTS

Numbers correspond to measurements in "Sitter's Measurements."

The degree to which actual measurements should be used as a prop or discarded as a tie, will always be, to some extent, a matter of temperament. In the last resort the character of the sculpture will be determined by the order of the sculptor's will to form and, whatever be the method used, it is surprising to observe how strongly this order will always assert itself throughout the works of each individual sculptor.[1]

The tape measurements in "Sitter's Measurements" generally does not fix distances as accurately as does the caliper when used between fixed bony points, but the novice will find the tape measurements most helpful to supplement the caliper measurements.

The aspiring sculptor is well advised to do his first portraits in life-size. Proper proportions and placements in structure, features, etc., are most vital in a portrait. It is much easier to transfer the sitter's exact measurements to the clay or plasteline model when doing your work life-size. The larger or reduced sculptural portrait requires additional effort to change measurements to suit the changed size.

Notes, Diagrams, Sketches

Make frequent notes of what you observe about your sitter—before beginning to model, during the modeling sessions, between sessions. Such memorandum, no matter how slight and informal, may become salient points in establishing a convincing portrait—facts that you might otherwise overlook. One single note could hold a clue to a better portrait.

Needless to say, if you can supplement your notes in the form of a diagram or sketch—no matter how crude your effort—just setting down in this simplified form of drawing the lines, shapes, proportions, and placement of head structure and features—of frontal view and profile—you will have a more permanent record than memory alone can provide to sustain your impressions of the essential characteristics of your sitter. Don't try to make a finished portrait in your diagram or sketch. It is not a sophisticated drawing you are attempting to make. Accuracy isn't absolutely necessary, for what you are seeking in your diagram or sketch are simple guidelines. Time will be well spent on this additional effort. You will be delighted to discover how much you can do by way of a simple diagram or sketch. Getting your impressions down on paper by notes, and diagram or sketch, and referring to them from time to time, will prove a valuable aid, particularly when, as is often the case, the sculptor finds himself tired, and his impressions of the sitter becoming blurred or lost to him.

If you are doing a life-size portrait, you may want to make your diagram or sketch in the same proportions; if the sculptural

portrait is larger or smaller than life-size, the diagram or sketch could be adjusted to the changed size.

If sculpturing is a hobby or pastime with you, training in drawing is not a prerequisite; the simplified diagram or sketch will be sufficient to serve your needs. However, if you are contemplating a professional career as a sculptor, thorough training in drawing is as vitally essential as any other form of instruction in sculptural art.

If you have no time, desire or ability to make a diagram or sketch from life, take some photographic shots of your sitter. You may find them very useful as a reference for detail. Read "Working from Photographs" for fuller details.

Make drawings of your projected sculpture, primarily as sketches—also line and form studies to guide structure. The sculptor's drawing is generally basic and simple.[12]

It is imperative to bear in mind the composing of lines—therefore advisable to make a sketch before start of work.[10]

It is advisable to make quick drawings of the profiles and front view, as our first impressions are apt to become blurred and lost by constantly looking at the model. Also the model gets tired and bored, the muscles sag, the spirit goes and the work begins to reflect something without life or spirit.[13]

It is a good idea to make a simple drawing of your subject, with no attempt at detail, and refer to it often as you work.[11]

Lighting

Poor lighting can have an adverse effect in getting your statement of likeness, etc. It is important that your sitter and your work be in good light. Good lighting not only means an abundance of light, it is the quality of the light that is essential. The best light is that which gives the same effect of light and shade simultaneously to your sitter and your work. If possible, the light should enter from one window only, preferably a side window for side-light effects of light and shade; not emanating from different directions which cause cross-lights and troublesome reflections. Sunshine, or any other glaring light, should not play on your sitter or your work for obvious reasons. North light is highly desirable as no direct sunshine comes in, and the light is uniform. For right-handed sculptors, your modeling stand or turntable should be placed so that the light falls on your clay or plasteline form from the left. This avoids having to work in your own shadow or the shadow of your right arm. The opposite is true if you are left-

handed. If your modeling is being done at night, the fluorescent light is the best substitute for daylight.

Self-Portrait

The making of a self-portrait is suggested for the budding sculptor. It gives the aspiring sculptural portraitist a wonderful opportunity to experiment. He can gain experience leisurely because he is doing his own portrait; doing the portrait of another, he is working frequently against time—the sitter's time. One thing that can be said of a self-portrait—it relieves the sculptor of flattering the sitter or his family. With a self-portrait, you can sculpt the truth; you can represent it honestly, model what you see without hurting anybody's feelings. You will probably find your own face interesting and a bit of a revelation, for how many of us really see ourselves. The revelation can be so surprising that you may have the feeling of sculpturing a stranger. It will prove quite an experience that, although you have gazed at yourself countless times, you suddenly discover that when modeling your own ear, eyes, mouth, etc., you really never knew what they actually look like. Making a statement of your own expressions and personality is a subtlety indeed. In doing a self-portrait, any mirror will do. Simply place it on some table, or any other kind of elevation, in front of you, with the clay or plasteline work between you and the mirror. The mirror image should be slightly above your work. In this simple arrangement, your head will be moving as little as possible while you transfer the mirror image to the model. You can add a profile view (how many of us are really familiar with our profile view?) with the use of another mirror at right angles to your modeling stand or turntable.

Modeling Children

The sculpturing of a child's portrait is of much interest and pleasure to many sculptors, even though it presents special problems to them. One problem, for instance, is to make the portrait reflect the right age of the child. It is not an insurmountable problem, yet one fraught with difficulties. A matter of five years, more or less, will not make much difference in the sculptural portrait of an adult; obviously, it would make a considerable difference in a child, for even one year's difference in age reflects significant changes in a child's head and features. The difference in head structure and features between the child and adult must be well understood before you attempt to do a sculptural portrait of the

SELF-PORTRAIT

child. You will find a child's head larger in proportion to his body than that of an adult. The proportions vary according to age: at age one to one and one-half years, the child's head proportion to its body proportion (total head and body) is approximately 1-to-3½ or 4 heads; at age five it is approximately 1-to-4 or 5 heads; at age seven it is approximately 1-to-5 or 6 heads; at age ten it is approximately 1-to-6 or 7 heads. The adult proportion is approximately 1-to-7½ or 8 heads.

The child's cranium is larger than the facial portion. Whereas in the adult head the area from the top of the head to the median line (which passes through the corners of the eyes) is approximately one-half of the head, the same upper area in a child twelve to eighteen months of age is approximately two-thirds for the upper portion, and one-third for the area below the median line; at age four to six years the same upper area is approximately a little more than one-half while the lower area is approximately a little less than one-half; at about ten or more years of age, the proportions are about the same as in an adult. Forehead occupies the greater part of the cranium in the earlier years of a child.

Since there is not much evidence of bony structure in a child's face due to the distribution of fat, rounded contours, and lack of crisp lines, it gives the sculptor less to "get hold of" for like-

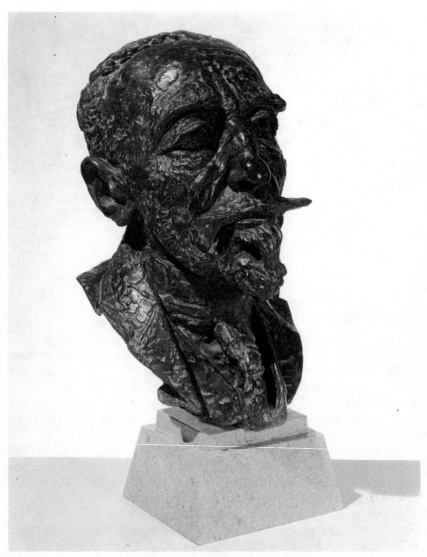

JOSEPH CONRAD, by Sir Jacob Epstein (1880-1959). *Philadelphia Museum of Art.*

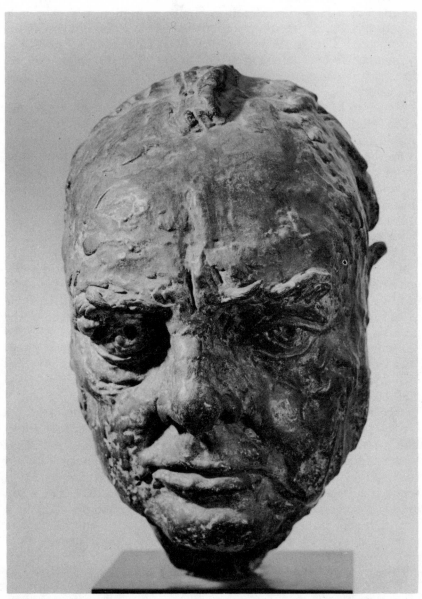

WINSTON CHURCHILL, by Sir Jacob Epstein (1880-1959). *Courtesy of the Louvre (Musees Nationaux), Paris. Photograph by Service De Documentation Photographique De La Reunion Des Musees Nationaux, Paris.*

ness. Individual characteristic expressions in a child's face are unformed, as compared to the visible evidence of expression in an adult's face. It is the difficulty of getting hold of a child's individual characteristics which offers a test of the sculptor's ability to capture. The relationship of features in a child's face differs from that of an adult, and some details of these differences are discussed under respective chapters relating to ears, eyes, nose, mouth, etc.

Children by nature are full of energy. How to keep a child still while doing his sculptural portrait is, of course, the most obvious problem that confronts the sculptor. The sculptor must realize from the very start that a child is not physically or mentally capable of keeping still for long periods of time. The child's endurance, therefore, should never be taxed beyond a reasonable length of time. Giving young sitters many short periods of rest is the best answer to the problem. Give it to them before they really get tired, rather than wait for them to get restless and peevish. It is better to work accurately for short periods of time while the child is comparatively still than to continue working under adverse conditions. In the case of very young children, these short periods of time may be fairly short spurts, and modeling should be done as expeditiously as possible. How to make the child realize the necessity of keeping still for a pose becomes a matter for each sculptor to solve. No two sculptors use exactly the same method. It is generally done by learning as much about the child as possible—his state of health, his temperament, etc., and adjusting the method for best results.

The sculptor may, in a number of ways, reward the child for his co-operation, making the child feel, as in the case of an adult, that he is contributing to a good portrait; by flattering a child that he is making a better sitter than most children; by amusing a child with radio or other forms of musical presentation; by other diversions such as reading to a child, or letting him play with a toy or doing some clay or plasteline modeling. Keeping a child in a settled mood for extended periods of time, long enough to get some progress in your work; to get him to regard sittings as a treat and adventure . . . takes much thought and ingenuity on the part of the sculptor.

The sculptor needs a great deal of patience in handling children. Since children lack patience, the sculptor, in turn, must have plenty to spare to meet the demands made upon it. He must wait and watch for expressions he would like to record—and to store in his memory sight-impressions for the period when the child is not sitting.

It is better to work on older children first, and gradually go to the younger ones. The older ones react to a certain amount of

discipline and will pose reasonably well for longer periods of time than the very young. Children will, very likely, be the first of your portrait commissions, so a knowledge of children—their natures, moods, reactions, etc.—is a "must" before working in this field.

The use of a diagram or sketch, or a photograph, to refresh memory is more of a necessity when modeling children than with adults, for the difficulties of doing a child's portrait require more time between working sessions for detailed study and reflection. Read data on "Notes, Diagrams, Sketches" and "Working from Photographs" in this volume.

Teach Yourself to "See"

Observe the people around you. Look keenly at the contours of their heads and faces, and the subtleties of their features—what particularizes one individual from another. Study expressions or "look," and try to discern the mood or feelings they seem to reflect at the moment. Are there any striking characteristics of head or features that distinguish that one man from another, that one woman from another? Can you identify any personal distinctiveness that would throw some light on the individual's personality? Note the pose of the head for it may be a characteristic of the person you are studying. Note that while the basic forms of the head and face are similar in people, the variations created by nature are endless, as many as there are human beings. Note the variations in the sizes and shapes of ears, eyes, nose, mouth, etc. You will never tire of these observations. Your streetcar, bus, or train ride will never be a dull, monotonous routine if you continue to make these observations. The more people you observe, the better you will be able to evaluate what you see. The more you truly "see" people, the more accurately and faithfully your work will reflect your observations. The more you observe, the more you will store away in your memory and recall at will, and put to good use when modeling your sculptural portrait. As you progress in your work, your enriched observations will be set down by you with greater sensitivity and integrity. You might try sketching during your observations, if possible; set down the salient characteristics of the fellow you are observing on the streetcar, bus or train—not a meticulous drawing of every detail, but a jotting down of impressions. If you can't conveniently do it at the moment of observation, how about recalling details from memory when you get home!

12
Working From Photographs

There are a number of issues to be considered when a photograph will be used in the making of a sculptural portrait. Obviously, when the subject of a portrait is deceased, there is no alternative to the use of a photograph or a series of photographs. In this instance, no ethical question is involved for the posthumous portrait, either relating to the subject, or to the sculptor's professional principles. They should not be used, of course, unless the photograph or photographs are sufficiently clear to construct a likeness, and to show individual characteristics to guide the sculptor's interpretation—otherwise they can only produce a badly constructed portrait. By studying a series of photographs taken over many years, it may be possible to pick out certain characteristics that have remained unchanged. Photographs may prove undesirable if retouching has taken place and some of the individual characteristics, so essential to good sculpture, are eliminated by such retouching. Some photographs, however, especially if they clearly define likeness, and have caught characteristic expressions, can be the basis of an amazingly successful sculptural portrait. Sometimes there is available a better photograph of the deceased when he was much younger. Such a photograph can be very useful, for the general contour of the head, shape of face, and other structural forms do not change with the passing of time. It can be a striking resemblance of the subject in his later years, minus wrinkles, etc., which he had acquired with the passing of time. A profile view is highly desirable as it outlines the head form, and shows the angle of the face, degree of projection of forehead, nose, chin. It takes a good measure of experience to visualize the essentials of a three-dimensional sculptural portrait from a two-dimensional photograph; without that experience the interpretation can indeed be a surface one.

If the subject of your sculptural portrait is alive, one school of thought says that it is professionally unjustified to use a photo-

graph. They express the added opinion that there is no feeling for interpretation when working from a photograph; that there is no pleasure in the work; that the ultimate result is an uninteresting, unconvincing, and unsatisfactory piece of work—far removed from creative art. They object even to a limited use of a photograph which some sculptors make. use of while working from life. Such sculptors work from life only. Another school of thought, generally coming from the non-professional ranks, feels ethically justified in using photographs of a living subject to supplement their observations. They argue that it gives them an opportunity between sessions to study the sitter's likeness, characteristics, etc., leisurely and at great length, instead of doing so with some embarrassment during working sessions. They also justify the use of photographs when the subject is unable to give the sculptor a sufficient number of sittings, or when a fidgety child is involved. They take from the photograph or photographs what information they want, no more, and then set the photographs aside so that this source does not endanger their sculptural interpretation. Some sculptors use photographs of a live subject only to plan the pose of the sculptural portrait. They take a number of photographs of different poses, and the most characteristic one is chosen as a basis of their interpretation. They sometime make enlargements of the pictures to life-size for greater clarity. After this planning stage, they do not refer to the photographs again.

If the sculptor is sufficiently experienced to take good photographs, he should do so himself, otherwise he uses the services of a professional photographer. For details, the larger the picture, the better. Enlargement to life-size is desirable. The pictures shouldn't be retouched, of course. Do not limit the number of photographs taken. The more you take, the more likely you will come up with one or more that catches the sought-for likeness and characteristics. Remember, too, that photographs are only to be used as a help in your work, particularly as an aid to memory. Using them intelligently in this way justifies their use. There is no justification, however, for using them for copying.

Whether to use photographs of celebrated persons who will never be available to you for sittings—heads of governments, for instance, and other prominent men and women from different walks of life—and who are always interesting enough to do, is a matter for each sculptor to decide. There is generally available an abundance of photographs of such individuals from newspapers, magazines, etc., and it is possible to interpret their form for a good sculptural portrait. It's worth a try, if you are willing to take your chances.

Snapshots and even badly printed photographs can be of assistance if

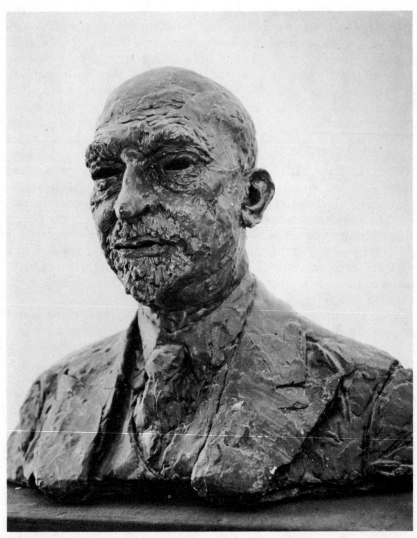

CHAIM WEIZMANN, by Sir Jacob Epstein (1880–1959). *The Israel Museum, Jerusalem.*

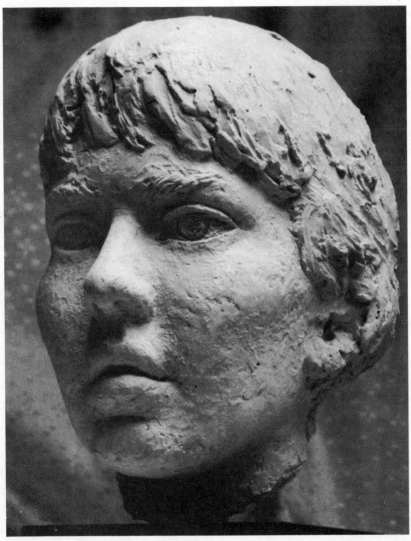

NANCY CARPENTER, by Philip Fowler. *Courtesy of the National Sculpture Society,* N.Y.

the sculptor has enough experience to be forewarned of the dangers in relying upon two-dimensional guides. A good three-quarter view can often help to verify the line of a profile by determining the projection of the nose and lips from the facial plane. Every minute detail in any view of the face can be of assistance in constructing a portrait either when the subject is unable to give the artist enough sittings or if the sculptor is making a portrait after death.[6]

It might be interesting sometime while you are working on a portrait to study, if they are available, photographs of your subject when he was much younger. You will find that though none of the wrinkles and calluses he has collected with age appear in his face, yet he resembles himself. The shape of his face, the general contour of his head, the characteristic forms which make the man look as he does, do not change. If the sculpture is made with that in mind, twenty years from now it still will be a portrait of your subject—and more important, it will be a good sculpture.[11]

13

Measurements On Clay or Plasteline Model

Purpose

Just as there are those who are opposed to measuring the sitter, there are sculptors who likewise are opposed to measurements on the clay or plasteline model—who prefer to train the eye to transfer to their work the sitter's head construction and its features in their proper proportion, placement, and relationship to each other. They feel that the powers of observation are of far greater importance to the success of a sculptural portrait than any mechanical means of measurement. To them it is a matter of seeing correctly, and carrying their observations of the sitter accurately to the clay or plasteline model. The budding sculptor, on the other hand, feels justified in the use of mechanical measuring instruments since he feels that his eyes—his observations—are not yet to be trusted. He believes that in the sculptural portrait, he is dealing with subtly shaped complex forms, and for their proper construction he must establish as many reference points of measurements on the clay or plasteline model as he possibly can. Any other way to him would be guesswork and a gamble. To him the caliper and tape measure, and the "carpenter's level" to establish more accurately vertical and horizontal positions, are indispensable tools in his sculptural effort. My advice to the beginner, the amateur, and the student: use the mechanical measuring instruments, but eliminate them as soon as they are not needed. As time passes and you gain more experience, you will yourself rely more and more on the powers of observation. The "Sitter's Measurements" (*see* "Working from Life"), and the number of reference points suggested in this chapter, will appear excessive to the expert sculptor, but this book is designed for the aspiring sculptor who may need all, or at least some, of such help.

The purpose of taking measurements is advocated as a check upon free observation, especially where the eye is not fully trained, rather than as a

123

mode of mechanical reproduction. None the less if any doubt as to the proportion or measure occurs as the work progresses, it is well to check up from as many ascertaining points, one to the other each time, as possible; each further measure will help to check up their relative positions with greater accuracy. If the student feels sufficiently confident to dispense with all the points fixed in advance by the matchsticks, then by all means let him proceed without them. For some, a method of this sort is an aid, while to others, it can be a limitation of freedom. But the method itself is well worth consideration as giving the idea of regulated growth into space from a central core. This is important. In any event, the student would be wise to mark some of the proportions in height on the center line at first, and to check up some of the measurements with the calipers, both as regards height and width, as the work progresses. It is very easy to lose the relationship of one part of the modeling to another, while one view is worked upon and observed over too long a period of time. The projection of that one part can easily be so advanced, that its relationship to the main shape is overlooked or lost. It would be wise, also, to preserve, at least, the measuring point marked with a matchstick where the eyebrow line crosses the vertical center line; and also such major marking points as the matchstick at the bottom of the chin and that at the back of the head (marking the distance from the point between the eyebrows to the back of the skull). These few points, and particularly the first can, then, always be returned to later for reference.[1]

Lines and Markers for Reference Points

On the clay or plasteline model, when the sitter's head structure is built to intended size, it is important to accurately establish the placement of the sitter's features and their relationship to each other by incising the following lines and using matchsticks or other recommended means to mark the reference points.

Center line (vertical)
Incise a straight line in the center of the clay or plasteline form from the baseboard in front, up the center of the face, over the head, and down the back center line to the baseboard in the rear— dividing the form in half. It is the starting point for all your measurements.

Top of head
A cuticle stick, or a long knitting needle (firmly attached to the center of the armature) (suggested in "Place Armature Centrally in Clay or Plasteline Form" in the chapter "Armature"), helps to establish the center of the top of the head. Another method of establishing the center of the top of the head is to incise a straight vertical line in the middle of the profile side of the head starting from the baseboard on one side, up the neck and side of the head, over the top of the head, and down the other side of the profile to the baseboard. Where it intersects the above-mentioned vertical

line running from front to back is the center of the top of the head. Place a marker at this intersection, or let the projecting cuticle stick or knitting needle serve at this reference point. The highest curve or crown of your sitter's head may be at this center of the top of the head, or somewhat forward or back of it.

Transverse lines (horizontal)

Brow level
Incise a line at the brow level (level of eyebrows), and where it crosses the vertical front center line and rear center line, place a marker at each intersection.

Median level
Incise a line midway between the top of the head and the chin level. This is the median line or level, and where it crosses the vertical front center line place a marker. Median line runs through the corners of the eyes.

Nose base level (bottom of nose)
Incise a line one-third or more down from the median level. This is the nose base level (bottom of nose), and where it crosses the vertical front center line and rear center line, place a marker at each intersection. Some nose base levels can be as much as one-half between median level and chin level. Nose length of sitter is the governing distance, not the length conforming to any idealization of beauty.

Mouth level
Incise a line one-third down from the nose base level. This is the mouth level, and where it crosses the vertical front center line, place a marker. There can be a slight length difference in individuals between the nose base level and the mouth level.

Chin level
At the bottom of the chin where a line, or an imaginary one, crosses the vertical front center line, place a marker. This is the chin level.

Ear line
Continuing the line or angle of the upper jaw (Ramus), incise a line to the brow level (as the upper jaw-bone is angled, so normally is the ear). On this ear line at the brow level (top of ear) and the nose base level (bottom of ear), place markers to show angle and length of ear. This angle of the forward part of the ear usually parallels the slant of the nose.

Other reference points

Other reference points may be needed by the novice such as the outer limits of the eyes (left outside to right outside corners), and other major measurements for distance. See additional measurements under "Sitter's Measurements" in chapter "Working from Life." These additional measurements can give considerable guidance to the budding sculptor for the proper proportion and placement of forms on the clay or plasteline model. Markers may be placed at such points for the length of time needed.

Markers

While matchsticks are generally used for markers, a thick blunt-

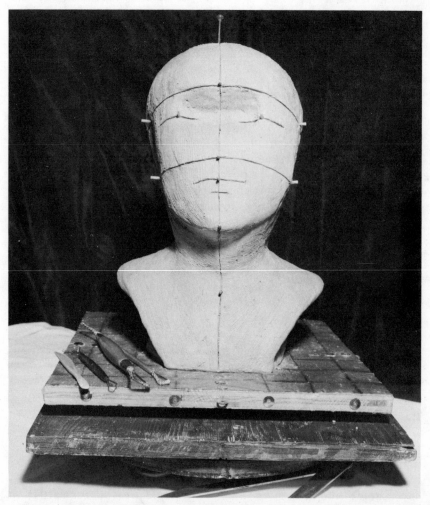

Marking points on the clay form. Basic shape of Eugene Ormandy portrait bust (front view).

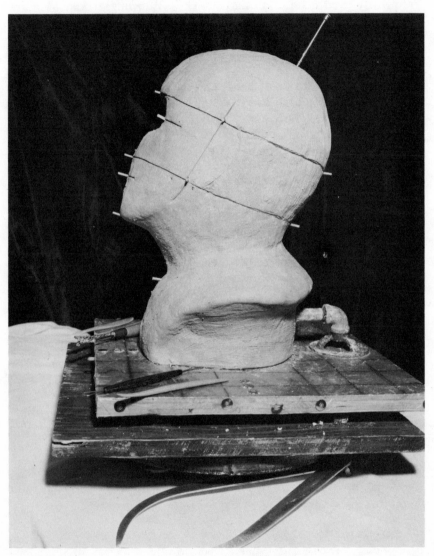

Marking points on the clay form. Basic shape of Eugene Ormandy portrait bust (profile view).

pointed metal tapestry needle may prove more satisfactory. The latter is rigid and unbreakable, and should hold its place as a marker much better than the wooden matchstick. Toothpicks are frequently used instead of matchsticks. Whichever type of markers you use, remove them when you feel that you no longer need their help. Some markers you will need longer than others. Make the clay or plasteline around the markers firm to keep them in place.

Markers show levels of brow and nose base at the vertical front center and rear center lines of the tilted head; mouth and chin levels at vertical front center line; "Pit of Neck" at front center line; median line and outer limits of eyes (left outside to right outside corners); "hinge" of the upper jaw at nose base level (bottom of ear); ear line from nose base level to brow level continuing the angle of the upper jaw.

Note the exposed portion of a long knitting needle (firmly attached to the center of the armature) projecting out of the center of the top of the head. It is an excellent way to show how well the armature is centrally placed within the form.

Note the outside portion of the armature piping leading into the self-hardening clay form. This type of armature is intended for self-hardening clay (*see* "Armature for Self-Hardening Clay" in chapter "Armature").

Note parallel lines on baseboard every two inches, both directions, used as guidelines to keep outer form within prescribed bounds. Note thumbtacks on baseboard which helps to show center position of form on the baseboard (*see* "Baseboard" in chapter "Tools and Equipment").

Note transparent plastic cover for baseboard to prevent clay or plasteline from sticking to baseboard (*see* "Baseboard" in chapter "Tools and Equipment").

Note "eyes" on sides of baseboard (two of the four "eyes" at center of each side of the baseboard), to which are attached the hoops of the aluminum wires (*see* "Keeping Cloths Away from Surface" in chapter "Clay Model Care").

Where the line crosses one another, insert used matchsticks as markers, projecting a quarter inch or more from the clay.[1]

You can make measurements visible by sticking in a small point of wood about one inch long to mark the spot in the clay, its tip left just above the surface.[6]

Additional Measurements on Clay or Plasteline Model

The following additional checks on the model will help to keep the form equipoised:

		Center line		Left side	Right side
		Front	Back		
Brow level	—Front center line to ear line			____	____
" "	—Ear line to rear center line			____	____
" "	—Brow level to baseboard	____	____		
Median level	—Outside eye corner to ear line			____	____
" "	—Ear line to rear center line			____	____
" "	—Median level to baseboard ..	____	____		
Nose base level	—Front center line to ear line			____	____
" " "	Ear line to rear center line			____	____
" " "	Nose base level to baseboard	____	____		
" " "	Bottom of ear to baseboard			____	____
	for bust				
Armpit level	—Front center line to armpit			____	____
" "	Rear center line to armpit			____	____
" "	Armpit level to baseboard ...	____	____		
Shoulder level	—Center line to shoulder ends			____	____
" "	Shoulder level to baseboard ..	____	____		

Compare the measurements on the clay or plasteline model with "Sitter's Measurements."

Checking for Errors

Back away from your work and study both sitter and the clay model. Compare frequently. Is the head structure correct? Are you remembering that likeness, etc., will come only when the characteristic basic forms are right? Is the profile just as it should be? Are the placement of the features, and their relation to each other, correct? Are you giving thought to your sitter's salient characteristics, perhaps emphasizing them for expressive resemblance? Take your time! Don't hurry your work! Don't run away from an obvious error! The sooner you catch your mistakes, the easier it is to correct. Be careful when correcting one measurement, you are not throwing others out of balance. If so, make whatever adjustment is needed.

Check measurements as work progresses. Add clay, if required, to meet model's exact measurements as shown by matchsticks, particularly forehead, the top of the head, the chin, etc.—points that suggest outline pattern.[1]

Occasionally look at your model and your clay head from above and below.[11]

Walk away—back away from your work—so that the detail is lost in the big masses—the big directions—the large movement of planes.[2]

By looking up at the head from under the chin we can quickly notice where the construction has been neglected or badly built up. One cheekbone may be found to be set farther forward in the face than the other, or one eye is too deeply set under the brow. This will give the face a curious weakness in its general effect. This fault will not be so evident if the work is lighted from a window, but if it is lighted from directly above, or if the light is held under the chin, it will immediately accentuate the defect and help the sculptor to judge of his errors.[6]

14

Modeling the Head Structure

Advantage of Head Modeling

For the beginner, amateur, and student the modeling of a head serves his first efforts better than the modeling of a figure—the former having compact design, while the latter, with its flowing forms and extended parts, perhaps proving a little more difficult for the novice. Another advantage—models for portraiture (family, friends, relatives) are obviously much more available than models for the figure. Last, but not least, the casting of the mass volume of the head presents considerably less problems than the casting of a figure.

Notwithstanding the compactness of the head, its modeling still remains as complex as any other aspect of sculpture the sculptor is called upon to do. The subtleties of a sculptured head composition—design, rhythm, unity, simplicity, proportion, balance—all remain a challenge to the sculptor. The challenge is not restricted to the aspiring sculptural portraitist, for the professional sculptor, too, is faced with the same problems. In portraiture, the sculptor has always the problem that there is no other head in the world like that of his sitter—that he must particularize to the nth degree on that one portrait, for it cannot look like any other person—that he must also strive, not only for his sitter's likeness, but must capture his or her distinctiveness of expression, personality—yes, even the spiritual quality of his sitter.

Sound Head Structure a "First"

One common mistake among the budding sculptors is their failure to recognize the importance of sound head structure. A convincing sculptural portrait is no mere surface matter, but the result of sound head structure from the very beginning of the modeling process. No matter how sculpturally expert you become, you will always have to begin with this basic fact. The slightest

variation in skull shape and proportion makes for one of the countless heads of the human race, and it is up to the sculptor to define his sitter's head structure to make for the individual, identifying portrait he is seeking. He must ask himself many questions as he studies his sitter. Is the sitter's facial angle straight (classical), convex. or concave? Is the face shape oval or squarish? Is the dome high or low? Does the forehead protrude or recede? Is the jaw narrow, wide, heavy, square? How much angle forward is his sitter's neck? A few right and wrong details of head structure are listed below. If you seek proof of the value of sound head structure, just remember how often you have recognized someone from the distance by the distinctive contour or shape of his or her head, long before distance was shortened to enable you to recognize his or her features. How often have you recognized someone solely from the shape of the back of the head?

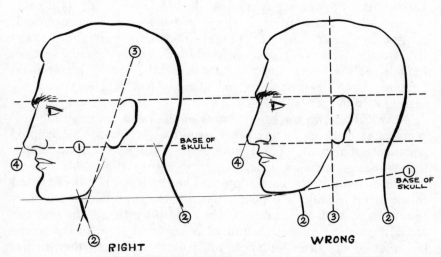

A FEW RIGHT AND WRONG DETAILS OF HEAD STRUCTURE

RIGHT	WRONG
(1) Base of skull—usually level with nose base level	(1) Base of skull too low
(2) Forward angle of neck	(2) Neck too straight
(3) As the upper portion of the jaw-bone is angled, so is the ear	(3) Ear does not follow angle of the upper portion of the jaw-bone
(4) Nose usually parallels angle of the ear	(4) Nose does not parallel angle of the ear

It is an established fact in making a portrait that, important as the features are in establishing likeness, expression, etc., they must be placed on a correctly constructed head. This basic fact must not be overlooked, otherwise your portrait will be a bad one indeed. It bears repetition to say that in modeling a sculptural portrait, sound head structure is a "first."

When doing a portrait, it is essential to get a good structure before developing features.[9]

The egglike shape of the head reveals two-thirds of the likeness. Were you to model each feature perfectly, you would still find likeness eluding you unless you have designed the features in relation to each other within the egg-shape of the head.[5]

The head can be suggestive of a person even before the features are put in. Spotting a friend from the rear just from the back of the head, or recognizing him from the distance long before you see his face, is a commonplace occurrence. The shape of the head describes the person a great deal. Achieving a physical likeness in a portrait is primarily a question of sound structure. Details do not make a likeness unless the fundamental structure is valid.[14]

Basic Size/Shape

Size

If you conceive of the head as a cube, rather than an egg-shaped oval, the cube of an adult head averages 8″ high from chin level to top of head; 6″ width from side to side at forehead level; 7½″ depth from front center line to rear center line at the forehead level—using a caliper for such measurements.

The average size adult male head is 8″ high, 6″ wide, and 7½″ from front to back at the widest point in the forehead.[6]

Shape

There is a frequent tendency on the part of the novice to forget that the shape of the head from the front view is an egg-shaped oval, and he is likely to model the face somewhat flat. If you view the head from the front, either when it is thrown back or lowered, you will get a clearer perspective of the oval shape by the way the face slopes away from the center line. Notice how the forehead, cheekbones, mouth, and jaw follow the general slope. In speaking of the head as an egg-shaped oval, this is true of the front view, with allowance for the tapering of the jaw-bone. The profile view, however, is not egg-shaped, for it will show the front outline to be straight (classical), convex, or concave.

The basic forms of the male and female heads are the same in respect to their geometric construction. The proportion of the

female head varies only slightly from the male head, being some-
what smaller. Bones and muscles in the female head are lighter
and less prominent.

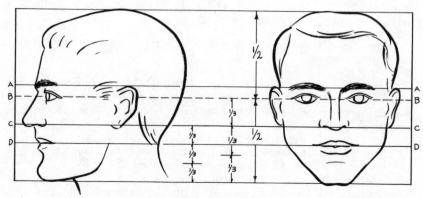

BASIC LEVELS OF HEAD STRUCTURE

A. Brow level (level of the eyebrows)

B. Median level
 Median level is half-way between the top of the head and chin
level. Median level runs through the corners of the eyes.

C. Nose base level (bottom of nose)
 Nose base level is approximately one-third or more down from
the median level to chin level. Some nose base levels can be as
much as half-way down from median level to chin level. Nose
length of the sitter is the governing distance, not a length con-
forming to any ideal type of beauty.

D. Mouth level
 Mouth level is approximately one-third down from the nose
base level to the chin level. There can be a slight length difference
in individuals between the nose base level and the uppermost edge
of the red lip portion of the upper lip.
 (The approximation of these levels vary in individuals. Placing
them on the clay or plasteline form as near to the over-all correct-
ness of the sitter's positions will provide guidelines for the place-
ment of his features, and their relations to each other.)
 (Childrens' head structure vary with age. *See* "Modeling Chil-
dren" in chapter "Working from Life.")

 The female head is slightly smaller than the male. The shoulders are
narrower.[6]

If the teeth are gone, or appreciably worn down, as in old age, the lower half of the face is shortened.[14]

Great age in sculpture is presented, not so much by a wrinkled surface as by form. The "nutcracker" face is an example of changes age has wrought on structure.[5]

Starting with the mass of form, check side view to give you an outline of the skull. Shape of the head is important.[9]

Type of Head to Be Modeled

Analyze the type of head to be modeled. What are the structural characteristics of the sitter's head? Is its structure broad or narrow? Is the highest curvature of the head somewhat forward of the center, or is it somewhat to the back of the head? Is the forehead prominent, or does it recede? Does the profile view show the front outline (facial angle) to be straight (classical), convex, or concave?

Your sitter's face belongs to one of these three broad categories. The frontal shape may be in advance of, over, or behind the facial angle.

Convex shape	*Straight shape*	*Concave shape*
Receding forehead and chin usually accompanies the convex face; nose has a more prominent forward projection	Classical Greek standard: The profile view will show an outline in which a vertical line could be drawn which would touch the brow, the lips, and the chin	Protruding forehead and chin accompanies the concave face; nose projection is not as forward as forehead and chin

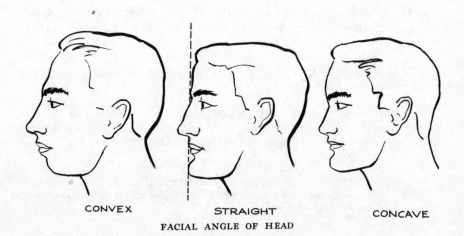

CONVEX STRAIGHT CONCAVE

FACIAL ANGLE OF HEAD

Decide on the type of head to be modeled. There is the perpendicular (classic), concave (Bob Hope, Mussolini type); convex (with receding chin). Make up your mind which type your sitter belongs to.[2]

Has your subject a round-shaped head, a long narrow head, an angular oval or what.[11]

First get the general shape of the head. Is it broad or long? Flat or deep? Square, round, pointed, oval or rectangular? The shape of the head tells a great deal about the person you are going to describe.[14]

Profile

To obtain a successful portrait, the direct profile view must be returned to constantly while modeling. It must be accurately conceived if a likeness is to be obtained, particularly because it establishes the relationship between the forehead, nose, and chin, and their respective projections, for the frontal shape (straight, convex or concave)—and also because it establishes the contour of the entire cranial portion of the head. How the head sits on the neck is best shown by the direct profile view. You also need your direct profile view to determine the direction of the jaw-line from the point of the chin to the angle of the jaw, and from this latter point the direction of the upper portion of the jaw (Ramus) to the "hinge" of the jaw and ear. The depth of the head is established while modeling the direct profile view, and other measurements become more accurate when the direct profile view is properly conceived.

If, for any reason, you have some doubts of accuracy while doing the frontal view, turn to your direct profile view which can offer answers to your mistakes.

One speaks of the infinite number of profiles or views if the three-dimensional aspects of sculpture are truly to be conceived "in the round," and that each profile or view must be equally good. The direct profile view especially must be conceived with authenticity.

The secret of the form and spirit is in the silhouette and in the design of the various profiles.[13]

Look carefully at the model in profile. Notice the position of the chin in relation to the forehead. A plumb line (plumb level) may help for the purpose of striking a vertical line and so ascertain the angle.[7]

It would be well, even at an early stage, to have a good look at the subject, particularly in direct profile, and take note of the general pattern which this makes, especially with regard to the degree of projection which one part makes with the other.[1]

The sculptor Auguste Rodin said, "A head may appear ovoid or like a sphere in its variations. If we slowly encircle this sphere, we shall see its successive profiles. As it presents itself, each profile differs from the one preceding. It is this succession of profiles that must be reproduced, and that is the means of establishing the true volume of a head. Each profile is actually the outer evidence of the interior mass; each is the perceptible surface of a deep section, like slices of a melon, so that if one is faithful to the accuracy of these profiles, the reality of the model, instead of being a superficial reproduction, seems to emanate from within. The solidity of the whole, the accuracy of the plan, and the veritable life . . . proceed therefrom."[1]

Back of Head

We speak of recognizing someone from the shape of the back of the head. This is frequently so, and we should bear this in mind while modeling the back of the head. Also bear in mind that the complete head is the portrait, and that the back of the head plays its part. Note that the end of the cranial mass (skull) in back, and where the neck begins, is on the level of the bottom of the nose (nose base level). It is the common error of the novice to place the base of the skull too low in the rear (below the line of the nose base level).

The shape of the face is very important and particularly the shape of the back of the head.[9]

The back view is never thought of, yet people are recognized from this view which proves that it is important. The complete head is the portrait— the face is just a part of the whole.[7]

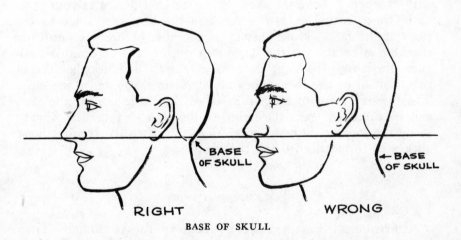

RIGHT WRONG

BASE OF SKULL

Planes

Planes are surface areas. They are defined by a change of direction by straight line, curve, etc. By defining them clearly, your statement of shape and dimension of the plane becomes a part of the structural composition. The relationship of each plane as it meets another plane contributes toward expressing form, and in turn helps to establish the individual's likeness, etc. Planes suggest the bone and muscle structure underneath the outer surface. Planes of the head and face, with their ridges and valleys, their shapes, placement, and proportion, have subtle and varied direction, and it is best to organize them in simple shapes. Their simplicity helps to clarify composition.

> Everything has a top, back and sides. These surfaces or planes are what gives shape and form to anything whether it is a head, figure or any part thereof. The sculptor must learn to observe the direction and shape of these planes. He must see where they come together and how they meet— whether in a ridge or a valley. It is the formation and relationship of planes that give any object a feeling of solidity and volume. In sculpture you are not dealing with lines and tones as in painting, but with ridges, planes and volumes. Look at the human head; realize the multitude of planes. Each contributes to the total form by its placement, its shape and its direction.[13]

Relation of Forms

As suggested before, the forehead is the "first" in modeling, and to this the other forms are related. If the forehead is "out," so to speak, everything can go wrong. So I would stress that the forehead must be right. Avoid making the forehead "square" with "corners" above the eyes. Build the cheekbones as your "second" form, taking care to give them the necessary slope to the sides of the face. Avoid putting on the nose before you finish the cheekbones because of the danger of getting the face out of balance, the nose becoming, as it were, a wall dividing the face in two, instead of the cheekbones taking their shape under the nose. The "third" form to be considered is the projection of the jaw, and its direction from the point of the chin to the ear. Always be on the lookout to make corrections, but these corrections must always be in relation to the forehead.

Masses in Form

At first keep the main masses of the head always in mind—as to their structure, and relationship to each other. Seek out, therefore, the major forms of the head, for the big main shapes are

the basis for sound head structure. Your treatment is a broad one, and one intended for a solid foundation that is so vital for a successful portrait. The ears, eyes, nose, mouth, etc., despite their individual importance, must be subordinate to the main masses—at first anyway. The correct shaping and placement of these features is a very satisfying part of your work, but the development of such details should be done only on the surface of a well-constructed head.

In early stages, work on your head from your idea and from your drawings without the model present; studying your clay model from the point of view of mass relationships, structure, balance and design. Always keep in mind the big simple forms. Likeness will take care of itself if the basic form relationships are right and the planes well defined.[13]

Do not stop to indicate any small details but keep building the shape of your composition. Develop all parts of the work evenly. Do not try to finish one part at a time. First develop the general shape of your piece.[11]

In starting, overlook detail. Start with the big masses, the big movements in the form.[2]

Do not give to subordinate and trifling forms undue prominence at the expense of the big structural forms.[8]

We are faced with two problems. We want to make a good likeness and we want to make good sculpture. In almost every head, the solving of one problem will help you to solve the other. If you capture the characteristic big forms, you probably cannot avoid making the head sculpturesque. And if you make the head sculpturesque, using the big forms you discover in the head of your model, you probably cannot avoid likeness. Sometimes you hear it said that a portrait is more like the person than the person himself. This is because all uncharacteristic trivialities have been omitted.[5]

"Line" in Form

"Line" is usually thought of as a guide or measure in two-dimensional art, forming a part of the design as distinguished from shading or coloring. In three-dimensional art, it is thought of as representing outline; or indicating the edge of a form, and defining the shapes they suggest or enclose. In the latter instance, whether full or thin, hard or soft, straight or curved, they should be sensitive enough by its rhythm and flow to help express the forms to which they belong.

Underbuild the Form

Invariably, in the modeling process, you are adding a little more clay or plasteline here and there to fill out the form, or to correct

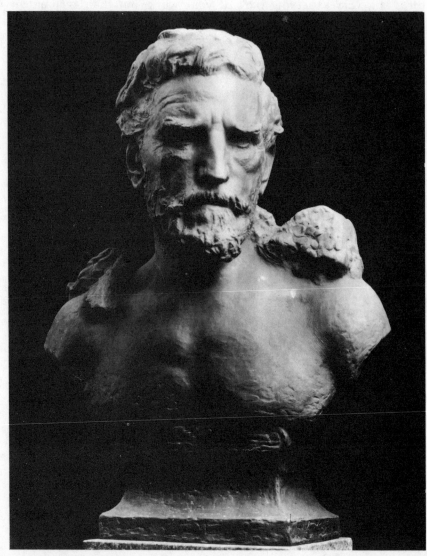

AUGUSTUS SAINT-GAUDENS, by James Earle Fraser (1876–1953).
The Hall Of Fame For Great Americans at New York University.

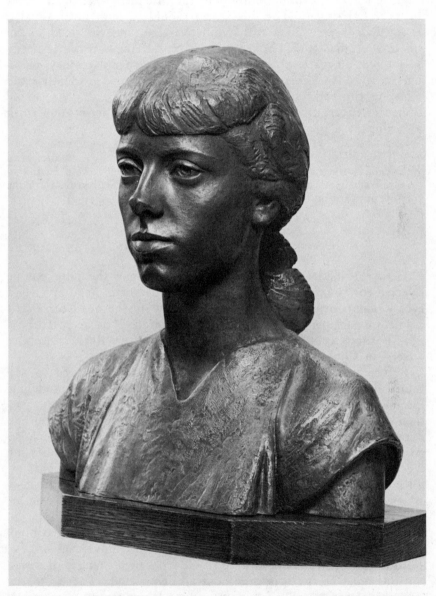

MAIZIE, by EvAngelos Frudakis. *Courtesy of the National Sculpture Society, N.Y.*

an imbalance. If you are not careful, you may make the head larger than life-size (assuming you intend the head to be that size), hence it is a good rule to underbuild—making the head form slightly smaller in dimensions than the intended size, particularly in its initial stages. The final form should be built up gradually, layer upon layer. This will avoid oversize, and the need to cut off clay or plasteline. When mistakes or changes make it necessary to cut off material, remove a little more than necessary, building back to the correct form. By building up gradually, and allowing the form to evolve naturally, you make it grow as all things in nature grow—from the inside out. It gives your work a feeling of a growing, living thing.

It is well to start by building up the forms just a little smaller than the final surface will demand, for by so doing you will avoid having to cut off and remove surplus clay, and the whole piece will grow from the inside outward until completed.[6]

Posing the Clay or Plasteline Model

How the model is to be posed depends upon the pose you've selected for your sitter. Some people look best with head erect and eyes looking forward; others look better with the head turned to a side, or perhaps slightly uplifted or lowered. The accepted best pose is the one most natural to the sitter. *See* "Relax/Pose the Sitter" in Chapter "Working from Life."

Before proceeding with modeling, check the armature to see that it is centrally located for that pose. Perhaps, after modeling the main forms of the pose you have chosen for your sitter, you then decide to change that pose. This can be done, of course, but it takes some skill. Assuming it is a head without a bust whose pose you wish to change, place both of your hands firmly behind the ears, and with gentle pressure turn the head left or right, or tilt it upward or downward, or any combination of turn and tilt— in whatever degree desired. Position of shoulders, too, can be changed by placing both of your hands on the shoulders, one in front of a shoulder pushing backward and the other hand behind the opposite shoulder pushing forward. A likely movement or dislocation of clay or plasteline may result from such changes of pose, and this must be taken into account and corrected. There are, as you must perceive, added burdens of modeling in any pose other than a level, straightforward one, and the aspiring sculptor should give second thought to the departure from the latter one.

Begin modeling with an erect position of the head—the pose may be changed afterward, if desired.[6]

When the column of the neck has been built up and the main forms of the head and shoulders roughed in, the head may be posed. Everyone has a characteristic pose, a particular way of carrying the head. The pose decided upon (which adds considerably to the production of likeness), grasp form firmly behind the ears and turn the head in the desired direction.[4]

Termination

A portrait may be conceived of in various ways—as a head alone, and in one of various poses; or including a bust of various sizes and shapes. Some sculptors like to terminate their neck at the "pit of the neck" where the torso begins; others include the bust for decorative or other reasons. They terminate the bust at different positions—mid-way from neck to shoulders, full-shouldered, or at various levels of the torso. Will a plinth be a part of the portrait head or portrait bust? If so, termination of the piece must take this base into consideration. It is all a matter of preference and good taste; however, consideration must be given as to whether the termination enhances the design and rhythm of the composition, or detracts from it.

Termination of head is a matter of taste—full shoulders, midway of the shoulders, or at the base of the neck—wherever the line seems to add to the rhythm of the composition as a whole. The final designing of the cut-off can enhance a head greatly or detract from it.[2]

In planning a head, I advise just concentrating on a head set on a neck; the neckline terminating where the neck joins the torso.[13]

Plinth

The plinth (base) is a part of the sculptural piece when used, as distinguished from a detached base. Its size and shape will primarily depend upon the weight and type of structure above it —how well it lends itself to the compositional balance—how well it enhances the sculptural piece as a whole. It should be of a size to support the weight above it, and enough of it forward under the head so that there isn't the feeling that the head is about to topple forward on its face. When the plinth is too small, it tends to make the structure above it larger. If the plinth is too large, it tends to dwarf and detract from the appearance of the structure above it. Difference of plinth from the rest of the sculptural piece may be emphasized by a contrast in surface texture.

Build a base for your work. The professional term is "plinth." Build

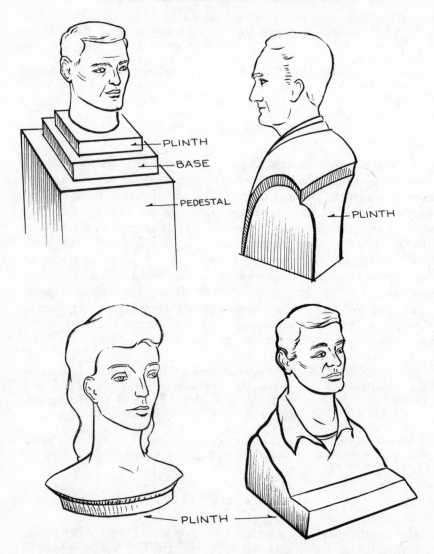

the plinth about one-half inch thick on a shellaced baseboard. It should be roughly in the shape of a flat square, rectangle or circle—that is decided by the shape of the composition. The base of your piece (plinth) is as much a part of your sculpture as the nose or eyes.[11]

Texture

Texture are surface qualities. For the portrait in clay or plasteline, intended for casting into permanent bronze, it is a matter of surface treatment. In these mediums we fortunately have control over the shaping of the material so that we can conceive in-

teresting textural surfaces, or a combination of surface textures on the one sculptural piece. The final finish may be inspired by the subject matter . . . a rough one, generally emphasizing strength (identified with the male head), or a smooth one emphasizing a softer appearance (identified with a woman or child). Surface textures can be created by the imaginative use of modeling tools, or the ingenious use of a miscellaneous number of commonplace objects. A wide range of textural surface can be obtained by the jagged edge of a piece of wood or stone, by pressing the rough texture of a burlap cloth into the surface, a flat or pointed end of a pencil, or experimenting with the odds and ends found in the home or shop. Whatever tool or object is used, the surface texture must always have an esthetic appearance to justify its use. In addition to visual effects, the surface is tactile—capable of being touched. Most sculptors take this tangibility also into consideration when deciding upon a sculptural texture.

> My finishing tools have serrated edges and surfaces which give an all-over hand-tooled aspect to the piece—the "touch of the hand" that is so important today to differentiate from mass-produced surfaces on which you never see the unself-conscious sort of texturing that only the hand of man performs.[3]

Rough surface

In a male head, a rough surface may be found to be more interesting than a smooth surface. Masculine strength and character appear more evident in the rougher surface. Light and shadow is reflected in a rougher surface than in a smooth one, reflecting a more vibrating appearance. Building up a surface with pellets creates an attractive hammered or stippled effect. Many sculptors like to retain every imprint of tools on the unsmoothed surface. They regard such treatment in the same way as sculptors leave tool marks on sculptured wood or stone, or as some painters leave brush marks on their work to identify their style of painting.

> A rough surface is often attractive: it seems to catch the light and make the metal (bronze) live and have more character.[10]

> A final surface built up of pellets can produce a lovely, hammered quality. If these surfaces have not been tamped down, the surface has a lively, stippled effect. This can be left (as in Epstein) and give a molten effect in bronze.[13]

Smooth surface

In a woman's or child's head, the smooth surface, emphasizing their softer appearance, is more appropriate. There is much more serenity in a smooth head than in a rougher one. Texture in a child's

head should, of course, always be smooth to reflect the softness of a baby's forms and features.

For smoothness, rub form with a circular motion with a knife or the back of a spoon. Fill indentations with tiny clay or plasteline scraps. Sandpaper, rasp, steel wool, or pumice stone are all helpful to obtain a smooth surface on self-hardening clay when it is sufficiently air-dried for their use.

Many sculptors do their work in the rough, cast it that way into plaster, and then smooth the plaster cast with rasp, sandpaper, etc., before casting into the permanent bronze.

> For smooth finish, press wooden tool to clay and give it a gentle circular motion. Some sculptors are tempted to smooth the surface with their thumbs—that is dangerous because it often will weaken their work.[10]

> Many sculptors like to cast a rough clay model in plaster and then work on the plaster with rasps and sandpaper.[13]

Signature

The sculptor usually affixes his signature to the sculptural piece. Name of person whose portrait was sculptured is often placed on the piece by the sculptor, as well as his own name. The signature of the person whose portrait was sculptured is occasionally obtained, as in the case of the French wartime premier Clemenceau who signed his name to the portrait bust made by Jo Davidson.

Separation of Finished Work From Baseboard

The finished work can be separated from the baseboard with the use of a thin copper wire. A flat knife can be used to serve the same purpose. One simple way to prevent clay or plasteline from sticking to the baseboard is to cover the board with a piece of plastic sheet, tacked at the sides. The plastic bag usually provided by a laundry when returning men's shirts will prove effective.

When Is the Portrait "Finished?"

It is always a vexing problem to tell with certainty when your sculptural portrait is finished. There comes a moment when this decision must be made. Sculptors generally feel that it is finished when they have satisfied themselves that they have reached as nearly as possible the original goals to which they set themselves. There comes a time, too, when one can overdo one's goals by adding on detail that could very well mar the portrait. One must bear

in mind that there is a limit to how much can be achieved in a particular material, and that when that point of accomplishment is reached, further work may indeed spoil it. There is one way to tell when a sculptural portrait is finished—it is when your client (and the family of your client, if their approval is needed) accepts it without reservation. It would be a foolish sculptor indeed who would add finishing touches after that moment.

Sculpture usually finishes itself. The sculptor comes to the point where he can go no farther or where further work is just marking time. The best way to kill a surface is to continue to smooth out the form endlessly. The edges of the planes should always be held sharp until the very end and when they can be blurred or softened here and there as desired.[13]

15

Anatomy

"Artistic Anatomy" in Sculpture

It is beneficial in sculpturing to have a clear idea of the bony structure of the cranial and facial masses, and to recognize that the various forms of the head visible on the surface get their shapes from this skeletal structure. It is not difficult to learn the names and locations of the head bones, for their numbers are limited. They are set forth in this chapter. The prominent muscles that give movement to the lower jaw and neck should also be learned, as well as the facial muscles that make for shape, movement, and changes of expression. These, too, are set forth in this chapter. How much anatomy should the sculptor know? He need not be bogged down with every detail, but he should know enough of the underlying bony structure, and the prominent muscles, to know their effect upon the external appearance of the outer forms. His understanding should be that of "artistic anatomy"—that is to say, the interpretation of the underlying structure as it affects the outer forms, rather than the knowledge of anatomical parts per se. It is interesting to note that the study of anatomy was very much a part of the learning process in the art schools of past years. Such great sculptors as Michelangelo and Leonardo daVinci were strong believers in the importance of anatomical knowledge for artistic accomplishment, even engaging in dissection.

The understanding of anatomy and bone construction should be a part of the mental equipment of every sculptor. It should be studied and memorized, and stored away in the subconscious mind where it may be referred to at any time.[6]

The skeleton, the texture, chemical composition, and the marrow of bone does not concern the sculptor (we are not doctors). Our only concern with the bones of the body is to what degree they affect the outer contours of the body. We have a little more interest in the structure of the muscles because of the variety of shape and movement that results from that structure.[11]

If the student can, as he should, gain some working knowledge of anatomy this could help him to understand how the infinitely subtle arrangements of shape in the natural forms of the head are made up in reality, veiled and harmonized by the outer covering of the skin. A clear grasp of the bony structure of the skull and a simple knowledge of the muscular system which operates over it must always be very helpful, if not absolutely indispensable.[1]

The skeleton is the architectural or structural base of any body. A certain amount of study of anatomy is good for the sculptor; it increases his knowledge of human and animal forms by familiarizing him with the functions of muscles and bone structure. But the study of anatomy should always have as its object the increasing knowledge of the way form functions, never with the idea of correcting one's figures. They have to stand on their own as works of art, with or without anatomy.[13]

Anatomy of the Skull Bones

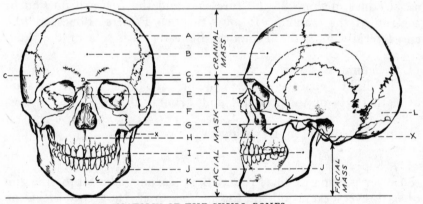

ANATOMY OF THE SKULL BONES
(Front and side views)

Cranial Mass

The cranium (the "brain-case"—that part of the skull containing the brains) is a nearly smooth, ovoid structure, and represents the main portion of the skull. Its bones are joined together by serrated sutures which form a solid mass after early childhood, and these sutures eventually become indistinct. The six bones of the cranial mass—the Frontal Bone, the two Parietal Bones, the Occipital Bone, and the two Temporal Bones—make up the outer surface, and are of interest to the sculptor. Two more bones make up the cranial mass, and these are not stressed since they do not affect the external appearance. They are here set down so that

you may know of their existence. They are (1) the *Sphenoid Bone* (Illustrated as (M): the outer wall of one of its wings forms a small wedge between the Frontal, Parietal, and Temporal bone on each side of the skull. Its interior structure, a keystone bone for the entire cranial mass, extends transversely through the skull from side to side (2) the *Ethmoid* Bone: an irregular bone located inside of the skull between the medial walls of the eye sockets, the cranial floor, and the nasal bones.

(A) Parietal Bones

The two Parietal Bones round out the top of the skull, joining the Frontal Bone, and sweeping back in the rear to the Occipital Bone—also form a large part of the side walls of the cranium adjoining the Temporal Bones.

(B) Frontal Bone

A single bone rising from the top rim of the eye sockets and nasal bones, making up the forehead and the forward portion of the top of the cranium. It joins the two Parietal Bones on top, and laterally joins the Temporal Bone on each side of the skull.

(C) Temporal Bones

The slightly concave temple bone on each lower side of the skull beneath parts of the Parietal and Frontal Bones.

Occipital Bone (*see* (L) below)

(D) Superciliary Arch

Lower portion of the Frontal Bone forming the top of the rim of each eye socket, and the top of the nose. Its arched elevation on the brow acts as a visor over the orbital cavities (eye sockets) to protect the eyes.

Facial Mass

Though it is smaller in size than the cranial mass, the facial mass has about twice as many bones as the cranial mass. The chief bones described here affect the appearance of the face, and are of importance to the sculptor.

(E) Nasal Bones

The nasal bones, one on each side of the nose, are thin, rectangular bones, forming a wedge which joins at the top. They form the bridge of the nose.

(F) Cheekbone Arch (Zygomatic Arch)

Each cheekbone has a side arch which starts at the outside rim of the eye socket, sweeping back below the Temporal Bone.

(G) Cheekbone (Malar or Zygomatic Bone)

Formed as a part of the lower rim of the eye sockets, and extending below, the two cheekbones form the central mass of the face. Its base aligns with the nose base level. Its structure forms the prominence of the cheeks.

(H) Upper Jawbone (Maxilla or Superior Maxillary Bone)

Situated on both sides of the nose and flaring out to the cheekbones, the two maxilla bones, forming the whole upper jaw, meet in the center below the nose. They form part of the rim of the eye sockets, the roof of the mouth, the nasal cavity, and the arch that holds the sockets of the upper row of teeth.

(I) Lower Jawbone (Mandible or Inferior Maxillary Bone)

(J) Lower Jawbone (Mandible or Inferior Maxillary Bone)

(K) Lower Jawbone (Mandible or Inferior Maxillary Bone)

A movable bone shaped somewhat like a horseshoe, establishing the contour of the lower face—the only movable bone in the head structure. It is the largest and strongest bone in the face. It joins the Temporal Bone by the only movable joint in the skull. There is the centralized, lower portion which forms the chin (K); the arch that holds the sockets of the lower row of teeth (I); the angle (jaw corner) of the lower jaw is at the point of union of the lower, and upper Ramus portion of the bone (J). The almost flat upper Ramus portion rises somewhat vertically from the jaw-corner and double-hinges under the Zygomatic Arch to permit movement.

(L) Occipital Bone

The Occipital Bone forms the rear bulge of the skull below the Parietal Bones, and joins the sides of the Temporal Bones. Brain and spinal cord connect through an oval opening in the Occipital Bone. The Occipital Bone belongs to the cranial mass.

Muscles of the Face (Front and Side Views)[16]
A—FRONTALIS—A muscle originating in the deep tissues of the scalp and inserting into the skin of the forehead, its function

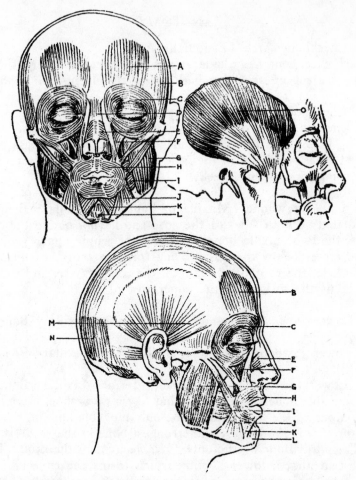

MUSCLES OF THE FACE (Front & Side Views). From "Artistic Anatomy" by Walter Farrington Moses. Courtesy of the Borden Publishing Co., Alhambra, California.

being to raise the eyebrows and wrinkle the forehead.

B—TEMPORAL FASCIA—A fibrous coating over the muscles of the side of the head.

C—ORBICULARIS OCULI—A muscle originating in the frontal bone, inserting into the skin of the eyelids, forehead, temple and cheek, its action being to close the eyelids.

D—PROCERUS—A muscle originating in the occipitofrontalis muscle, inserting into the cartilage of the nose, its action being to depress the inner angle of the eyebrow.

E—NASALIS—A muscle originating in the upper jaw bone, inserting into the skin of the nose, its action being to narrow the nostrils.

F—LEVATOR LABII SUPERIORIS—A muscle originating in the inferior margin of the bone surrounding the eye, inserting into the upper lip, its action being to lift and protrude the upper lip.

G—MASSETER—A muscle originating in the zygomatic arch, inserting into the lower jaw, its action being that of chewing.

H—ORBICULARIS ORIS—A muscle originating in the nose and lower jaw, inserting into the sides of the mouth, its action being to close the mouth.

I—BUCCINATOR—A muscle originating in the jaw bones, inserting into the orbicularis oris, its action being to compress the cheeks.

J—TRIANGULARIS—A muscle originating in the lower jaw, inserting into the side of the mouth, its action being to pull down the side of the mouth.

K—DEPRESSOR LABII INFERIORIS—A muscle originating in the lower jaw-bone, inserting in the lower lip, its action being to depress the lower lip.

L—LEVATOR MENTI—A muscle originating in the lower jawbone, inserting into the skin of the chin, its action being to raise the lower lip and wrinkle the chin.

M—AURICULAR MUSCLES—Three muscles originating in the mastoid process of the temporal bone and the occipitalis and frontalis muscles, inserting into the ear, their action being to pull back, raise and draw the ear forward.

N—OCCIPITALIS—A muscle originating in the occipital portion of the skull, inserting into the deep portions of the scalp, its action being to draw the scalp backward.

O—TEMPORALIS—A muscle originating in the side of the head, inserting into the lower jaw, its action being to close the mouth and retract the jaw.

Muscles of the Neck (Front and Side Views)[16]

A—SPLENIUS—A muscle which rotates and extends the head and neck and flexes it sidewise.

B—STERNOCLEIDOMASTOID—A muscle which rotates and flexes the head.

C—TRAPEZIUS—A muscle which draws the head backward and sidewise and rotates the scapula.

D—SCALENUS MEDIUS—A muscle originating in the first rib, inserting into the second to sixth cervical vertebrae, its action being to flex the neck laterally.

E—SCALENUS ANTERIOR—A muscle originating in the first rib, inserting into the third to sixth cervical vertebrae, its action being to support the head and flex the neck sidewise.

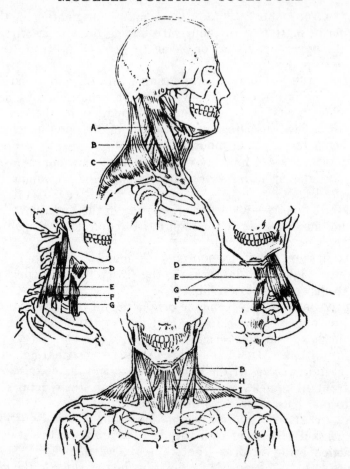

MUSCLES OF THE NECK (Front & Side Views). From "Artistic Anatomy" by Walter Farrington Moses. Courtesy of the Borden Publishing Co., Alhambra, California.

F—SCALENUS POSTERIOR—A muscle originating in the second rib, inserting into the three lower cervical vertebrae, its action being to bend the neck laterally.

G—STERNOTHYROID—A muscle originating from the sternum, inserting into the voice box (larynx), its action being to depress the larynx.

H—OMOHYOID—A muscle which pulls back and depresses the hyoid.

I—STERNOHYOID—A muscle which depresses the hyoid bone and larynx.

16

Modeling The Features

Likeness

All faces are basically alike in construction, whether they be long and thin, broad and fat, strong or delicate, beautiful or ugly—but here the similarity ends. Occasionally you will find among people resemblances to each other in head structure or a feature in the face, but the likeness you seek for your portrait will be that of only one person—your sitter. You are to regard him or her as unlike any other person in the world. To seek out the subtleties that make your sitter so individualistic will be the most trying, yet most fascinating, part of your job. You will find some likenesses difficult to capture. The very handsome looking male, as a rule, proves difficult to model because there are no striking individual characteristics "to take hold of." The female "film star type," so to speak, seem all alike, as if they were cast from the same mold, particularly if artificial aids for beauty are applied. Their "pretty girl" faces can be dull and lifeless for sculptural purposes, and without individual characteristics to distinguish one from another. You are more likely to capture the likeness of an ugly face since there are marked individual characteristics "to take hold of." Older people are easier to sculpt because their features have been molded, and their characters established, with the passing of time.

A sculptured portrait of a matured woman should show something more than "prettiness." The passing of years, and motherhood in particular, adds a measure of beauty to any woman's face. She will, most likely, retain much of the youthful glow in her face, mellowed by motherhood and the upbringing of children. This feminine beauty, made sweet and gentle by maturity, will more than offset "good looks," and more likely lend a meaningful quality to the portrait. In seeking a woman's likeness, it is very necessary that lipstick, and any penciling of eyebrows, be removed so that you can better discern the forms and planes of the features they overlay, and the expressions that go with the features.

When modeling older women, emphasize the personality and

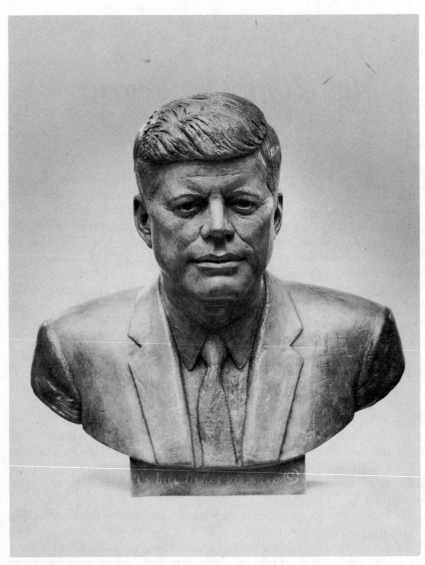

PRESIDENT JOHN F. KENNEDY, by EvAngelos Frudakis. *Courtesy of the National Sculpture Society, N.Y.*

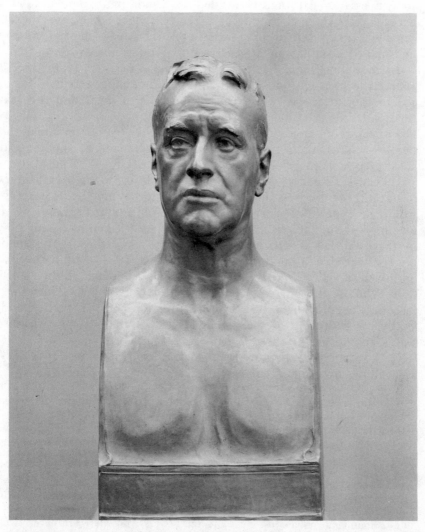

MORRIS GRAY, by Charles Grafly (1862–1929). *The Metropolitan Museum of Art, Gift of Mrs. Cortlandt Parker, 1953.*

character that time has given them. When these characteristics are maintained, you will please your older clients more so than effecting an idealized appearance that has faded with the years and no longer exists. All that is needed is sympathetic modeling. Of course, artistic freedom may be taken to reduce some ravaging effects of time, like deep crevices and wrinkles—but not at the expense of creating an appearance that does not exist.

In modeling male heads, their strongly marked features will reflect the anatomy more so than when modeling a female head, for in the latter case the forms are less prominent and the features softer.

Fortunately, more and more people have come to know the qualities that make a good sculptural portrait, and are honest and sincere enough to be sculptured as they are.

Likeness, however, is not enough in itself for a sculptural interpretation. If likeness was all the sculptor sought, the portrait would be superficial indeed. A photograph would be sufficient if all that was sought was external resemblance. Likeness is only one of the essentials of the sculptural portrait, and the artist should always bear this in mind, for to be concerned solely with a "speaking likeness" is to limit the interpretation to but one of the essentials to make the portrait a worthwhile work of art. The other essentials are the characteristics of expression and personality, and finally the capturing of the "inner spirit" of the sitter which animates and gives "life" to the portrait.

It is worth repeating that much of the likeness you seek will naturally grow out of correct head structure.

To the average person a sculptured head is a realistic likeness of someone—a recognizable portrait of a person he knows. To the artist a sculptured head is registering in permanent form not only the likeness, which is surface resemblance, but the spirit and sculptural character of the person.[13]

The idea that likeness is the main object of a portrait is misleading, for a sculptor should be far more concerned in the making of a work of art than in merely reproducing the features of his subject in a speaking likeness. Sound movies do just this, and far better. Also there are never two people who agree as to what anyone really does look like. One remembers him smiling, another always sees him in a serious mood. One is sure the eyes are too small, and a fourth is perfectly certain that his lips curled back more and his nostrils were wider. Try as we may, we are beaten before we start if we attempt to make just a likeness. An enlarged photograph fills that need and takes far less time, trouble, space and money. I have heard a portrait well defined as "a likeness of a person, with something wrong about the mouth." The quality that gives each face its own inherent character must always be sought.[6]

Expression

Getting "expression" (indicative of your sitter's thoughts, mood or feelings) is no simple matter. It is subtle—it is difficult. It haunts the portrait sculptor. No general rules can be laid down to achieve it. It is unlikely to be achieved by one feature alone. The muscles controlling the movable portions of the face are interrelated, and expression may come from a combination of features which the muscles control. A small form like the corners of the mouth, eyelids, or any of the small forms surrounding the eyes, etc., can have a marked bearing on expression.

We humans have different faces at different times, for our expressions change with moods and emotions. How contrasting is the countenance when one loves or hates; when we are happy or sad; when we smile or frown; when we are taken by pleasant surprise; or are startled—just to mention a few of our moods and emotions. It is likely that your sitter's expression will pass through different stages during the sittings, and the sculptor must be alert to capture that one expression or "look" most characteristic of the sitter. The expression will add a great deal more to the portrait than mere likeness. It gives vitality to the sitter's face.

There will be many moments when you will be concerned with "expression"—whether you have really captured it in your portrait. One thing for certain—it cannot be superimposed on a lifeless head. If you've done your head structure and features well, the expression most natural and characteristic of the sitter should evolve naturally.

The more elusive of objectives are the characteristic qualities of expression and individuality of the sitter. Select and perfect shapes which are considered characteristic and expressive of the sitter's personality.[7]

There is generally one expression which is more habitual than another and by which the individual is recognized. That expression—the fourth dimension in sculpture—must be sought.[6]

Placement of Features

The placement of the features is as important as their construction. They also must be placed in proper relation to each other. Inaccuracies in placement play havoc with likeness. Wrong set eyes, for example, can give a cross-eyed look when placed too close together, or appear wall-eyed when placed too far apart. When the eyelids are too open, they appear to stare. The mouth and

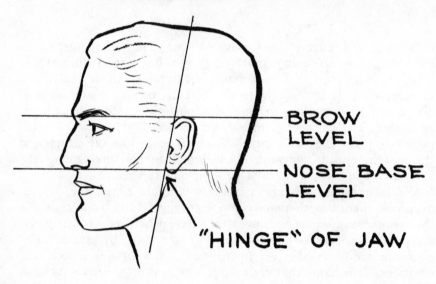

BROW
LEVEL

NOSE BASE
LEVEL

"HINGE" OF JAW

lips, when incorrectly modeled, can turn an intended pleasing expression into an unpleasant one. Other inaccuracies when modeling should be watched for. The face as a whole can take on an unpleasant look if any of the features are placed incorrectly.

Before placement, review some salient points about your sitter's features, any one of which can have a marked influence on likeness. For example: how deep are the eyes set in the sockets? How close or how far away from the head are the ears? Is the nose prominent or small? What is the shape of the nostrils, wings, and bridge of the nose? What is the width of the cheeks in relation to the temples above, and the jaw below? Have you given sufficient thought to the shape and proportion of the mouth and lips, and their important contribution to facial expression? Fix these examples, as well as others, in your mind—jot them down so you don't forget—review them before you begin to model.

Check placement of ears, eyes, nose and mouth so that they are not off-balance.[13]

Eyes, ears, mouth and nose—it is how these features are placed in relation to each other, and their relation to the whole mass of skull, that makes the quality which gives each face its own inherent quality.[6]

Emphasizing the Features

Emphasizing some prominent, characteristic feature often dra-

matizes the sought-for likeness. The accent of only one feature in the face may do the trick; however, the emphasis can be on a number of features at the same time. The sculptor may wish to emphasize one or more of the following opportunities at the same time: bushiness of eyebrows, a drooping arch over an upper eyelid, a strong chin or a large nose, some characteristics about the ear. The so-called "artistic convention" is the sculptor's privilege to take advantage of any strongly marked feature, and to emphasize or modify it to give dramatic effect to his sculptural interpretation. Remember, too, that there can be a need to de-emphasize or eliminate some disagreeable or unnecessary detail. There is the matter of asymmetry of the facial feature or features that can be noted for likeness. Care must be taken, however, that there is no over-emphasis that can lead to exaggeration or distortion. This, too, should be said: that to emphasize or modify a feature, the novice should have a thorough knowledge of the actual construction of the feature. Only then does he have the discrimination to successfully make a change.

Exaggeration of Features

The so-called "artistic convention" which permits the sculptor to emphasize or modify a feature for dramatizing a likeness is one thing—over-accenting the emphasis or modification to a point of exaggeration or distortion is quite another matter. While the sculptor has the right in his creative and interpretative planning to emphasize or modify, and often highly desirable to do so, there is the danger that the sculptured portrait does not gain thereby— where changes create untruths in likeness, expression or personality. Over-accentuation might even result in a sort of caricature.

Liberties may be taken with anatomical truths; exaggerations are permissible and often desirable. Emphasize what is important to the vitality of the piece—sculptural characteristics most to be desired in composing. To achieve such quality, it is sometimes necessary to abandon realistic proportions and details in favor of arbitrary forms which are perhaps distortions, but contribute more to the composition than would be natural.[12]

We are really making a piece of sculpture, and in doing so we are fully justified in indulging in reasonable liberties with the forms of nature according to the requirements of our subject. Exaggeration or modification of the forms of nature are the undisputed prerogative of the creative artist, and it is only the abuse of this legitimate license which results in revolting deformity and malformation.[8]

People who think of sculpture only as a replica of nature, may be disturbed when they observe a stone, bronze or wooden figure that has

proportions different from those found in nature. They do not realize that since the beginning of time, artists have made arbitrary rules of proportion called "artistic convention"; and that even the sculptured figures that we are apt to accept as having "natural proportions" often do not repeat the relationships normal to nature. Ever since man has translated nature into art, there has been a question in the minds of many people as to what right an artist has to take liberties with human and animal forms. The artist's answer is: In the first place, when painting a picture or making a piece of sculpture, the artist is not dealing with flesh or blood but with material—stone, wood, clay, or paint—and because of this he should have as much liberty as he wishes to take, to do whatever he wants to with the material. It gives him possibilities of expanding and enlarging his range of expression. In other words, it gives him a greater freedom and power.[13]

Asymmetry of Features

Symmetry is defined in the dictionary as a "harmonious relationship of parts . . . the correspondence or similarity of forms, dimensions, or parts on opposite sides of an axis, center or plane." Asymmetry, then, is the want of symmetry. Though in principle a head is symmetrical, in fact, it is very likely that you will find a head far from that. A feature on one side of the face may vary somewhat from the position, size, or shape of a similar feature on the other side of the face. This may be true of more than one feature on the same face. The folds of a cheek are not always in a corresponding place on the opposite side; one eye opening may be slightly wider than the other; an arch above one eye may droop more than the arch over the other eye; the upper lid itself may droop over one eyeball more than over the other; one corner of the lips may be slightly elevated, or may have a quirk in it.

Showing asymmetry can add to likeness, but care must be taken not to mar the likeness to a point of exaggeration or distortion. The asymmetrical feature, so frequently noticed in people, often imparts character to the face. An ugly face with its asymmetrical features can make a sculptural portrait very much alive and vitally interesting. A too symmetrical face can lack interest and vitality. A pretty girl's face can be dull and lifeless. The novice would do well not to show asymmetry to any marked degree, but to rely on sound head structure and accurate shape, proportion, and placement of features for his likeness. Asymmetry, like overemphasizing a feature, can lead to exaggeration or distortion.

The double-sidedness of most faces should be noted, also the difference of the profile as seen from the right or left side.[6]

It is not to be assumed that a person's features—eyes, ears, etc.—are alike in size, shape or position. They may differ. Whenever you can note

slight variations, take advantage of them, for they add interest if not exaggerated to the extent of looking deformed. Since symmetry tends to be static, any asymmetry in the face gives character and expression and a more active appearance. You may find one corner of the mouth curled up a little more, one eyelid more slanting, or note an actual difference in the placement of a feature—perhaps one nostril higher than the other. In reality, as we know, no one is perfectly symmetrical.[14]

Work Simultaneously on All Features

Work on all features simultaneously, not finishing one feature before you start another. Each feature is only right in its proper relationship to the head structure and all the other features. Hair, nose, eyes, mouth, etc., cannot be thought of separately, but must be regarded as intimately interrelated. One must not forget that the sculptural head is three-dimensional—that all parts and all sides must be a unified whole. Avoid getting involved in small areas when you should be seeing the head and face as a whole. Avoid the foolish method of some beginners, amateurs, and students who finish one side of the face before starting on the other side. Above all, the novice should avoid trying to get a likeness at the earliest possible moment. He should be ever mindful of the paramount rule in sculpturing a head—that he is to hold back feature details until the head structure is correctly established; that if he makes his features too soon, he will probably have to do over the features which he has so assiduously modeled. The normal progress of sculpturing a portrait is to advance it by degrees. When all the features are advanced by degrees, and as late as possible, the result will be a cohesive composition and a successful portrait.

> Bear in mind that you are working in three dimensions, not simulating, but actually building those dimensions. The front, back, and sides of your work must be done in unison and not one at a time independent of the other. Keep turning your work on the turntable and try to keep all sides at the same state of development throughout the work.[12]

Age Changes

There are, of course, unwelcome signs of age that come to us all, and how much to emphasize is the choice of the sculptor. It is his problem to decide how much is important and how much should be left in, and how much should be left out. Age changes need not be overstressed. Leaving out signs of age is not a matter of flattering the sitter, but one of just how much is necessary for a convincing portrait. Less pleasing forms can be modified

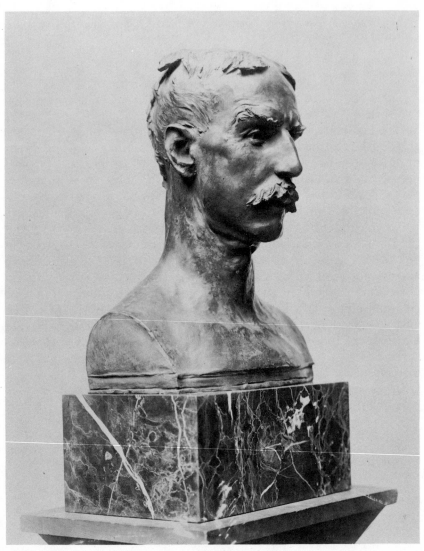

THOMAS P. ANSHUTZ, by Charles Grafly (1862–1929). *Courtesy of the Pennsylvania Academy of the Fine Arts, Philadelphia, Penna.*

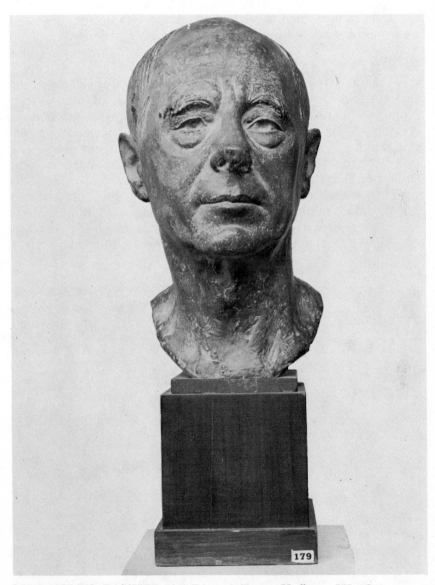

SCULPTOR'S FATHER, by Edward Fenno Hoffman III. *Courtesy of the National Sculpture Society, N.Y.*

somewhat by the sculptor. A little chivalry is always in order, and some reasonable adjustment of the signs of age should not compromise the sculptor. The changes in many faces, particularly in women, is often slight as they advance into maturity. The signs of age in the faces of old men and women, with their strongly marked features due to time and stress, can establish much interest and character, if the modeling is done sympathetically.

Wrinkles

With the passing of youth and their taut, shapely forms and features, fat accumulates and the body forms fill out. As age progresses, the skin and muscles lose their elasticity, and wrinkles develop. Most of the wrinkles can be left out in modeling, and your sculptural piece will be the better for it. You can get likeness without them. Make the wrinkles you do leave in appear natural. Do not establish them by cutting into the clay or plasteline. They can be better shaped by superimposing them on the form, and then shaping them—eliminating as much of the material as possible so that the wrinkles do not appear too marked. Modeling to reflect age changes is always a difficult test of the sculptor's ability.

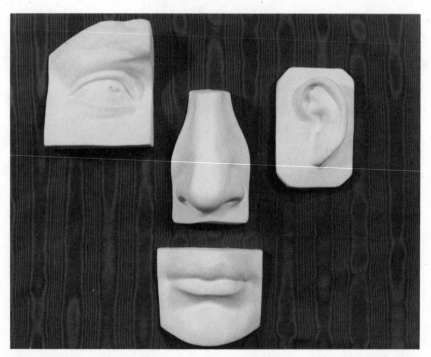

Eye, nose, and mouth from Michelangelo's DAVID. Courtesy of Joseph M. Zinni Art Supply House, Philadelphia, Penna.

Other age changes

Some age changes in specific features may be found in respective chapters on ears, eyes, mouth, etc.

Learning From Plaster Casts

You may be interested in a plaster cast of an eye, ear, nose, or mouth for modeling exercises. They can be purchased at most art supply stores. They have some value for the novice in his early effort to model—to judge pattern forms, planes, proportions, etc. —but the budding sculptor should avoid too much copying as the plaster cast is lifeless and tends to dull creative effort. The plaster cast furnishes very little pleasure as compared to the joy of modeling directly from life.

Cheeks

The cheekbones (malar or zygomatic bones) are usually clearly revealed, the upper and more prominent portion forming the lower rim of each eye socket. The two cheekbones together form the central mass of the face. Its lower edge aligns with the nose base level (bottom of nose). In many people, the upper portion under the eye sockets is especially prominent, and this facial characteristic should be so defined. The projection of the cheekbones, forehead, and chin are the forward points of the facial angle, and they must be modeled in correct relationship to each other. These fixed, immovable points form the foundation of good head structure. Care should be taken, when modeling, not to make cheeks unequal in area (unless they are actually different), or to place one cheekbone farther forward on the face than the other . . . an error common to the neophyte. The latter defect can best be determined from a profile view, and should be corrected before modeling the nose. As a matter of fact, the cheekbones should be built up evenly on both sides before modeling the nose. If this evenness or balance is not first established, the nose will become a dividing wall that may make it difficult to see that one cheek is more forward than the other. Note the plane of the nose as it joins the cheeks. Make sure that the eye sockets are properly set in depth in relation to the cheekbones and the brow. Occasionally, the cheekbones with the side arches (zygomatic arches) define the widest part of the face, being wider than the temples above or the jawbone below. Make sure that the two sides of the face slope away from the center. Young childrens' cheeks are almost round as a ballon. They appear fuller under the cheekbones, than the area above them. Cheekbone lines become more prominent as the child grows into adolescence, and the accumulation of fat fills out the cheeks. A child's cheeks frequently have dimples in them. With advancing years, the skin loses its elasticity and wrinkles develop. As the flesh sags, cheeks grow hollow, and the cheekbones become more evident.

Zygomatic Arch
Each cheekbone has a side arch called the "zygomatic arch"

which starts at the outside lower rim of the eye socket, and sweeps back below the Temporal Bone.

Note the outermost projections of the cheeks such as the prominent upper edge of the cheek-bones.[1]

Note how the cheekbones join the ridge of the nose.[5]

By looking up at the head from under the chin we can quickly notice where the construction has been neglected or badly built up. One cheek-bone may be found to be set farther forward in the face than the other, or one eye is too deeply set under the brow. This will give the face a curious weakness in its general effect. This fault will not be as evident if the work is lighted from a window, but if it is lighted from directly above, or if the light is held directly under the chin, it will immediately accentuate the defect and help the sculptor to judge of his errors.[6]

18

Ears

Characteristics

The external human ear is mostly cartilaginous with a thin layer of skin over it. It consists of a series of folds which follows the same basic pattern in all people, although they show a great variety of size and shape in individuals. Notwithstanding the fact that ears are more or less rigid and immobile, and should be modeled without too much difficulty, they are probably the most slighted of all the features in head structure. Perhaps this is due to their relative detachment from the skull itself. Yet ears are fascinating with their series of folds and rhythmic convolutions, and should merit more attention in the modeling process. Their outlines are sufficiently sharp for a good modeling job, and appropriate time and effort should be expended on them. Ears add to likeness, of course, no less than other features. Avoid having the ears stand out too prominently from the head, unless your sitter's ears do so, and you wish to be very realistic about it in your modeling.

At birth, the ears appear round, and generally flat to the skull. They lengthen as the child grows older. In younger children, ears appear larger in relation to the rest of the head. In the aged, the ears appear slightly larger in proportion to the rest of the face due, no doubt, to the loss of fullness in the rest of the features as the later years advance.

The ear, of all the features going to make up the portrait, may be regarded as the most individual detail and is as characteristic of the person as any other feature.[7]

The convolutions of the ear are interesting to study, as they differ in every individual. It is the variant from the norm that gives character, and capturing it makes sculpture exciting.[2]

Shape

The ear is shell-shaped in form. Its outer contour is formed like

HELIX (OUTER RIM) ⸺⸺⸺⸺⸺
(CAVITY) OF THE HELIX ⸺⸺⸺⸺
DARWIN'S TUBERCLE ⸺⸺⸺⸺
FOSSA (CAVITY) OF THE ANTIHELIX ⸺⸺

ANTIHELIX (INNER RIM) ⸺⸺⸺⸺

TRAGUS ⸺⸺⸺⸺⸺⸺

ANTITRAGUS ⸺⸺⸺⸺
CONCHA (CAVITY) ⸺⸺⸺⸺

LOBE ⸺⸺⸺⸺⸺⸺⸺

EAR CONSTRUCTION

the letter "C," wider at the top and narrower below. Ear shapes vary widely; construction, however, does not vary a great deal. Whether the ear is large or small, oval or triangular—whatever its shape—thickness must be considered. In children, size and shape of ears vary according to age. With the passing of time, ears change in size, and very often in shape. They appear larger in old age, as indicated above. As in other features, ear size and shape may be influenced by heredity.

This rather complicated shell-like feature has, like all the features, basic shapes, and like all the other features an infinite variety of arrangements. No two are alike, not even on the same head.[7]

The ear is not a maze of directionless forms as it is so often drawn and modeled. Study its contours so as to discover their paths and planes.[12]

Each shape should be built up as one unit and not built up with squirmy little swirls and lumps of clay. The ear usually grows within the area between the brows and nose tip.[11]

Length

Unlike classic Greek sculpture where the ear and nose was generally modeled in the same length, in life this is not the rule. People may have ears much longer or smaller than the nose length. Generally speaking, the length of a well-proportioned ear is between the levels of the brow and nose base (bottom of nose). This rule applies to adults only, for the length of a child's ear varies with age. The child's face is relatively smaller when com-

pared to its head as a whole, while the ears and nose are much smaller when compared to the size of the face.

From angle of eyebrow to the wing of nose.[15]

Ears are variously placed in nature but usually the top of ear comes on a line with the eyebrows and the bottom of the ear on a line with the bottom of the nose—and continues line of jaw.[13]

Usually top of ear is on line with the eyebrows and the lobe on a line drawn from the nostrils.[2]

The ear usually grows within the area between the brows and nose tip[11]

Width

The width of the highest part of the ear—the outer rim or helix—is about one-half the length of the ear. The width narrows, of course, below this point.

Helix (Outer Rim)

This is the wide, outer encircling rim of the ear, shaped like the letter "C"—wider at top and growing narrower in its descent to the lobe. Thickness of the ear, particularly the helix, should be taken into consideration. On the upper outside curve of the helix is a small knoblike prominence called the "Darwin's Tubercle."

Anti-Helix (Inner Rim)

The anti-helix is the inner, smaller rim forming in part the edge of the Concha (cavity of the ear). It divides at the top forming a bent "Y" shape. The anti-helix should be modeled somewhat recessed from the helix. If its distance is as far out from the head as the helix, this has a tendency to make the ear look flat— typical of the pugilist's so-called "cauliflower" ear.

Concha (Cavity)

This bowl-like depression is many-shaped, depending upon the contours of the other parts of the ear, particularly the inner or anti-helix. It should not be modeled too deeply. Harder cartilage surrounds the Concha, attaching the ear to the head.

Do not make cavity of the ear too deep. This will create a dark cavity that you do not see in a flesh-and-bone head, for flesh is relatively transparent, clay is dense.[5]

Tragus

Projecting from the side of the face to the Concha, about midway of the ear length, is the Tragus, an irregularly shaped flap of cartilage covered with skin. It covers a short funnel-shaped canal which is the external auditory opening leading into the ear drum. Since the shape of the Tragus follows the shape of the canal opening, it, consequently, should be modeled accordingly—not flat, as is frequently done by the novice. On the ear opposite the Tragus is an area called the Anti-Tragus.

Lobe

The lobe is a soft mass of fat enclosed in the skin, while the rest of the ear is composed of a mass of elastic cartilage. The lobe has definite forms of size, position and shape, and should be carefully modeled for any distinctiveness. In some ears the lobe will be quite long, and sometimes bulbous—on other ears, it is surprisingly small. Check whether the lobe rests upon the cheek, or is there a space between lobe and cheek? Does the lobe parallel the side of the skull, or does it angle somewhat forward?

Ear Line (axis or angle of ear)

As the upper jawbone (Ramus) is angled, so the ear is usually angled. This ear line usually parallels the slant of the nose . . . there are exceptions, of course, which the novice will observe all the more for knowing the general rule.

Axis of ear is usually parallel to the angle of the nose.[2]

Distance From Head

Viewed from the rear, the ear stands away from the head at an angle. This angle varies in degree with each individual; sometimes the angle is different for both ears on the same individual. Some ears can be very close to the head. Generally speaking, if the ears are modeled too close to the head, the width of the face

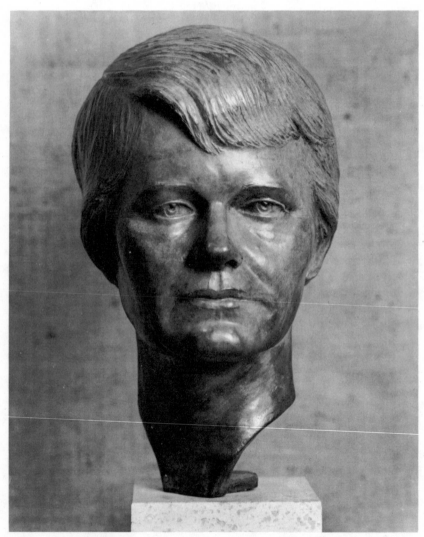

MRS. ALEXANDER FOWLER, by Edward Fenno Hoffman III. *Courtesy of the National Sculpture Society, N.Y.*

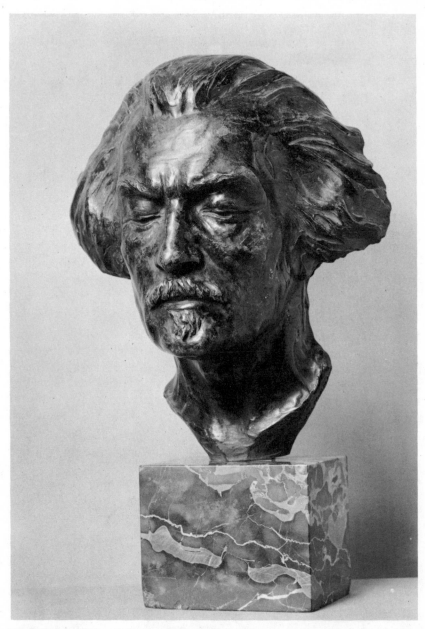

PADEREWSKI, THE ARTIST, by Malvina Hoffman (1885–1966).
The Metropolitan Museum of Art, Purchase, 1940, Francis Lathrop Bequest Fund.

will appear narrow. It is highly important to study your sitter's ears, not only from the front and side views but also from the rear, and to model all views as one more means to secure a likeness.

Distance that the ear stands out from the head is important, too. There is a tendency to make the ear too flat.[2]

Look at its angle in relation to the head. Does it lie flat against the skull, or does it stick out at an angle to it.[7]

Back View

Rear view reveals the rounded back wall of the Concha. Modeling of the back of the ear should conform to this shape.

The back view has to be modeled.[2]

There is a tendency with the beginner when modelling the ear to turn the clay model to a side view and work from that. Study it from all views, particularly the front and back.[7]

Placement

The placement of the ears is of major important, and requires much care. If placed too far forward on the head, it would appear as if they were crowding the other features of the face. The face would look smaller, and the rear of the head larger. If placed too far back on the head, the opposite would hold true—the face

PLACEMENT

would look larger and the rear of the head smaller. If the ears are set too high, the lower part of the face will appear too long, and the cranium too small. If the ears are set too low, the opposite would hold true—the lower part of the face would appear too short, and the cranium too large. Remember, from a side view, the ear line must be carefully related to the angle of the upper jaw-bone.

Several of the "Sitter's Measurements" in the chapter "Working from Life," particularly the distance from the outside corner of the eye to the ear line (angle of ear) (#23 in the "Sitter's Measurements"), should place the ears in about the right position.

There seems to be a natural tendency to crowd ears forward among the other features losing the three-dimensional base of the head.[13]

Attach Firmly To Head

In modeling an ear, make sure it is firmly attached to the head, and that it looks like it is a part of the head, and not something stuck on. When the position of the ear is finally decided upon, dig out the area back of the ear line (normally between the brow and nose base levels) about 1½" to 2" wide and to a depth approximately one-half inch. Build up the ear from this depth which will give it a firmer attachment to the head.

Eyes, Eyelids, Eyebrows

The Eye (Eyeball)

The eyeball is about an inch in length, and is spherical. It lies within the deep eye socket (orbital cavity), and its protrusion from the cavity depends a great deal upon the fatty tissue in the socket upon which the eyeball rests. It rolls in the socket like a ball-bearing held in place. Its visible portion—the elliptical opening between the lids—is only a small part of the eyeball, the rest being hidden within the socket. The visible portion consists of the "white of the eye," iris, pupil, and cornea. The cornea makes a slight bulge on the eyeball as it fits over the iris and pupil as a transparent cover. You can feel this bulge as it moves from side to side when you place a finger over a closed upper eyelid. Nature has done a remarkable job in protecting the eyeball from injury; the overhanging ridge of the brow and its superciliary arch above and to the outer side of the socket, the nasal bone to the inner side, the cheekbone beneath the socket, and the eyelids that cover the exposed portion—each contributing its share of the protection. Make sure you model the eyeball inside the bony structure of the socket, and inside the lids. Your front and profile views should clearly show it that way, otherwise the eyeball will appear to be popping out between the eyelids.

The basic structure of an eye is a ball set within the folds of the eyelids and protected by a bony structure of the brow.[13]

The eye is a round ball which sets down in the socket, being protected from harm by a ridge of bone all around—the frontal bone always projects far beyond the eyeball.[2]

Expressiveness Of Eyes

Many sculptors regard the eyes as the most expressive part of the face. Of course they do not mean the eyeball alone, notwithstanding its mobility and animation, for the eyeball itself is very much alike in all people. It is in the many forms that surround the eyeball where expressiveness of the eyes is obtained. Let us

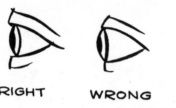

RIGHT WRONG

EYEBALL

Keep the eyeball inside the lids.

consider these forms: (a) the flexible muscles around the eyes, and those of the forehead, which expand and contract with an individual's thoughts, moods, or emotions (b) the eyelids with their endless variety of shapes, thickness, droop, etc., that one is consciously (or perhaps unconsciously) aware of when meeting another person (c) the overhanging brow which makes for shallow or deep-set appearing eyes. When the overhang of the brow is less pronounced, there is less shadow cast over the eyes, and the eyes appear shallow in depth. When the overhang of the brow is more pronounced, shadows are cast over the eyes, and the eyes appear deep-set. Shallow eyes suggest a lighter color for iris and pupil; deep-set eyes suggest a darker color for iris and pupil. Modeling of the iris and pupil should be made accordingly—*see* "Color" in this chapter. (d) wrinkles across the forehead, perhaps across the upper frontal bridge of the nose, and particularly those at the outer eye corners. All of these wrinkles are accentuated with certain thoughts, moods, or emotions (d) sac or pouch under the lower eyelid which frequently tells a story of illness or age, or perhaps some mode of living.

Another evidence of the effectiveness of the surrounding forms for expressiveness of the eyes may be found in sculptural portraits on which the sockets are without eyeballs. In these instances, had the eyeballs been set in and the iris and pupil modeled thereon, it would not have added to the expressiveness of the portraits, for their sculptors safely relied on the surrounding forms to create the sought-for expressiveness of those eyes.

Everything about the eyes contributes its part toward total expressiveness, and a full understanding of all forms is essential for the success of the sculptural portrait.

The expression of the eye is attained by studying the forms around it— not in the eyeball itself.[2]

It is the structure around the eye that gives it characteristic expression, emotional quality, etc.[11]

Muscles are developed differently in every face. There are eyes that smile and crow's-feet that record these smiles, eyes that are sad, lids that droop and give a weary look to them, etc. There is generally one expression which is more habitual than another and by which we are recorgnized. We must learn to indicate the color of eyes, and their expression.[6]

Eyes and Their Sockets

One eye must not be brought more forward on the face than the other. Though this is obviously wrong and unrealistic, it is a common failure of the novice. To discover such an error, check the forward position of the eyes carefully from the top and bottom of the frontal view, also from a profile view. The relation of the depth of the eyes from the ridge of the nose is also helpful in determining whether the respective depths of each eye are in balance. To avoid the mistake of bringing one eye more forward on the face than the other, the very first need is to start with the proper construction of the eye sockets (orbital cavities), formed by the rims of the surrounding bony structures. To begin with, make sure that the sockets are on the same horizontal level. Also make sure that you have spaced the sockets equidistant from the center line. *See* "Placement" in this chapter for further details. Model the sockets somewhat elliptical in shape to conform to the longer visible area from corner to corner. It is important, as you can see, that the construction of the eye sockets be correct from the very beginning of their modeling.

One eye may be too deeply set under the brow. Check carefully as this will give the face a curious weakness in its general effect.[6]

If the recession beneath the eyebrows both sides of the nose seem insufficient, do not hesitate to cut these back further into the plane of the cheeks with the wire tool, making hollows to take the eyeball. At the lower edge of these hollows, if necessary, cut the clay back so that it makes a gentle incline into the cheeks, perhaps somewhat flattening the cheek planes as formed by the original basic clay ovoid each side of the bridge of the nose, in so doing.[1]

Model the bridge of the nose with the most careful attention to the receding planes to each side, more particularly where the junction between those planes and the sockets of the eyes occur, so that the corners of each eye has been placed as exactly as possible in position and depth, in relation to the bridge of the nose.[1]

Placement

Eyes must be properly placed, otherwise they will appear queer and give a weakness to the face. As expressed under "Eye Sockets,"

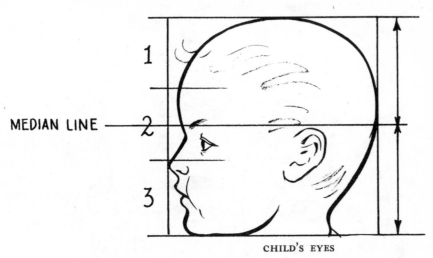

CHILD'S EYES

Child's eyes below median line.

though obviously wrong and unrealistic, this is a common failure
of the novice. Make sure that the eyes are on the same horizontal
level, and that they are spaced equidistant from the center line.
The normal distance between the two inner corners of the eyes
should be the length of one eye. If the eyes are too far apart, they
will (a) make the nose look too wide at the root and bridge (b)
bring the outer corners of the eyes too far to the side of the face,
giving the effect of too wide a face. If the eyes are placed too near
each other, they are taking up space needed for the construction
of the nose (making the bridge of the nose pinched and lacking
body), and needless to say that this, too, is as unrealistic as making
them too far apart. I repeat that the normal distance between the
two inner corners of the eyes should be the length of one eye.

If you place the eyes too deep, the cheekbones will be inwardly
recessed too much which, in turn, will make the nose stand out
too far from the face. If you make the eyes too low, the nose,
obviously, will look too short; if you make the eyes too high, the
reverse would be true. Need more be said about the importance
of making sure that the eyes are properly placed. Modeling both
eyes at the same time should help to prevent errors. Remember
that the median line or level runs through the corners of the eyes
for adults.

Eyes should be above the median line for adults.[15]

Eyes should be below the median line for children.[15]

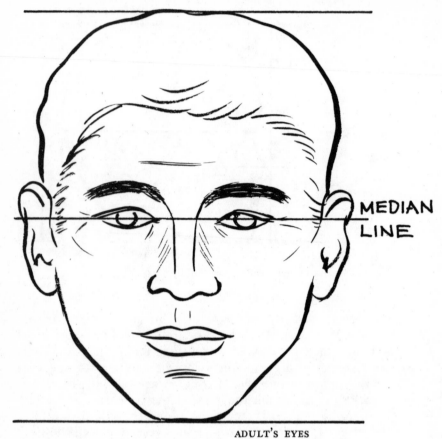

MEDIAN
LINE

ADULT'S EYES

Median line passes through corners of adult's eyes.

In children the cranium being larger than facial portion, eye level is below center.[14]

Shape, Size

The eye (eyeball) is spherical in shape. Remember when modeling that the sphere of the eyeball is the same as the sphere of a ball or any other round object—in all directions—not only from side to side as often modeled by the novice. Eyes that appear larger are usually a matter of the eyelids being open wider. If the lids are only partially opened, it gives the illusion of small eyes.

One problem of the sculptor is to make the eyes a pair. This involves making them exactly the same shape and size, with the

lids being particularlized for the individual. An eyeball at birth is at full growth. The eyes of a child, therefore, are mostly iris and pupil, with very little of the "white of the eye" showing. They appear large and expressive in a child. Their appearance is generally called "round eyed." Since the cranium of a child is larger than the facial portion, the eye level is slightly below the median line or level. Placed higher, it would make the child look a little older. With the passing of time, the shape of a child's eyes changes to adult appearance. Old age finds the eyes sinking into the sockets as the cushiony fat behind the eyeballs decreases. Lids droop. The skin on the arch beneath the brow looses its elasticity and droops over the upper eyelid. Deeper wrinkles form at the outer corners of the eyes.

About one inch will mark the width from the tear ducts or inner corner to the outer corner. While you may be doing the sitter's eyes perfectly, by making them too small or too large or wrongly placed in the face, you may miss the likeness.[14]

It is not to be assumed that both eyes are alike in size, shape or position. They may differ; whenever you can note slight variations, take advantage of them, for they add interest, if not exaggerated to the extent of looking deformed.[14]

The idea of a spherical form of the eyeball should not be lost.[1]

Color

Deep-set eyes suggest a darker color for iris and pupil. When the eyes are shallow in depth beneath the brow, with less shadow thrown on the eyes thereby, the illusion is that of eyes of a lighter shade. In seeking color for the iris and pupil, in addition to their depth under the brow, the depth of an incised line if it be used for the iris, or the depth of a hole if it be used for a pupil, should help to reflect the illusion you are seeking. The deeper the incised line or hole, the darker the color is suggested.

Even the color of the eye can be indicated—the depth of shadow caused by cutting in deeply gives the illusion of a dark eye, while the less deep undercuts which do not throw shadows will give the impression of light eyes.[2]

Cutting sockets in deeply gives the illusion of a dark eye—less deep does not throw shadows, hence gives impression of light eyes.[6]

The dark color of the iris and pupil are suggested by carving a hollow the depth of which is decided by the color of the eyes of the model.[4]

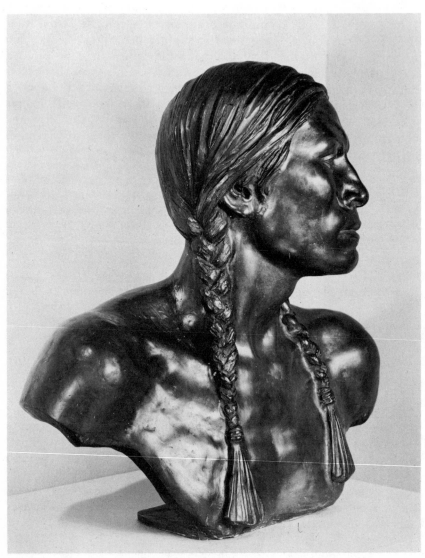

APACHE BRAVE, by Malvina Hoffman (1885–1966). *Field Museum of Natural History, Chicago, Illinois.*

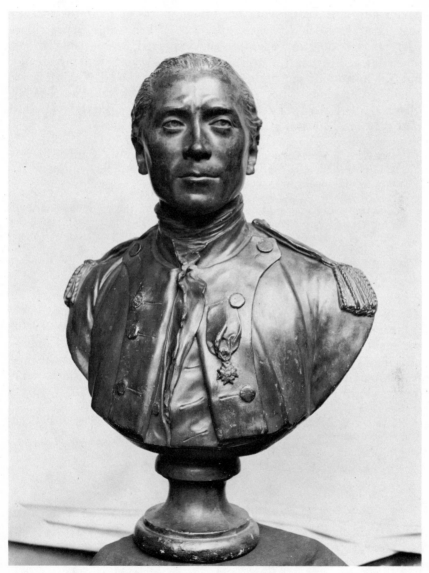

JOHN PAUL JONES, by Jean Antoine Houdon (1741–1828). *Courtesy of the Pennsylvania Academy of the Fine Arts, Philadelphia, Penna.*

Iris

The iris is the colored portion of the eyeball, with the pupil in the center. The whole of the iris is seldom seen, since the upper eyelid normally crosses the iris' upper portion, as if the iris was suspended from under the upper lid. When some expression—surprise or fear, for example—is indicated, the raising of the upper lid will reveal the entire iris. When eyes are looking straight out, the bottom of the circle of the iris meets the edge of the lower eyelid. When modeling, see that the size of the two iris are identical, and that they are on the same horizontal level—also that they are identically focused.

Iris vary in size as compared to the whole eye. As the iris is concave, a side light illuminates the far side and leaves the near side in shadow. . . . Lower eyelid usually does not cut across iris.[14]

The iris is round, a perfect circle as seen from the front, but normally the top section is hidden; be extremly careful, therefore, that you locate upper lid and iris at precisely the right points. Use the black center (pupil) as a guide. [14]

Pupil

Since the top of the iris is normally hidden by the upper eyelid, the pupil, though in the center of the iris, would in modeling be placed nearer to the upper eyelid than the middle of the eye. Amount of light on the pupil, as well as individual's size, makes for the slight variances of size in the pupil.

Though the center of the eye is a focal point, remember that pupils vary according to the individual and the amount of light.[14]

Cornea

The cornea makes a slight bulge on the eyeball as it fits over the iris and pupil as a transparent cover. You can feel this bulge as it moves from side to side when you play your finger over a closed upper eyelid. The eyeball, therefore, while spherical in shape, has this bulge in front.

The cornea is a crystallized form; and because it is raised from the eyeball, it causes a bulge. The position of the bulge establishes the direction in which the eyes are looking.[5]

Close your eyes and place your finger lightly on the drooped eyelid. Now glance quickly from side to side without raising the lid. You will feel the

iris move back and forth, and this will show you that the eye is not a ball, but a ball with a bulge on the front. This bulge houses the lense over the pupil and will become more apparent as the eye turns more into profile. The thickness of the lids, too, will then be more evident.[14]

Focus

The iris and pupil must be properly focused on the eyeball. If they are placed inward on each eyeball, or if one iris and pupil is in proper place and the others on the opposite eyeball placed inward, the eyes give the appearance of being "cross-eyed"; If they are placed outward on each eyeball, or if one iris and pupil is in proper place and the others on the opposite eyeball placed outward, they create a "wall-eyed" look. Wrong focusing creates a weakness in the face that should be avoided.

Focused on a near object, the eyes converge, but avoid making them look cross-eyed. Focused on a far object, the eyes are almost parallel which gives them a far-away look, but if turned outward, they look wall-eyed.[14]

Stare

Normally the top of the iris is hidden by the upper eyelid, as previously stated. If the entire iris were to be shown, with some white eyeball area showing all around—as is frequently the case in expressing certain emotions—the effect would be that of a stare.

If the eyes seem to stare, perhaps you have made them too far open. When we stare, the lid slides up and allows the light to strike the upper part of the whites and irises.[14]

Corners Of The Eyes

The corner of each side of the eye where the upper and lower eyelids meet is called the "canthus." Inner canthus differs from the outer canthus markedly, for the inner canthus has a somewhat horizontal "U" shape where the tear ducts are located. Observe that the outer corner is usually slightly higher than the inner corner, and is slightly recessed in relation to the inner corner because of the slope of face. While the outer corner is usually slightly higher than the inner corner, as above stated, it may well be that the corners of your sitter's eyes are on a horizontal level, or that the outer corner is slightly lower than the inner corner. These variances make the eyes interesting, and should be particularly noted.

The outer corner is always higher than the inner corner.[2]

Outer corner elevated—common; outer corner depressed, uncommon.[15]

Establish the characteristic angle of each eye as regards its horizontal axis.[1]

Determine whether eye is level or whether the outer corner is higher or lower than the inner corner.[14]

Sculptural Treatment Of The Eyeball

Below are listed ten conventions or treatments for sculptural eyes. They range from sockets without eyeballs, eyeballs without indication of iris or pupil, miscellaneous treatment of iris with or without pupil, cavity on the eyeball for iris or pupil, etc. Since the expression of the eyes have so marked a bearing on a convincing portrait, selection of one of these ten conventions should be given careful thought. The one selected should best satisfy the sculptor's interpretation, and to satisfy the sitter. If more than one is satisfactory, the final choice may well be one you excel in doing. That final selection may result from the effectiveness of the modeling tool or object with which you are best able to incise a circle or make a cavity.

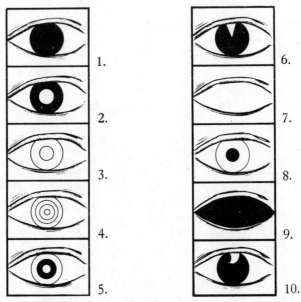

SCULPTURAL TREATMENT OF THE EYEBALL

1. Cavity on eyeball for iris—no pupil.

2. Cavity on the eyeball for the iris, and a circle of clay or plasteline built in the center of the cavity for the pupil. The latter is intended to catch the light. Serving thus, the latter helps to give luminosity to the eyes.

3. Circles incised on the eyeball for the iris for iris and pupil. Color of eyes may be suggested by incising circles lightly or deeply.

4. Round projection on the eyeball for the iris—narrowing at the top to suggest the pupil.

5. An incised circle for the iris—with a cavity for the pupil, and a dot of clay or plasteline in the cavity to catch the light. The latter helps to give luminosity to the eyes.

6. Cavity on the eyeball for the iris. A small wedge-shaped piece of clay or plasteline in the upper center of the cavity under the upper eyelid intended to catch the light. The latter helps to give luminosity to the eyes.

7. Blank eyeball of clay or plasteline set in the socket (no iris and pupil). A Greek custom, and not generally used in present-day portraiture. Blank eyeball is likely to create a glassy, fish-like stare.

8. A circle incised for the iris and a hole for the pupil (no dot of clay or plasteline in the center as in #5). Color of eyes may be suggested by incising circle lightly or deeply.

9. Empty socket—(no eyeball, iris and pupil). This is an archaic method, the space between the upper and lower eyelids simply being hollowed out.

10. No circle or cavity for an iris. Pupil is a small cavity, appropriately sized. A small wedge-shaped or crescent-shaped piece of clay or plasteline is left at top of cavity to catch the light. The latter helps to give luminosity to the eyes.

One satisfactory way of making an iris and pupil *when using self-hardening clay* is to model a blank eyeball set in the socket as indicated in Item #7, then let the eyeball dry along with the rest of the piece. When dry, use an electric drill with an appropriately sized bit, or any other instrument, to make a hole representing the pupil—after which the round circle of the iris can be incised. In this way, you do not disturb the shape and contour of the eyeball itself which frequently happens when you attempt to fashion the iris and pupil while the eyeball is in a moist or soft condition.

Leave a wedge-shaped high spot on your eye to catch the light and serve as a highlight, giving luminosity to the eye.[2]

Incise the iris and pupil lightly or heavily according to depth of colour it is desired to suggest, or they may be treated somewhat as in an archaic mass, the space between the upper and lower lids being simply hollowed out.[1]

The eyes will play a great part in making a portrait live or not. It is a question of feeling—whether to cut in the eye sockets of the eyes deeply or not; whether to leave a point of material to catch some light, or whether the pupil is better built on the eyeball with certain line tracings—or will the complete eyeball left blank better depict the elusive thing called "personality."[10]

<div align="center">EYELIDS</div>

Characteristics Of Eyelids

Eyelids follow the curve of the eyeball. When modeling the eyelids, make them seem to lie upon and closing over the eyeball, and, of course, following the convexity of the curve. The profile view should clearly show the eyeball set inside the lids, otherwise the eyeball will appear as if they were popping out between the eyelids. The lids have a certain thickness which must be expressed. The upper eyelid frequently has a droop or slant in varying degrees overhanging the eyeball—the pattern of droop or slant may be different on each eye of the same individual.

In all cases, the convexity of the globe of the eye must be described by the lids.[15]

Lids conform to the round contour of the eyeball.[2]

Observe the relationship of the lids, their shape, the changes that come with movement. Note the planes of the lids as they meet the planes of the cheek and eyebrow. Note the construction at the corners where several planes come together forming a characteristic design.[13]

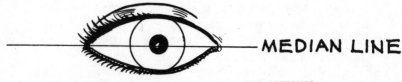

MEDIAN LINE

EYE OPENING

Almond-shaped.

Placement Of Eyelids

The profile view should tell you how far forward the upper and lower lids project. Model the eyelids to their proper thickness, as you judge the sitter's eyelids to be; any tendency to make the lids thin gives a weak look to the eyes. Making the lids fairly flat adds to their richness.

The lids should be laid on as flat pieces as nearly as you can judge the size and thickness of your model's lids. By laying these pieces over the eyeballs, they will mold themselves to the contour beneath. Edges should not be too thin.[4]

Upper Eyelid

The upper eyelid rises abruptly from the inner corner and sweeps across the eyeball to the outer corner where it overlaps the lower eyelid. It sweeps across the eyeball in a wider arc than the lower lid. Its contour follows the convexity of the eyeball. Since the iris and pupil, and the cornea covering both, is the most forward projecting part of the eyeball, it follows that the upper eyelid directly above the iris and pupil is the highest point of its forward projection. The lid is larger in the center than at its ends. The upper lid is longer and thicker than the lower lid, and is by far the more mobile. The upper lid normally hides the upper portion of the iris, and makes the latter appear as if it is suspended from it. When the upper eyelid is raised, the withdrawn lid folds upon itself with a crease or creases between the lid and the arch above it. These folds are of varying degrees of length and depth with each individual, and most frequently not the same on each lid of the same individual.

The upper eyelid rises abruptly from the inner corner and sweeps over the eyeball to the outer corner.[4]

Look for the angles in the upper lid and the location of the points where they join. Is the particular eye triangular on top, square or arched.[14]

The upper lid folds upon itself, making the line of demarcation between it and the arch of the brow more strongly marked than the junction of the lower lid and the cheek.[4]

The folds of the upper lid have shapes that are determined by the thickness of the lid, the convexity of the eyeball and the depth at which it is set plus any habits such as squinting, frowning or blinking, some of which date back to childhood. All eyes have a crease in the upper eyelid. It may be deep or not, and maybe wider at either corner, or may or may not repeat the line of the lid's edge. The crease may extend out beyond

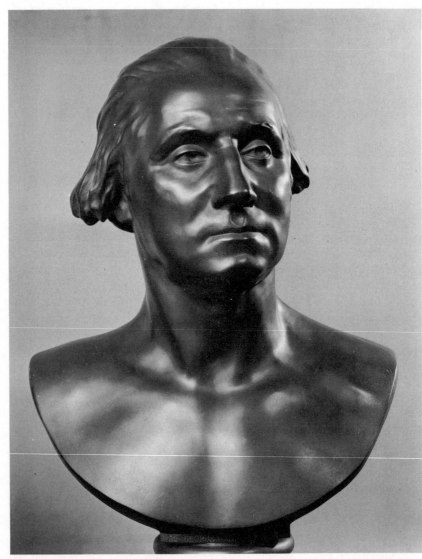

GEORGE WASHINGTON, by Jean Antoine Houdon (1741–1828).
*This is either a modern replica, or a reproduction from the marble original
sculpted by Houdon from life at Mount Vernon in 1785, now lost. The
Metropolitan Museum of Art, Gift of George Ackerman Coles, 1908.*

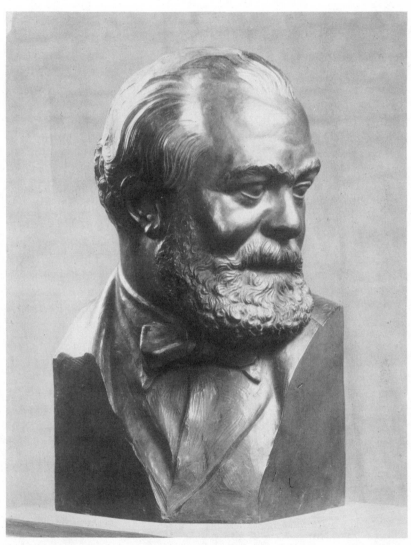

JO DAVIDSON, by Cecil Howard (1888–1956). *Collection of Whitney Museum of American Art, New York.*

the eye itself and seem to make it larger, and may turn down or up joining the "crinkles" of good humor.[14]

Lower Eyelid

The lower eyelid sweeps across the visible bottom of the eyeball from the inner corner to the outer corner where the upper lid overlaps it. Its sweep across the eyeball is at the bottom of the circle of the iris. Its outer corner is slightly higher than the inner corner. The lower lid is thinner than the upper lid. Its arc is smaller than the arc of the upper lid, and is not as curved as the latter. The smaller arc of the lower lid and the wider arc of the upper lid is best seen from profile view. The lower lid is normally not as forward on the face as the upper lid. It lies somewhat on a backward slope from the more advanced upper lid. The downward plane from the edge of the lower eyelid to the cheek slants inward to conform to the receding convexity of the eyeball. A sac or soft pouch under the lower eyelid, if there is one, can change the direction of this plane.

> The lower lid is somewhat straighter than the upper lid until it reaches the outer corner of the eye where it sweeps upward to the upper overhanging lid.[4]

> Lower lid shows its edge, and usually does not cut across the iris.[14]

Sac Under Lower Eyelid

A sac or soft pouch under the lower eyelid may be found in all adult ages, but generally it is found in older people because the skin surrounding the eyes is less elastic in older people. Sometimes illness, or a mode of living with loss of sleep, accentuates the sac.

> Indicate sac below eye, if there is one.[1]

EYEBROWS

The eyebrow and the arch beneath it are important parts of the forms surrounding the eye, and which gives character and expressiveness to the eye. The eyebrows form an elongated mass of fine hairs, generally being fuller at the inner portion of each eyebrow. As the eyebrows approach the nose, they frequently dip under the overhanging brow. They vary in shape, length and thickness with each individual. They may be short or long, straight or arched, thin or bushy. The eyebrows, of course, have a cosmetic value, but they also have a very practical value in helping to protect the eyes against the entrance of foreign bodies. Be careful not to

place the eyebrows too high above the eyes, otherwise you will get a quizzical expression you did not intend.

Children's eyebrows, as a rule, are straight and scant.

A male's eyebrows are generally straight, or slightly arched, and appear closer together than that of a female. They are bushier than female eyebrows.

A female's eyebrows in its natural state are slightly more arched than that of a male, and invariably arched more than normal when artificially penciled, or changed as fashion dictates. When a woman replaces natural eyebrows with artificially established ones (often where nature never intended it to be), much of the character and expressiveness of the eyes are lost. In starting the sculptural portrait of a female, it is necessary that any artificial penciling of the eyebrows be removed, otherwise the sculptor will be unable to discern the characteristic shapes of the area's forms.

When modeling, the use of threadlike markings for the eyebrows will provide texture for the short hairs that grow there—contrasting with the texture of the surrounding skin. Direction of hair growth must be considered, as they may be straight, sloping, arched, or a combination of directions even in the same eyebrow.

The eyebrow line and the arch beneath it above the eyes give character to the frontal overhang of the forehead.[1]

Eyebrow shapes are different with each face and the angles or directions of both eyebrows (the two are not always similar) should be observed carefully.[14]

Eyebrow hairline highest and widest over the outer third of the eye.[15]

Children's eyebrows are not too heavy—make hairline straight, instead of curved, to accentuate youth.[4]

Arch Beneath Eyebrows

The area between the eyebrows and eyes is a recessed plane from the brow. As the lids follow the curve of the eyeball, the same curve is generally maintained for this area or arch; however, the form of the arch can be altered by age, fat, flabbiness—causing the skin of the arch to sag or droop over the upper eyelid. The sagging takes on varying shapes, and may not be the same on each eye of the same individual. This sagging or drooping over the upper eyelid can have a marked bearing on appearance, and its characteristics should be clearly defined if a likeness is to be obtained.

Is the upper lid, or some portion of it, obscured by sags of flesh hanging from the brow?[14]

20

Forehead

The forehead is the lower portion of the Frontal Bone. Its plane sweeps upward and backward. It may be forward of the facial angle of the head, over or back of the facial angle. The profile view will best reveal its position with relation to the facial angle of the head.

The two rounded left and right "frontal eminences" in the upper part of the forehead are more or less revealed with each individual. These left and right eminences or lobes often merge into one. They are more characteristic of the female head than of the male.

Beneath the frontal eminences is the brow with its two superciliary arches forming the upper rim of the orbital cavities (eye sockets), and the top of the nose. The elevation of the superciliary arches is more characteristic of the male head than of the female.

The overhanging brow and its superciliary arches acts as a visor over the eye sockets to protect the eyeballs. It has a strong effect upon the character of the eyes as more fully described under "Expressiveness of Eyes" in the chapter "Eyes, Eyelids, Eyebrows."

The forehead has a series of thin muscles. With the passing of time, they generally form wrinkles. When the brows are drawn together as in deep thought, or are lifted, these "thought muscles" as they are called will show in varying depths. When modeling, it is not necessary to show wrinkles of the forehead too strongly as they may appear on your sitter's forehead, particularly on a woman's head. A suggestion of these wrinkles will be just as convincing. Also avoid modeling the forehead square looking, for its plane changes direction as it turns sideways to the temples.

The projection of the forehead, cheekbones, and chin are the forward points of the facial angle of the head, and they must be modeled in correct relationship to each other. These fixed, immovable points form the foundation of good head structure. As indicated in "Relation of Forms" in chapter "Modeling the Head Structure," the forehead is the "first" in modeling, and to this the cheekbones and chin are related. If the forehead is "out," so to speak, everything can go wrong. So I would stress that the fore-

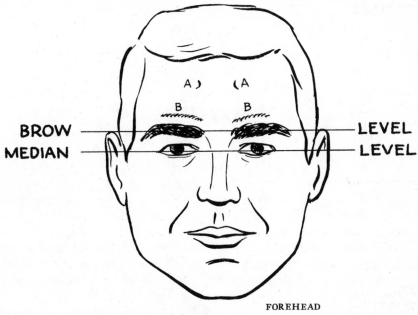

FOREHEAD

A. Frontal Eminences
B. Superciliary Arches

head be right. Avoid making the forehead "square" with "corners" above the eyes. The plane of the forehead recedes as it turns to the side of the face.

The forehead occupies the greater part of a young child's cranium. In the young child, the forehead is dome-shaped, and protrudes forward of the facial line.

The frontal outline may be in advance of, over or behind the facial line.[15]

It must not be made too square in section where the plane changes direction, front to side, particularly on a realistic portrait.[1]

The brow in the male are usually marked by the frontal sinuses occurring on either side and above the root of the nose, over which the forehead rises in a smooth plane curving backward at the top where the hair veils its form.[4]

21

Hair

Treatment

Since hair is superimposed on the cranium, it should be organized with due regard for the contour or shape of that portion of the head; therefore, keep the head structure in mind at all times as you model the hair. If integrated well with the contour of the cranium and the facial shape, the effect will be one of a unified whole . . . and it will be orderly, convincing, and esthetic. Hair masses have interesting form, particularly on a woman's head. A well-modeled sculptural coiffure adds immeasurable richness to her portrait. A male's hair, too, modeled tastefully and harmoniously, considerably improves the male portrait. Take careful note of your sitter's hair, and model it as individually distinctive as possible. Well done, it will play a great part in making for your sitter's likeness, and will give character to the whole head. If hair modeling is done badly, the whole likeness and character of the head can be changed—adversely affecting the portrait, no matter how good the other forms of the head may be.

> The question as to how far the hair should be simplified and incorporated into the general shape and volume of the head, or how far it should be treated as an added textural or decorative feature, giving richness and contrast to the more or less smooth surface of the rest of the head is, of course, an aesthetic one. This will be determined differently in the case of each work, by its formal or informal character—and of course, as with all such problems, integration of the whole work will be the aim. Singleness of purpose, taste and consciousness of the character of the work as a complete sculptural statement will be the guiding considerations.[1]

Pattern Of Growth

Find the design or pattern of growth of your sitter's hair, and follow its natural direction for authenticity. Compose the hair pattern so as to identify your subject's type of hair—which may be wavy, curly, or straight.

The big masses should first be ascertained, and these subsequently distributed into their smaller patterns. Do not attempt to reproduce every lock, wave, or curl of hair. Changes of planes and surfaces are much more effective than a naturalistic representation of every lock, wave, or curl. Strive for a simple, rhythmic effect. Well-placed incised lines may be all that is necessary to establish a convincing head of hair.

Whatever method you use to establish your sitter's hair, it must not altogether hide or mar the underlying contours of the head, for the outline of a well-formed head is in itself an important factor for a successful sculptural portrait.

Long hair, as in the case of a woman, is a challenge for the sculptor, for there is a rhythmic movement in her hair pattern that should be captured for sheer beauty. Its natural growth direction is most interesting. Whether her hair pattern be made up of a series of crisp curls, sweeping waves, or straight hair, there is always sculptural quality to be found in her hair style. Look also for the generally interesting pattern in the growth of a woman's hair at the nape of the neck.

Short-cropped hair, typical of the male head, permits the shape of the head to be seen; extra care, therefore, must be maintained to see that the underlying contour remains well established.

If you use incised lines for hair pattern, do not scratch them all over the head. Limit these incised lines where they are sufficient to show the hair pattern—at the forehead, temples, crown of head, parting of hair, and areas on the back of the head to the neck.

Hair style for children should be modeled appropriate to the age of the child.

No attempt should be made to copy exactly the naturalistic texture of the hair, but the attempt should rather be made to establish in the clay, boldly and rhythmically, the general design of its masses.[1]

As it becomes necessary in female heads to make special disposition of the hair, to gather it up without affectation in some natural form or support suited to the shape of the face is all that is required. Nothing can exceed the beauty of the natural outline of a well-formed head. It should never be altogether obscured, nor its natural proportions defaced.[15]

Whether it is a springy mass of wavy hair, slick hair, curly hair or straight hair, in each case, I try to compose the hair shape to the whole sculpture unit, and try to preserve the hair character.[11]

Study the way the hair grows, the rhythm of a wave, the soft shadow occasioned by a curl. Make the levels distinct and you will find there is an underlying pattern—hair grows in a pattern, layer upon layer.[2]

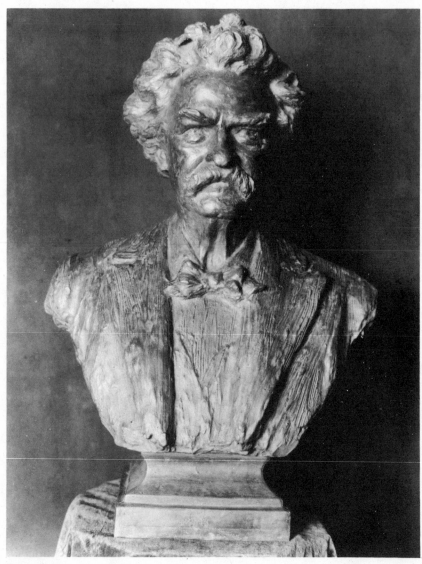

SAMUEL LANGHORNE CLEMENS (MARK TWAIN), by Albert
Humphreys. *The Hall Of Fame For Great Americans at New York Uni-
versity.*

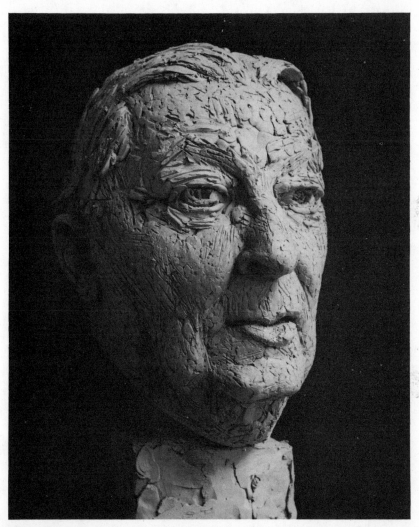

SIR HUGH DOW, by T. B. Huxley-Jones. *Courtesy of the Artist, Broom-field, Chelmsford, Essex, England.*

Texture

The texture of the hair should offer a contrast to the smooth texture of the face. Its characteristic disposition should be that of softness, and it should provide a richness and decorative quality to the head form. It should frame the face, and complement its forms. Texture of hair is particularly evidenced where the hair grows from the skin. These edges must be carefully modeled to effect a soft, gradual blending with the skin. Too sharp an edge will make the hair look like a wig.

> The texture is best suggested at the overlapping edges of the masses, and by a judicious breaking up of these edges, and a few incised lines carried across the masses at well chosen points—suggests character of the hair more beautifully than by scratching over the whole surface with finely incised lines.[4]

> Hair presents a glorious opportunity for design. Its texture can be made to contrast the texture of the face. The more or less arbitrary arrangement can be used to balance or repeat an area.[5]

Color

It is possible to achieve hair color through textural treatment. Long, smooth surfaces which catch the light suggest light hair. Deeper, unsmooth surfaces which cast shadows reflect dark hair. Undercuts, accentuating detail, will give the effect of dark hair. Variety in proportion of one mass, in contrast to other masses, and creating varying planes and surfaces, receives light and shade which give effect to lightness and darkness of hair. All these sculptural treatments make for color.

> Attention should be paid to the color. Very dark shadows may not be satisfactory if the model is fair.[7]

> Dark hair requires a more trenchant (sharp, deep) treatment than fair hair. The deeper shadows tend to convey the impression of darker hair.[4]

> The texture can be made to approximate the lightness or darkness of your sitter's hair. Long smoothness which catch the light suggests light hair. A relatively broken surface to which a lot of shadow clings suggests dark hair.[5]

> Very often the depth of color, and the fineness or coarseness of the texture of the hair can be suggested by the shape and scale of the pellets or strips of clay which are used to form its basic masses in conjunction with the intervals of space between each application of clay. The intervals of space may be deep, giving darkness and suggesting strong tonal colour or slight, giving luminosity.[1]

Hairline

Pay strict attention to where the hair grows from the forehead, temples, behind the ears, and the nape of the neck. Where it visibly grows from the skin, as in these areas, the change should be soft and gradual, gently merging where the hair blends into the skin. If these edges are defined with sharp, hard lines, the hair will look like a wig. Hair must appear as growing on, rather than looking like it has been stuck on. Hairlines of beards and mustaches, too, must be modeled like the areas above mentioned.

Where the hair grows from the forehead, undercuts should be very soft—let it merge gently into the face. A sharp hard line gives the effect of a wig.[2]

Avoid the appearance as though the head was crowned with an ill-fitting wig.[4]

Study carefully where the hair leaves forehead and temple. It grows from there, and if this fact is not expressed what can the effect be other than the suggestion of an ill-fitting wig.[7]

In so far as the work approaches naturalism in intention and scale, such matters as the variety of edge where the hair makes junction with the skin—softly melting into it perhaps, at the sides of the forehead above the ears, more boldly patterned at the top of the forehead and so on—will have to be observed and registered.[1]

Crown Of Hair

The top of the head has an interesting crown or central point from which the hair grows in all directions. Model its particular position where found on your sitter's head, and let the spiral or swirl from this crown provide interest to the top and back of your sculptural head.

Crown of head has a swirl or spiral that lends interest to the top and back of head.[2]

Hair Part

The parting of the hair in almost all male heads, and in many female heads, needs attention, too. The hair part is obviously on the surface of the head—and should not be cut below the surface as so many novices show it. Like the hairlines of forehead, temples, behind the ears, and the nape of the neck, the blending of the hair from the part should be soft and gradual. There is a partic-

ular angle or direction that your sitter's hair part takes, and this should be properly indicated.

Do not make the hair part so deep that it goes below the level of the contour of the skull—part the hair with a brush, not a meat axe.[2]

Tools To Sculpture Hair

A wire-end tool with a spiral wiring around it is a suggested tool for creating an over-all texture for hair. In fact, any tool or object may be employed, but care must be taken that the use of the instrument does not make the hair appear scratchy, artificial and unnatural.

The texture is suggested by a few well placed strokes of the modeling tools, or a piece of wood snapped across the grain and the jagged edge of the fracture used with restraint.[4]

Press the butt-end of a rough-sawed board or stone into the surface of the clay for creating an over-all texture. Though these are a matter of preference, nurture them, for they can develop into an individual style.[3]

Jaws, Chin

Upper Jawbone (Maxilla or Superior Maxillary Bone)

Situated on both sides of the nose and flaring out to the cheek-bones, the two maxilla bones, forming the whole upper jaw, meet in the center below the nose. They form part of the rim of the eye sockets, the roof of the mouth, the nasal cavity, and the arch that holds the sockets of the upper row of teeth.

Lower Jawbone (Mandible or Inferior Maxillary Bone)

The lower jawbone is the only moveable bone in the head structure, and is shaped somewhat like a horseshoe. Its shape is to be considered when modeling, for it decidedly marks the contour of the face as a whole. There are many variations in jaw shapes, as one can very well see from observation—from the pointed to the softly rounded, the weak angular to the broad angled, from the recessed to the jutting jaw, the concave to the fleshy one. Its upper portion (dental arch) serves as a receptacle or sockets of the lower row of teeth.

In a child, there is hardly ever an appearance of a continuous jaw-line from chin to ear—what jaw-line does appear curves upward in an unbroken sweep from chin to ear. In adolescent and adult life, this line becomes more level. Most males have a strongly marked jaw. The jaw of a female is seldom as strongly marked as that of a male. As flesh sags at the side of the jaw in old age, the jaw-line appears to change its shape, generally more downward and sharp-angled. The bones of the jaw then become more evident. When teeth wear down in old age, or are lost, the jaw seems to project forward more than usual, with the face expression somewhat loose and weak.

Look at the shape of the jaw. Is it square, round, pointed?[9]

Continued on either side back to the angle just below the ear, it may be strongly marked, or softly rounded, square or sharply rising.[4]

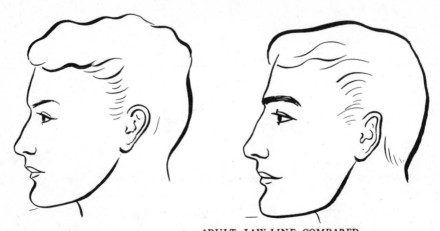

ADULT JAW-LINE COMPARED

Average outline of the female and male jaw-line.

Form of lower jaw may be: a weak angular, a round jaw, a square jaw, concave jaw.[15]

Angle Of Lower Jaw

From the central portion of the jaw (chin), the jaw-line rises to the jaw corner ("angle of the jaw") from which point the almost flat rear (Ramus) rises almost vertically to the "hinge" of the jaw in the cavity of the Temporal Bone near the ear. As this ascending upper portion of the lower jawbone is angled, the ear is normally angled.

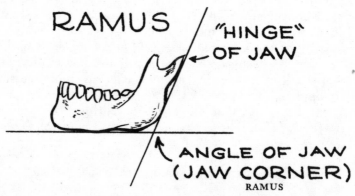

Upright portion of the lower jawbone.

Having got the forehead (first line of modeling) satisfactory, and built up the cheek bones (the next line) in relation to it, the next form to be considered is the lower part of the face—the angle of the jaw-bone from the ear.[7]

"Hinge" Of The Lower Jawbone

Lower jawbone ascends to fit into the cavity of the Temporal Bone. It moves freely on a "hinge" under the zygomatic arch near the ear as the mouth opens and closes. It is a double-hinged joint which allows backward, forward, and lateral movements of the lower jawbone. The "hinge" is approximately on the nose base level (bottom of nose and ear), and for sculptural purposes is so indicated on measurements No. 9 of "Sitter's Measurements" in chapter "Working From Life."

CHIN

The chin is the central portion of the lower jaw. It protrudes from below the valley under the lower lip, and extends to the base of the jaw (jaw level). It has many variations—from the prominent chin to the receding chin; it may be pointed, round, or square. Prominent chins are generally large, though this is not always the case—for it may be a small, yet a prominent chin. Receding chins are generally small and weak looking—this, too, may not always be the case. In short, the variations are many, and a proper modeling is important as the jaw and chin are characteristic features that add immeasurably to likeness, etc. Note the vertical depression or cleft in the lower central portion of the chin—it may be slight or deeply marked. This central cleft has two lateral lobes, more or less marked in individuals, bounded by the pillars of the mouth.

When modeling, check the profile view for the relation of chin to forehead and cheeks. It will give you a good idea whether the facial line is straight, convex, or concave, and whether there is a proper relationship to these three fixed points in the outline.

Check the distance of the canopy under the jaw (distance from chin point to neck), and model this distance accordingly. Sometimes it is a short distance; in some individuals, particularly those with a jutting jaw, the distance is longer.

In a young child, the chin is small and recedes. It is often so diminutive in a young child that it is scarcely visible beyond the cheek as you look at the profile view. As the child advances to adolescence, the chin becomes more evident as the chin and jaw develop. In old age, age changes in the jaw gives added prominence

GENERAL CLAIR LEE CHENNAULT MEMORIAL MEDAL, by
Dexter Jones. *Courtesy of the National Sculpture Society, N.Y.*

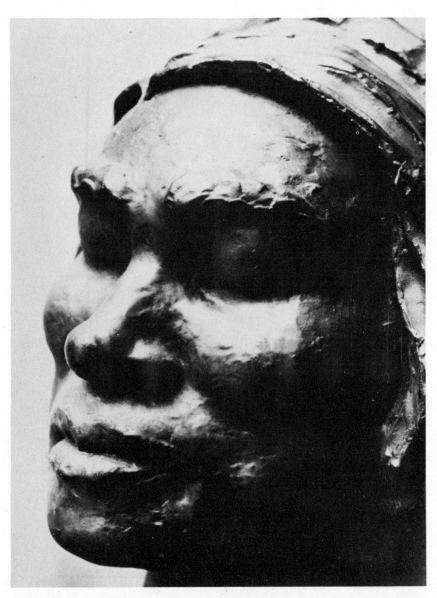

MARIAN ANDERSON, by Nicolaus Koni. *Collection of the Washington County Museum of Fine Arts, Hagerstown, Maryland.*

to the chin. Chin is less prominent in a female.

Underside of chin, particularly folds that suggest the so-called "double chin," should receive its share of attention.

Look carefully at the model in profile and notice position of chin in relation to forehead.[7]

Mouth, Lips

Expressiveness of Mouth

When we speak of the expressiveness of the mouth—and most sculptors (and painters) think of the mouth as the most expressive of all the facial features—we must consider not only the lips, but all the forms encompassing and surrounding the mouth. These forms—corners, pillars, muscles giving movement to the mouth and to expression, etc.—contribute greatly, each in its own way, not only to the expression of the mouth and lower part of the face, but to the entire face itself.

The mouth, because of its delicate forms and the mobility of the surrounding muscles, is so flexible and changeable a feature that it is seldom twice alike, for it instantly changes as it reflects inner thought, mood and feeling at any given moment. The smallest change in the contour of the mouth can alter your sitter's appearance and expression, and must, therefore, be observed and recorded with the maximum of fidelity. Try for that distinctiveness of form and expression about the mouth that best characterizes your sitter; the one distinctiveness that will most likely identify him. One thing is certain: if the contour of the mouth is modeled incorrectly—if it is set in an expression unlikely and unnatural to your sitter—it will ruin your sculptural portrait. Then you will soon hear the complaint so familiar to both the two-dimensional painter and the three-dimensional sculptor, that "I like the portrait, but there's something wrong with the mouth."

The mouth has so much mobility, usually too much, as your sitter will talk to you, so that it is a matter of selecting what mood the mouth shall express.[2]

Shape

Individual mouths vary so much in shape, size, and proportion that modeling them presents special difficulties to the sculptor. The variations are endless. Whatever the shape, size, and propor-

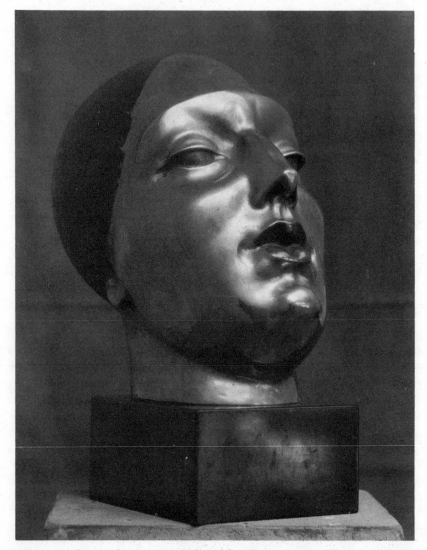

HEAD, by Gaston Lachaise (1882–1935). *Collection of Whitney Museum of American Art, New York.*

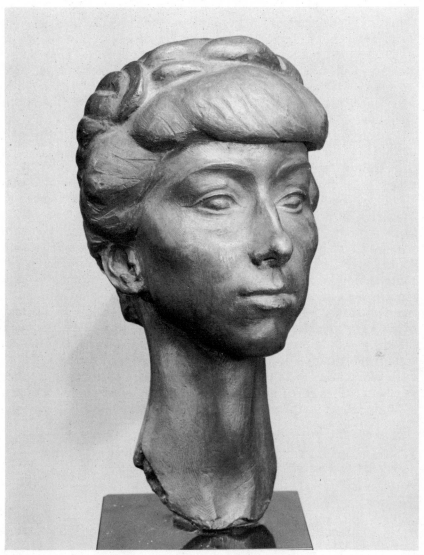

MARIANNE MOORE, by Gaston Lachaise (1882–1935). *The Metropolitan Museum of Art, Gift of Lincoln Kirstein.*

tion of the mouth, one thing must be impressed upon the beginner, amateur, and student: the mouth must not be modeled flat. This is a common error with the novice. In modeling the mouth, you must shape it to conform to the horseshoe-shaped curve of the jawbones. Lost in the fleshiness of the overlying lips and surrounding forms, the neophyte may overlook the curve of this sub-structure. If you have any doubt about the curve of this underlying structure, just take a bite out of a piece of bread. The shape of the bite will reveal the curve. It is well to re-check at all times your knowledge of the two dental arches that are a part of the sub-structure of the mouth—the upper maxillary arch that holds the upper row of teeth, and the lower mandibular arch that holds the lower row of teeth. Satisfy yourself that the mouth also looks right from the profile view.

A child's mouth is small and round, with a "cupid's bow" in the center of the upper lip. The upper lip in the child is fuller than the lower lip, and its convex form protrudes forward more so than the latter. In a child, the corners are slightly lower than in the center. Mouths in children vary according to age. With the passing of childhood, the mouth tends to straighten out and become longer, with less of a bow as time passes.

In the female, the mouth is generally smaller than the male mouth, the mucous or red lip portion fuller, and the surrounding cutaneous or skin areas smaller. In starting a sculptural portrait of an adult female, it is very necessary that lipstick be removed, otherwise the sculptor will be unable to discern the true shape, etc., of the mouth, and the expression that goes with it.

In old age, as teeth are worn down or lost, the mouth muscles sag and roll inward, making the lips appear narrower, and the mouth smaller as the muscles sink in. The upper lip is frequently hidden altogether.

The mouth takes on a curved form when viewed from underneath—the corners of the mouth are the two ends of a bow.[5]

Size

Size of mouth varies with each individual, but on the average it is about one-half times wider than the bottom of the nose from wing to wing. Some sculptors establish the width of the mouth by making its ends or corners to a perpendicular line below the pupils of the eye. Since the width of mouth is variable in individuals, the sitter's mouth, as in all other features, will be the governing width.

Mouth one-half wider than the nose.[15]

Position

Divide the space between the bottom of the nose (nose base level) and the chin level into three parts: place the mouth approximately one-third down from the bottom of the nose. There can be a slight length difference in individuals between the bottom of the nose and the level of the mouth.

Corners

The curved shape of the mouth makes the corners deeper than the center. The corners are slightly tucked under the surrounding muscles. The shape of the corners can be very distinctive with individuals, and expressive of one's thoughts, moods, and feelings. It is said of the mouth corners that they are the seat of expression. If the corners of the mouth turn up, it is said that the person has a pleasant personality, hence many portraitists, both in the two-dimensional painting and the three-dimensional sculpture, find it advantageous to turn up the corners of the mouth slightly so as to give the face a more pleasing expression. A strong upturn of the mouth corners, the upward and backward stretch of the lips, and the raising of the cheeks, produces a smile; care, however, must be taken that the effect is not that of a pointless grin. It should be remembered that a smile or laugh will naturally enlarge the width of the mouth, reveal the teeth and deepen the corners; the upper lip becomes more horizontal and the lower lip less convex. A smile or laugh produces folds at the sides of the mouth, and perhaps dimples.

A grim or sad expression results from any droop or lowering of the mouth corners. Frequently, in modeling, even when the mouth corners are modeled straight (without a droop or downturn), a grim or sad expression takes place. This should be avoided, of course.

The corners of the mouth are deeper than in the center. The twist in the planes surrounding the mouth, particularly at the corners, should be carefully realized or the lips will lack mobility.[4]

Do not be afraid to go in deeply for the corners. Here exists one of the salient points for likeness.[2]

Study the corners and the transition that takes place where they join the muscles of the cheeks.[13]

Pillars

Associated with the expression of the mouth are the fleshy

eminences covering the corners of the mouth, also the pillars of the mouth which separate the form of the cheek from the top of the wing of the nose—pressing downward and dropping away at the level of the mouth corners or below.

Pillar is the fleshy eminence covering the corner of the mouth.[15]

LIPS

Characteristics of Lips

Lips are flexible muscles that draw together, expand and open at will—so rich in form and suggestion of mobility as to make the mouth and lips the most expressive of all the features. Often the curve or shape of lips can make an individual's face memorable, or perhaps cause aversion and disgust. Shapes and proportions vary greatly in individuals, and, needless to say, the sculptor must model the lips as characteristic of the individual sitter as he possibly can.

The mouth is the most flexible feature of the whole face, and careful observation is necessary to get the most characteristic position of the lips. They may be tightly closed, or slightly open, perhaps pulled a little to one side. They may turn up or down at the corners, or one corner might turn up and the other down. The mouth is always in a constant state of change.[7]

Structure

The structure of the lips is largely due to the curvature of the dental arches in the horseshoe-shaped upper and lower jawbones. While the common forms—three in the upper lip, two in the lower—are generally present, their volume, proportions, projections, and recessions vary with each individual. Their differences range from the prominent to the compressed lips, the latter sometimes being hardly discernible. They may be straight, curved, appear hard or soft, etc.

You may find the "carpenter's level" a useful tool with which to determine the horizontal axis of the mouth and lips, and from this horizontal line establish whether your sitter's mouth and lips are straight, slightly elevated on one side, or have any other variations.

The length of the lips—longer above, shorter below—must be considered, and how they tend to get thinner and move inward as they approach the corners. Projection of the lips can best be seen from a profile view.

Male shapes are generally straighter and firmer due to the strong male muscles surrounding the mouth. Female mouths are generally smaller than a male mouth, and the former's lips are generally more fully rounded, softer and delicate. Lips lend beauty to the face when the upper and lower lips blend softly together as they meet.

Let me warn you that the mouth is never flat. Most beginners make this mistake. The lips conform to the underlying shape of the teeth which is round. When you bite into a sandwich, you bite a curve. The corners of the mouth are deeper in than the center.[2]

The shape of the dental arch determine the outer appearance of the lips.[14]

The recessions and projections of the forms of the lips themselves must be shown as they occur along the horizontal axis of the whole mouth, which must, itself, conform to the horizontal section of the head at this level. That is to say, it must not be drawn flatly but, as it recedes from the center, it should be modelled in depth in accordance with the curvature of the jaws.[1]

Lip structure is common in all human beings. Proportion and volume may vary, but the common structure is always present. There are three units in upper lip, two on bottom.[11]

Edges

When modeling lips, reflect the thin marginal rim or edge of the red lip portion as it meets the cutaneous (skin) portion. Do not make these edges too pronounced; rather, softly blend the red lip portion with the skin portion.

The thing that is very important in modeling the mouth is to hold the edges and the tiny platform of the edges. It is important to accent the form and the character of this most expressive feature.[13]

Elevated edges separate mucous portion of the lips with the cutaneous portion.[15]

Space Between Lips

Note how the two lips close softly together. Actually, there is no "line" between them, straight or otherwise, for the two have their own distinct forms of varying shapes and proportions. When the lips are parted slightly, there is the appearance of "breathing" to the portrait. The flexibility of the lower jaw permits the mouth to open wider, and, of course, the space between the lips to widen.

The line between the lips is more uniform in depth—not a cold, hard line—but one of varying depths and moving play of light and shade. Sometime, particularly with children, a breathing look can be captured by leaving the lips slightly parted.[2]

Does it go up, level or down at the corners? Allow for the modulation of this line by a single "cushion" in the middle of the upper lip, and the two "cushions" either side of the center of the lower lip.[14]

Upper Lip

Cutaneous (skin) portion

Two planes separated by a vertical groove form the cutaneous (skin) portion of the upper lip. Distance from the bottom of the nose to the red lip portion of the upper lip varies in individuals. If the cutaneous portion of the upper lip is not attached midway of the nose projection—between the back of the nostrils and the tip of the nose—the effect could be of a nose stuck on the face instead of it being a part of the face.

The way the upper lip fits into the little valley which surrounds the nostrils is a subtle detail which should not be overlooked.[6]

The upper lip usually attaches midway of the width of the nose. Most beginners attach the upper lip too far back, or at a sharp angle. There is a small plane dividing the nose and the lip and this gives a feeling of life to the silhouette.[2]

Central vertical groove

The vertical depression or groove running from the septum at the bottom of the nose to the red lip portion of the upper lip may show very little depth, or it can be markedly deep and conspicuous. It is narrow at the top and widens somewhat as it peaks itself forward at the bottom.

Red lip portion

The red lip portion of the upper lip consists of three main forms: the central mass marked by the peaked thrust of the groove above it, and the two side wings which get thinner and move inward as they retreat to the depressed corners. The central mass fits into the slightly depressed center of the two masses of the lower lip. The upper lip is generally thinner than the lower lip. It is comparatively flat, more angular, and protrudes slightly forward of the lower lip. Covering the larger dental arch of the upper teeth (maxillary arch), the upper lip is more arched than the lower lip, and is, therefore, the longer of the two.

The upper lip is made up of three main shapes, the lower one of two.[7]

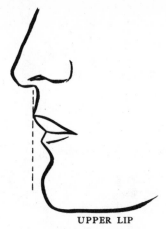

UPPER LIP

The upper lip protrudes slightly forward of the lower lip.

Mucous portion of upper lip composed of three parts: center body and two wings.[15]

Lower Lip

Cutaneous (skin) portion

As the cutaneous portion slopes backward from the red lip portion of the lower lip, there is a valley or depression which meets the advancing plane of the chin. This inward slope helps to give shape to the lower lip. Model it convincingly as it helps to establish likeness to this area of the face.

Red lip portion

The lower lip is usually fuller than the upper. It is convex, and softly rounded. It sets back slightly from the upper lip; however, this would not apply to individuals who have pronounced or jutting jaws in which case the lower lip would protrude and the upper lip recede in varying degrees with different individuals. It is made up of two side shapes that come together with a depressed center between. The peaked thrust of the center of the upper lip fits into this depressed center. The lower lip, resting on the smaller arch of the lower row of teeth, is shorter than the upper lip, and tucks itself under the latter at the corners. The lower lip is much more active than the upper lip due to its placement on the moving lower jaw.

The under lip is thicker than the upper lip. It is composed of two parts, viz., right and left lobes.[15]

The lower lip is made up of two shapes while the upper lip has three.[7]

Teeth

Seldom are teeth modeled in a sculptural portrait. If absolutely required, suggest them. Do not model them in detail.

24

Neck, Bust

Shape: Size of Neck

The neck is a column supporting the head. Treat it as a cylinder, with a slightly forward angle as it proceeds upward following the curve of the spine. The chin canopies it in front, and the back of the head (occipit bone) overhangs it. Its sides, from a front view, appear to run straight down from the "hinge" of the jaw; from the profile view it shows the forward angle. Its front has its base at the "Pit of the Neck." The seventh vertebra terminates its back.

Necks vary in their shapes; they may be short or long, small or large in circumference, weak or strong in appearance. Some necks are quite muscular looking like that of many athletes.

A child's neck is straight at birth, and is not strong enough to support the head. At that time it is quite small as compared to the size of the head, and sometimes all but completely hidden. Modeling a child's neck longer than it really is, even an inch longer, can make a child look a couple of years older. With the passing of time, the child's neck grows stronger, and the neck angles forward. Length and thickness grow with the passing of childhood and adolescence.

Model a male's neck somewhat differently than a female neck. You will note that the male neck is generally shorter and thicker than a female neck, and because of the shortened length and larger size appears to rise almost vertically from the sloping shoulders. The size of a male's shirt collar is a good indicator of his neck's circumference. A female neck is longer and slenderer, and has a more forward, graceful direction. Since the muscles in a female neck are less pronounced, it appears more cylindrical. Avoid a swan-like appearance in the female neck. The forward angle of the neck in adults is also influenced by posture.

In old age, as posture sags, or when a person is round-shouldered, the neck is inclined to angle forward more so than usual. As fat decreases in old age, flesh hangs loose, and the neck muscles will be more evident.

The neck is a column-like structure supporting the head and as much part of the portrait as the features.[7]

Neck may be small in size and height, large and muscular, long, etc.[15]

Compare the thickness of the neck with the width of the skull behind the ears. Is the neck much narrower, or is it almost as wide as the head? Consider the length, thickness and angle of the neck.[14]

Angle of the Neck

The neck is not a vertical column as it may appear to be from the front view. The profile view clearly establishes that it is set forward and upward at an angle following the curve of the spine from the seventh vertebra. Remember to set your armature in the neck as central as possible, with particular attention to the area of the "pit of the neck." You don't want the armature sticking out anywhere in the neck which is likely to happen if the angle of the neck is not taken into consideration.

Note the angle of the neck to the shoulder from the side view, as it has a great influence on the natural pose of the model. It never will be vertical.[7]

Most students make the back of the head and the neck on a straight

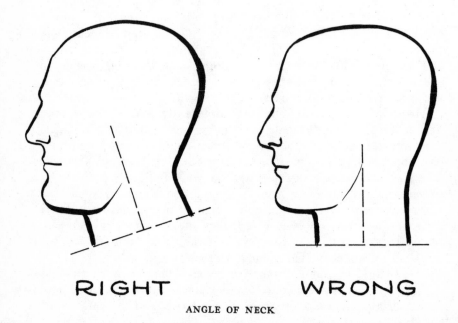

RIGHT WRONG

ANGLE OF NECK

line. This never happens. If you have studied your skull, you know it sets forward at quite an angle from the seventh cervical vertebra.[2]

With the armature set, and the image of your proposed sculpture clearly in mind (or perhaps you have a model or sketch), start building the mass of clay, keeping in mind the egg shape of the head and the angle and balance of the neck.[9]

Pose

Whichever pose is most characteristic of your sitter, you should carefully study this added element of likeness. The way your sitter holds his or her head—erect, to the side, perhaps tilted slightly upward or downward—should be noted. Care also should be taken to treat the head, neck, and shoulders as a unit, giving it a cohesiveness. If the head is set badly on the shoulders, the whole structural effect will look awkward.

Each individual has a characteristic way of holding the head—some forward, some very erect, some to one side. The characteristic pose of the head on the neck is essential to the final likeness, so before you begin to pile on clay, study this carriage of the head carefully and bend your armature accordingly.[2]

Chin As A Canopy

The chin acts as a canopy over the neck. Model the distance of the canopy of the neck from chin point to neck (No. 5 of "Sitter's Measurements" in chapter "Working from Life") to conform to sitter's dimensions.

Sterno-Mastoid Muscles

There are two broad, strap-like muscles that run from behind the ears to the "pit of the neck." These are the sterno-mastoid muscles. Each muscle divides into two in the front, one branch attaching to the sternal end of the collarbone (clavicle) and the other attaching itself to the top of the breastbone (sternum). The upper ends of the sterno-mastoid muscles attach to the mastoid bone.

The head turns by means of these two muscles; when you turn your head to the left, the right sterno-mastoid muscle stands out—when you turn your head to the right, the left sterno-mastoid muscle stands out. When either of the two muscles stand out, it dominates the form of the neck, and, therefore, the muscle's strong

form should be emphasized. Normally, when the head is not turned, emphasizing the sterno-mastoid muscles may give the neck a bony appearance. Also avoid making them look too stringy. A more pleasant effect is to round them out, blending them into the neck. In this way, the beauty of the neck is retained. The lower ends of the sterno-mastoid muscles, helping to form the "pit of the neck," terminate the neck at the front.

> They attach back of the ear and come forward and attach on the collarbones, thus forming a hollow called, usually, the pit of the throat.[2]

> Note the mastoid muscles. They come from the base of the skull behind the ears and go down to the pit of the neck. Turning the head from one side to the other will make one mastoid muscle more prominent than the other.[7]

Pit of the Neck

Together with the collarbone and the breastbone, the sternmastoid muscles form a hollow called the "pit of the neck." At this point, the neck terminates. Because of the forward and upward direction of the neck, there will be less clay or plasteline at the pit of the neck, hence care must be taken that the armature at this point be accurately placed so that it does not stick out. You must also make a fairly accurate calculation as to how high above the pit of the neck will the neck be at the chin level (No. 8 of "Sitter's Measurements" in chapter "Working from Life") which will indicate the length of the neck at front.

> On the side of the head just behind the ears are attached the mastoid muscles. They go to the breastbone and together with the collarbones form the pit of the neck.[7]

> Relatively little clay covers the armature at the pit of the neck. The armature at this part must therefore be most accurately placed.[5]

Adam's Apple (thyroid cartilage)

The "Adam's Apple" in the front of the neck is a projection formed by the thyroid-cartilage in the neck. It is more pronounced in a male's neck than in a female's. It should be expressed, but not too strongly.

> The Thyroid cartilage is smaller in women than it is in men. The Thyroid gland is larger in women than in men. Consequently in women the neck below the thyroid cartilage should be somewhat fuller in women than it is in men.[15]

Back of Neck

In a small, thin neck the back is generally concave, with the Occipital Bone overhanging it; in a large and muscular neck, it may be even with the Occipital Bone, or convex to it. The back of the neck is of shorter length than the front.

Concave behind; convex behind, or nearly even with the back of the head?[15]

Trapezius Muscle

Unlike the sterno-mastoid muscles which dominate the neck in front when the head is turned, and which is of sculptural interest to the sculptor, the trapezius muscle in the back of the neck, though it braces and gives strength to the neck and helps to control movement of the head, does not dominate the neck in back to the extent that it would greatly interest the sculptor. The muscles have a wide range; from the base of the skull it descends obliquely to cover the neck, the outer third of the two collarbones, shoulders and the upper part of the back. It is rarely shown in portraiture work, as the pose of the neck in a portrait is relaxed and the appearance of the trapezius muscle is superficial. The full effect of its appearance is found in some figure modeling where there is movement of the arms and shoulders.

Seventh Vertebra

In the neck there are seven vertebras. The first six are generally obscured by the muscles of the neck. The seventh vertebra (the lowest) is of particular interest to the sculptor because it is a projection, more or less, marking the end of the back of the neck. Though it is the lowest of the cervical (pertaining to the neck) vertebras, it is still higher than the pit of the neck in front. The relative positions of the pit of the neck and the seventh vertebra are "landmarks" in modeling the lower portion of the neck.

The seventh cervical vertebra, though lowest in neck, is still higher than the top of the sternum.[15]

From the top of sternum you will measure to the back of the neck and find the position of the seventh cervical vertebra. These are the two most important points to establish, and great care must be taken to ensure that the armature is buried centrally between them.[8]

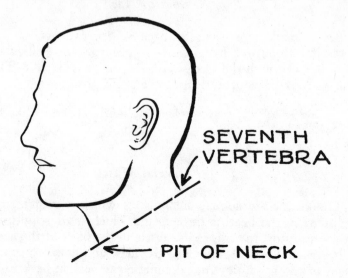

SEVENTH VERTEBRA

PIT OF NECK

SEVENTH VERTEBRA HIGHER THAN PIT OF NECK
SEVENTH VERTEBRA

The first part of the spinal column is the neck, composed of seven bones. Move your neck now. The seventh bone is the most prominent. You can feel it with your hand. This protuberance, in relation to the pit of the neck, places the position of the neck in relation to the shoulders. When viewing the figure from the side, the protruding bone is higher than the pit of the neck. Students are likely to slight these relative positions and thus lose a sense of the tremendous mobility of the neck.[5]

Bust

A bust for sculptural purposes may be defined as the upper part of a human body—between neck and waist. The outer forms of the bust which holds the sculptor's interest are (a) the breastbone (sternum) and the collarbones (clavicles) which, together with the neck's sterno-mastoid muscles, form the "pit of the neck" (b) the shoulders, and the shoulder blades (scapulas). Ribs are not generally over-emphasized when modeling a portrait bust in the nude unless some physical or athletic effects are intended. The termination of the portrait bust for sculptural purposes may be

at any point dictated by specific needs and good taste—what best complements the portrait as a whole. It may be half-shouldered, or full-shouldered. It may include the arms from shoulder to some point above the elbow, or the arms may be folded or arranged in some desired position. It may be in the nude, or clothed. Clothing may dictate its termination. Its base may be on the same level all around, irregular as often seen, or the rear of the base higher than in the front. A plinth may be needed, and its type and size best suited to the portrait bust, must be considered.

Breastbone (Sternum)

The breastbone is an elongated, flat, dagger-shaped bone, running down the front center of the chest. Its top has a shallow concavity which, together with the sternal ends of the collarbones and the neck's sterno-mastoid muscles, forms the "pit of the neck." Here is where the neck slopes upward and forward, and the chest begins its downward oblique angle. The area of the pit of the neck where the breastbone, the collarbones, and the sterno-mastoid muscles meet is of special interest to the sculptor because of its relationship to the neck and shoulders, and for a well-balanced bust construction. The first seven pairs of ribs are directly attached to the breastbone, the next lower three pairs are attached indirectly, and the lowest two pairs are unattached.

Collarbones (Clavicles)

The collarbones are two in number extending horizontally more or less across the top of the chest. Their sternal ends join the breastbone (sternum) at the front below the "pit of the neck," and the shoulder blades in back by muscular attachment. They have somewhat of an elongated "S" shape, its outer curve being concave forwards and its inner curve being convex forwards. The collarbones, together with the shoulder blades, form the shoulder girdle for its mobility. The collarbones are of interest to the sculptor for the appearance they give to the area between the neck and top of the chest.

Shoulder Blades (Scapulas)

They are two in number, flat and triangular in shape, with the base upward and the apex down. A projecting ridge on the inside known as the "spine of the scapula" runs obliquely from the top

of the inner border of the shoulder blade to the shoulder where it hooks on through muscular attachment to form the shoulder's cap. The blades have elasticity to permit free movement of the arms. While much of the shoulder blade is hidden by muscles, the upper portion or projecting ridge ("spine of the scapula"), and the inner border (the side toward the vertebra) are visible, and strongly influences the appearance of the back. In modeling the shoulder blades, give effect to the valley between them.

Shoulders

The shoulders are the side projecting upper parts of the bust formed by the bones and muscles where the arm joins the trunk. They project beyond the sides of the body. They have a variety of movement, in fact, the movements are almost unrestrained. The shoulders of a female are narrower than that of a male. The slope of the neck and shoulders of your sitter should be studied for individual appearance.

Nose

Characteristics

The nose is a distinguishing feature that gives authority to a portrait. If the nose is wrong, you will never get a likeness. Modeling it accurately will help considerably in getting the likeness. In this one feature are found differences in the races, marked family resemblance, even occupations such as the pugilist.

The most immobile and yet the most characterful feature of the face is the nose. Here is seen ancestry, nationality and individuality.[2]

It is important to concentrate on the difference that makes the particular nose individual and the proportions that give it individual expression.[13]

Shape

The nose is a triangular, wedge-shaped form rising from the planes of the cheeks. Its basic structure in all people is the same; notwithstanding, the variations are many.

Two nasal bones form the upper bony structure of the nose. This bony structure or bridge is narrow and depressed at the top (root of the nose where eyeglasses rest), and in its downward extension becomes wider and more prominent. The bone structure narrows a bit at its lowest level as it enters the cartilaginous portion of the nose, the latter consisting of the flaring wings, the ball or tip, and the septum cartilage which joins the upper lip to form the nostril cavities. The cartilaginous portion is quite movable.

The buttress-like sides or planes of the nose blend into the cheeks. The angle to the cheeks varies with individuals, and from these widths between the cheeks, sizes and shapes of noses run from the high to the low in projection, thin to wide, small to large—noses that are straight, concave or convex.

The side planes of the nose at the level of eye corners should be noted and carefully modeled so that the position and depth of

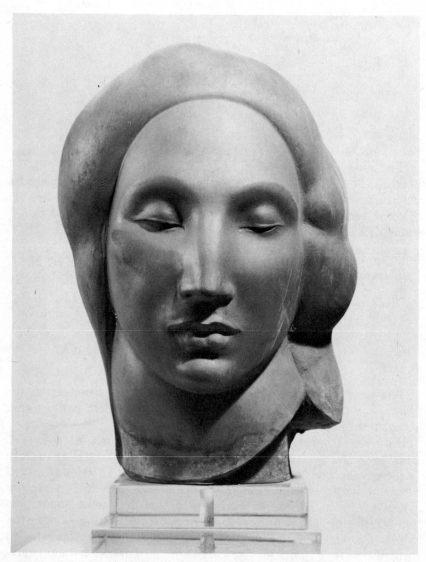

HEAD OF A WOMAN, by Gaston Lachaise (1882–1935). *Collection of Whitney Museum of American Art, New York. Bequest of Mrs. Sam A. Lewisohn.*

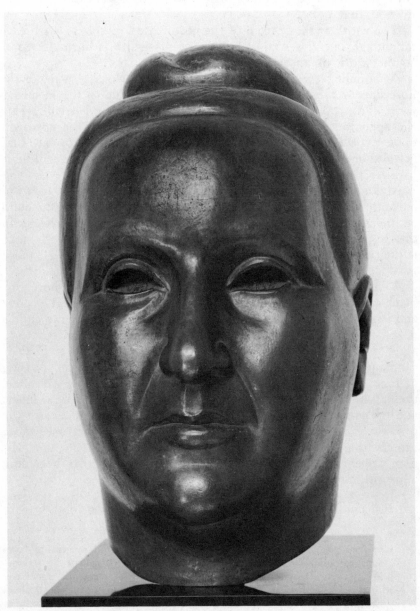

GERTRUDE STEIN, by Jacques Lipchitz. *Courtesy of the Louvre (Musees Nationaux), Paris. Photograph by Service De Documentation Photographique De La Reunion Des Musees Nationaux, Paris.*

the eyes are as correct as possible in relation to the top of the nose at that point.

The width at the bottom of the nose varies, of course, with each individual, but in a well-ordered face, its width is normally equal to the width of an eye.

A modeling error, particularly with the novice, is to make the nose appear too short or too long, generally due to the misplacement of the eye position. If the latter is set too low, it will create the appearance of a short nose; if placed too high, the nose will appear too long. I repeat: model the nose carefully, for one that is too short or too long involves much correction, for you will have to alter the forms of the mouth, cheeks, etc.

Make sure that your cheeks have been built up evenly forward on both sides of the face before modeling the nose. If you build up the nose before you have correctly established the cheeks in this respect, you may be building a dividing wall that will make it difficult to see that you inadvertently built up one cheek more forward on the face than the other.

A young child's nose is small—the so-called "button-nose" or "stub-nose," mostly made up of small tip and nostrils. It is low, and its sides are more rounded than angular. As a rule, the child's nose is turned up, with its nostrils opening forward; as the child ages, the nose straightens out. The bridge of the child at birth is cartilage—it has not yet developed into bone. With the passing of time, the bridge becomes bone and more prominent. In a female, the nasal bones are less prominent than in a male, the nose thinner, and the nose tip somewhat more uptilted than in the male. In the growth of a female head, the length of the nose increases more rapidly than its height. As the adult advances into old age, the nose appears to turn down, with the tip and nostrils becoming more prominent.

Build up the side planes of the nose—take note of the width between them.[1]

Consider the nose as a block—an oblong or a pyramid projecting from the flat or rounded plane of the face. Study the structure of the nose— how it rises from between the brows, from the cheeks, from the upper lip. Notice the form where the bone rises at the bridge and where the muscles are attached. Observe the structure around the nostrils and the tip. Note where the different planes meet. Every nose, every feature, is different but the basic construction is universal. The basic construction must receive your first attention.[13]

Position

Nose base level in an adult is approximately one-third or more

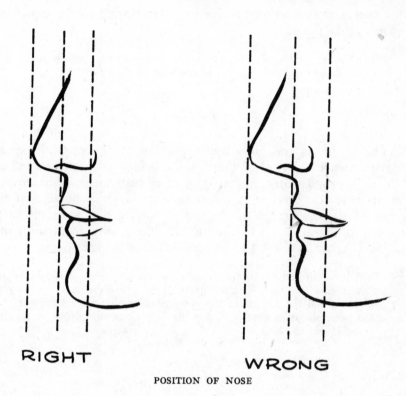

RIGHT WRONG

POSITION OF NOSE

down from the median level to chin level. Some nose base levels
can be as much as halfway between the median and chin levels.
Nose length of sitter is the governing distance, not the length con-
forming to any ideal type of beauty. The nose base level of chil-
dren vary according to age. Since the upper lip grows from the
middle of the nose (halfway between the tip and rear of wing),
the nose is set back in the face as much as it extends from it. If
the nose is set too far forward of the upper lip, it will appear
as if it were stuck on the face.

Root

The root of the nose is the narrow, depressed top portion of
the bridge, where eyeglasses rest. The plane of the forehead at
that point drops inward to the root of the nose. Widths of the
root of the nose varies with individuals; depths are influenced by
the projection of the forehead. It is most important that its side
planes be modeled accurately so that the position and depth of

the eyes is as correct as possible in their relation to the top of the nose at that point.

The "root" of the nose is where the bridge of the glasses rest. Note the drop from the forehead line to the root of the nose.[14]

Bridge

The bridge is the bony upper portion of the nose. From its narrow, depressed root at the top, the bridge in its downward extension becomes wider, higher, and more prominent. It narrows a bit at its lowest level as it enters the cartilaginous portion of the nose. Model the bridge of the nose amply, giving sufficient space for the ridge on top, and the buttress-like planes from the ridge to the cheeks. Avoid a skimpy, pinched-like bridge.

Model the bridge of the nose with the most careful attention to the receding planes at each side, more particularly where the junction between these planes and the sockets of the eyes occur, so that the corners of each eye has been placed as exactly as possible in position and depth in relation to the bridge of the nose.[1]

Tip

The ball or tip of the nose is many shaped, from the small and delicate one to the bulbous. It rises from the middle of the upper lip at the septum and extends to the bony structure, flaring out to the sides to form the wings. Its forward projection from the cheeks must be considered. Remember, the nose is set back in the face as much as it extends from it. The tip is cartilaginous as you can see from bending or twisting it. Both frontal and profile views should be convincingly modeled. A slight vertical valley is sometimes noted in the lower middle area.

Underside, Septum

The underside of the nose from the tip to the lip juncture is generally not seen in its fullness, unless there is an upward incline to its shape—a "turned-up" nose, as it were—or when the head is tilted back. The septum juncture with the upper lip is a slight curve, not a sharp angle. Check the underside from the underneath view as you model. Correct eye-level and underneath views are both needed to establish the likeness of the nose. The septum or dividing wall between the two nostrils is a cartilage. Its lower

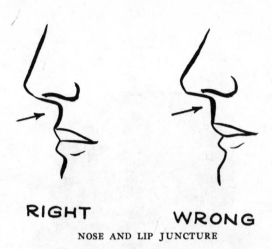

RIGHT WRONG

NOSE AND LIP JUNCTURE

portion should be on a level slightly below the bottom of the wings to permit a little of the lower portion of the nostrils to be seen, especially in profile. The septum should not be modeled too wide, otherwise the nostrils will be too far from the center line.

Note the underplane of the nose and the angle at which it juts out from the face.[14]

The shape of the nose as seen from below gives an unmistakable expression to the face, and the way the upper lip fits into the valley which surrounds the nostrils is a subtle detail which should not be overlooked.[6]

There is a tendency with beginners to make the nostrils just two holes in a flat shape underneath the nose. Notice that from the front view the cartilage dividing the two nostrils is much lower than the wings of the nose, otherwise very little of the nostril could be seen from the profile.[7]

The septum is a narrow strip of cartilage which runs inward to the upper lip. The juncture with the lip is not a sharp angle, but a gentle curve.[4]

Nostrils

Nostrils have many shapes, more or less oval or pear-shaped. They are not round. Their axis may be horizontal, or have an upward or downward angle from the septum. Observe them carefully as their size and shape will influence your modeling of the underside and projection of the nose, and the shape of the wings. It is important not to model the cavities too deep, for unnecessary depth creates unwanted shadow.

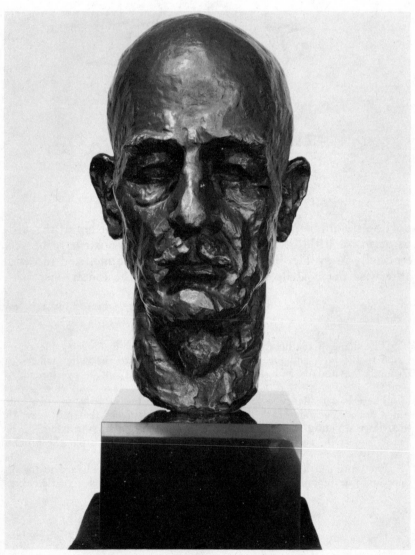

R. STURGIS INGERSOLL, by Jacques Lipchitz. *Philadelphia Museum of Art.*

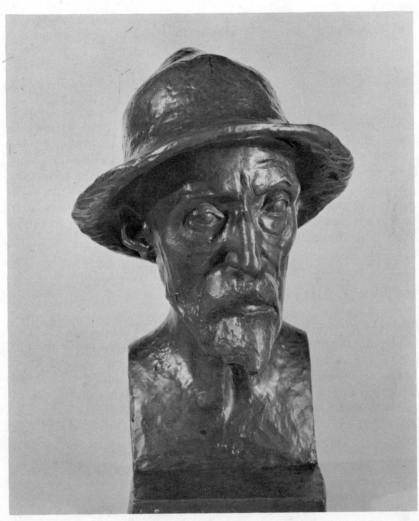

RENOIR, by Aristide Maillol (1861–1944). *The Metropolitan Museum of Art, Edith Perry Chapman Fund; from the Museum of Modern Art, gift of Mrs. Cornelius J. Sullivan, in memory of Cornelius J. Sullivan.*

Do not make the cavities of the nostrils too deep. This will create dark cavities that you do not see in a flesh-and-bone head, for the flesh is relatively transparent. Clay is dense. So with a much shallower indentation, you will achieve the proper amount of shadow or color.[5]

The shape of the nostrils, how they flare, is important to observe, and the ridge between the nostrils, whether it is thin or wide, defines the shape of the nostrils. Watch this form carefully from below.[2]

Wings

The wings of the nose and the shape of the nostrils bear a relation to each other. Wings flare out in varying sizes, and their axis can be horizontal, upward or downward. Wings can be flat or puffy. Their shapes have a wide range, from almond-shape to triangular. Wings give a strong touch to the individuality of the nose. The depth of the sides of the wings where they meet the cheeks adds its part to the shape of the wings, adding that much more to the individuality of the nose.

Is wing elevated or depressed, narrow or large?[15]

Profile

The correct angle of the nose in profile is essential to the ultimate likeness of the face. In viewing your work from profile, check on the relationship of the bridge of the nose and the forehead, particularly the angle. These are fixed, bony points that make excellent guidelines to establish the facial angle of the face. The angle of the nose and the angle of the ear generally parallel each other.

Assess the angle which the profile of the nose marks from the brow between the eyebrows and the tip of the nose.[1]

26

Drapery, Clothing

Sculptural Value

Drapery and clothing are very much a part of sculpture. They have their own esthetic value. They have been designed and used in sculpture since the beginning of man's attempt to portray life about him.

Their sculptural value to the portrait bust lies in how convincing they are in their own right—how much they are treated as a separate form superimposed on the body beneath them—how much they contribute to the composition as a whole—how much they enhance the sculptural piece.

When we here speak of drapery, we refer to the loose or flowing coverings, from fashions in the biblical and Grecian periods, and other ancient times, down through the years to the present time; when we here speak of clothing, we refer to raiments in general (not the loose or flowing variety) worn in past and present, and which, most likely, will be worn by the person who will be your sitter for a portrait bust. You will, in all likelihood, be covering the bust with present-day garb; in uniform, some other special attire, or clothing in general use. The aspiring sculptor should, therefore, have a definite knowledge of drapery, and of clothing which is another form of drapery. In cooperation with the sitter, you must choose attire best suited for the portrait bust, and one that will contribute to the composition as a whole—one that will enhance the sculptural piece. You should also give thought to the permanence of your work which requires avoidance of any extreme fashion in garb that would become incongruous at some future time.

In providing basic information on the use of drapery or clothing, stress will be laid on giving the reader a simple understanding of the characteristics of such covering—to make the bust's outer effects as convincing as possible. Styles and fashions change with times, but the basic principles of drapery and clothing arrangements remain.

Drapery forms a vital part in sculpture. It gives solidity to the figure, rhythm to the design, it gives motion.[2]

You have probably visualized your idea clothed. Clothes are natural to us. Our kind of clothes. Some ham sculptors have a notion that only Greek togas make good sculpture. Anything can make good sculpture.[5]

Drapery has its own laws and principles which must be studied and thoroughly understood before the student tackles it; he must not start with the idea that any lines modeled over the nude in vague folds and directions may serve to represent drapery. When the nude figure is completed and well suggested in all its contours and planes, the lines of the drapery which you superimpose on the figure must be carefully chosen to accentuate just what you wish to emphasize in the pose of the figure. You must select the main theme line of the drapery and then design the less important folds to compose with this main theme.[6]

Different Materials, Different Folds

Assuming you wish to clothe your portrait bust, your sitter and you have a wide range of materials to choose from—for the material, and type and style of clothing, will be influenced by geographic location, climate, season, time of day, social and sports activities, etc. All kinds of materials are used for clothing—cotton, muslin, wool, velvet, flannel, satin, silk, etc. . . . any one of them can make good sculpture. The sculptor should have a knowledge of the material's texture and weight, for each fabric produces folds of distinctive character, with the direction or movement of fold influenced by the material. Heavy materials will make thick oval folds, slow in movement, and fewer in number than folds made by lighter materials; lighter materials make fine or more delicate folds that are more angular in shape, swift in movement, and in greater numbers than folds made by heavier materials.

You will find that different materials make very different folds. Folds of silk come to sharp points, folds of wool or velvet or a heavy material fall in rounded forms.[2]

Every material may be suggested by different treatment in the modeling. The depths of the folds differ, and the actual design made by the heavy or light materials have a wide variety of possibilities.[6]

Essential Folds

Only folds that lend themselves to sculptural enhancement should be used. This means that unessential folds, and vague and

unneeded smaller folds and creases, should be eliminated. What to leave out is just as important as what to put in. This gives simplicity to your design. Utter simplicity—by using only those folds that are essential—in fact any detail that is simplified—gives better sculptural effects. You will be enriching the garment which, in turn, will enhance the portrait. An otherwise good portrait can be spoiled by the improper handling of a clothed bust.

The folds of the front and back, and from profile view, must be joined, and look well from every point of view. Remember, that the inner part of a fold needs as much care in modeling as the more visible parts. When modeling, begin by laying on small amounts of clay or plasteline, adding to it small quantities until the proper shape is obtained. It is much easier to build up in small quantities, rather than scrape away excess of clay or plasteline thereby distorting shape and arrangement of folds.

Have in mind that the bigger and broader the area, quite devoid of detail, the more effective will be the few folds employed. It will be usually found that the great majority of folds can be dispensed with entirely by a careful readjustment of the principle ones. The fewer folds employed, the more effective will be the result.[8]

You want to simplify details; don't get them overworked and fussy. A fold in the clothes can stress the direction of a plane and emphasize the emotional quality of the work. Perhaps a shoulder is raised, indicating pride. The line of the drapery can help make the gesture more decisive. Don't forget the spiral within the small parts reaching out toward the larger ones.[5]

Suspension and Radiation of Folds

In the arrangement of drapery or clothing, there is a general direction or movement that the fold takes. The direction or movement generally has more than one source of suspension or starting point depending upon arrangement, fixed points of support, or pose or action . . . particularly in the figure. Each suspension or starting point becomes a center of radiation for the folds. In raiments for a portrait bust, the main centers of radiation for folds are inside of a bent elbow and the areas of the shoulder and armpit. It is from the "eye" of these starting points that the direction or movement of the folds takes place. Its extension may meet with a fold from another "eye" and die away; other folds terminate abruptly. Folds seldom parallel each other since space widens between them as they move away from their suspension or starting point. The number of times a garment is worn may add more folds.

The grace, rhythm, and harmony of folds, and their relation to each other in the arrangement, are a matter of artistic feeling,

FOLDS

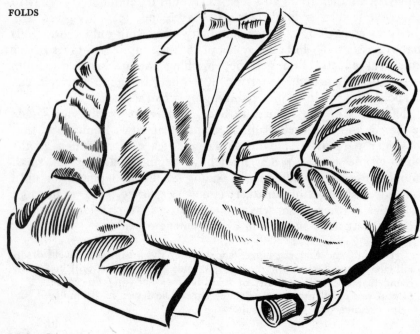

Male Garment

Female Garment

and must be sought for by the sculptor. Avoid modeling false directions of folds, for they are not only unrealistic but distort the underneath body form as well. Avoid folds of equal size which would make for sameness and monotony. Difference in volume of folds provides a variety of light and shadow, and adds "color" to the arrangement. Do not crowd folds—remember that there must be plain surfaces between them, and in surrounding areas. These plain surfaces are areas of rest for the eyes, without which the full value of the folds would be lost.

Folds take shape in a variety of ways—curved, straight, V-shaped, spiral, drop, zigzag, etc.—each playing its individual role in the arrangement. More than one formation of folds will be found necessary for effective arrangement; to use only one formation would indeed make the drapery or clothing monotonous, dull and uninteresting.

> It is important to locate the main points on the figure from which the drapery hangs. It is from these that the folds take their direction, and when studying which group of folds is to be the most important, it is wise to eliminate all others, which in most cases merely confuse or destroy the main structure of the design. If the artist succeeds in suggesting drapery with a few fundamental lines, the effect is always more convincing, and the simple surfaces between the folds rest the eye and give emphasis to the groups of separated folds.[6]

> In almost every draped figure there are (a) definite areas of suspension from which the drapery hangs vertically (b) groupings formed by the bending of a limb, etc., from which the folds radiate from a common point. The synchronization of these two groups of folds, broadly speaking, represent the sculptural anatomy of drapery.[8]

Natural Action

Model the coverings in the same manner in which one puts them on in dressing. By modeling in this manner, each layer of clothing will overlap in natural succession. In providing clothing for a bust, select simple garments. Be careful that they hang naturally. Model garments while worn during the working session, not later when your sitter is away. Articles of clothing when worn create their own particular folds—different from the folds made when unworn, or when hanging. You will find that the folds of the two arm sleeves are rarely the same, particularly if elbows are bent somewhat differently. A garment placed over the body should follow the body form. It is superimposed on the body form, and therefore should be modeled to fit *over* the body. A collar, for example, should be modeled to fit over the neck, and not to appear as if it had been cut into the neck. It seems superfluous to

make this statement, but novices so frequently fail to distinguish this obvious point. Of course, natural action is rhythm action as well, for the laws of rhythm play a distinct part in folds, as rhythm does in all forms of sculpture.

> Avoid realism to extent of exact reproduction. You can best suggest the nature of the draped material by its natural action rather than by a simulation of the texture itself.[12]

Cutting Below Surface

Depths of folds differ. Avoid cutting recessions too deeply, for you may be cutting into the body surface. Remember that drapery or clothing is superimposed on the body surface, so there is no excuse for cutting into it. This is a tendency with the learner. Remember, too, that drapery or clothing must not in any way change or distort the body form underneath; rather, it must complement and enhance the body.

> In modeling drapery on a form, do not cut so deeply that you cut into the form. Remember, drapery is superimposed on the form.[2]

> Folds must never suggest that any line of the drapery has been cut into the actual surface of the form.[6]

> Avoid cutting into the big forms you have established. This is a student's tendency. You have established the big plane of an arm area, for example. Don't let folds of drapery cut into the arm itself, for the arm plus its drapery have determined the volume of this area.[5]

Color

The patterns of light and shadow in sculpture are referred to as "color." The color in sculpture then is a matter of plane organization to reflect shades of light and shadow. In drapery or clothing, color is achieved when the folds are so developed that their projections and recessions reflect light and shadow in varying degrees—when the fold's high points gleam and shadows settle in their recessions, and when the surrounding flat areas reflect inbetween tones of light and shade. The feeling of cloth, and the appearance of its lightness and heaviness, can also be realized when the folds are skillfully modeled.

> Fill in the hollows between the folds according to their required depth, emphasizing the "color" and interest in one area only, and subordinating everything else to this principle spot of interest.[8]

Textural Efforts

Any number of handy devices in addition to modeling tools, some homemade, can be effectively used to create textural effects, and it can be fun to give full play to the imagination. However, all that is needed texture-wise to give good effect to sculpture is to give the garment a realistic appearance of cloth to distinguish it from the skin of the body. Again, a reminder to keep drapery or clothing as simple as possible, and as a means to enhance the portrait.

To differentiate between flesh and drapery, it is sometimes interesting to use a different finishing technique—to let tool marks remain on drapery gives a little roughness to the surface which can make a slight contrast with the smoothness of the handling of the flesh.[2]

Even though you may vary texture somewhat to aid in simulating realism, an excessive use of varying textures cheapens and weakens the large sculptural quality to be obtained by simplicity.[12]

27

Plaster Casting by "Waste Mold"

Purpose of Casting

The process of transferring a model of moist clay or plasteline (since both of these substances are fragile) into a relatively durable plaster cast is known as casting. This intermediate step is necessary for the final casting from the plaster cast to the metal bronze. All kinds of casting have the same principle: a negative (female) mold is made over the original moist clay or plasteline form, the clay or plasteline is removed, and into the negative mold the casting plaster of Paris is poured or inserted to make a positive (male) cast.

Casting for the Aspiring Sculptor

While the making of a mold and the casting of the positive cast is an integral part of sculpturing, and a knowledge of these processes gives the sculptor a broader range for his sculptural expression, and helps to control his work to the ultimate end, the beginner, amateur, and student is much better off not to do his own casting. Casting for the novice could result in a great deal of discouragement should he lose his first efforts. It would be wiser to turn over his first pieces to a professional caster until he is well versed in the casting procedures. However, should the aspiring sculptor choose to do his own casting, the instructions here will lead him to a basic understanding of the subject. The beginner, amateur, and student may find it advisable at first to use self-hardening clay which does not need casting (*see* chapter on "Clay-Self-Hardening). Most non-professional sculptors, and many professional sculptors, most frequently use professional casters to cast their clay and plasteline models into the intermediate plaster state.

Tools and Materials

Basin: bowl
 —for mixing the plaster.

Bluing
 —ordinary bluing to color mixture of plaster for mold's first coat.

Brush
 —for wetting down clay form with water before application of mold's first coat; for application of clay water (*see* "Clay Water" below) ; for clearing away clay after opening the mold; for applying, and clearing out soap lather when cleansing the mold.

Burlap
 —for sealing seam of mold's two sections when reassembling the mold; for binding cord and reinforcing irons to strengthen reassembled mold; for strengthening positive cast at weak points like neck and at base. (Jute and Plaster Fibre can also be used.)

Chisel
 —for opening of mold; for chipping away mold.

Clay
 —a lump of clay to clear away bits of clay after opening mold; lump of clay to seal any leak while pouring plaster for positive cast.

Clay Water
 —a mixture of a bit of clay and water to prevent adhesion of mold's first and second coats.

Cloths
 —cloths, soft material, or old carpet under base to prevent shock while chipping away mold.

Cord
 —for tying up the two sections when reassembling the mold.

Cup
 —to mix small quantities of plaster.

Flit Gun
 —for wetting down clay form with water before application of mold's first coat (instead of brush or sponge).

Glass: Jar
—for water to be poured into cracks of mold to facilitate its opening.

Knife
—to draw a line on clay form for the dividing wall; to scrape edges of the dividing wall; to insert into cracks to pry mold loose from the clay form; to scrape off excess plaster from base when making positive cast.

Mallet: Light Hammer
—for opening mold; for chipping away mold.

Modeling Tool
—any suitable tool to scoop out clay from front section of mold after its opening; any pointed modeling tool to clear out clay from undercuts.

Newspapers
—as a protective covering for floor, walls, etc., to prevent damage by plaster.

Olive Oil
—for the coating of pail, basin and bowl to facilitate cleaning; for the coating of shims; an alternative to clay water to prevent adhesion of mold's first and second coats; a final release agent or separator after cleaning of mold to prevent bond between mold and the fresh plaster poured for the positive cast.

Pail: Carton
—for discarded plaster.

Plasteline
—bit of plasteline to hold shims together; a lump of plasteline to remove small bits of plasteline if sculptural piece is made up of this material.

Plaster of Paris
—for the making of the negative mold; for the making of the positive cast; for making repairs to cast.

Reinforcing Irons
—placed on mold before second coat sets to strengthen the mold, and to prevent its cracking or breaking.

Rubber Ball
—for mixing small quantities of plaster instead of use of cup.

Sandpaper

—for removing any projection of plaster on inside edges of mold; for repairing cast.

Scissors

—for the cutting of brass sheeting to make shims.

Shims

—for making the dividing wall (fence) on mold between front and back sections to facilitate removal of the sections, and to provide a snug fit for reassembly of the two sections.

Soap

—Tincture of Green soap, or ordinary soap, for the cleansing of the mold after sections are opened.

Sponge

—an alternative for wetting down clay form with water before application of the mold's first coat (instead of brush or flit gun); for clearing away clay after opening mold (instead of brush); for applying, and clearing away soap lather when cleansing the mold (instead of brush); for washing dirty casts after soaking.

Stick

—to tighten cord around mold when reassembling the two sections.

Tablespoon

—for stirring plaster in basin or bowl; to hold plaster when mixing small quantities of "killed" plaster.

Water

—moderated to room temperature for mix with Plaster of Paris; for pouring into cracks of mold to facilitate its opening; hot water as an "accelerator" to hasten setting of plaster; hot water for mixing soap for lather when cleansing mold; cold water as a "retarder" for slowing setting of plaster; running water to wash away bits of clay for the cleansing of inside surfaces of mold.

Preparation

Plaster casting is a messy job at best, and it is unlikely that you will want to do it in the house where floor and walls can be splattered, and rugs and furniture damaged. The garage is the best place for casting, particularly if your garage has running water. Moist newspapers which stay put, several sheets thick, should be

MY GRANDDAUGHTER ISABEL NATTI, by Paul Manship (1885–
1966). *Courtesy of John Manship, New York.*

JAMES A. FARLEY, by Paul Manship (1885–1966). *Courtesy of John Manship, New York.*

placed on the sides of the modeling stand if one is used, on the table or stand if one is used, on the floor over a sizeable area, and on the walking path to the source of water. It is well to have all the tools and materials for casting available on a nearby table or stand, first covering the table or stand with the moist newspapers. A lined carton or a pail, or any other type of container, should be available for discarded plaster.

Waste Mold

This chapter deals with only one kind of mold—the "Waste Mold." The mold is made up of plaster of Paris, and its function is to hold the shape of the moist clay or plasteline form you modeled, so that a plaster cast can be made from it. After the Waste Mold hardens, the clay or plasteline is removed, and the fresh plaster of Paris is poured into it to make the positive cast which is an exact duplicate of the original clay or plasteline form. When the cast in turn hardens, the mold is chipped away and becomes waste. It is this waste that gives the mold its name "Waste Mold." Only one cast is possible by the Waste Mold method. Casting in plaster by the Waste Mold method is the simplest of the molding processes, and is generally used. The aspiring sculptor would do well to stick to this method (assuming he has the will to do his own casting) which, in itself, is quite an accomplishment. Other methods of casting—piece mold, rubber mold, gelatine mold, etc.—should be left to the professional caster. A Waste Mold may be laid aside if upon its completion the pouring of the plaster for the positive cast is not convenient at that time. It is to be remembered that plaster that has set and dried will absorb moisture from the fresh plaster intended for the positive cast, hence it is necessary for the dried out mold, before using, be soaked in water until it absorbs all the water it will take. Bubbling will cease when the mold is thoroughly soaked. Wash with a soft moist sponge after soaking if the mold became dirty during its set-aside period.

Moisten Clay

There are a number of reasons why clay should remain moist: it is assumed (1) that during modeling you found it advisable to keep the clay form moist for convenience of modeling, (2) that you are aware that the clay form needs to be kept moist to dig it out of the mold, (3) that you are aware that hardened clay adds difficulties when making the mold, for shims cannot be readily

pushed into the hard clay form to make the dividing wall, (4) that
the mold frequently cracks or breaks if it must be removed from
any hardened clay form, (5) that it is also advisable to fine-
spray clean water over the clay form before applying the mold's
first coat of blue colored plaster. This additional moisture will
prevent the clay from absorbing the moisture of the mold's fresh
plaster, as would be the case if the clay form was dry. (6) the
additional moisture by fine spraying will also help to prevent air
bubbles in the mold, and (7) it will also act as a mild separator
between clay and plaster. It is interesting to note that the portrait
bust illustrated in this chapter had to be broken up while clearing
it from the Waste Mold because of its hardness.

Dividing Wall (Fence)

The waste mold should be made in two sections. A dividing
wall (fence) is necessary so that the mold can be more readily
removed from the clay or plasteline form. Thin-gauge brass or
copper shims, suitable for making a dividing wall, are available
in most art supply stores. One alternative is ordinary thin tin,
which should be avoided if at all possible as tin rusts and stains
the mold. The dividing wall or fence runs from the baseboard
at one side of the form, over the head, and down the other side
to the baseboard, just behind the ears. It would be well to draw a
line for the dividing wall with a knife blade before inserting the
shims, for a straight, even line is essential. Most casters prefer
the shims back of the ears to facilitate the removal of the back
section. It is, obviously, much easier to remove the back section
with no ears or any other projection, or an undercut (that part
of the form so shaped that it prevents the easy removal of the
mold) to prevent pulling the back section away. The dividing wall
back of the ears also helps to eliminate from the front view any
trace of the dividing line or seam which may show a little on the
finished plaster cast. Other casters place the dividing wall in front
of the ears, finding it more convenient to leave the ears as a part
of the back section. In either case, the section with the projections
and undercuts needs more care in its removal from the form to
avoid damaging any of the details in that section. Each caster must
decide for himself where the dividing wall goes, bearing in mind
that you are seeking the best possible way to keep each of the
two sections intact, to conveniently clean and soap each section,
to secure an accurate fit for the reassembling of the two sections,
and for the pouring of the positive cast. It is important to make
keys or markers in the dividing wall as a guide to assure accurate
reassembly of the two sections. Bending three or four shims around

Front view of the Eugene Ormandy portrait bust showing shims for dividing wall. Note the clean edges, with each shim flat against the next one on an even line. Shims were made out of an ordinary, aluminum pie plate. Portrait bust was made from self-hardening clay which was air-dried hard before plaster casting. It had also been colored ("patined") before casting. Because of its hardness, it had to be broken up while clearing it from the Waste Mold.

a pencil makes a key shape for a perfect register, and for the exact locating of one point to another when reassembling the two sections. A conical impression, a scooped depression, or "V" notches at three or four points in the dividing wall for keys or markers should be equally effective in forming registration points for accurate fit when reassembling the two sections.

Shims (shape, size, fit)

Shims should be coated with olive oil, and the oil then wiped off before insertion into the form. They should be set into the clay or plasteline deeply enough to be firm, overlapping each other slightly to make an even and continuous dividing wall along the drawn line just behind the ears from the base of one side, over the head, to the base on the opposite side. Cut metal sheeting with a scissors in width 1" to 1½" wide, 2" deep, tapered inward or curved, to expedite insertion into the clay or plasteline where each best fits the curves of the form. Set them uniformly along the drawn line—if uneven, they may produce undercuts between the two sections. The tops of the shims should be even, unjagged. To help hold the shims together, squeeze small balls of plasteline to the tops. Set shims about ½ into the form, with about ½ projecting out of it. Carefully done, you should have an excellent dividing wall, not only to guide the removal of the mold from the clay or plasteline form, but an accurate edge for easy reassembly of the two sections.

SHIMS

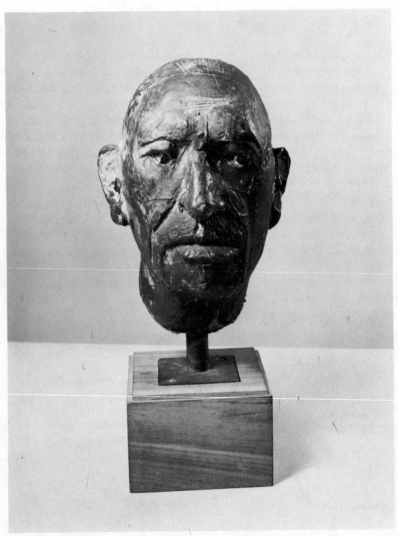

STRAVINSKY, by Marino Marini. *San Francisco Museum of Art, Gift of Mr. and Mrs. W. A. Haas.*

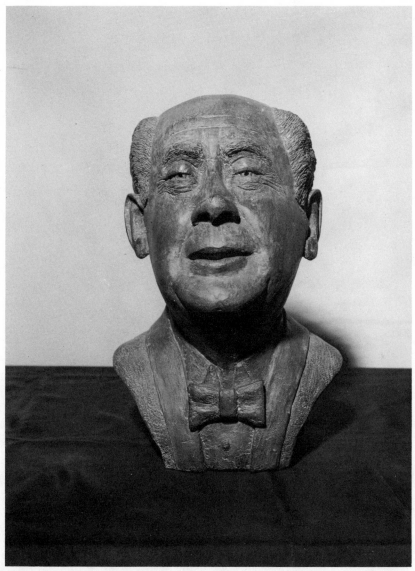

EUGENE ORMANDY, THE MAESTRO (front view), by Louis E. Marrits. *Courtesy of the Author.*

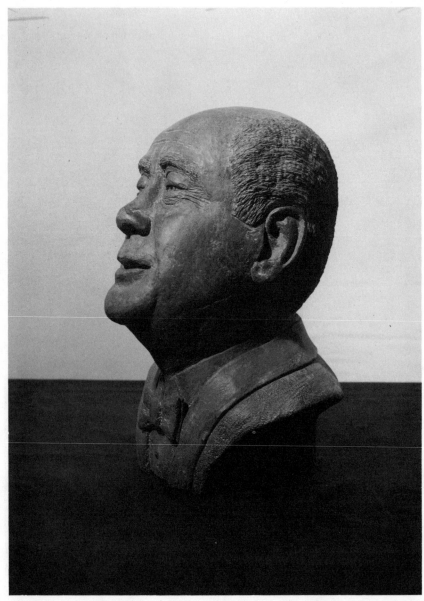

EUGENE ORMANDY, THE MAESTRO (side view), by Louis E. Marrits. *Courtesy of the Author.*

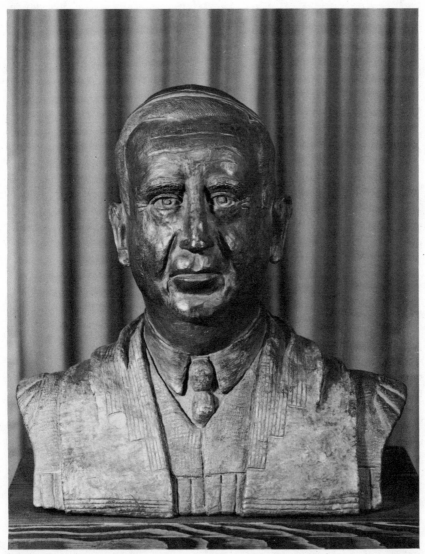

RABBI ELIAS CHARRY, by Louis E. Marrits. *Courtesy of the Author.*

Plaster of Paris

Gypsum is a solid mass, crystalline in nature. It is mined or quarried from underground deposits found in many parts of the world. There are gypsum deposits in the environs of Paris, France, and where "plaster of Paris" gets its name. It is from this parent mineral that plaster of Paris is manufactured by partial calcination or dehydration through heating the gypsum, then it is crushed and finally ground to make the plaster. The finer grained plaster of Paris is preferred for sculpture as it produces smoother and better detailed casts. Reliable art supply stores generally carry a good grade of plaster of Paris for sculpturing purposes which should set properly. Some professional sculptors, however, take the precaution to mix a small quantity of it to see how well it sets, and how long it takes to set. Obviously, poor plaster of Paris that does not set properly can ruin a cast.

When the powdered plaster of Paris is made creamy in consistency through mixing it with water, it recovers the approximately 75% of water the gypsum lost during its partial calcination. When the plaster of Paris sets into a solid mass, it has substantially the same composition as the original gypsum.

Things to remember when making mixture

1. You add plaster to the water, not the water to the plaster.

2. Use clean drinking water—water from the faucet is generally satisfactory. Plaster of Paris is at its highest solubility when mixed with water at room temperature. Setting time for a normal mix (about one-half hour) appears sufficient for most sculptors, however, some sculptors find it useful to use cold water to retard the setting time which gives them a little more leisure to work and check on the other details of the moment. There are a number of "accelerators" and "retarders" for hastening or delaying setting time, the simplest of which is hot water for hastening the setting, and cold water which is the least harmful and safest retarding agent to use.

3. Plaster of Paris should be sifted through the fingers, scattering the plaster uniformly over the entire surface of the water. Obviously, larger quantities should not be dropped into the water as you will have a lumpy mixture.

4. *Normal mix:* A normal mix—normal in terms of plaster-to-water ratio—is just enough plaster that the water can absorb (sink into the water). Just as soon as all the plaster becomes wet, and no island or mound piles up to suggest that the water cannot absorb any more plaster (a matter of about two minutes), you have a normal mix. A normal mix is generally achieved, to be exact, when, in volume, water is about two-thirds of the desired volume of mixed plaster; in weight, a plaster-to-water ratio is

the use of one pound seven ounces of plaster to one pound of water, or relative proportions thereof. If uniformly and thoroughly mixed, it makes for a smooth, creamy consistency, fluid enough to (a) enter and fill the crevices and hollows of the clay form when applying the mold's first coat (blue colored) to make a perfect negative mold (b) enter and fill the crevices and hollows in the negative mold to make a perfect positive cast (c) avoid the danger of fracturing the mold as might be the case if too thick a mix was used for the positive cast. The normal mix is a smooth, free-flowing creamy consistency when first mixed; it will start to thicken in a few minutes and soon thereafter will become steadily thicker until it becomes too hard and no longer plastic to use.

5. *Slightly thicker mix:* A slightly thicker mix would be a little more plaster in its ratio to water than in the normal mix. The slightly thicker mix is suggested for the Waste Mold's second, final coat (white color) . . . also when applying plaster to the burlap when binding the reinforcing irons to the mold's second coat . . . also when saturating the burlap when binding the reinforcing cord to the reassembled sections of the mold to prevent its possible expansion when pouring plaster for the positive cast . . . also when saturating the burlap, hemp fibre or jute scrim when strengthening the positive cast at the neck or base. The thicker the mix, the faster will be its setting time.

6. *Thinner mix* (for "killed" plaster): A thinner mix for "killed" plaster, used for repairing casts, is a lesser amount of plaster with a greater ratio of water. Since the amount of such mixture for most repairs is small in quantity, the preparation of the following amounts are suggested:

(a) Cup-full: Sift the plaster of Paris into a cup half-filled with the usual clean drinking water, moderated to room temperature. Follow the directions for making a normal mix—just enough plaster that the water can absorb (sink into the water). In a normal mix, when all of the plaster becomes wet and no island or mound piles up, remaining so for two or three minutes, you then begin to stir the mixture. However, in making a thinner mix for "killed" plaster, your next step is to add water to the mixture until the cup is filled to the top. Allow it to stand without stirring until it begins to set under water (about two or three minutes). Then stir a little until you have the desired consistency. Instead of a cup, you may find a hollow rubber ball (made by cutting a hollow rubber ball in half) suitable for mixing smaller quantities.

(b) *Tablespoon-full:* Sometimes the quantity of plaster needed for the repair is so small that a tablespoon-full is sufficient. Sift the plaster into a tablespoon, about one-half full. Submerge the tablespoon with the plaster into a basin or any other receptacle containing clean water. Allow it to remain submerged under the

water until the bubbles cease rising. Lift the tablespoon out of the water, and drain the water from it. It will soon thicken the desired consistency.

7. *Stirring:* For a mix other than a thinner mix, you let the plaster sink beneath the water, remaining so two or three minutes before stirring. Stir at a moderate rate—about two or three minutes should be enough, for too much stirring makes the plaster set quickly. Stirring rapidly, with resultant splashing or drawing in of air into the mixture, will create air bubbles and foam; if stirred slowly, thereby prolonging the mixing, the plaster becomes too thick and may set before you have a chance to use it. Stirring should be continual until the desired consistency is achieved. Stir the mixture without taking out the spoon as this may create air bubbles. After initial stirring, no additional plaster or water should be added. If you feel that you made an error in your mixing, discard the plaster and start all over again. It is best to make a new batch of plaster, rather than use a wrongly mixed plaster, or plaster that has set. Stir the bottom of the mixture, not the top, as stirring at the top may create air bubbles.

8. Remove any scum that may arise while stirring—break or blow away any air bubbles.

9. Mix a quantity slightly more than you need for a specific task. The time it takes to mix another bowl of plaster allows the first applied plaster to set somewhat, and the next applied fresher plaster may have a weaker adhesion where it joins the first applied plaster . . . hence the advisability of mixing a quantity slightly more than you need for a specific task. Making that bowl of additional plaster may rob you of time you can use to better advantage in other phases of the operation in these critical moments.

10. Plaster of Paris thickens rapidly and sets in about one-half hour, hence has to be used immediately after it is made, otherwise it must be discarded.

11. Keep the bowls or basins used for mixing plaster—preferably porcelain ones—free of set plaster left over from a previous batch. The normal setting of fresh plaster is interfered with by bits of set plaster. Oil your bowl or basin lightly with olive oil each time you use them for mixing.

12. If you are satisfied with results achieved, use the same plaster of Paris on your next work. You then know something of its characteristics, the amount of plaster needed in its plaster-to-water ratio, how well it sets, and the setting time. Keep a record of each of your casting experiences. It will stand you in good stead.

First Coat (Blue Colored)

First coat must be of a different color than the second, final

coat. The blue colored first coat is intended as a warning layer, for it gives notice when chipping away the mold from the plaster cast that the cast surface is close at hand, and that care must be exercised not to chip it. There are casters who make the mold one section at a time, preferably the front section of the head first. However, this chapter will deal with casting the entire head at the same time, as most casters do.

Oil a medium-sized mixing bowl slightly with some olive oil to facilitate its cleaning later. Now fill your bowl half to two-thirds full of faucet water fit for drinking, moderated to room temperature. Pour into it one and one-half to two tablespoons of ordinary bluing, making the color deep blue (the white plaster of the second coat will lighten its color to a marked degree). Sift the plaster of Paris into this deep, blue-colored water evenly through your fingers. Sift uniformly over the entire surface of the water. Do it quickly, not hurriedly, however, and in small amounts—larger amounts will create a lumpy mix when dropped into the water. Your mixture of plaster-to-water should be a "normal mix" for the first coat—just about enough plaster that the water can absorb (sink into the water). As soon as all the plaster becomes wet, and no island or mound piles up to suggest that the water cannot absorb any more plaster (a matter of about two minutes), you have a normal mix. Add no more plaster than is necessary for a normal mix, for any excess will thicken the plaster too much. The normal mixture should have a smooth, creamy consistency, fluid enough to enter the crevices and hollows on the clay form in order to make a perfect negative mold. Let the plaster sink beneath the water, remaining so for two or three minutes before stirring. Stir for a little while—about two to three minutes should be enough; too much stirring makes the plaster set quickly. Stir at a moderate rate, but not too rapidly; rapid stirring or whipping creates air bubbles. Stir the mixture without taking out the spoon, otherwise air bubbles may be created. If air bubbles or scum arise on the surface, skim them off. Make a little more of the mixture than you need—it is better to have a little more available than not enough.

Before the plaster starts to thicken, start flicking the plaster onto the clay or plasteline form. Use a cupped hand to flick, with the back of your hand nearest to the work. Flick vigorously in an upward direction, making sure you cover the ears, eyes, nostrils, etc. Blow it into the crevices and hollows with your breath, where necessary. Start from the top and work down, or from the bottom and work up, whichever method is best suited to you, catching and throwing back any plaster that runs off. Don't cover too thickly— about one-quarter inch will do. Try to do it evenly over the entire form, not too thick in one place and too thin in another, although a little extra thickness could be added to all protruding parts. The

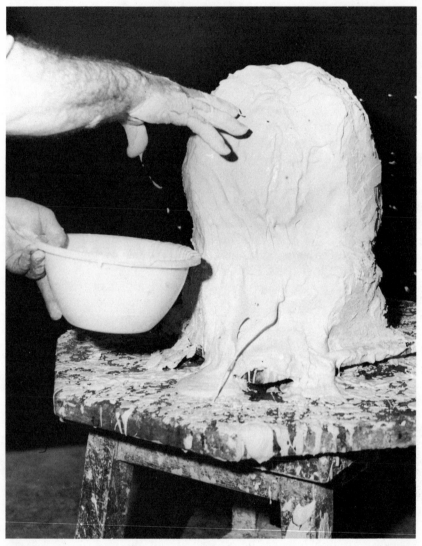

Flicking on plaster (first and second coats), with back of hand toward the work.

first coat is very important and must be done right for it determines the inner surface of the mold and eventually the surface form of the positive cast—details will be lost if the mix is too thick or too thin. Remember to scrape off the plaster from the top edges of the shims immediately. They must be kept clear of plaster so that when both coats are applied, the areas adjacent to the dividing wall will be level with the top edge of the shims. This will assure a snug fit when reassembling the sections, and facilitate the chipping away of the mold later on.

Setting (blue colored coat)

After the blue-colored coat has thoroughly set, say in about thirty minutes, and before the second, final coat of white plaster is applied, an application of clay water (a bit of clay mixed thinly in water) will help to prevent adhesion between the two coats. With a soft, wet brush, dab on the thinned clay water sparingly. The clay water will facilitate the separation of the second, final coat from the first, blue-colored coat when chipping away later on. Olive oil dabbed over the blue-colored coat will serve the same purpose. An inch margin along both sides of the dividing wall should not be dabbed at all with either the clay water or olive oil, so that the second coat will better adhere to the first coat. This makes for a stronger mold along the line of the dividing wall on both sides, needed when opening the mold, and when chipping the mold later on. Clean the baseboard after application of the first and second coats. It is easier to gather up the plaster when it is soft, and makes for a less messy job.

Second Coat (white colored coat)

Plaster for the second coat is mixed without the bluing. The consistency is slightly thicker than the normal mix of the first coat, meaning you use a little more plaster in your plaster-to-water ratio. Stir in the same manner as you did the first coat, about the same length of time, and skim off any air bubbles or scum that may arise on the surface. Remember to make a little more of the mixture than you estimate for the second coat. Apply in the same manner as you applied the first coat, the combined two coats totaling three-quarters to one inch in thickness over the entire head. Make sure this thickness exists over the protruding parts like the ears, nose, and chin—in fact, a little extra thickness should be added over the projecting parts. The area along the full length of the dividing wall—both sides—should be built up level with the top edges of the brass shims. If the shims are lost to sight, expose the top edge along the entire wall by scraping off the plaster. A clear edge assures a snug fit when reassembling the sections, and facilitates the chipping away of the mold later on. If you are using reinforcing irons, now is the time to apply them before the plaster sets. Remember to keep your baseboard clean when applying either of the two coats.

Reinforcing Irons

Some sculptors use reinforcing irons on top of the second coat

while it is setting. It is intended to strengthen the plaster which may become brittle and break when it sets. Reinforcing irons, when used, are usually bent to follow the shape of the mold—one on each side of the front section, one on each side of the back section. Small irons may also be placed at the neck, the weakest point of the mold. The best way to bind them to the plaster is to wrap them with a few strips of burlap soaked in slightly thicker plaster. Reinforcing irons are usually found to be needed where the mold is made over a clay form which has been allowed to harden. Opening the mold then becomes more difficult, and the risk of breaking it becomes greater. Generally, Waste Molds for casts of heads and busts up to and including life-size need no reinforcing irons.

Setting (white colored coat)

Feel the mold—if it is warm, you know that it is setting properly. When it is cold, it has set. Allow thirty minutes or so for the second coat to set before you begin to pry the sections loose from the form. While setting, see that the keys and markers in the dividing wall are clean and clearly visible for the accurate reassembly of the two sections.

Opening the Mold

The very first thing to remember when opening the mold is not to force the opening. Forcing will break it. Patience and gentle handling is needed. Light tapping of a broad, blunt, carpenter's chisel (about one inch in width) with a wooden mallet or a light hammer is the one sure way. It is the back section that is first pried loose from the clay or plasteline form because the back section behind the ears has little, if any projections or undercuts that will stand in the way of its easy removal. Start by placing the chisel at the top of the mold on the back section slightly angled against the dividing wall. Avoid keys or markers. Tap the chisel lightly. Do not make a large gash—try for a thin crack. The thinner the crack, the more accurate will be the reassembly of the two sections. When a crack appears, pour some water from a glass or jar into it. This will help to separate plaster from the clay or plasteline, breaking the suction between plaster and clay or plasteline caused by the hardening of the plaster (use hot water for a plasteline form—to soften the material). Repeat the same gentle operation several places at the top of the mold on the back section, and wherever a crack appears, pour some water into it. Keep opening cracks along the back section of the dividing wall

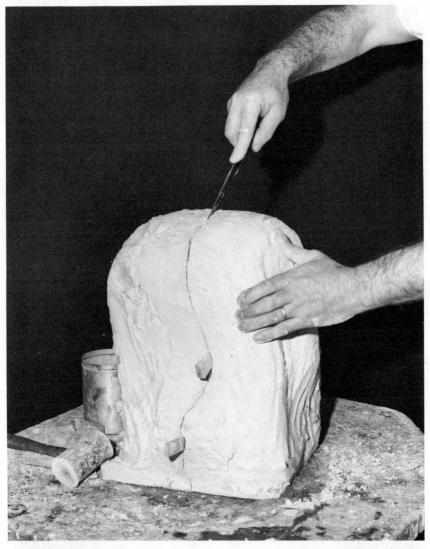

The use of a chisel was found unnecessary in opening this Waste Mold. A knife blade alone was used for the advantage of making a thin crack; the thinner the crack, the more accurate will be the reassembly of the two sections. Wedges helped to open the crack.

down the sides to the baseboard, and keep pouring water into the cracks. By inserting a knife blade into each crack, and by using the slightest leverage to pry the mold loose, the back section should be showing signs of loosening. Repeat this slight leverage pressure at each position in turn, pouring water into all cracks if the mold still seems tight. When the back section shows signs of being loose, take hold of it with your hands and with patient rocking, the back

section should lift away with ease. Be careful to place the removed section where it will not be damaged, laying it down with inner surface upward. Clear away any clay or plasteline that still adheres to the mold, using a soft brush or sponge. Running water will wash away remaining bits of material, but do not apply strong water pressure as the plaster is still soft and the inside surface could easily be damaged. A larger lump of clay when pressed on a small bit of clay is most effective in removing the small bits of clay.

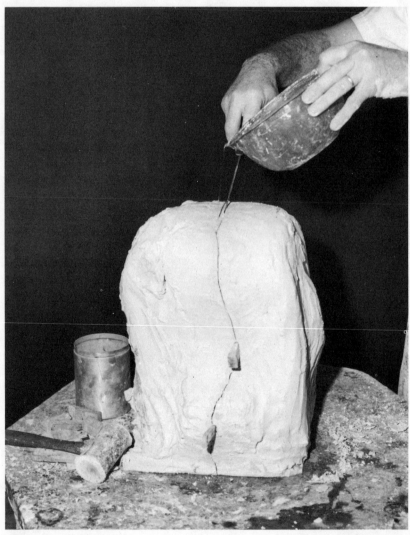

Note the pouring of water into the crack to help separate plaster from clay. Water helps to break the suction between the plaster and clay (or plasteline) caused by the hardening of the plaster used in the casting.

(Likewise, a larger lump of plasteline when pressed on a small bit of plasteline will remove the small bit of plasteline.)

Clearing Clay Or Plasteline From Mold

Your next step is to remove the clay or plasteline from the front section. This, too, must be carefully done so as not to injure the inside surface of the mold. Start by hollowing out the clay or plasteline around the armature. Any suitable tool to scoop out the material will do, and freeing the armature should follow easily. Do not scoop out material too deeply, for you may mar the inside surface of the mold. Leave about three-quarters to one inch of clay or plasteline still attached to the inside surface of the mold for more careful removal later on. Remove this remaining clay or plasteline in small amounts. It is never advisable to remove any material in large lumps because the delicate parts of the mold can easily be broken and pulled away with such amount of material. If the clay or plasteline is caught in an undercut, or in the nostrils for example, it should be picked out most carefully with a pointed tool. As discussed under "Opening the Mold," running water will wash out bits of clay or plasteline that still adhere to the mold— but do not apply strong water pressure as the plaster is still soft and the inside surface of the mold could be damaged. You may also use a larger lump of clay—when pressed on a small bit of clay it will remove the latter. (If plasteline is used in modeling, bits of plasteline adhering to the mold can be removed by pressing a larger lump of plasteline against it. If this fails to do it, a little benzine on a brush will dissolve the plasteline.)

Cleansing the Mold

Before cleansing the mold, look for and repair cracks and breaks. Also look at the inside edges of the divided sections. They may have a thin projection of plaster where the shims were pushed into the clay or plasteline form. Remove these edges with sandpaper, so as to prevent them from making a line or seam on the positive cast. Start the cleansing process by first washing the interior of the two sections of the mold of any material still clinging to them. This can be done by running water in the sink or bathtub, but there is always the danger of clogging the drain pipes. It is safer to use a garden hose, with a mild stream of water, and gently brush away any material with a soft brush or moist sponge so as not to injure the surface. Again, look for any damaged parts which must be repaired. The interiors must be prepared for the new plaster which is to become the positive cast. To do so, the

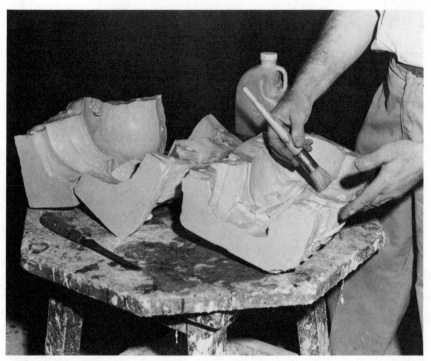

Cleansing the mold after removal of the clay model. The back section was purposely cast into two parts in anticipation of the difficulties of clearing the air-dried, self-hardening clay model from the mold.

pores of the interior surface of the two sections of the mold must be sealed to prevent a bond with the fresh plaster. The best release agent for penetrating the surface and sealing the pores is Tincture of Green soap which is economical and available at all drug stores. Mix the soap in hot water. Use a rich but not too heavy-bodied a lather—add water when too thick, green soap when too thin. An alternative is to melt any ordinary white soap—a piece 2″ x 1″ will do—in a pint of boiling hot water. Add to it a tablespoon of olive oil. Boil the mixture until thoroughly dissolved. Cool before using. Gently brush on either of these release agents or separators until you have a good lather which is to be left on for about 15-20 minutes. Tip the two sections of the molds in every direction to make sure that all of the surface is covered, with special attention to crevices and hollows in the ears and other features. The molds should absorb all the soap they can—the 15-20 minutes should do it. The oil from the soap seals the pores, thus preventing a bond with the fresh plaster. Now remove the excess lather with a dry brush or sponge, for the lather interferes with the setting of the

plaster when left in the molds. Do not use water; rather, pick up as much of the lather as possible with the soft brush or moist sponge—squeeze soap out of the brush or sponge, and repeat until all the soap is removed. Check for air bubbles—remove them. Interior surfaces of the molds should now feel smooth and oily. After removal of the soap, a final release agent or separator—a minute amount of thin olive oil—may be applied. It is an additional, simple, and effective aid in preventing a bond with the fresh plaster. Use only a minute amount of olive oil as too much oil causes pinholes, on the positive cast. When using a brush in cleansing a mold, use it very gently, otherwise you may ruin the surface.

Reassembling the Mold

The method of pouring plaster into each of the two sections of the mold and then bringing them together is used by some casters. Reassembling the two sections *before* pouring the plaster to make the positive cast is the method generally used, and will be discussed here. In putting the two sections of the mold together, care must be taken to see that the edges of the seam are flush and unbroken, and fit into the keys or markers you made when making the dividing wall. Now tightly tie up the two sections so that there is no possibility of their loosening while pouring the fresh plaster. Remember, too, that the fresh plaster may swell as it hardens, causing the mold to swell and open. The cord must be strong, and firmly tied up around the mold at two or three levels. Placing some slightly thick fresh plaster along the cords and at the knots will help to prevent them from loosening and slipping down the mold. A wedge, or a stick, or any other means of torsion, is advisable to tighten the cords around the mold. The seam where the two sections meet must be sealed with a slightly thick plaster to prevent any leakage when the fresh plaster is poured for the positive cast. Burlap dipped in a slightly thick plaster and placed over the seam will strengthen the seal.

Pouring Plaster Into the Mold

It is best to make a hollow cast of a life-size head since a hollow cast is stronger and more durable than a solid one, and of course much lighter in weight for handling and transportation. After the mold is cleansed and soaped, and reassembled, it is ready for the pouring of the plaster for the positive cast. Stand mold upside down with the opening upward. Support it on all sides so that it will remain that way without falling, leaving room so that the mold can

be tilted in every direction or turned around, which will help to settle the plaster in the crevices and hollows of the mold. Have several lumps of clay available to plug leaks, should they occur. The plaster for the cast, mixed as before when making the mold's first coat, should be a normal mix, smooth and creamy in consistency, fluid enough to fill the crevices and hollows in the Waste Mold for a perfect positive cast. Plaster of Paris expands slightly when it sets. Make a normal mix for the positive cast; too strong a mix creates additional heat and expansion while it is setting, and the Waste Mold can be fractured by this additional expansion, notwithstanding the cords tied around the mold. To make a hollow cast, pour plaster in slowly, filling the head about one-half full— preferably pouring along sides instead of directly into the opening, for any splashing will create air bubbles. Tilting or vibrating the mold gently, or turning it around slowly while the plaster is being poured, helps to release any air bubbles in the mold. Avoid quick pouring as this creates air bubbles. Keep tilting, vibrating, or turning the mold so that the plaster will penetrate and adhere to all surfaces of the mold in a thin film which will soon thicken and set slightly. Do this first pouring carefully as the plaster will be the outer layer of the cast. Any plaster remaining in the mold should be allowed to run back into the mixing bowl by gradually lowering the mold to a horizontal position. Let this coat set slightly. Repeat the process slowly in order to allow the plaster to set slowly, again allowing excess plaster to run back into the bowl. Repeat the process until there is a substantial layer built up, say about three-quarters to one inch in thickness, and as evenly as possible. Some casters like to strengthen the neck because it is the weakest point in the cast by using burlap dipped in slightly thicker plaster, even if it makes the neck solid . . . likewise, they like to make the base solid in the same manner so that the bottom of the cast will be heavier than the upper portions and thus create a better balance to the whole plaster cast. If used, do not let the burlap project beyond the lower edge which, obviously, should be as level as possible when the cast is resting on its base. Trim off any excess plaster at base with knife or ruler for the same reason. Let the plaster set while in the upside-down position.

If the head is smaller than life-size and you wish to make a solid plaster cast, or should you wish to make a solid plaster cast of even a life-size head, pour the freshly made plaster into the mold until it fills up. Do the pouring slowly, preferably along the side, so that no air bubbles form. Tilt, vibrate, or turn the mold for reasons set forth above. Remember to have several lumps of clay available to plug leaks should they occur. Trim off any excess plaster at the base with a knife or ruler so that the head when placed upright will be as level as possible when resting on its

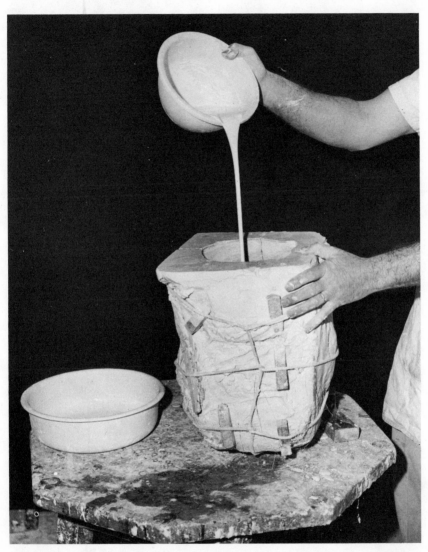

Pouring plaster for cast after reassembly of the sections of the mold. Note the sections bound tightly with heavy cord, with wood wedges to increase the tightness.

base. Let the plaster set while in the upside down position. The beginner, amateur, or student may find it advisable to pour a solid head, instead of one that is hollow, for it is a much simpler process. (The reader is reminded of the alternative method of making a hollow sculptural head with self-hardening clay—*see* "Hollowing" in the chapter "Clay-Self-Hardening.")

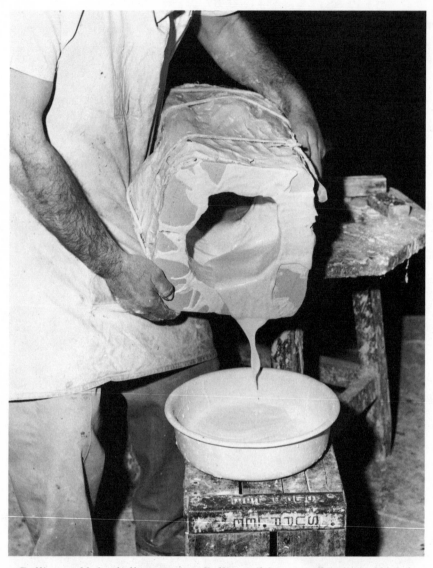

Rolling mold for hollow casting. Rolling, tilting, or vibrating mold helps first coat of plaster to penetrate and adhere to all surfaces of the mold. After slight setting of first coat, repeat process of pouring and rolling until ¾" to 1" layer is built up.

Setting Of Plaster Cast

With the mold in an upside down position, with the opening upward, let the plaster cast set one or two hours if the removal of the mold is to be done the same day—overnight would be better to allow the cast to be thoroughly cooled and hardened.

Removing (Chipping) the Mold

Removing the Waste Mold from the plaster cast is done by slowly and carefully chipping away the mold. The principle of chipping is to break the mold away from the cast by fracturing it, not sharply cutting it away. Before starting the chipping, pull away any burlap along the seam, cords, knots, and where placed for a leak; also remove any reinforcing irons if you had used them. Chipping should be done with a broad, blunt carpenter's chisel, about one inch in width, preferably with its edges rounded—and a mallet. Both help to reduce the blow so that its impact will not damage the cast. If a wooden mallet is not available, use a light hammer. A heavy hammer will create too much pressure on the chisel which can result in a deeper fracture of the mold and possible damage to the cast.

The head is upright and resting on its base when chipping away. Cloths—any soft material or an old carpet—placed under the base are also recommended to soften the shock of the chipping. With the chisel at right angles to the surface, chip away as lightly as possible with sharp, light taps with the mallet beginning at the

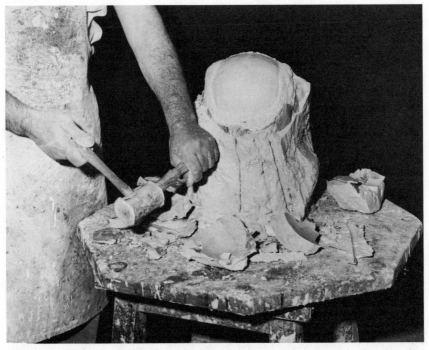

Note chipping from top to bottom, leaving area from chin to base last for support during fracturing of upper portions.

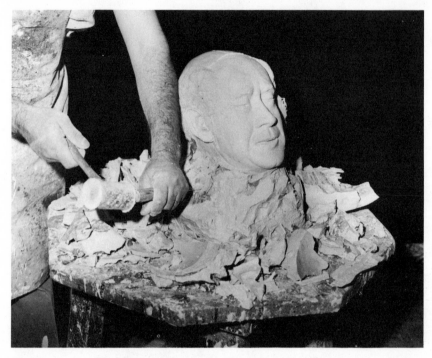

The Eugene Ormandy plaster cast emerges.

top of the head, about one inch from and parallel to the dividing wall on both sides. Large chunks of the mold may come off at any point, usually in the back section, but it is most advisable to try for small areas since larger pieces can pull away some delicate part of the cast. Never, never force off any part of the mold. With patience, the mold will come off. It is best to chip from top to bottom, leaving the area from chin to base last as it acts as a support during the fracturing of the upper portions.

The chipping from the front section containing the features should be done with extra care. Be particularly careful around the ears and other features, using a smaller, blunt carpenter's chisel or a screwdriver to loosen the limited area involved. Avoid chipping directly over or too near the features.

The white coat will come off first wherever the clay water was properly applied to prevent adhesion between the first and second coats—exposing the blue coat which is nearest to the cast. The white coat should be removed over the entire head, except the supporting area from chin to base which is done last. Now nibble away at the blue coat. Use the smaller chisel or screwdriver. Nibbling is just the right word for this operation. Just as you nibble

or take a small bite, you are to do just that in this process—taking
small areas at a time away from the cast. Some of the blue coat
will, in all probability, cling to the undercuts in the features, and
this will have to be cleared away carefully with the pointed end of
a small steel tool. Do the areas between the chin and base last,
as you did when removing the white coat. There are likely to be
small marks or slight damage to the cast caused by the chisel strik-
ing it, but with careful, unhurried chipping the damage should be
minor and easily repaired. Remember to keep the chisel at right
angles to the surface when chipping. In this way, you avoid chip-
ping into the cast and breaking off any feature like the ears
and nose.

Repairing the Cast

Don't be discouraged if your cast bears some scars from the
chipping away of the mold. Experts have the same problem. Any
raised portion on the positive cast can be smoothed down with
fine sandpaper, a sharp knife or a fine rasp. Little scars and pin-
holes caused by air bubbles can be easily remedied by promptly
applying fresh plaster with the fingers after the mold is removed.
A crack in the plaster, however, should be treated more thoroughly.
The repair must be made in depth, otherwise a substantial section
could break off. Take a thin modeling tool and press it into the
crack as far as it will go, open the crack a little if possible, and
then fill in the space with the fresh plaster (keeping the adjacent
area moist to prevent the moisture from the new plaster being
absorbed by the old.) I repeat—do your repair work as soon as
the mold is removed, and while the cast is relatively moist. If the
cast is moist, it will not absorb the moisture from the new plaster.
In addition to keeping the adjacent area moist, also thoroughly
wet the spot to be repaired until the cast at this point ceases to
absorb water. Thorough wetting is necessary for adhesion. A soft
brush or moist sponge will be found suitable for wetting. Keep
the tool applying the plaster wet during the repair to help keep
the fresh plaster moist and in a workable condition.

The fresh plaster must be "killed" before using it for repairs.
If not "killed," it would set harder than surrounding plaster, be-
come chalky and brittle when set, and would have a somewhat
darker color. Being a little harder than the surrounding plaster,
unkilled plaster becomes a little more difficult to scrape down
should there be a need for retouching the cast. "Killed" plaster
will set with the hardness and color near that of the rest of the
cast. To "kill" plaster, see "Thinner Mix for 'Killed' Plaster"
in this chapter.

Prevent any movement of the repaired parts until the fresh plaster is thoroughly set, particularly for a piece which had been broken off. Remember, too, to wet both surfaces where the broken piece is to be mended. In any repair work, whether on plaster cast or self-hardening clay model, remember to "feather in" the edges of the newly placed material for a better adhesion. Sandpaper, steel wool, or pumice stone are good tools for smoothing out surfaces.

Drying Period For Cast

The plaster cast should be allowed to dry thoroughly by natural, slow evaporation of the moisture. It may appear dry externally, and yet internally it may still contain a substantial amount of moisture. Atmospheric conditions, temperature, air circulation, and size of sculptural piece affect periods of evaporation of moisture. Play it safe by letting the cast thoroughly dry naturally for a week or two before further handling for coloring ("patining") to imitate bronze, or for casting into metal bronze. As the moisture evaporates from the cast, the physical strength of the cast increases.

Disposal Of Plaster

Liquid plaster should not be emptied into a sink, bathtub, or any drainage outlet. It can cause untold damage to the drainage system as plaster hardens and becomes an obstruction. It is best to let it harden a little, then gather it up for the trash.

Brushes and Tools

Wash brushes and tools in clean water as your work progresses. Brushes will be ruined if the plaster is allowed to harden on them. Wash brushes in any suitable container filled with water, and let the water drain off the brush. Plaster in the container should be allowed to harden a little, and then gathered up for the trash.

Pails, Basins, Bowls

Porcelain pails, basins, and bowls are more suited for casting as they are easier to keep clean. Oiling their insides makes them easier to clean. Oil sparingly, wiping off oil from the container.

Care of Plaster Cast

Cleaning Untreated Cast

A plaster cast left untreated soon picks up dust from the atmosphere. Outer surfaces become darker, while recesses quite frequently remain lighter in shade. As time passes, the freshness of the plaster is also gone, and indeed the cast looks lifeless. If the plaster cast also becomes dirty (as it inevitably will), it can be cleaned in the following manner: first try sandpaper or fine steel wool. Rub either of these abrasives on the surface lightly making sure the surface is not disturbed. It should clean the cast; however, if the cast still remains unclean, submerge it in clean water for three or four hours, allowing the cast to become thoroughly saturated. When the cast cannot absorb any more water, any air bubbles which were arising will cease to rise. By this time, all the dust and dirt should be loosened by the soaking, and by applying a sponge to the surface while submerged the cast should become quite clean. If, after this soaking and sponging, the cast remains dirty in appearance, resubmerge it in fresh, clean water and while submerged again sponge off, or brush off, or lift up with a blotter, any remaining particles. Do not lift the cast above the surface of the water unnecessarily as it will collect any scum that is floating there —if it does, allow running water from the faucet to run over the cast to wash away the particles. Allow the cast to dry thoroughly in a dust-proof place, before any further work is done on it—like using shellac for the sealing of pores for coloring.

Soak completely the best part of a day in a receptacle of water. The water should cover it entirely and dust marks may be gently sponged away while it is still under water.[1]

Dirty plaster must be washed, but not in the ordinary manner. The cast must be submerged entirely under water and left to soak. While still submerged, a sponge may be rubbed over the surface lightly. The dust will loosen and float on top of the water. Each particle of this must be lifted off on a blotter, and when no sign of dust is seen, the cast may be removed and left to dry in a dustproof place. A thin coat of shellac may be applied later, which makes a stronger and easier surface to keep clean.[6]

Should the cast be dirty, it will be necessary to clean it before applying the shellac. If it is merely a surface layer of dust, it may be possible to remove it with a duster, or even with a fine sandpaper, providing the surface modeling is not interfered with. Should these methods prove unsuccessful, the cast will need to be washed. By washing I do not mean wiped over with a damp sponge or cloth, for this would be fatal. The dirt that was previously on the surface will permeate with the moisture from the sponge; become difficult, if not impossible, to remove from the plaster. The only way to cleanse the cast is to immerse it completely in water and allow it to remain untouched until it has absorbed all the water it is capable of holding. When the bubbles cease to rise, and when on being removed from the water the surface remains wet, it should be returned to the water and wiped over with a clean sponge, which will detach the dirt and leave it floating in the water. If a sponge is used before the plaster is saturated, the dirt will be absorbed, and as stated before, will be impossible to get rid of. Needless to say, the plaster must be allowed to dry before the shellac is applied.[4]

Repairing Cast

See "Repairing the Cast" in chapter "Plaster Casting by 'Waste Mold'."

Outdoor Limitations

A cast made of plaster of Paris is not recommended for permanent outdoor display. The plaster's porosity permits moisture penetration, the cast is affected by hot and cold weather, and by dirt and dust. This material is unable to withstand outdoor exposure for too long a time. In ideal climates, a sculptural piece made of plaster will survive a period of time if it has been carefully prepared for that purpose. First of all, if the piece is intended for the outdoors, it should be cast with thickly mixed plaster to eliminate porosity and to make it hard. The ratio of plaster-to-water has a determining effect on porosity and hardness—a thicker mix, with a smaller ratio of water-to-plaster makes for less porosity, and hardens the plaster. Commercial plasters vary in their qualities for setting time and hardness, and a proper selection of plaster of Paris for outdoor purposes would indeed be guesswork by the novice. There is also the need for the addition of a chemical-hardening ingredient in the mix (lime water, gum arabic, etc.) to achieve hardness. A surface hardening, impregnating ingredient (borax, alum, paraffin, varnish, linseed oil, etc.) is also necessary to achieve a harder, non-porous surface. Waterproofing substances (wax, shellac, resin, etc.) are also employed to reduce surface porosity on the finished cast, forming a film on the surface to resist

the effects of moisture. All in all, the sculptor would do well not to think in terms of displaying his work outdoors.

Plaster has no value as an outdoor material.[9]

Plaster is not an outdoor medium but if it is painted with hot linseed oil or with a good spar varnish, it will stand up out of doors for some time.[13]

To harden the surface of plaster casts, they may be soaked in hot paraffin or thoroughly brushed over with a melted solution of stearine. When dry, the surface may be rubbed to a high polish. For larger figures or reliefs in plaster to be set out of doors, after the plaster has been thoroughly dried it is brushed over inside and out with linseed oil, two or three coats. When this has penetrated all the pores and hardened the surface, the plaster may be painted with waterproof paint, and it may be finally colored to imitate stone or bronze; it should be able to withstand exposure out of doors for two years.[6]

My "Shulamith" figure was exhibited at the first Sculptor's Guild Outdoor Exhibition. I gave her a number of coats of Spar varnish to protect her from the weather. Spar varnish is used to waterproof wood railing aboard ships. In spite of this powerful varnish, after a few rainy weeks areas of the plaster surface was pock-marked and rotted from exposure.[11]

Coloring ("Patining") Plaster Cast

Purpose

The cost of casting a plaster cast into metal bronze is very expensive, and the budding sculptor may wish the intermediate plaster to serve until he can afford the pleasure of seeing his work in its ultimate stage. He may also feel that his first efforts in his development as a sculptor do not justify the extra cost, reserving the pleasure of seeing his efforts cast in bronze for his later sculptural pieces. By then his work should have a quality surpassing his earlier efforts, and justifying the additional cost of the permanent bronze. In the meantime, he will want his plaster cast which has a deary white dullness (or his self-hardening clay model) to show to advantage, perhaps for exhibition, or to give a client a general idea what a true patine on metal bronze will look like, or to show the foundry what effects he is seeking. This is possible by coloring it, or "patining" it as some sculptors speak of coloring a plaster surface. Actually, "patine" or "patina" is the thin greenish coating formed on copper or bronze (caused by oxidation of the metal surface) when it has been buried underground for a long period of time, or exposed to moist atmosphere. You have observed, no doubt, this patine on old coins and other objects in the museums which had been dug up from the ground after many years there, and on statuary in the open parks which had been exposed to the elements for some time. Some sculptors feel that the simulation of bronze on plaster is a subterfuge, a dishonesty, and should not be done. They are firm in their position that true patine should not be fouled. Other sculptors accept "patine" treatment on plaster surface (or self-hardening clay) not because they are less esthetic, but in belief that it is better to brighten up the piece for the reasons above stated. There is an infinite variety of "patination" colors that can be achieved—browns of various shades, black shades, greens in a multitude of tonal variety, a little of the blue and

purple colors running through other shades—very often some of the coloring or "patination" achieved is almost as alike in appearance as the true patine on the metal bronze. One point to be remembered at all times is to make sure that in imitating metal bronze, the finish color on the plaster cast (or self-hardening clay model) must have an approximation of the former's true patine. The finish to be achieved must be suited to the particular piece of sculpture, for any improper coloring vulgarizes the work. Esthetic taste in coloring always enhances the sculptural piece. External coloring, of course, is quite fragile and can easily be chipped off, or if improperly done will peel off. To avoid this, some sculptors prefer to use integrated color, that is to say, powdered color mixed with the plaster of Paris, the color becoming uniformly distributed throughout the plaster in the making of the positive cast.

Esthetic Taste In Coloring

There are many colors, and hues of colors, used to imitate metal bronze, and it is a most gratifying experience to try as many variations as you possibly can. Try a new "patine" every time you have need to color a plaster cast or a self-hardening clay model. An appreciation of a fine surface, and its relation to the piece itself, is all that is needed. Do not hurry your "patining." Let it take days or weeks—it is worth the time and effort. Remember that an esthetic color finish in sculpture enriches the art quality of the piece. Remember, too, that the color finish should have a unifying relationship, a harmony with the surroundings in which the sculptural piece will be set.

Perhaps the best advice that can be given on this score is to suggest that you visit the museums, the private galleries, exhibitions. See for yourself the many bronze finishes—light browns, dark browns, dark reddish browns, brown and gold, the jet-blacks, dark shades over rich red undertones, the gold, purple and blue streaks and traces running through the various shades of brown, black, green and other colors—the opaque and semi-transparent finishes —a range and variety of beautiful colorings that will act as an inspiration for your color finishes.

GENERAL OUTLINE OF PROCEDURES

(a) *RE-EXAMINE CAST BEFORE COLORING*
 See "Semi-Transparent Finish" in this chapter
(b) *THOROUGHLY DRY AND CLEAN CAST BEFORE COLORING*
 See "Semi-Transparent Finish" in this chapter

(c) *SEALING PORES WITH SHELLAC*
 See "Semi-Transparent Finish" in this chapter
(d) *COLORS: PAINTS: SOLVENTS: DYES*
 Casein colors: Casein paint may be used for coloring. Some sculptors find it practical to mix dry Casein flakes in hot water, adding dry colors for a desired hue.
 Oil colors: Oil colors mixed with turpentine may be used for coloring. Any finely ground oil color is suitable. I prefer oil colors that are "Ground in japan," i.e., mixed with japan dryer. They are a finer paint than enamel, although the flat finish (not glossy) of the latter can be used.
 Powdered colors: Powdered colors mixed in thinned shellac (shellac thinned with alcohol), or mixed in turpentine, may be used for coloring. Mixing in thinned shellac is the favored method, but you may want to consider turpentine where a change of solvent from a prior coating is desired. (Read "Sealing Pores with Shellac" in "Semi-Transparent Finish" in this chapter.) Powdered colors (dry; not diluted in solvent) may also be used for change of color when the plaster cast (or self-hardening clay model) is still "tacky" with paint or paste wax.
 Paints of Interest: Umbers: Raw umber (brown, with slight olive cast); burnt umber (chocolate brown)—both good, bronze-like colors. *Siennas:* Raw sienna (dark oak); burnt sienna (a dark, reddish brown color) . . . umbers, siennas, and ochres which are earth colors mainly black and red, are opaque; thinning has very little effect in making these colors transparent.
 Colors of Interest: Dull Green: A combination of black and yellow ochre; *Olive Green:* Yellow ochre or raw sienna with a finger-nail amount of blue: Greens are excellent in all shades for a color finish. The lighter shades are more suitable for semi-transparency. *Purple:* A combination of red and a touch of blue. *Gray:* White and black combination; black and yellow ochre; white and raw umber. Terra-cotta: A combination of venetian red and a small amount of yellow ochre, with a little white added, will make a lighter shade of terra-cotta.
 Solvents: To thin oil colors, mix in turpentine; to thin powdered colors, *see* "Powdered Colors" above.
 Analine Dyes: Powdered analine dyes can be used for coloring ("patining") of plaster casts (or self-hardening clay models.) A very specific advantage in the use of analine dyes is their penetrating qualities into the porous plaster (and clay.) With this penetration there is less likelihood that a slight scratch or small chip will show, as would be the case where the surface is more superficially coated with paint. Another advantage of analine dyes is its quick-drying property, for it takes but a few minutes for each coat to dry. Analine dyes are soluble in alcohol, water, oil,

and alcohol-water . . . fast drying in alcohol, slower in water, still slower in oil. It is more economical to use analine dyes soluble in water, and all analine dye colors you use should preferably have the same soluble base. Since analine dyes fade in the sun, remember to ask for, and use sun-fast analine dyes. Powdered analine dyes may be purchased in small quantities at some art supply stores, some paint stores, and elsewhere where "Dyes and Dyestuffs, Colors and Pigments" are sold. The yellow pages of a telephone directory lists many of these firms.

Application of analine dyes: First thing to remember— the plaster cast (or self-hardening clay model) must remain un-shellaced. Do not seal pores as dye will not penetrate form. The powdered analine dye you will very likely purchase is soluble in water—dissolve it in boiling hot water (about two to three ounces of dye to one gallon of water.) Pour dye gradually into the hot water. Stir well until color is completely dissolved. Strain through mesh cheesecloth. Place in an airtight jar. Store it in the jar.

A finished "patine" can be had by brushing on several coats of analine dye (second coat can be the same color as under-tone, or a different color), or the undertone can be one or two coats of analine dye, with the color finish in an oil or powdered color, either opaque or semi-transparent (*see* "Opaque Finish" and "Semi-Transparent Finish" in this chapter.) Between coats of analine dye, let it dry for a few minutes; let the dye dry thoroughly overnight before the oil or powdered color finish is applied.

Avoid heavy applications: Whether it is a solvent, paint, powdered color, dye, varnish, or any other covering—use it sparingly. Heavy applications clog up forms, and some of the original modeling can be lost.

Color selection: There is practically no end to the pos-sibilities of color finishes, but it must be remembered at all times that the finish must be compatible to the concept—an integration of the sculptural form and the particular color selected for it— and always in esthetic taste. Selection should also be influenced by the color of the surroundings in which the sculptural piece is to be placed. A correlation with the surroundings will considerably enhance the piece.

(e) *BRONZING POWDERS*

Bronzing, like paint or dye, is a means of simulating a metal bronze surface to a plaster cast (or self-hardening clay model.) Bronzing powders come in a number of shades—gold, natural copper, antique copper, green, etc.—and can be combined for a desired hue. They can be purchased in small quantities in any art supply store, or at paint stores that carry art supplies.

Solvents for diluting: Bronzing powder may be diluted

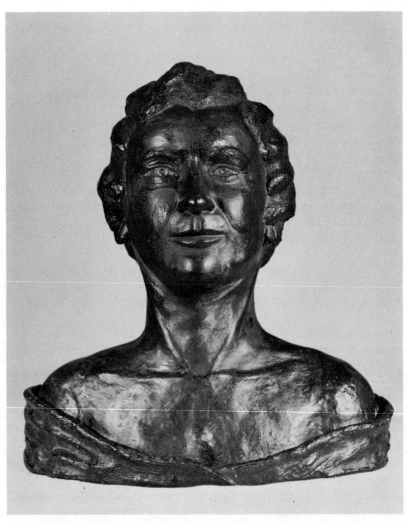

MY WIFE CECELIA, by Louis E. Marrits. *Courtesy of the Author.*

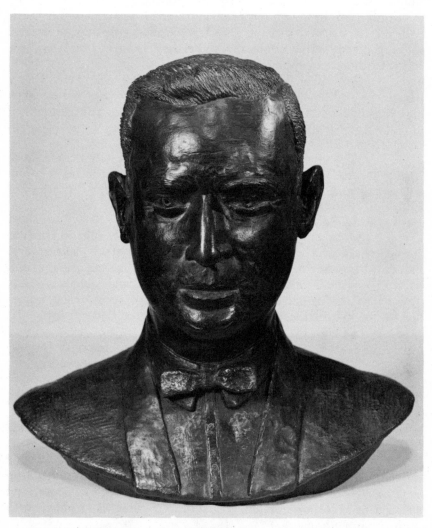

SELF-PORTRAIT, by Louis E. Marrits. *Courtesy of the Author.*

in thinned shellac, turpentine or bronzing liquid. The weight of the metallic particles in bronzing powders will cause it to settle out of the mixture, and the mixture, therefore, should be stirred each time when dipping brush into it. Generally, when the coating of thinned shellac used for sealing pores, or any coloring with thinned shellac in it as a solvent, is thoroughly dry, a succeeding application of bronzing powder in thinned shellac as a solvent will not loosen and pick up the first applied covering; however, to be perfectly safe, dilute the succeeding bronzing powder in a solvent other than thinned shellac.

See "Bronzing-undertone highlighting" in "Semi-Transparent Finish" in this chapter. Also *see* "Bronzing-color finish highlighting" in "Opaque Finish" in this chapter. Both methods offer interesting uses of bronzing powders.

(f) *CHANGE OF COLOR (if desired)*

A change of color can be accomplished if the color finish is still "tacky." It can also be accomplished after the last process of waxing and polishing. For full details *see* "Semi-Transparent Finish" in this chapter.

(g) *TALCUM POWDER, FRENCH CHALK*

Ordinary talcum powder (or the cheaper powdered French chalk which is purchasable in any paint store) has several values (1) gets rid of the glossy, painted look—creating a dull or mat eggshell finish esthetically pleasing, and enhancing any "patine" (2) for mixing with any powdered color when applying to "tacky" surfaces (3) helps "pull together" the colors.

(h) *WAXING: POLISHING*

See "Semi-Transparent Finish" in this chapter.

Coloring Plasteline

The relatively soft state of plasteline sculpture does not preclude coloring, but it is best to first cover the plasteline with coats of "Sculp-Metal" which hardens the surface. Sculp-Metal can be purchased at any art supply store. Some sculptors apply a thin coat of shellac to plasteline sculpture which closes the pores, and subsequent coloring applied. It is best to first experiment with both these methods.

Brushes

Brushes should be cleaned after use. Do this before paint has stiffened the bristles. Paint should never be left to dry on them. Replacing brushes is too expensive, and for economy sake, as well as having good brushes to work with at all times, they deserve

better care. Rinse them after use with an appropriate solvent . . . turpentine, alcohol, paint thinner, kerosene, or any of the preparations sold in reliable paint stores. Newspapers are handy for squeezing out excess paint. After rinsing with solvent, wash brushes with warm water and laundry soap. Hardened paint on brushes may be removed by soaking them overnight in a solvent. If this doesn't work, use the liquid brush cleaning preparation sold in reliable paint stores. Lay brush flat, or stand them with bristles on top, when drying—they should never stand on the bristles when drying, for the bristles bend and get out of shape. Use good brushes for coloring, even though they are expensive. Cheap brushes shed their bristles much too frequently, and their removal from the cast is quite annoying. Incidentally, if shedding of bristles does occur, common tweezers is the handiest tool to use to remove them. Use hog brushes (bristles from pigs) in your work—nylon brushes are generally harsh and scratchy.

SEMI-TRANSPARENT FINISH

(a) *RE-EXAMINE CAST BEFORE COLORING*
 Do not start to color until you have thoroughly re-examined your plaster cast. Now is the time to look sharply for any defects caused by casting in plaster. Read "Repairing the Cast" in chapter "Plaster Casting by 'Waste Mold'" for procedures. This last minute attention before coloring may pay you big dividends, not only in improving the piece, but in the satisfaction that you have not overlooked the smallest detail in your creative effort.
 (If you have been using self-hardening clay in modeling, any changes, if needed, can be made at this time. Read "Repairing" in chapter "Clay-Self-Hardening" for procedures.)
(b) *THOROUGHLY DRY AND CLEAN BEFORE COLORING*
 The plaster cast (or self-hardening clay model) must be thoroughly dry before applying the shellac thinned in alcohol which seals the pores before color application. The adhesion of color is greater on a dry surface than on a damp one as the latter is absorbent. Use fine sandpaper, steel wool, or pumice stone, if necessary, to remove particles of dust and dirt. In plaster casts, if the dust or dirt cannot be removed with these means, it will be necessary to soak the cast as more fully detailed under "Cleaning Untreated Cast" in chapter "Care of Plaster Cast." During the entire process of coloring, keep the work in a clean place, and provide if possible a hood or cover to prevent dust from falling on and adhering to the surface.
(c) *SEALING PORES; USE OF SHELLAC*
 Seal pores with thinned shellac whether you are creating this semi-transparent finish, or any other color finish (but do not

seal pores when using analine dyes for coloring). If shellac is not thinned, it will crack and peal off. The solvent for thinning shellac is denatured alcohol. Both shellac and alcohol are available in any paint or hardware store. Use white shellac (not brown), preferably a four pound cut. Mix about two parts white shellac to about one and one-half parts denatured alcohol. If it thickens with the passing of time, a little alcohol can be added. Keep it in a closed jar at all times. If the jar lid sticks when opening, let hot water from the faucet run on it to loosen it up. With a soft brush, apply two coats of thinned shellac to the plaster cast—two coats are necessary because the plaster is porous and absorbent. (One coat of thinned shellac is generally sufficient on self-hardening clay as this type of clay is less porous than plaster.) The strength of the solution—proportion of shellac to alcohol—is a factor, too, in determining the number of applications required. Brush from top down, and avoid too frequent brushing over the same spot as it may disturb film of shellac which has a tendency to set quickly. Brush out any excess shellac (and as an early reminder, any paint in subsequent coloring) in crevices, hollows and undercuts as this clogs up the form and impairs the crispness of the texture. Dry thoroughly after first coat of shellac (about an hour or two) so that the second coat of shellac, when applied, will not soften and lift up the first coat. I prefer a more thorough overnight drying for safety sake. Likewise, dry thoroughly after final sealing of pores (a day or two) so that the solvent for the succeeding coat of color (turpentine, as later on indicated) will not soften and lift up the shellac. Remember this principle: since the solvent for shellac is alcohol, the solvent for the succeeding undertone should be different. A change of solvent, from shellac to paint or from one paint to another, is regarded by some sculptors as unnecessary if the preceding coat (be it shellac or paint) has been left to dry thoroughly. In either principle, a thorough drying of any prior coat is the key to prevent this softening and lifting up danger.

(d) *OPAQUE UNDERTONE*

Either oil colors or powdered colors may be used for the solid, opaque undertone, but whichever one is used, it is best to have turpentine as its solvent since the solvent in the shellac used for the sealing of pores was alcohol (although there are sculptors who prefer to mix their powdered colors in thinned shellac for the undertone, relying on the thorough drying of the prior shellac to prevent its softening and being pulled up by the succeeding solvent). Pour some turpentine into a small glass jar and into it mix some burnt umber which is an earth color. Any earth color can be used (umbers, siennas, ochres) but burnt umber is recommended because it is a warm, bronze-like color and makes an excellent undertone. The right amount of each ingredient is always

a problem with the inexperienced. The right amount of turpentine
and burnt umber is to make the mixture lighter than regular house
paint—that of a light creamy consistency—because in applying
coatings to sculpture, whether it be shellac or paint, the consistency
must always be thinned out. Thick layers of shellac or paint may
crack and peel off, also will clog up the crevices, hollows and under-
cuts, impairing the crispness of the texture. It is to prevent this
cracking, peeling, and clogging up of the form that the thinner
consistency is advisable. Apply with brush, top to bottom, doing
small areas at a time to prevent running of paint—where it does
run, feather-in to make for evenness of color, but do not go over
the same spot too often to make for a thick coat. Make sure you
paint all crevices, hollows and undercuts, and one way of being
certain about it is to turn the form upside down which helps to show
up missing places. Brush out these spots so that no excess paint
remains in them. If too thick a coating has been applied, it can
be reduced or removed by applying a soft cloth damped in turpen-
tine (alcohol, if powdered color mixed in alcohol was used), and
a light coating re-applied, if necessary. If the sealing of the pores
was satisfactory, one coat of color undertone should be sufficient,
however, a second coat may be needed, and it also may be applied.
Dry thoroughly between first and second coat (overnight) if two
coats are applied, and dry thoroughly overnight after the final
application of the undertone. The addition of beeswax to the
turpentine-color mixture is optional for an undertone. I find no
need to add the beeswax. The cast at this point will be shiny and
can be left that way since it is an undertone; if you like a mat
surface for the undertone, dab on ordinary talcum powder or the
cheaper French chalk as more fully detailed below under "Stippling
for Semi-Transparency."

 (e) *BRONZING (UNDERTONE HIGHLIGHTING)*

 You do not bronze the whole surface, but pick out and
touch up (highlighting) the tips, ridges, edges and projections of
the ears, nose, chin, eyelids, cheeks, hair. In other methods of "pat-
ining" where highlighting is the final step (see "Opaque Finish"
in this chapter), it is important that the highlighting not be garish,
vulgar and artificial looking; however, since highlighting in this
instance is an undertone (in addition to the burnt umber under-
tone), some aggressive highlighting is in order as the color finish,
though intended to be semi-transparent, will cover to a marked
extent both the bronze and umber undertone. For additional de-
tails on bronzing, read "Bronzing—Highlighting Opaque Finish"
under "Opaque Finish" in this chapter.

 (f) *SEMI-TRANSPARENT FINISH*

 Since we are seeking a semi-transparency of the color
finish, giving the sculpture piece two or more tonal colors (mean-

ing that we want some of the undertone to show through), we
should have for the color finish a lighter shade than the undertone.
Green is a very suitable color for semi-transparency, and in this in-
stance we are going to add this shade to the beeswax-turpentine
solution. The first step is to finely shred some beeswax, using a knife
or that common variety kitchen gadget, the potato peeler. Place the
shredded beeswax in a small glass jar, cover it with turpentine and
let it soak overnight. The turpentine should dissolve the beeswax
with this overnight soaking, and the solution should then have a
jelly-like consistency. If too thick, add more turpentine and repeat
the overnight soaking. If still too thick, do not hesitate to add
more turpentine since a thin "wash" is a "must" to achieve semi-
transparency. Use a larger glass jar for any increased solution,
and repeat the overnight soaking. Into the jelly-like solution of
beeswax and turpentine, mix the green color you have decided
upon for the semi-transparent shade. Mix just enough color so
that it acts as a coloring to the beeswax-turpentine solution to the
shade desired.

The ratio of the turpentine to the beeswax-turpentine-color com-
bination depends upon the thickness you want the mixture to be. The
answer is to see that the mixture for a semi-transparent color finish
has a sufficient amount of turpentine to thin out the mixture to a
"thin wash." Keep the mixture a "thin wash" throughout the
coloring process. If the color thickness, add a little turpentine to
it. If the mixture hardens between sessions, as it undoubtedly will
with the passing of time, place the jar under running hot water, or
in a pan of hot water, and the mixture should return to its liquefied
consistency.

The color of green you decided upon for the semi-transparent
shade may be a oil or powdered color. I prefer an oil color "ground
in japan" which is a finer ground paint than enamel (although a
flat, not glossy, enamel can be used). Artists' oil colors direct from
the tube can also be used. The "ground in japan" Prussian Blue
color (only a small amount is needed, no more than the amount
that can go on a thumbnail), mixed in "ground in japan" Burnt
Umber (or Raw Sienna, or Yellow Ochre which is somewhat
similar to Raw Sienna), will make an appealing olive green shade
of fine tonal quality.

Beeswax-turpentine-color mixture

Beeswax is made by melting and refining the honeycomb of the
bee. It is the foundation of most wax formulas. Dissolved in tur-
pentine, with or without coloring, it adds smoothness and unity
to the mixture. It also acts as a protective coating against dis-
coloration by dust or dirt for any color finish on a plaster cast
(or self-hardening clay model), and on metal patination. Some

sculptors dissolve beeswax more quickly by heating shredded pieces of it with turpentine in a receptacle in a pan of water. Heating turpentine, even vapors of it, being highly inflammable, is a very dangerous procedure and should be avoided. Other sculptors place the shredded beeswax in a double boiler (without turpentine), melting it under a low flame. When the wax thus becomes liquefied into a jelly-like substance, the flame is shut off (see that it is) and the turpentine is then added. Others, like myself, cover the shredded beeswax with turpentine and let it soak overnight. This should dissolve it into its jelly-like substance. This overnight soaking method is the safest way of making the solution without risk of fire. Should you wish to use beeswax in the beeswax-turpentine-color mixture for an opaque undertone, to be as nearly exact as possible, use about six to eight ounces of turpentine to one ounce of beeswax. An approximation of each proportion should do. Beeswax is inexpensive and available at most paint stores. If unavailable, beeswax can be dispensed with in any turpentine-color mixture. Without the beeswax, the mixture will still remain suitable for coloring. Beeswax can also be used as a wax base for the changing of color when using powdered colors, and for a final waxing and polishing procedure.

(g) *STIPPLING FOR SEMI-TRANSPARENCY*

To get a semi-transparency for the final color finish, I prefer to stipple on the beeswax-turpentine-color mixture with an almost dry brush. Use any good soft brush, round in shape, preferably a soft hog's hair brush. To achieve an almost dry brush, do not dip the brush directly into the colored mixture as too much of it will be taken up by the brush; rather, pour a little of the mixture into a shallow receptacle (preferably a flat plate) and take up as little of the mixture as possible on the brush. Even though you take up only a very small amount on the brush, dab the brush, as an added precaution, onto a clean cloth to eliminate what little excess paint there may be on the brush, leaving it that much drier. As the cloth itself on which you dab off any excess paint becomes saturated, you can pick up enough paint from that source with the brush for part of your stippling. Only an almost dry brush, using the thin wash of color, will produce the even, softly graded color tone that is a "must" for semi-transparency. If the green, in this instance, is stippled on lightly, it will allow the umber and bronze undertone to show through. If the stippling is too heavy and is more opaque than semi-transparent, use a second dry brush to even out the color by "feathering-in" and spreading the color until a semi-transparent effect is achieved. Look for brush hairs on the surface while coloring. A tweezer is a handy tool to take off unwanted brush hairs. Alternatively, to relieve a heavy stippling, you may use a soft cloth lightly damped with turpentine. By dab-

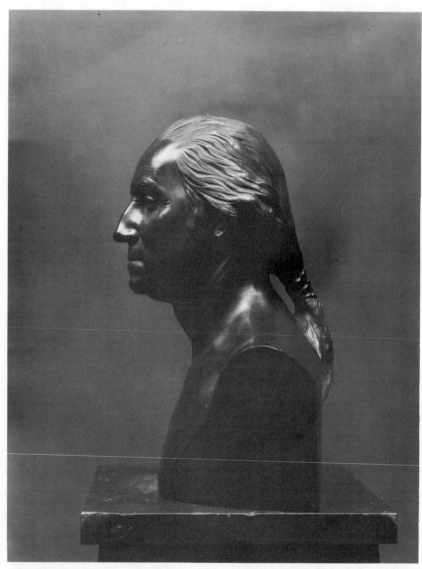

GEORGE WASHINGTON, by Clark Mills (1815–1883). *From the famous Houdon bust that had been sculpted from life at Mount Vernon in 1785. In the collection of The Corcoran Gallery of Art, Washington, D.C.; gift of the Artist.*

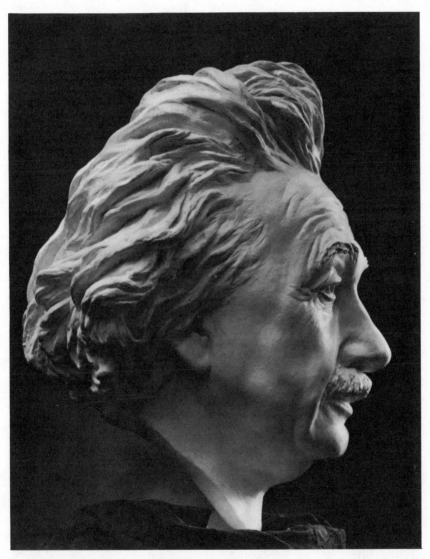

ALBERT EINSTEIN, by Eleanor Platt. *Courtesy of the National Sculp-*
ture Society, N.Y.

bing with the soft cloth lightly damped with turpentine, you should be able to reduce or remove the heavier, opaque application of the green paint, and it then can be re-stippled if necessary. If you wish for more transparency at this point, continue to lightly dab with the cloth dampened with turpentine, exposing more of the undertone. The cast will be shiny and may be left that way if you so prefer; however, if you want a dull mat surface, as most sculptors do, dab on ordinary talcum powder or the cheaper French chalk with a soft cloth or a lady's powder puff while the semi-transparent color is still "tacky" (almost dry). A dull mat or egg-shell finish is highly desirable as it permits the sculptural form to be better discerned; a shiny surface, on the other hand, reflects too much light and to a marked degree delimits appreciation of the form optically. Dab cloth or puff on lightly, making sure you are not picking up any green paint while you are dabbing. Look at the cloth or puff from time to time and if there is any green paint on it you are premature with your dabbing. Better wait a little while longer until the form is somewhat drier, then resume your dabbing. Talc in crevices, hollows and undercuts may prove a little difficult to brush out later on—a soft cloth damped with turpentine and lightly applied should remove the talc. If you fear the turpentine on the cloth will remove some color, try a brush lightly damped in water. Because of the beeswax in the mixture, thorough drying time may take longer—a week or two. Be patient —it will dry. A thorough drying is necessary before waxing and polishing. A premature waxing and polishing may rub off some color. Putting on a color finish, particularly for semi-transparency, should be done in broad daylight. Poor lighting, or artificial light-ing, makes an esthetic application difficult. Keep in mind that the whole idea of semi-transparency is to create a dark, glowing color undertone (with bronzing to highlight the prominences, if you wish) slightly concealed by a lighter, cooler shade above.

(h) *GAUZE OF CHEESECLOTH FOR SEMI-TRANSPARENCY*

An alternative method to stippling by brush to achieve semi-transparency is to use a small wad of gauze or fine cheesecloth. Dip a brush into the jar of beeswax-turpentine-color mixture and deposit a small amount from the brush into a shallow receptacle (preferably a flat plate) to limit the amount of color which is to be applied to the gauze or cheesecloth. When dipping gauze or cheesecloth into the paint on the flat plate, you will find that the color does not close up the spaces between the fibers, being ab-sorbed only by the fibers themselves. Dab lightly. Follow the gen-eral procedures for stippling. Another method is to brush color on lightly and then wipe off with a soft dry cloth, gauze or cheese-cloth—or using any of these items moistened in paste wax or dampened in turpentine. Follow the general directions for stip-pling.

Have you been doing all of your coloring up to now in a clean place where particles of dust and dirt have not been falling on your work? Check it.

(i) *SPATTERING FOR SEMI-TRANSPARENCY*

The trick in this method is to hold an almost dry brush with the bristles upright, and "flicking" or splattering on the color. Make sure that the paint splatters on the cast in very tiny speckles. The brush should be a straight one, not round, and the bristles must be cut short. Any toothbrush can also be used for splattering. It is wise to experiment with this procedure before using.

(j) *CHANGE OF COLOR (if desired)*
If color finish is still "tacky"

Perhaps you want to change color at the completion of any of the methods for the semi-transparent color finish. It can be done—probably at the cost of the semi-transparency. (Likewise, you may want to change color at the completion of the color finish in "Opaque Finish" in this chapter). If the color finish in either case is still "tacky" (almost dry), mix some dry powdered color, or a combination of colors to the hue desired, with some talcum powder or French chalk. Stipple on this dry powdered intermixture with a soft brush, or dab it on with a soft cloth or lady's powder puff. Make sure it is sticking to the "tacky" surface. Also make sure that you are not lifting up any paint. Look at the brush, cloth or puff repeatedly, and if there is any trace of paint on it, you are premature with your change of color—better wait a little while longer until the plaster cast (or self-hardening clay model) is somewhat drier, then resume your change of color. Let it dry overnight if you want to re-highlight with the bronze powder. Let it dry for a week or so before waxing or polishing. Waxing and polishing before colors set may rub off some of the color.

(k) *WAXING AND POLISHING*

Beeswax

If beeswax was used for the mixture in the finish color, no further waxing is necessary. Polishing must wait until the color finish is thoroughly dry (a week or so), otherwise the polishing may rub off some of the color. Use a soft cloth for polishing. Rub gently at all times to insure that the colors do not come off.

Paste Wax

If beeswax was not used for the mixture in the finish color, follow the finish color with a waxing by paste wax (not liquid)— again, a word of caution not to use wax until the plaster cast (or self-hardening clay model) is thoroughly dry (a week or so). Waxing before colors are set may very likely remove some of the color. A gentle rubbing of the paste wax with a soft cloth will give a polished look to the sculpture piece. Use of talc or chalk

helps in the polishing, imparting a pleasing bloom. Polish the en-
tire head, or restrict polishing to specific areas intended for con-
trast or highlighting, as you wish. Later on, from time to time,
go over your sculpture with the paste wax—with a little gentle
polishing you will retain that soft, glowing effect.

Wax as a protection coating

Wax polishes are generally the best finishing medium to fix the
coloring, and for protective care. Applied to the plaster cast (or
self-hardening clay model), it adds a protective coating. Likewise,
applied to metal bronze, a beeswax solution or paste wax acts as
a protective coating. Applied two or three times a year, it keeps
the patine looking its very best.

(1) *CHANGE OF COLOR (if desired)*
 After Waxing and Polishing

Perhaps after some period of display you wish to change color
finish. This can be done in two ways (1) Use beeswax-turpentine
solution, or paste wax. Cover the entire head. When the wax cov-
ering is "tacky" (almost dry), apply powdered color. Follow the
same procedure outlined above under "if the color finish is still
'tacky'." Make sure it is sticking to the "tacky" waxed surface. If
the surface is not "tacky" enough, only a limited amount of the
powdered color will adhere to the waxed surface (2) use oil or
powdered color. Cover the entire head. When paint is still "tacky,"
use cloth or powder puff and dab on talc or chalk for a dull, mat
finish.

OPAQUE FINISH

(a) *RE-EXAMINE CAST BEFORE COLORING*
 See "Semi-Transparent Finish" in this chapter.
(b) *THOROUGHLY DRY AND CLEAN BEFORE COLORING*
 See "Semi-Transparent Finish" in this chapter.
(c) *SEALING PORES; USE OF SHELLAC*
 See "Semi-Transparent Finish" in this chapter.
(d) *OPAQUE UNDERTONE*
 See "Semi-Transparent Finish" in this chapter.
(e) *OPAQUE FINISH*
 For the sake of economy, let us use what is left of your
undertone burnt umber color. If you wish, a little vermilion red or
venetian red mixed with the umber will change the burnt umber
shade to a slightly reddish hue which will make a fine, warm
color finish. Either oil or powdered colors may be used for a
solid, opaque color finish, but since the undertone in this instance
has turpentine for its solvent, it is preferable to use a powdered
color mixed in thinned shellac for the color finish (although there
are sculptors who prefer to mix their oil and powdered colors in
turpentine, relying as they are in this instance, on the thorough

drying of the prior turpentine-color mix to prevent its softening and being pulled up by the succeeding solvent). Let us go along with these sculptors, and we, too, will use an oil color mixed in turpentine for the color finish, as our undertone color has had a thorough drying period. A proper mixture, and its application, is the same for an Opaque finish as an opaque undertone. One coat of paint is usually sufficient for the opaque color finish, however, where there is a change of color between undertone and finish, a second coat for the finish may be needed. Dry thoroughly overnight between the first and second coat, if two coats are applied. You may use beeswax in your turpentine-color mix, or not, as you see fit. Look for brush marks on the cast while painting. A tweezer is a handy tool to take them off. Brush marks will ruin the illusion of true patine. When "tacky" (almost dry), dab on talcum powder or the cheaper French chalk to eliminate the glossy shine of paint, giving the cast (or self-hardening clay model) a dull-colored mat finish. The talc or chalk will help to pull the colors together. Use a soft cloth or lady's powder puff—dab lightly and make sure you are not lifting up any paint. Look at the cloth or puff repeatedly and if there is any traces of paint on it, you are premature with your talc or chalk—better wait a little while longer until the cast is somewhat drier, then resume your dabbing with talc or chalk. Talc in crevices, hollows and undercuts may prove a little difficult to brush out later on. A soft cloth damped with turpentine and lightly applied should remove the talc. If you fear that the turpentine will remove some color, try a brush lightly damped with water. Let dry thoroughly overnight, and then highlight with the bronzing powder as hereinafter explained.

(f) *CHANGE OF COLOR (if desired)*
If Color Finish Is Still "Tacky"
See "Semi-Transparent Finish" in this chapter.

(g) *BRONZING (highlighting opaque finish)*
When bronzing for highlights as the last step in "patining" (before waxing and polishing), a softer tone is more suitable than a brighter one. The latter can appear garish, vulgar and artificial looking. Reducing the quantity of bronzing powder, and increasing the amount of solvent (thinned shellac, turpentine, bronzing liquid), will reduce the strength of the powder and soften its tone. Apply gently, and in small areas, using a tiny artist's brush. Afterward, use the ball of your thumb or a soft cloth to spread the highlighting, if needed. For highlighting, pick out and touch up the tips, edges, ridges and projections of the ears, nose, mouth, cheeks, chin, eyelids, hair. Highlighting should be done in broad daylight. Poor lighting, or artificial lighting, makes an esthetic application difficult. Let dry thoroughly—a week or so—before waxing and polishing. Waxing and polishing before colors or bronze highlighting is set may rub off some of the color or bronzing.

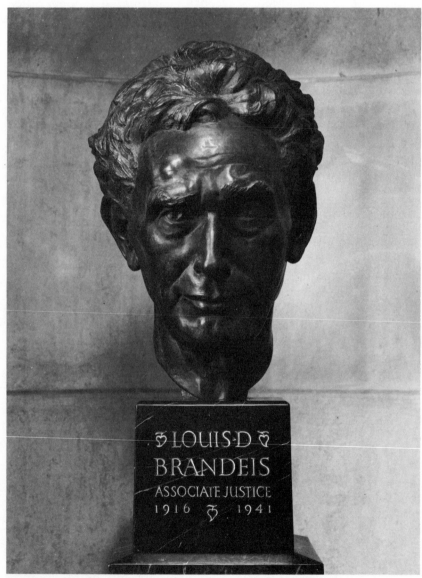

LOUIS D. BRANDEIS, ASSOCIATE JUSTICE, by Eleanor Platt.
*The Metropolitan Museum of Art, Gift of Charles F. Burlingham, Bernard
Flexner, and Thomas D. Thacher, 1942.*

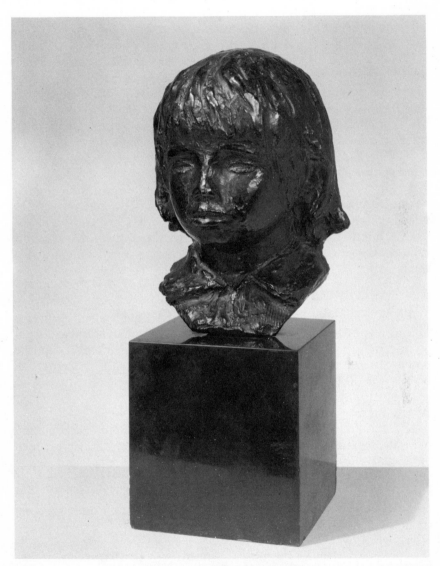

HEAD OF COCO, by Auguste Renoir (1841–1919). *Philadelphia Museum of Art.*

Application

Pour a little of the gold or other suitable bronzing powder in a small receptacle (a small glass or measuring cup will do) and mix into it a small quantity of solvent (thinned shellac, turpentine, bronzing liquid). I prefer in this instance thinned shellac or bronzing liquid because either of these solvents is different from the turpentine used as a solvent in the color finish. From the receptacle, transfer a little of the mixture onto a flat plate which makes it possible to pick up only small quantities at a time whether by brush (a tiny artist's paint brush) or a soft cloth. For further data on bronzing, read "Bronzing Powders" in "General Outline of Procedures" in this chapter, and "Bronzing-undertone highlighting" in "Semi-Transparent Finish" in this chapter.

Application by Brush

If you are using bronzing powder in liquid form, apply lightly with a tiny, artist's paint brush. Dip brush lightly into mixture to avoid taking up too much of the mixture. It is safer to pour some of the mixture onto a flat plate, and to dip the brush onto this type of shallow receptacle—picking up only a small amount at a time.

Application by cloth

When using dry powder instead of the liquid form, I prefer placing the bronzing powder in the palm of my hand (spreading it on the palm), and with wax paste on a soft cloth take up the powder from the palm of the hand. Powder should be smoothed out on the cloth so that no clots remain.

Avoid aggressive highlighting

If the highlighting appears too aggressive, spread the bronzing with the ball of the thumb, or a soft brush—or it can be taken off with a cloth slightly moistened in paste wax or solvent (same solvent used in the mixture for highlighting). Also, instead of spreading or taking off the aggressive highlighting, it can be covered with a semi-transparent thin wash. Highlighting must be done thoughtfully, for esthetic taste is here required.

(h) *WAXING AND POLISHING*

 See "Semi-Transparent Finish" in this chapter.

(i) *CHANGE OF COLOR (if desired)*

 See "Semi-Transparent Finish" in this chapter.

OTHER "PATINE" FINISHES

Terra-Cotta

When certain types of clay have been fired, it is called "terra-

cotta" which means "baked earth." It is this terra-cotta effect, from a light buff to deeper reddish hues, that we wish to achieve by the superficial coloring ("patining") of the plaster cast surface (or on the self-hardening clay model). As in previous recommendations, re-examine cast for any defects that need repair, and make sure that the piece is thoroughly dry and clean, before sealing pores. It is especially important in a terra-cotta job to seal pores to prevent absorption, otherwise the terra-cotta finish may be uneven in appearance. Paint on one or two coats of venetian red mixed with a small amount of yellow ochre (or venetian red, a small amount of yellow ochre and some white for a lighter shade). Some sculptors like to apply a lighter shade first, and a darker shade for the second coat. The darker shade is then wiped off while wet, leaving the darker tones in the crevices, hollows and undercuts. Some sculptors try to achieve a semi-transparency effect by applying a darker shade first, and a thin wash of a lighter shade for the semi-transparency effect. Talc or chalk can be used for the dull mat surface. Polishing the entire head lightly, or just highlighting prominences by light polishing, is a matter of taste. Do not polish too much, as terra-cotta finishes do not look well if excessively polished. Waxing is in order. I presume you have done some "patining" under the procedures of "Semi-Transparent Finish" and "Opaque Finish" detailed in this chapter which should prepare you for achieving a terra-cotta finish.

White

Successive milk applications will give an untreated plaster cast a white, marble-like effect. Repeated saturations are needed— three, four or more times. Allow plaster cast to dry thoroughly between applications. Polish afterward to enhance the marble-like quality.

Ivory

For a soft ivory finish, give the plaster cast two coats of thinned shellac, allowing the cast to dry thoroughly overnight between coats. Use the same mixture of thinned white shellac you used for sealing pores. Some sculptors use a thinned orange colored shellac for the second coat. Others add a bit of powdered color to the second coat of white shellac like the colors of yellow ochre or raw sienna. If you wish a polished surface, cover piece with paste wax and polish.

Milk and Whiting (for semi-transparency finish)

Milk and whiting can be used for an interesting "patine." Try this method. You will probably like the effect. Seal pores, of course. Let shellac dry as previously explained. Paint on a burnt umber undertone. Now mix some whiting (inexpensively purchased at any paint store) with milk to a very light paste consistency. Paint entire plaster cast (or self-hardening clay model) with the mixture. The coating of milk and whiting over the burnt umber undertone will very likely dry on the piece in a most uneven manner. Don't mind appearance at this stage. Now try for a semi-transparent effect by using same procedures outlined in "Semi-Transparent Finish" in this chapter. The burnt umber and milk and whiting undertones will show through any color finish with somewhat of a granite-like effect.

30

Bronze Casting

Purpose

Every sculptor would like to see the results of his clay or plasteline modeling brought to its final conclusion—the casting from the intermediate plaster cast (*see* chapter "Plaster Casting By Waste Mold"), or from the hardened, air-dried, self-hardening clay model, into the permanent medium of bronze, for which his work was designed. Since the cost of casting into bronze is expensive (understandingly so, because of the intricacies and difficulties of the methods required, and the master craftsmanship needed for it), the beginner, amateur, and student may well feel that the beginning effort in his development as a sculptor does not justify this extra cost—that he should reserve the pleasure of seeing his work in metal bronze for his later pieces. The aspiring sculptor, however, though he need not have a complete knowledge of the many factors that go into bronze casting, chasing, patination, etc., should have at least an elementary understanding of the subject. The understanding of these methods will better help him to prepare his sculpture piece so that the best results in bronze casting can be obtained. We will here deal with the subject of bronze casting, not as a thorough technical presentation, but only as an outline of procedures toward this better understanding. Briefly, then, the following basic principles and procedures about the two time-honored methods of casting into bronze.

Lost-Wax (Cire-Perdue) Method

It begins with the making of a mold—either gelatine or rubber (which is the method described here, though other variations can be employed). When the mold is cured, it is removed from the plaster cast (or hardened, air-dried, self-hardening clay model). The mold is then put back together, and a melted wax coating, or coatings, is applied to its inside to a thickness desired for the bronze cast. The wax becomes a replica of the plaster cast (or

self-hardening clay model), and soon becomes sufficiently hard for handling. The sculptor can work on the waxen form for correction, if needed—a distinct advantage of the lost-wax method over the sand-mold method. The inside of the waxen thickness is then filled with a core material of ground brick, plaster, and water for the purpose of making the bronze cast hollow. This core material will quickly dry into a hard substance. The gelatine or rubber mold is then removed. Wax rods (called sprues or gates, and vents) are attached to the waxen form (the sprues to permit later passage of the molten bronze; the vents to allow escape of air, and the heated, pressure-forced gases formed at the time of the molten bronze pouring). The sprues or gates branching off from the main sprues or gates should angle upward to the waxen form. This is desirable, for the molten metal should enter the space vacated by the melted wax without agitation. That is to say, it should not fall into the space, rather, it should enter it only when the level of the molten metal is at that point. Also attached to the bottom of the waxen form is a wax drain to evacuate the wax at the time of heating (which will be plugged before the molten bronze is poured). Also at strategic positions, metal pins must be inserted through the wax into the core, with part of the pin left protruding from the wax into the negative containing (investment) mold which will be built up later on the outer side of the waxen form— thereby anchoring the core and negative containing mold in the same relative positions after the wax is melted out. The negative containing mold (made up of the same material as the core) is then built in a barrel-like shape to a desired thickness, and strong enough to withstand the force of the molten bronze. The entire assembly should be bound with wire to strengthen it. With the completion of the negative containing mold, and when it and the core is dry and hardened, the entire assembly is placed in an oven and heated, first to eliminate all moisture, secondly to remove all wax. The wax is melted out through the drain by the heat (approximately 1200 degrees Fahrenheit). When all of the wax has been evacuated from the mold, and any residue burned out, the oven temperature is dropped. When the mold has cooled to about room temperature, the molten bronze is then poured via the sprues into the space formerly occupied by the wax. Pouring is done while mold is wedged securely in a casting container or pit. When the molten bronze has cooled and hardened, the outer mold is broken away, and the core removed. Sprues, vents, and pins are now cut away. A bronze cast is thus born. It is the melting out of the wax that gives the name "Lost-Wax" to the process. Lost-Wax casting is generally done for the more complicated sculptural pieces, and usually produces a more faithful reproduction of the plaster cast (or self-hardening clay model) than casting by the Sand-Mold

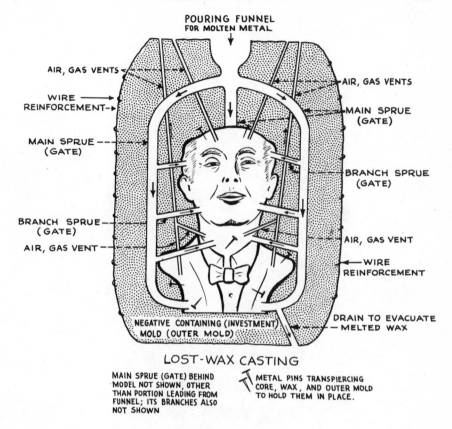

POURING FUNNEL
FOR MOLTEN METAL

AIR, GAS VENTS

WIRE
REINFORCEMENT→

MAIN SPRUE
(GATE)

BRANCH SPRUE
(GATE)

AIR, GAS VENT

AIR, GAS VENTS

MAIN SPRUE
(GATE)

BRANCH SPRUE
(GATE)

AIR, GAS VENT

WIRE
REINFORCEMENT

DRAIN TO EVACUATE
MELTED WAX

NEGATIVE CONTAINING (INVESTMENT)
MOLD (OUTER MOLD)

LOST-WAX CASTING

MAIN SPRUE (GATE) BEHIND
MODEL NOT SHOWN, OTHER
THAN PORTION LEADING FROM
FUNNEL; ITS BRANCHES ALSO
NOT SHOWN

METAL PINS TRANSPIERCING
CORE, WAX, AND OUTER MOLD
TO HOLD THEM IN PLACE.

method. Only one casting can be made from each wax pattern. Many wax patterns can be made from the gelatine or rubber mold. The "Lost-Wax" method has been used since ancient times.

Sand-Mold Method

The second method for bronze casting is the "Sand-Mold" method. The process was not known until the 14th or 15th century A.D. (*History of Technology*, edited by Singer & Hall, Oxford U. Press, 1956.) Like the Lost-Wax method, it requires a hardened form to cast, either a plaster cast, or a hardened, air-dried, self-hardening clay model. Both should be treated with shellac to prevent absorption of moisture from the sand.

A fine-grained sand is necessary for the sand mold—fine enough to make a perfect impression of the form to be cast, and yet strong enough to resist the pressures of the molten bronze. A preferred variety, producing a detailed bronze cast, is imported from France.

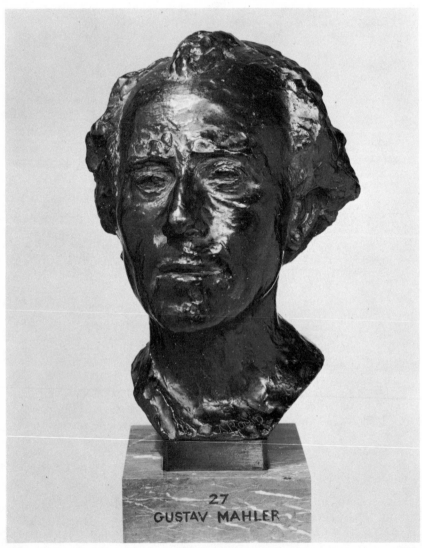

GUSTAV MAHLER, by Auguste Renoir (1841–1919). *Philadelphia Museum of Art.*

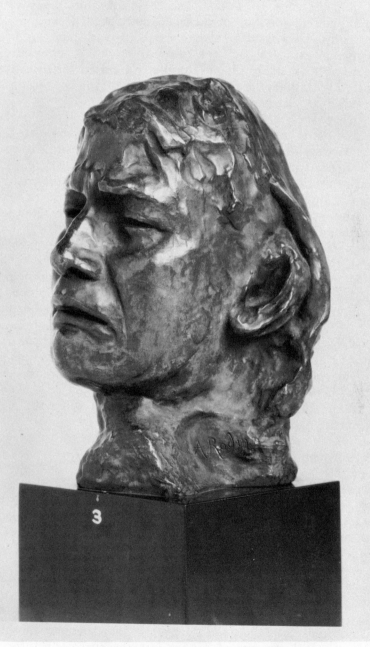

CRYING GIRL, by Auguste Rodin (1840–1917).*Rodin Museum, Philadelphia. Courtesy, Philadelphia Museum of Art.*

It is referred to as "French sand," and it is adhesive almost like clay which is a requisite of a sand mold.

The frames, known as "flasks" are used to form the sand-box to hold the form to be cast, and the sand mold. They are made up of either wood or metal, and are placed around the entire assembly. They must be strongly built to withstand the pressures of the molten metal, and the two frames must be close-fitting and held firmly together. Clamps and bolts are used for the latter purpose. The flask on the top is called a "cope"; the one on the bottom is called a "drag."

In making a casting, the mold-forming sand is dampened, and packed tightly around the form to be cast in one complete unit, or, as generally done, in sections or mold pieces. Mold pieces assure a better casting when the form is complex, and where undercuts and projections complicate the casting. When all the mold pieces are put together, an impression of the form to be cast is thus made, leaving every detail of its shape sharply outlined in the firm sand. An accurate impression is obviously very important for a successful cast. Since the form to be cast is imbedded in the piece-molded sand, the mold pieces must be taken apart for its removal. The mold pieces are then put back again, followed by the making of the core. The core, required for a hollow cast, is built up inside the impression made by the form, with sufficient space left between the core and the mold to the desired thickness of the bronze cast. It is this space which will later receive the molten bronze. Core must be held firm so that it will not shift in the mold. This is done by iron rods from mold to core. Cores are often eliminated where the saving of metal in the hollow cast, and weight reduction thereby, is minimal; also where there is a wish to avoid the problems attendant on the making of a core. Small sculptural pieces are usually not cored, but are cast solid.

Thorough preparation must be made for (a) iron rods to prevent shifting of the core (b) wax rods in the core which, when melted away by heating will form vents from the core to allow escape of air and gases (c) hollow pipe from core for escape of wax (d) funnel for pouring molten metal (e) sprue channels in the sand for passage of the molten metal (f) vent channels in the sand for escape of air and gases.

With the entire assembly completed, it is now ready for heating or baking. When the whole is thoroughly dry and hardened by the baking, the space between the core and mold is now ready to receive the molten bronze. The molten bronze is poured into a funnel, and from there into sprue or gate channels in the sand which channel the molten bronze into the space heretofore mentioned. Vent channels in the core and mold carry off the air, and the heated, pressure-forced gases formed at the time of the metal

pouring. The bronze cast is thus born. When cool, flask and sand mold are removed, core is shaken out, and the bronze cast lifted. Sprues and vents are now cut off. Chasing follows, after which the bronze cast is patined.

The Sand-Mold method is more economical than the Lost-Wax method. While both methods are used for casting sculptural pieces, the Sand-Mold method has a wider application for industrial uses. It is a method used with much frequency in casting less complicated sculptural pieces, both monumental and small, that have a minimum of undercuts and projections, or none at all. It generally does not produce as faithful a reproduction as the Lost-Wax method, and sometimes requires more surface finishing or "chasing." In the Sand-Mold method, duplicates in unlimited quantities can be made from the plaster cast (or hardened, air-dried, self-hardening clay model).

Both the "Lost-Wax" and "Sand-Mold" methods are normal practices in the present-day art foundries, with each foundry more or less specializing in one or the other method. The sculptor's detailed and often intricate modeling is not impaired in either method since the molten metal fills its allotted space completely. Both methods make hollow, shell-like castings which are economical of metal than the solid metal cast, weighs less than the solid cast, and is considered structurally stronger than the solid cast. While all bronze casts shrink in proportion to their volume, the hollow casting will have less shrinkage because of its lesser volume.

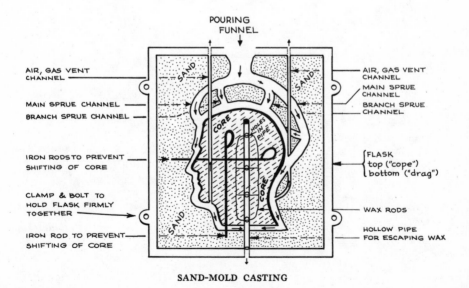

SAND-MOLD CASTING

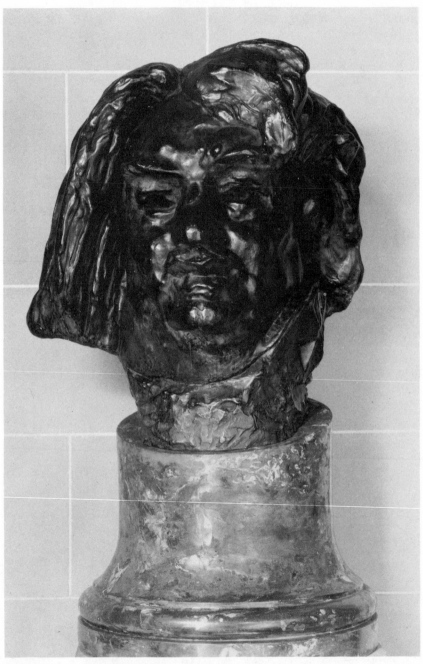

BALZAC, by Auguste Rodin (1840–1917). *Rodin Museum, Philadelphia.*
Courtesy, Philadelphia Museum of Art.

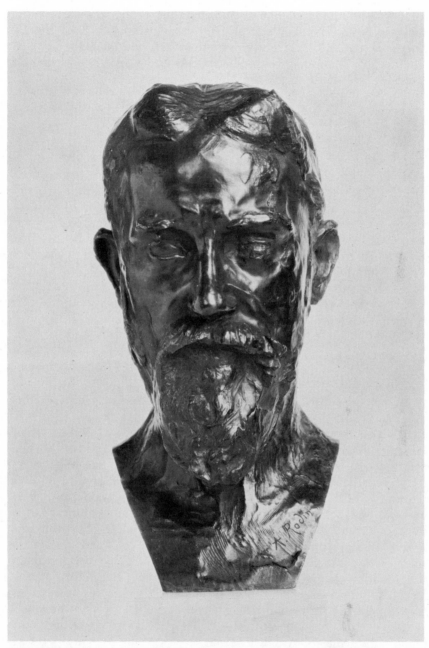

GEORGE BERNARD SHAW, by Auguste Rodin (1840–1917). *Rodin Museum, Philadelphia. Courtesy, Philadelphia Museum of Art.*

As indicated at the outset of this chapter, the details set forth in both methods are not a thorough technical presentation, but only an outline of procedures. The procedures of each of the two methods are much more involved than here stated, since many of the technical details were eliminated in the interest of an elementary presentation of the subject.

Chasing

Bronze casting rarely achieves a perfect surface. Almost all castings need surface finishing or "chasing" as the final job of working on the metal surface is called. Chisels, files, and other chasing tools, are used to remove the rough surfaces where sprues, vents, pins, etc., were cut away after the casting had cooled and hardened. Resulting from air bubbles in the molten metal, small blow-holes need taking care of; surface blisters need to be filed down; metal seams left from sand-mold pieces must be smoothed over. Dirt and "fire-scale" on the casting must be removed. After a thorough chasing, the worked areas can be burnished to make them indistinguishable from the rest of the surface.

Patina

Raw bronze, as it comes from the furnace, has an unsatisfactory raw quality to many sculptors, and requires "patining" to give it their desired surface appearance. If left "raw," a coating of oil enhances its raw appearance. A coat of fine lacquer helps to preserve the natural color or colors of the raw bronze, and to preserve it from oxidation. Left alone, bronze in time will acquire its own patina or color. To hasten the natural process of oxidation, there are two common methods of getting this result—that of heating by blow-torch, with the application of acids while the bronze is hot; the second method is done by applying cold chemicals to a cold metal surface. While a few sculptors do their own patining, the foundry is generally called on to do it. Patinieres at the foundry, with a high degree of technical skill, can produce an infinite range of colors with the many acid solutions and chemicals at their command—different effects being obtained from different acids and chemicals. While the patina is one of personal preference, consideration must be given to the sculpture's intended architectural surroundings, its intended atmospheric environment, and the relationship of its colors to the decorative scheme of the area. A good patina should appear completely natural, and should be sufficiently thin and transparent as to emphasize the bronze's

metallic qualities. Most sculptors like to anticipate the effects time and atmosphere would have given the piece. Needless to say, a suitable patina always enhances appearance and appreciation of the sculptural piece.

Care of Bronze

Bronze sculpture on display at home and elsewhere should not be left uncared for. Surfaces should be kept clean and radiant by removing soot and dirt every week or two with a clean cloth. Rubbing should be gentle and even. Rubbing too hard is to be avoided, especially on projections like nose, ears, etc. Get soot and dirt out of the crevices, hollows, and undercuts by using a soft brush. A light rubbing with paste wax helps to keep the lustre at its best. Take care of your bronzes as you would take care of fine woods.

31

Relief

Meaning

"Relief" is a sculptural form in any medium which either projects from a flat surface, or is recessed from a flat surface. The flat surface remains as an integral part of the design. The sculptor chooses the degree of projection depending upon the design and composition, and the use to which the relief is to be put. The degree of projection from the flat surface background is called low-relief (bas-relief or basso-relief), medium-relief (half-relief or mezzo-relief) or high-relief (haut-relief or alto-relief). When the design is recessed below the level of the flat surface, it is called intaglio-relief. Intaglio-relief appears to be man's earliest effort to depict the world around him, dating back to prehistoric times. The design and composition in relief can be made to require a minimum of modeling or carving, or can be made elaborate in detail requiring substantial work. While both methods of making a relief—projected or recessed—are accepted practices, present-day tendencies is to build up the forms in bas-relief, medium-relief, or high-relief. Relief sculpture is a contrast to sculpture in the round, the latter being free in space and capable of being freely viewed from all sides, while the former presupposes its existence on a wall with no view from its rear. For this reason, relief sculpture is thought of by many as "pictorial" sculpture, belonging to drawing or painting instead of sculpture. Architectural panels carved in walls, or attached to walls, are placed in the "Relief" category.

The term "Relief" means a sculptured design raised from a flat surface. The relief can be any depth—from very flat to medium high which can be almost full round except that it is still set against a background. A relief, which is a step between painting and sculpture in the round, can be far more pictorial than a sculptured block. It is a dimensional picture which creates the illusion of depth greater than it is. It can be decorative and flat with just a minimum of modeling, or a skillfully modeled or carved sculptural design, either low, medium or high in depth.[9]

Attached to a background, in opposition to sculpture in the round.[1]

Materials and Equipment

Modeling board

Since clay or plasteline for the relief is applied directly on the surface of a wooden board, care must be taken to prevent the wood from warping. This can best be achieved by using a strong, flat plywood board, rather than a regular one-piece board. Plywood, because of its cross-layers of wood, makes for less likelihood of warping. Cross-strips of wood on the back of the board also helps to prevent warping; cross-strips are also recommended to facilitate handling. Board should be square or rectangular so that the corners of the wall or fence can be mortised for a tight fit to contain the materials that make up the relief.

Wall or Fence

Most sculptors fasten strips of wood on the surface of the board at the two sides to contain the moist clay or plasteline (or self-hardening clay); others add a similar strip at the bottom of the board. The novice may feel more secure if the containing wall or fence was on all four sides. Fence may be nailed or screwed to the board. Screwing fence to the board is more desirable, as it needs to be removed and subsequently reset as described later on. The height of the fence should be the height of the surface of the background (about three-quarters inch on an average), and if needed, to an additional height which will be slightly higher than the highest point of the relief. Some sculptors make their wall or fence from plasteline when using clay as the medium.

> Nail around outer edge of both sides strips of wood with a depth equal to the required depth of the background.[1]

> Reinforce back with crossbars that will prevent warping and assure him of a flat, even surface on which to lay his background. The sculptor next fastens two strips of wood to the two sides, projecting to the top level which he wishes to establish for his background.[6]

> A couple of strips of wood the approximate depth of the relief are nailed parallel on a shellacked board.[11]

> The frame or board must be deep enough to contain the greatest projection of the relief and still allow for an inch depth of clay on the background.[8]

Easel

Working on a relief should be done by placing the board on an easel which, for greater convenience, should be tipped backward at an angle. Other sculptors find it convenient to lay the work on its back, or leaned against a wall. Use whichever method is

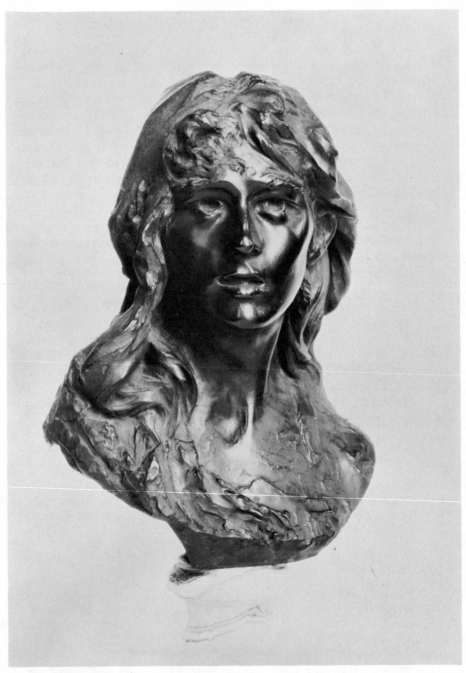

MADAME RODIN, by Auguste Rodin (1840–1917). *Rodin Museum, Philadelphia. Courtesy, Philadelphia Museum of Art.*

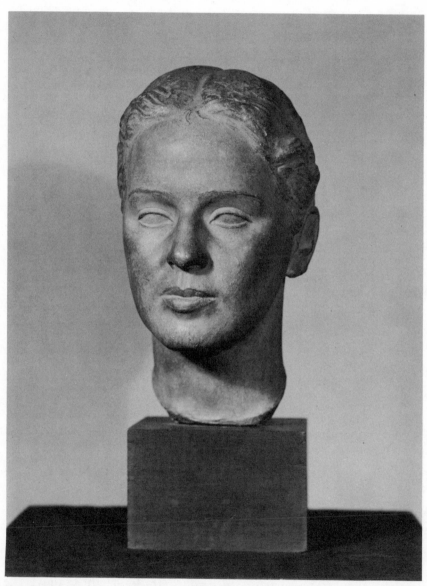

PORTRAIT OF A LADY, by Harry Rosin. *Courtesy of The Pennsylvania Academy of the Fine Arts, Philadelphia, Penna.*

best adapted to the size of the relief, and which best suits your convenience.

> Board should be clamped tightly on easel with a strong screw clamp so that you can stand or sit before it as you would in painting a canvas.[2]

Nails

To hold the material in place, flat-headed nails should be driven into the board two to three inches apart. Head of nail should project about one-half inch from the board.

> Some small nails put into the frame with heads exposed will help hold the clay.[9]

> Flat-headed zinc nails, half the depth of the final background, will help hold the clay.[6]

> Flat-headed zinc nails driven in backboard with heads projecting ½" or so assist the clay to adhere to its wooden background.[8]

Shellac

It is best to shellac the board several times until a hard shiny surface is obtained, to prevent its absorption of moisture from the clay and thereby save the board from warping—also to prevent the absorption of oil from plasteline if the latter is used. You may want to re-shellac the board when you use it for the second time.

> The board should be well shellacked to prevent absorption of moisture.[6]

> Heavily coat three or four times with shellac until board shows a hard shiny surface.[1]

> Paint board with two or three coats of thin shellac. The shellac will keep the board from warping or peeling when using moist clay, and will prevent the board from absorbing the oil from the plasteline.[9]

> Shellac the board to prevent the wood absorbing moisture from the clay.[8]

Modeling Procedures

Background

Build your moist clay (plasteline or self-hardening clay) background about three-quarters of an inch thick—slightly above the wall or fence containing it. This is an average depth for most small reliefs. Press material firmly to the board and sides. This avoids air bubbles. A firm, flat base or background is needed for modeling, therefore, let the moist or self-hardening clay harden just a little. In hardening a little, there might be a slight shrinkage

all around the fence. This can easily be filled in, and the surface again smoothed out. Whether you are building up your relief from the background, or cutting back the relief from the surface of the background, the background itself is very much a part of the whole composition, and must be incorporated into the design. Unless the relief is large, or is high-relief, there is seldom a need for a supporting armature. When an armature is used, it is generally made up of wood or lath strip, or wire, built on the surface of the modeling board. For very large work, some heavier material like flexible lead wire or piping which can be bent to conform to shapes to be modeled, would be used.

Build up a solid clay mass to the desired thickness.[9]

Make your placque about one inch thick. This will allow for a firm foundation and also give sufficient depth for intaglio or engraved aids to your sculpture.[12]

If the clay is not firmly pressed down and air holes are left beneath, the ground will later become lumpy and a lot of time can be wasted in obtaining a flat surface again. After flattening, let the clay harden a little. At the end of this time there may be a little shrinkage of the clay particularly where it touches the outside wooden surround. Further soft clay should be applied and the clay once more smoothed over. The whole panel should then be left exposed to the air for a short time until the background becomes firmer.[1]

Flatten Surface

First cover the board with your clay or plasteline slightly above the height of the wall or fence. Then, resting a strong wire or the edge of a ruler on the side fence, remove the surplus clay or plasteline by running wire or ruler from top to bottom. If any holes show up, fill them and repeat the flattening procedure until the surface is flat again.

Cover the board with clay firmly to an amount exceeding the quantity required. The surplus clay is then sliced off with a short length of wire provided with handles. The result is a level slab of clay ready for use.[8]

When you have built a solid area of clay, shave surface evenly by running a wooden ruler edge or a long even strip of wood up and down over the clay, the strip edges resting on the curb strips.[12]

A length of smooth wood—any good, firm sort of ruler will do for this operation, a slightly toothed one will give a texture, if required—reaching across the panel of clay from side to side, and with both ends resting upon the outside strips of wood, should be dragged very firmly from top to bottom of the panel until the superfluous clay is removed and the surface left level with the strips.[1]

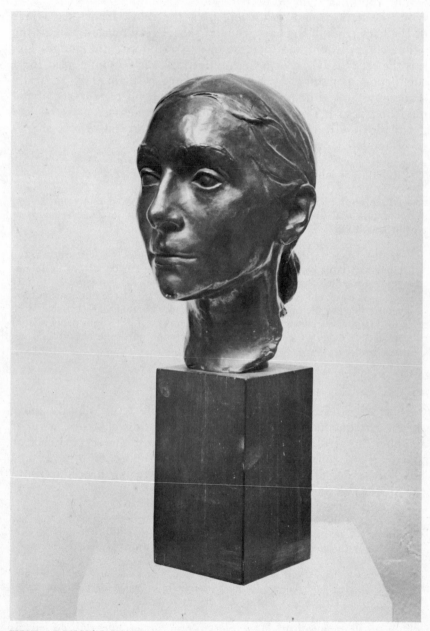

THE ARTIST'S WIFE, by Charles Rudy. *Woodmere Art Gallery, Philadelphia, Penna.*

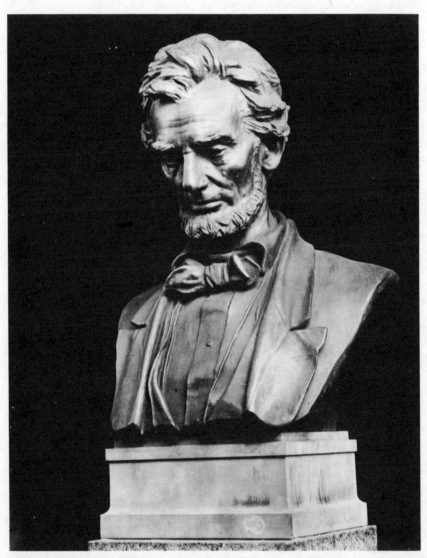

ABRAHAM LINCOLN, by Augustus Saint-Gaudens (1848–1907). *The Hall Of Fame For Great Americans at New York University.*

Keeping clay moist (between sessions)

Use a hand spray for a light moistening of the clay, then cover with cloth. A plastic cover over the cloth will help to keep the clay moist. A frame, or any other contrivance, set over the sides, will keep the damp cloth off the relief surface.

> In order to keep the clay moist when not working on it, lay flat and cover with damp cloths, laying a sheet of plastic material on top to prevent air getting to it. Keep cloth from actual surface of relief as required.[1]

Composition, Design

The relief you wish to make should be visualized beforehand. Relief strongly depends on a prepared drawing or design. There are a number of ways a sculptor composes a design for his relief: (a) by drawing a design on the wooden board itself (b) by drawing the design directly on the clay or plasteline surface (c) by drawing a full-size design on tracing or other thin paper, and transferring it to the clay or plasteline background with a pointed tool, or punching tiny holes along the outline (d) by "squaring up," which is transferring a small design on paper to a larger design on the material. This is done (i) by drawing on paper the design in squares (ii) the design on each square of the paper is

SQUARING UP

then drawn on the material, transferred proportionately larger to the corresponding larger square on the material until the whole design is carried over to the material. Drawing or tracing the design on the clay or plasteline surface are the more common methods as they allow for freedom of change or correction directly on the material; in tracing, however, you have the advantage of retaining the original drawing. Of course, none of these methods are needed by the skilled sculptor if he is capable of building up his forms directly without such guidance.

When composing, keep the design in profile. Avoid a three-quarters view which presents problems of foreshortening. Plan your composition carefully. It can be drawn on paper, and enlarged to exact size of relief. This can be traced or redrawn on the board or clay. Or better still, a small clay sketch can be made in proportion to the proposed relief. This can be very helpful when determining the depth of the various parts.[9]

The silhouette is of the first importance, and should be emphasized on the drawing in order that we may easily appreciate the relative value of the shape made by the pattern against the plain area of the background.[8]

The approximate design is drawn on a sheet of paper and traced through to the sheet of clay. On the sheet of clay the pressure of a wood tool is enough for transferring your drawing.[11]

If desired, full-sized drawing of subject can be transferred to panel from tissue or other soft and thin paper by pricking holes along the lines. But it is usually better, in a sense, that it allows more freedom, to draw the design directly on the clay.[1]

It is well to keep a definite outline edge always in relief so that the design will not fade out into the background.[6]

Two Methods of Making a Projected Relief

How are you going to make your projected relief? Will you be cutting back the relief by lowering the background around the relief outline, or will you be building up the forms enclosed by the outline outwardly from the background by the addition of material? With the subject-matter and treatment visualized beforehand, the possibilities of developing a good relief will be considerably enhanced. Present-day procedure (no doubt influenced by the softness of clay or plasteline as your medium) is to build up the subject-matter or design on the firm, flat surface of the clay or plasteline (modeling process), rather than the cutting away of the material from the surface (carving process). Both methods are used, however, with a great deal of esthetic satisfaction. In the modeling process, the concept should be one of the raised clay

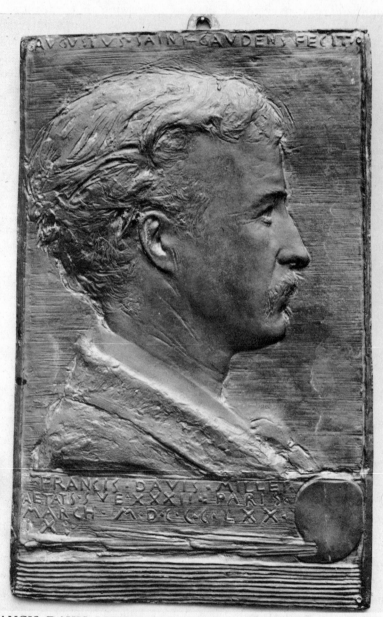

FRANCIS DAVIS MILLET, by Augustus Saint-Gaudens (1848–1907).
The Metropolitan Museum of Art, Gift of Mrs. F. W. Adlard, 1910.

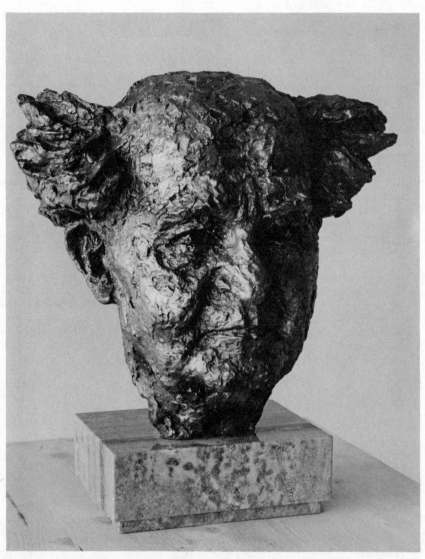

DAVID BEN-GURION, by Benno Schotz. *The Israel Museum, Jerusalem.*

or plasteline being an outward emergence, a living growth from the paternal background; in the carving process, there should be a feeling of unity with the solid mass of material from which the design is being freed and given life.

When you have drawn your design on the smooth surface, you have a choice of two procedures. You may scoop out to a depth of perhaps ½″ all around the outlines of your drawn design, thereby throwing the drawing into relief against a lowered background. Or you may simply regard the base as a platform upon which you add clay to build the figures of your design, raising them above the surface of the placque. You will, of course, be three sided rather than four, the fourth being suggested within the flat placque area. You may combine the two methods described here, using both the cut around and the build up. The choice of methods depends entirely on the needs of your concept.[12]

You may use several methods of making a relief, or you may prefer a combination of them. Either draw the design on board, and then using the board as a background, build the forms within the designated area. Or build up a solid clay mass the desired thickness, flatten the surface, and with a modeling tool or nail draw the design on the clay. Then scoop away the background. The forms can be developed in the raised area.[9]

In its simplest essential a relief may be merely a flat shape—figure or pattern—separated from its ground, either by the background being sunk back around its outline, or by the shape enclosed by the outline being raised from the plane of the background. It will be seen at once that the first method suggests cutting back the clay which is to form the background and is in a sense more suited to carving a hard material—though this can, in fact, be done quite easily in clay by using a flat-ended wire tool—whereas the second method is more suited to clay thought of as a soft pliable material. In practice there is nothing very much against either method in commencing a relief.[1]

There are two main methods used for producing a relief sculpture: (1) A built up relief on an established background (2) A carved relief from an established background. Both methods, although they differ in procedure, have the same esthetic objective. This is to create within a materially limited area the illusion of full-bodied shape—the same qualities as sculpture in the full round. There must be an over-all sense of unified shape.[11]

Relief Types

Low-Relief (Bas-Relief or Basso-Relievo)

In a low relief, the total height or projection of the raised parts from the background is limited. However, sufficient variations in planes and in shapes within the design must be arranged in a unified way to express desired depth. In low-relief, patterns of light and shadow play an essential part in creating the illusion of depth.

This type of relief is usually made without undercuts. Low-relief is particularly adapted for placement in shaded or dark locations where direct light does not over-influence light and shadow. Low-relief should be placed as accessible as possible, and as near to the eye level as possible, in order for it to be seen. Coins, and most medals and placques, are in the low-relief category.

All sculpture panels attached to or carved into walls are generally listed under one heading—Reliefs. Bas-Reliefs are sculpture panels that have a very slight projection from their background.[11]

Medium-Relief (Half-Relief or Mezzo-Relievo)

Differences between low-relief and high-relief is a matter of degree of projection. In-between is "medium-relief" whose raised parts from the background would be a little higher than low-relief, and often uses undercuts to give some roundness to the forms. It is not advisable to position medium-relief as high as high-relief where the onlooker is unable to discern the medium-relief projections, particularly from a distance. When too high or too distant, prominences in medium-relief is less distinguishable than in high-relief at the same height or distance. Forms and outlines under such circumstance becomes indistinct, and the appearance of roundness is lost. Medium-relief is best placed in an interior where there is visual accessibility to it.

High-Relief (Haut-Relief or Alto-Relievo)

High-relief protrudes more than low-relief or medium-relief, and some of its parts (arms, legs, as an example) may be almost entirely free. This type of relief can be an almost fully modeled shape in the round so long as it is not detached altogether from its background. Its modeling is so free that it might be a sculpture in the round, except for its attachment to the background. High-relief is usually placed in the highest part of a sculptural monument, building, etc. where it can be seen from a distance—and when exposed to full daylight. The full daylight invites and throws back light on the flat surfaces, and its projections cast shadows. The full value of high-relief is thus obtained.

Sculptors have worked in such high-relief as to make their placque a vertical background for virtually four-sided figures.[12]

The relief can be any depth, from very flat to medium to high (which can be almost full round, except that it is still set against a background).[9]

Alto Reliefs (high reliefs) have as much projection as a full-standing sculptured shape but still must be considered as reliefs since they are attached to and often composed on a wall or a panel limitation.[11]

Intaglio-Relief

When a relief is incised, that is to say, when the design is re-
cessed below the surface, it is called "intaglio." In this type of
relief, the highest points of projection are on level with the flat
surface. Clay and plasteline do not readily lend themselves to
intaglio because of the softness of material, hence you find this
type of relief sculpture on hard substances like wood, granite, or
marble. On clay or plasteline, lettering, however, is usually incised,
rather than building up the lettering on the surface.

> There are some reliefs that are incised and go beneath the background
> surface. This is known as "intaglio."[9]

Development of Relief Forms

Relief sculpture seeks the appearance of roundness in shape.
This effect is produced in a combination of ways: changes and
shapes of planes, the super-position of one plane over another,
levels of planes, heights of projections and recessions. It is these
different levels of relief planes, and these different variations in
form which give the illusion of depth, and its accompanying appear-
ance of roundness. This represents no small problem to the sculp-
tor, for the difficulties of effecting the perspective of roundness
needs both careful planning and skill to complete. Projections and
recessions, so essential to relief, must have a well-balanced rela-
tionship one to the other for tonal effects of light and shade. Con-
sideration must be given to architectural surroundings, and height
at which the work is to be placed. Outline of the raised form as it
joins the plane of the background—both the extreme outer back-
ground, or any subsidiary inside background—must be appropri-
ately treated: for incisiveness, by cutting back the design sharply;
for refinement, through soft blending; or any other manner that
will best define the rhythmical pattern of the design. No part of
a projected relief should ever go below the level of the background
plane. Forms must be conceived in relation to each other to give
unifying and harmonious effect to the whole sculptural piece. The
aspiring sculptor should avoid elaborate designs requiring sub-
stantial modeling or carving. Simplicity should be the main pattern
of the design, whether it be a portrait or figure.

> Some portion of the form can become a standard of the measure of pro-
> jection. Some of the forms may be rounded to give breadth and softness.
> Some of the returns, particularly toward the background at the edge, may
> be cut back sharply to give incisiveness to the design as a whole. In low-
> relief too soft an approach to background, or from one plane to another,
> can devitalize the work, although it may give refinement. A nice point

between the emptiness of too little modeling and the lumpiness of over-emphasis is something to be sought for. Simplicity gives breadth—over-emphasis of modeling and detail, smallness. The deepest hollows should be somewhat above the background level. A beautiful or otherwise expressive distribution of projection and recession, making the tonal relationship of the lights and darks meaningful as design, and well integrated over the whole panel, is the desideratum.[1]

Illusion of Depth

The novice should remember that there must be a harmony of planes, and in such a way as to give the illusion of greater depth than is actually there. Overlapping planes, the slanting or beveling back of a plane as it joins one in front, the distance-levels of the various planes of the form, projections and recessions—each help by its variations and contrasts to create the depth illusion. Reflections of light and shadow play a strong role in creating illusions of depth: strong light, like sunshine, when thrown on higher flat surfaces and projections, cast their shadows in depressed areas alongside of them—suggestions of depth also comes from light's play on the turns and sides of a plane, whether it be that of added light or deeper shadow. The illusion of depth, which gives the appearance of roundness to the form, is a basic principle of relief sculpture, and its accomplishment is indeed a major task for the sculptor.

Relief Casting by "Waste Mold"

The purpose of transferring a model of moist clay (or plasteline), since both of these substances are fragile, into a relatively durable plaster cast, is known as casting. This intermediate step is necessary for the final casting from the plaster cast to metal bronze.

At this point, it is suggested that you re-read Chapter 27 "Plaster Casting by 'Waste Mold'" for additional details on casting. It will help you to make a better relief cast.

For modeling, you had previously built a wall or fence on four sides of the board to contain the moist clay or plasteline. You had built it to the desired top level of the background (about three-quarters of an inch on an average), and, if needed, increased its height slightly higher than the highest point in the relief. We will assume that upon the background you built up your clay or plasteline sculptural forms. Upon completion of the modeling, you will need a still higher fence to contain the negative plaster mold, hence add height to your present fence, say about three-quarters of

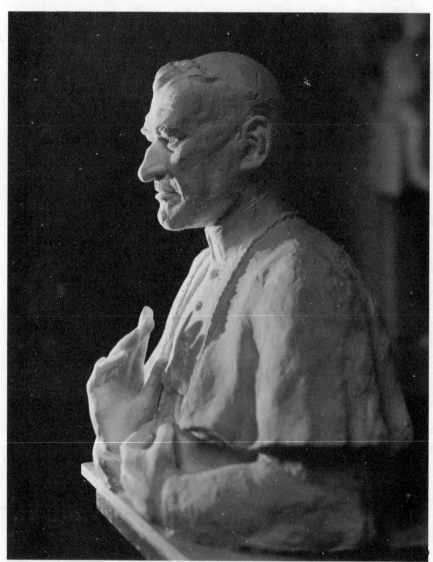

HIS EMINENCE, RICHARD CARDINAL CUSHING, by D'Suzanne
Silvercruys. *Courtesy of the Artist.*

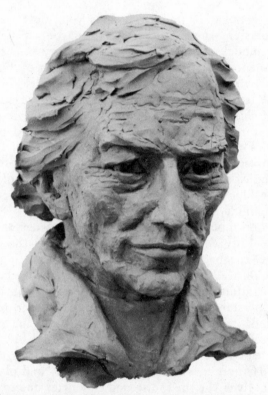

PADRE EUSEBIO FRANCISCO KINO (representing State of Arizona in Capitol Rotunda, Washington, D.C.), by D'Suzanne Silvercruys. *Courtesy of the Artist.*

an inch to one inch. Screw on this additional height of fence to the present one before pouring the negative plaster mold.

It is assumed that you kept the clay relief moist up to this point. Before pouring the negative mold, give the clay an additional moistening by spraying a thin coating of clean water. This will help to prevent air bubbles in the mold, and it will also act as a mild separator.

In making a negative mold, which is your next step, the first pouring of plaster which first comes into contact with the clay or plasteline model, should be of a consistency thin enough that it may freely enter all the crevices and hollows of the model. It should be a normal mix as discussed in Chapter 27, ("Plaster Casting by Waste Mold") and blue colored for reasons also discussed in that chapter. Rock the piece after pouring to ensure that the plaster enters all the crevices and hollows, and to eliminate any air bubbles developed while pouring the plaster. If there are air bubbles present, rocking will bring them to the surface. The second pouring of plaster to complete the negative mold is a white coat over the blue layer, and the thickness of both coats should be to the height of the containing wall or fence. This application of white plaster should be of a heavier consistency than the first coat as more fully explained in Chapter 27. If the size of the relief is large, the back of the negative mold (facing you) may be reinforced before it sets by pressing in strips of burlap saturated in plaster. In addition, some sculptors press in thin metal rods saturated in plaster to strengthen the mold. After the negative mold has dried, it is ready to be removed. First, unscrew the top section of the fence, or perhaps both the top and bottom sections of the fence will have to be unscrewed to facilitate the removal of the mold. If there are no undercuts, the clay and plaster should separate themselves (as the moistened clay dries due to the absorption of its moisture by the plaster, it should shrink away from the negative plaster mold), and you should find the negative mold lifting off the clay model without too much trouble. You should likewise have no trouble with the separation of plaster from plasteline.

After the mold is removed, and before the pouring of the positive cast, the inner surfaces of the mold should be cleaned, soaped, treated with separator, and re-touched, if needed. Read Chapter 27 for appropriate procedures.

It is now ready for the pouring of plaster for the positive cast. Before pouring, however, reset both the top and bottom sections of the fence to enclose the mold and to contain the new plaster for the positive cast. Remember to apply some olive oil sparingly to the sides of the fence to facilitate its separation from the positive cast.

Pour a normal mix of plaster to the height of the top level of
the fence, rocking the piece to remove any air bubbles. Strips of
burlap saturated in plaster may be used to strengthen the positive
cast, if large enough to be required. Flatten surface of the positive
cast facing you. When plaster is thoroughly dry, and if there are
no undercuts for the plaster to cling to, the negative mold may
come off without chipping. Try tapping it lightly with a mallet or
light hammer to help separate the mold from the positive cast.
If mold comes off whole without chipping, it can be used again
to make other positive casts. Obviously, if mold is not destroyed
by chipping, it can be said of it that it is not a "waste mold." If
the mold does not release itself in whole, it must be chipped away.
Further reading of Chapter 27 on chipping will be most helpful.
The use of self-hardening clay (*see* Chapter 7) eliminates the
need for casting.

Hanging On Walls

The relief you will be doing will eventually hang on a wall,
framed or unframed. It is best to hang a relief in the same manner
that paintings are hung: with the middle at eye level of a standing
adult. It should be hung flat, of course—not tilted. Proper light-
ing will enhance the effect of a relief. For hanging without a frame,
provide holes in the upper left and right corners of the cast when
it is dry. An electric drill is a good tool to make holes. Insert a
bolt and nut in each hole. Tie wire for hanging to the bolt and
nut exposed on the rear. A form for hanging, set in the plaster
before it dries, also makes a suitable means for hanging a relief.

You will probably want to hang the relief, so set a preformed wire
hanger into the plaster before it sets.[9]

Reliefs hang on the wall and require less space than a head in the round,
and there seems always to be a demand for them.[2]

Architectural Sculpture

In the past history of sculpture, a great deal of artistic accom-
plishment was in the form of architectural sculpture, designed to
give dignity and beauty to public edifices. It was a permanent,
integral part of the building, rather than a mere decoration. In
recent years, much architectural sculpture, generally for ornamental
purposes, was poorly produced and without esthetic considerations,
more or less planned as an afterthought instead of being treated
beforehand in harmonious relationships with the architectural

background. Today we find sculptors collaborating with the architect in designing for architectural sculpture—studying type and use of building and its architectural style, building construction material, environment or surrounding in which the work will be set, its proportions in relation to the size of the building, perspectives of height and distance, how the work will best be seen by the beholder—in order to achieve a unifying and harmonious relationship of sculpture and building. Today greater interest in architectural sculpture is being manifest in the efforts of industry and the various levels of government to beautify their buildings and surrounding areas—for example, the city of Philadelphia under a 1959 ordinance sets aside one percent of the cost of public buildings for artistic beauty. Other communities are following this idea.

All relief sculpture (except medallions, coins, etc.), whether high or low, should be considered as features of architectural sculpture. Even portrait bas-reliefs and placques will eventually be hung on some wall since they cannot be exhibited properly any other way. They must be considered as wall sculpture, therefore architectural sculpture.[11]

Knowledge of perspective and the principles of architecture should be part of a sculptor's mental equipment, for he should be able to read and visualize at a glance any plan or elevation of a garden or building. The artist would do well to give himself constant memory tests in gauging distances, heights, etc., so that when he is confronted with a proposed site he can calculate accurately the size and proportions of the sculpture needed, or the distances from which the group, figure, or medallion will be seen.[6]

Detached Bases

Type, Size, Color, Mounting

Detached bases may be made of any solid substance—wood, stone, marble, etc. Wood is commonly used as it is readily available, and can be more easily cut to size and shape. Grained hardwood is especially desirable. Whatever may be the material selected for the base, it must be integrated with the sculpture above it.

Size of the detached base depends a great deal on the size of the portrait head or portrait bust above it, its relation to the site, and its position with regard to the spectator. The sculpture above the base must not appear top-heavy, hence the base must be of a size which is sufficient in proportion to balance the volume above it. Contrary-wise, if the portrait head or portrait bust is of a limited size, the detached base must not be so large as to dwarf it. A proportional balance must be obtained. It should have a functional value in keeping the piece above it steady in its upright position, and to prevent it from being knocked off.

Sculpture in the round should be placed at eye-level. The spectator's eyes must be so directed that he sees the form in the way the sculptor wishes to emphasize the work. Height of pedestal, if any, on which the work and base will rest must be considered to enhance the visual effect.

Color of base must be selected in keeping with the coloring or "patining" of the plaster cast (or self-hardening clay model), or the patination of the metal bronze.

Unity and harmony between sculpture and base is very important, and must be sought for. In all, presentation must be such that all the factors in the selection of the base gives maximum benefit to the portrait head or portrait bust. A visit to the art museums, exhibitions, and private galleries offer opportunities to see how the experts arrange their sculpture in mounting, placing and lighting.

The correct placing of works of art is something that is very often treated with total indifference, although much more pleasure might be

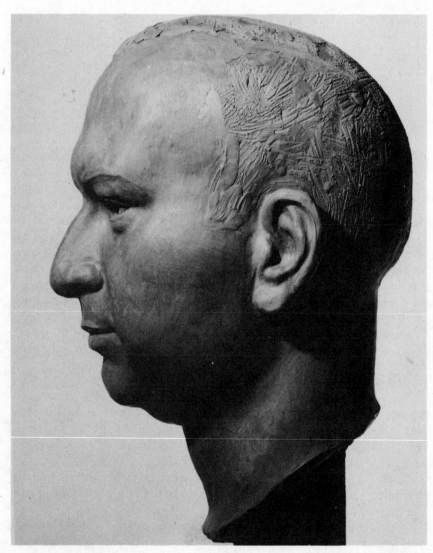

DR. RALPH E. SNYDER, by Louis Slobodkin. *Courtesy of the Artist.*

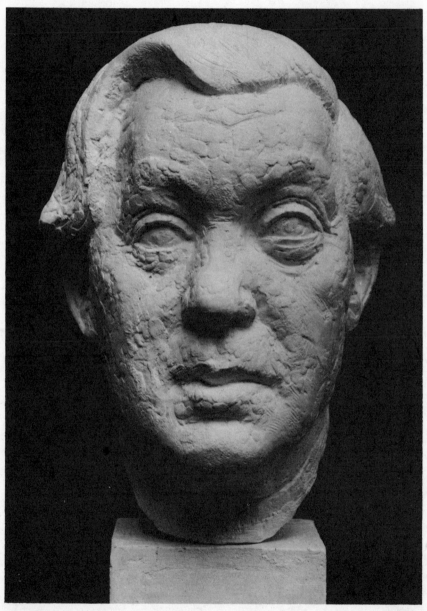

A. WALKOWITZ, by William Zorach (1887–1966). *The Zorach Collections, Brooklyn, N.Y.*

derived from marble and bronzes if the owners would spend a little time and money on their suitable mounting, placing and lighting.[6]

The base upon which the statue rests can be compared to a frame for a painting. A good statue can stand on its own without a base, but it never looks so good as it does with the right base, which can give it a finished look. For bronze, a fine marble or a beautifully grained hardwood provides the ideal complement for the sculptor's work.[3]

Fixing Work To Base

The work need not be fixed to a detached base, especially if it is placed in the home where it may be looked after with care; however, if you wish to fix the work to a detached base, there are a number of ways to do it. Two ways are common: (a) a rod placed in the positive cast when being cast, and then inserted into a partly or wholly drilled hole in the base (b) bolt and nut fixings of various types.

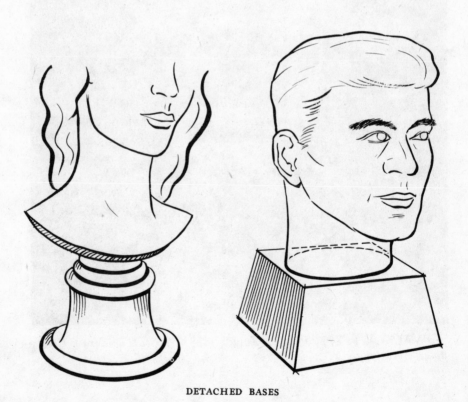

DETACHED BASES

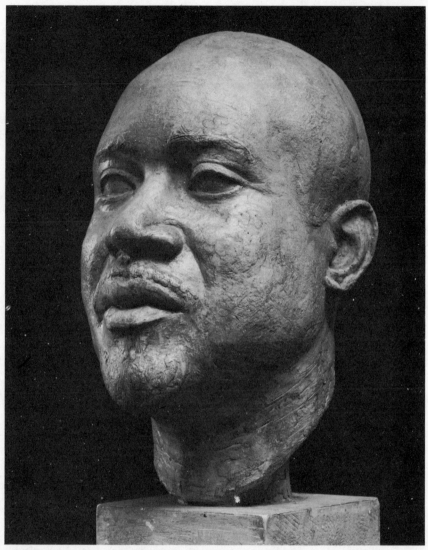

CHAUNCEY NORTHERN, by William Zorach (1887–1966). *The Zorach Collections, Brooklyn, N.Y.*

Staining and Waxing Woods

Staining for color over pine, fir or other light woods: apply stain with cloth and then wipe off. The use of a brush is not advised as it applies more stain than is necessary. For a dull finish, use wax after staining; for a lustre finish, apply varnish after staining. Because polishing and waxing may make the surface slippery and insecure, it would be well not to polish and wax the underside of the wooden base. Leave the underside rough, or glue a layer of felt to it which will both cushion it and prevent slipping.

33

Pictorial Epilogue

The reader, I am sure, would like to get a pictorial glimpse of the abstraction and the stylistic departures from representational portraiture in sculpture. On the following pages are photographic reproductions of the works of well-known sculptors whose creations are most illustrative of this phase of modern sculptural art.

Jettisoning naturalistic forms, these sculptors, with their new conceptions, came into being in the early years of the twentieth century because they found the range of nature's forms repetitious and restrictive, and posing limitations on their creative imagination. Some of these sculptors did away completely with realism as in the case of abstract, cubistic forms; other sculptors expressed themselves between the extremes of realism and abstraction in the area known as "stylization." In the latter area, simplified forms were favored over strict attachment to naturalistic forms. Though simplifying the realistic, they still wished to remain close to realism, even combining the two. These artists who favored abstracts and stylized forms saw limitless possibilities for inventiveness and creativity. New materials also influenced their thinking.

The Pictorial Epilogue shows various styles of sculptural heads and portrait busts in the abstract and stylistic categories. Pablo Picasso's and Jacques Lipchitz's cubistic heads—the gnarled, attentuated heads by Alberto Giacometti—the rounded, simplistic head by Constantin Brancusi—the elongated head by Amedeo Modigliani—the wrought iron heads of Pablo Gargallo and Julio Gonzalez—are some of the examples of this swing away from realism. These sculptural interpretations by no means cover all the categories of modern sculpture in portraiture. The diffusion of sculptural styles away from realistic portrayal is indeed diversified. This book, as stated above, offers but a pictorial glimpse of these abstractions and stylisitc departures from representational portraiture in sculpture, and of "construction portrait sculpture."

It should be obvious to the beginner, amateur and student that they must devote their energies first to the representational side of sculptural portraiture . . . that they must first give convincing

evidence of their abilities to express naturalistic forms before seeking to create forms away from realism—whether they are three-dimensional works of modeled portrait sculpture, or three-dimensional works in the form of "construction portrait sculpture" in metal or other mediums. They must prove their traditional craftsmanship on their journeys to newer forms. The modeling of head and portrait bust is the most convenient form of representational or naturalistic sculpture to achieve that end. Realistic modeling of portraitures also sets a standard of accomplishment for the aspiring sculptor, from which base of capability he can go on, if he wishes to create other forms to the limit of his imagination. *Modeled Portrait Sculpture* takes on an added value because it helps to instruct the aspiring sculptor in "first things first."

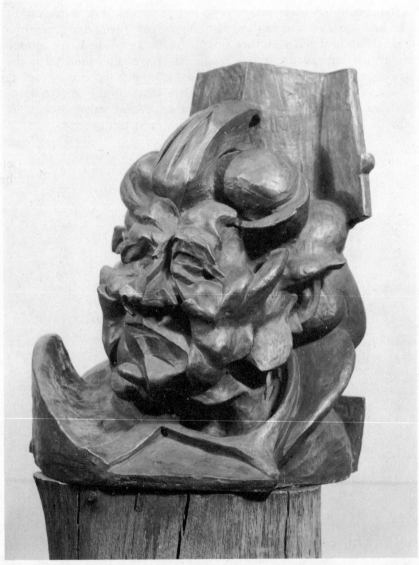

LA MADRE—THE ARTIST'S MOTHER, (Anti-Graceful) (1912),
by Umberto Boccioni (1882–1916). *The Lydia and Harry Lewis Winston
Collection. Courtesy of Lydia Winston Malbin, Birmingham, Michigan.*

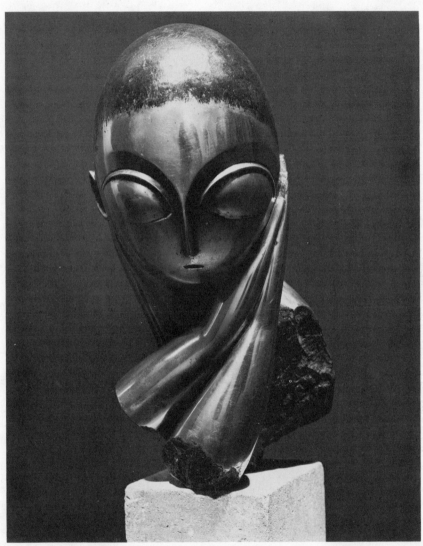

MLLE. POGANY (1913) (First stage after a marble of 1912), by Constantin Brancusi (1876–1957). *Collection, The Museum of Modern Art, New York. Acquired through the Lillie P. Bliss Bequest.*

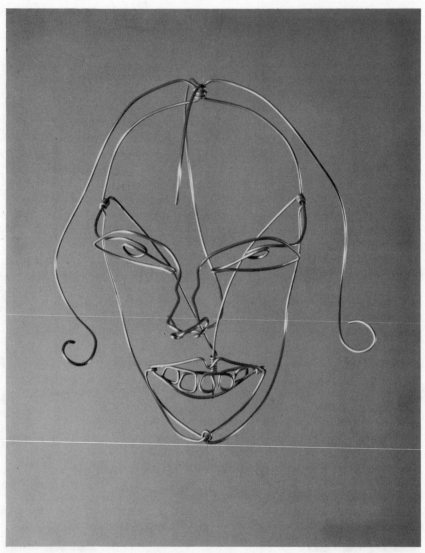

MARION GREENWOOD (1929–1930) (Brass wire), by Alexander
Calder. *Collection, The Museum of Modern Art, New York. Gift of the
Artist.*

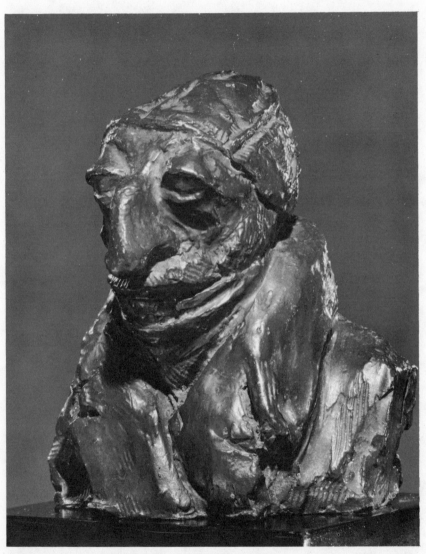

L'HOMME A TETE (c.1830–32), by Honore Daumier (1808–1878).
The Joseph H. Hirshhorn Collection, New York.

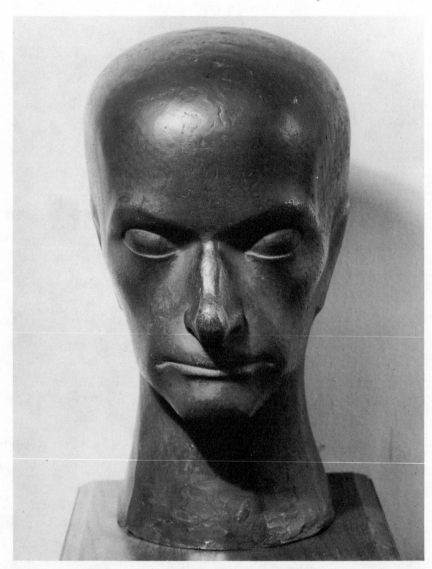

BAUDELAIRE (1911), by Raymond Duchamp-Villon (1876–1918). *Collection, The Museum of Modern Art, New York. Alexander M. Bing Bequest.*

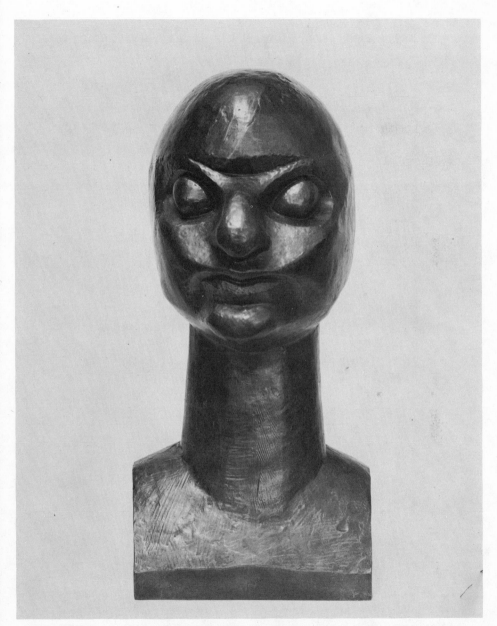

MAGGY (1911), by Raymond Duchamp-Villon (1876–1918). *The Solomon R. Guggenheim Museum, New York.*

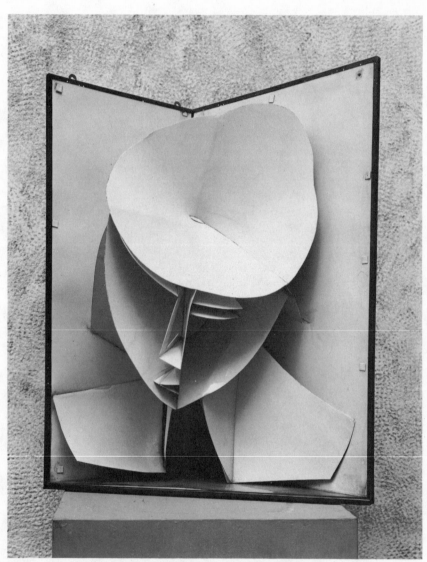

HEAD OF A WOMAN (c.1917–20) (Construction in celluloid and metal), by Naum Gabo. *Collection, The Museum of Modern Art, New York.*

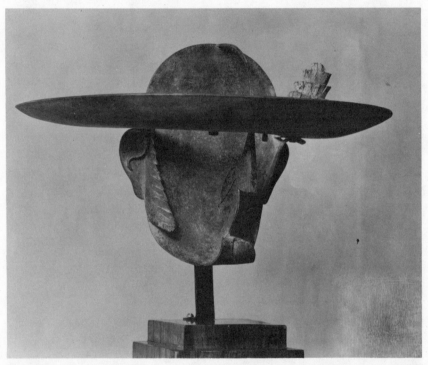

PICADOR (1928) (Wrought Iron), by Pablo Gargallo (1881–1934).
*Collection, The Museum of Modern Art, New York. Gift of A. Conger
Goodyear.*

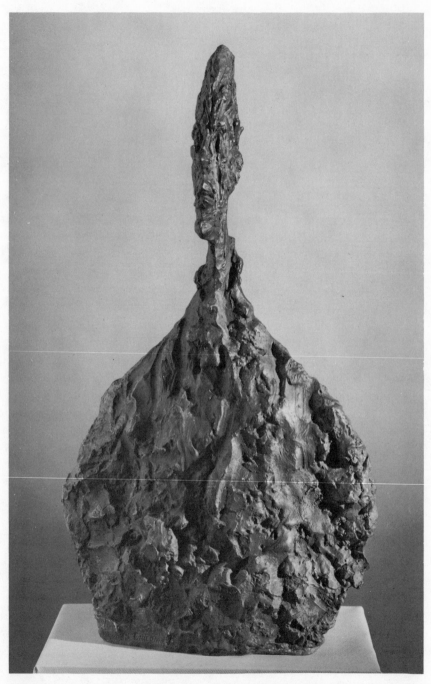

HEAD OF DIEGO (1955), Alberto Giacometti (1901–1966). *The Tate Gallery, London.*

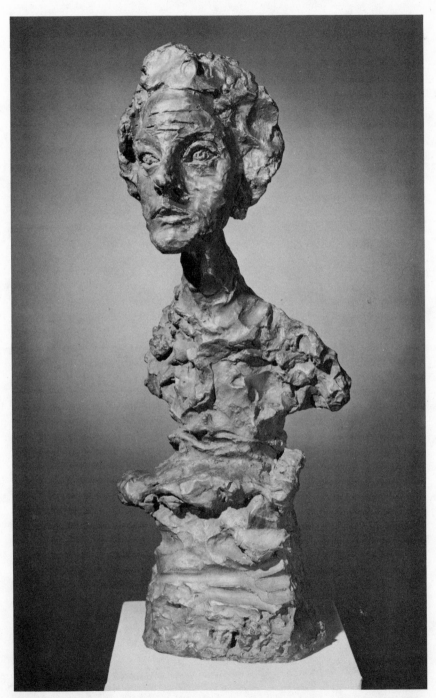

ANNETTE IV (1962), by Alberto Giacometti (1901–1966). *The Tate
Gallery, London.*

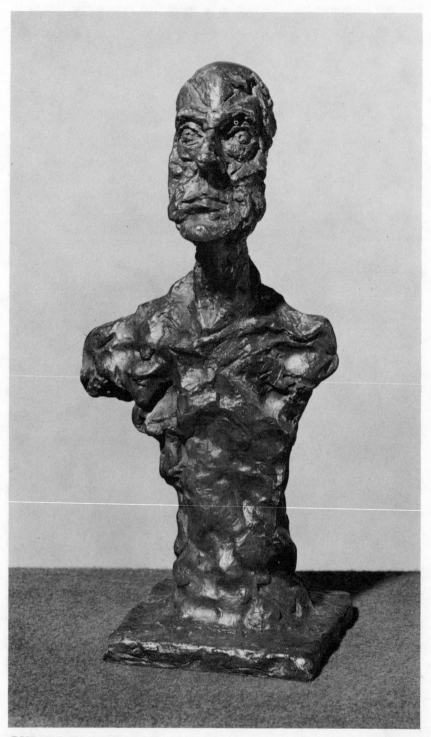

GHIAVENNA HEAD I, by Alberto Giacometti (1901-1966). *The Tate Gallery, London.*

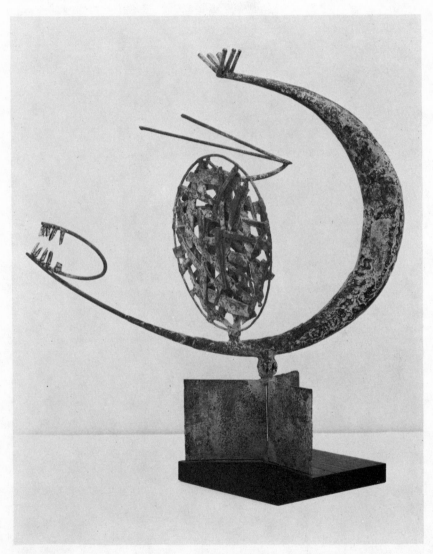

HEAD (1935 ?), by Julio Gonzalez (1876–1942). (Wrought Iron). *Collection, The Museum of Modern Art, New York.*

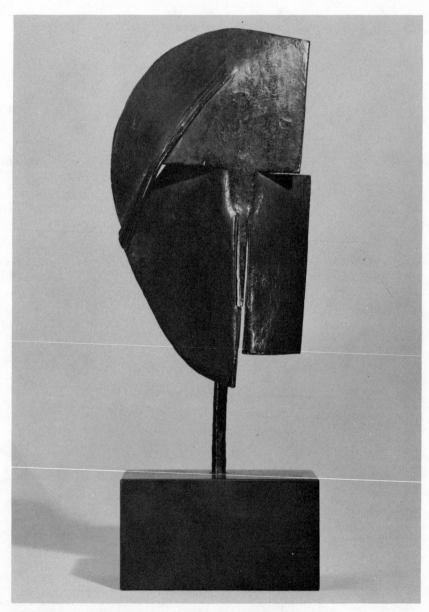

PETIT MASQUE (My), by Julio Gonzalez (1876–1942). *The Solomon R. Guggenheim Museum, New York. Gift, Mr. and Mrs. Andrew Fuller, New York.*

HEAD (1918) (Wood Construction), by Henri Laurens (1885–1954).
*Collection, The Museum of Modern Art, New York. Van Gogh Purchase
Fund.*

HEAD 1915, by Jacques Lipchitz. *The Tate Gallery, London.*

HEAD 1932, by Jacques Lipchitz. *Stedelijk Museum, Amsterdam.*

JEANNETTE I (Jeanne Vaderin, 1st. state) (1910), by Henri Matisse (1869–1954). *Collection, The Museum of Modern Art, New York. Acquired through the Lillie P. Bliss Bequest.*

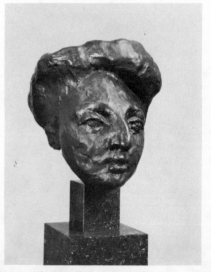

JEANNETTE II (Jeanne Vaderin, 2nd. state) (1910), by Henri Matisse (1869–1954). *Collection, The Museum of Modern Art, New York, Gift of Sidney Janis.*

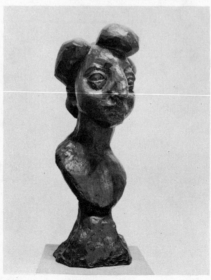

JEANNETTE III (Jeanne Vaderin, 3rd. state) (1910–11), by Henri Matisse (1869–1954). *Collection, The Museum of Modern Art, New York. Acquired through the Lillie P. Bliss Bequest.*

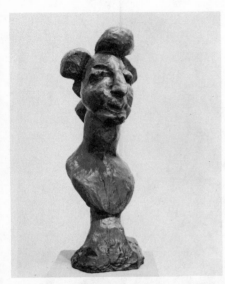

JEANNETTE IV (Jeanne Vaderin, 4th. state) (1910–11 ?), by Henri
Matisse (1869–1954). *Collection, The Museum of Modern Art, New York.*
Acquired through the Lillie P. Bliss Bequest.

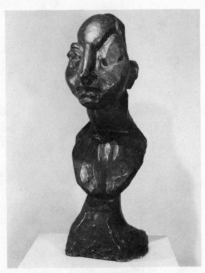

JEANNETTE V (Jeanne Vaderin, 5th. state) (1910–11 ?), by Henri
Matisse (1869–1954). *Collection, The Museum of Modern Art, New York.*
Acquired through the Lillie P. Bliss Bequest.

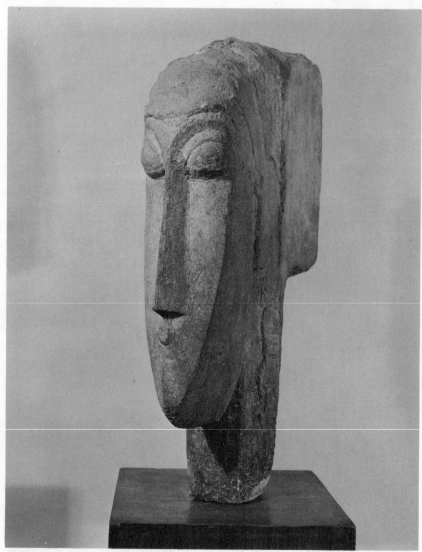

HEAD (1915 ?) (Stone), by Amedeo Modigliani (1884–1920). *Collection, The Museum of Modern Art, New York. Gift of Abby Aldrich Rockefeller in memory of Mrs. Cornelius J. Sullivan.*

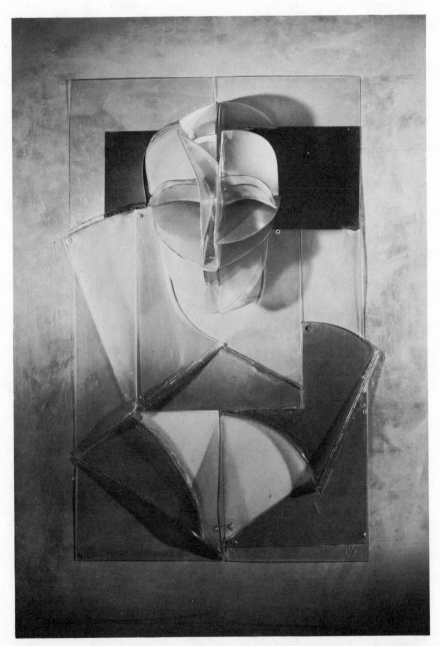

PORTRAIT OF MARCEL DUCHAMP (1926), by Antoine Pevsner (1886–1962). High relief construction, celluloid on copper (zinc). *Yale University Art Gallery, Societe Anonyme Collection, New Haven, Conn.*

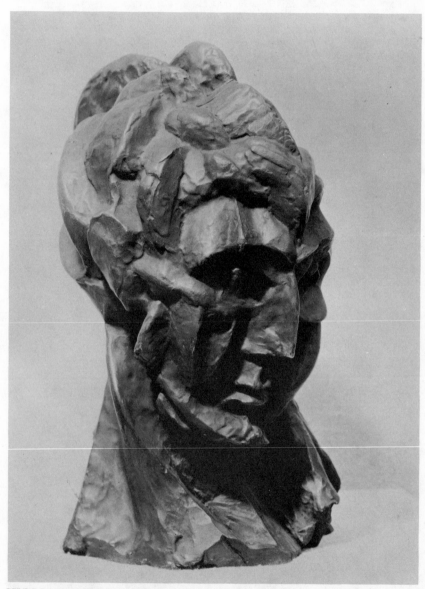

WOMAN'S HEAD 1909, by Pablo Picasso. *Collection, The Museum of Modern Art, New York.*

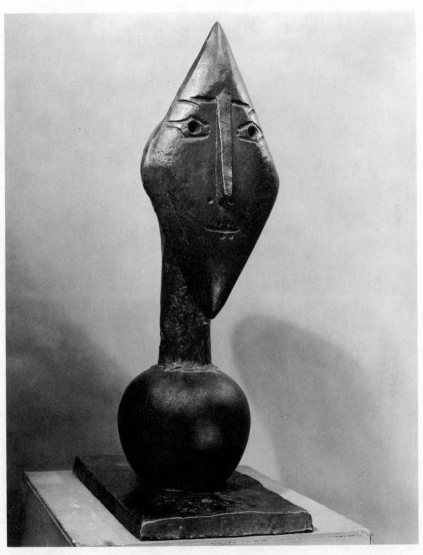

HEAD OF A WOMAN 1951, by Pablo Picasso. *Collection, The Museum of Modern Art, New York. Benjamin and David Scharps Fund.*

HEAD 1938 (Cast Iron and Steel), by David Smith (1906–1965). *Collection, The Museum of Modern Art, New York. Gift of Charles E. Merrill.*

Sources of Selected Quotations

as indicated by the numeral after each quotation

NUMERAL TITLE OF BOOK AUTHOR
Publisher

1. MODELED SCULPTURE & PLASTER CASTING — ARNOLD AUERBACH
Thomas Yoseloff, New York, 1961

2. FUN AND FUNDAMENTALS OF SCULPTURE — MARJORIE JAY DAINGERFIELD
Charles Scribner's Sons, New York, 1963

3. SCULPTURE — TECHNIQUES IN CLAY, WAX, SLATE — FRANK ELISCU
Chilton Company, Philadelphia, 1959

4. MODELLING & SCULPTURE — FREDERICK JAMES GLASS
Charles Scribner's Sons, New York, 1929
B. T. Batsford, Ltd., London

5. TECHNIQUES OF SCULPTURE — RUTH HARRIS & GIROLAMO PICCOLI
Harper & Row, New York, 1942

6. SCULPTURE — INSIDE AND OUT — MALVINA HOFFMAN
Crown Publishers, Inc., New York, 1939
W. W. Norton & Company, Inc., New York

7. MODELLED PORTRAIT HEADS — T. B. HUXLEY-JONES
Alec Tiranti, Ltd., London, 1960

8. MODELLING & SCULPTURE IN THE MAKING — SARGEANT JAGGER
The Viking Press, Inc., New York, 1933
Studio Vista, Ltd., London

9. SCULPTURE — LILLIAN JOHNSON
David McKay Company, Inc., New York, 1960

10. A PRIMER OF SCULP- SUZANNE SILVERCRUYS
 TURE G. P. Putnam's Sons, New
 York, 1942

11. SCULPTURE — PRIN- LOUIS SLOBODKIN
 CIPLES & PRACTICE The World Publishing Co.,
 New York, 1949

12. ANYONE CAN SCULPT ARTHUR ZAIDENBERG
 Harper & Row, New York,
 1952

13. ZORACH EXPLAINS WILLIAM ZORACH
 SCULPTURE Tudor Publishing Co., New
 York, 1960

14. PORTRAITS IN THE PHOEBE FLORY WALKER,
 MAKING DOROTHY SHORT and
 ELIOT O'HARA
 G. P. Putnam's Sons, New
 York, 1948

15. ART ANATOMY WILLIAM RIMMER
 Dover Publications, Inc., New
 York, 1962

16. ARTISTIC ANATOMY WALTER FARRINGTON
 MOSES
 Borden Publishing Co.,
 Alhambra, California, 1930

Index